Nineteenth-Century Watercolors

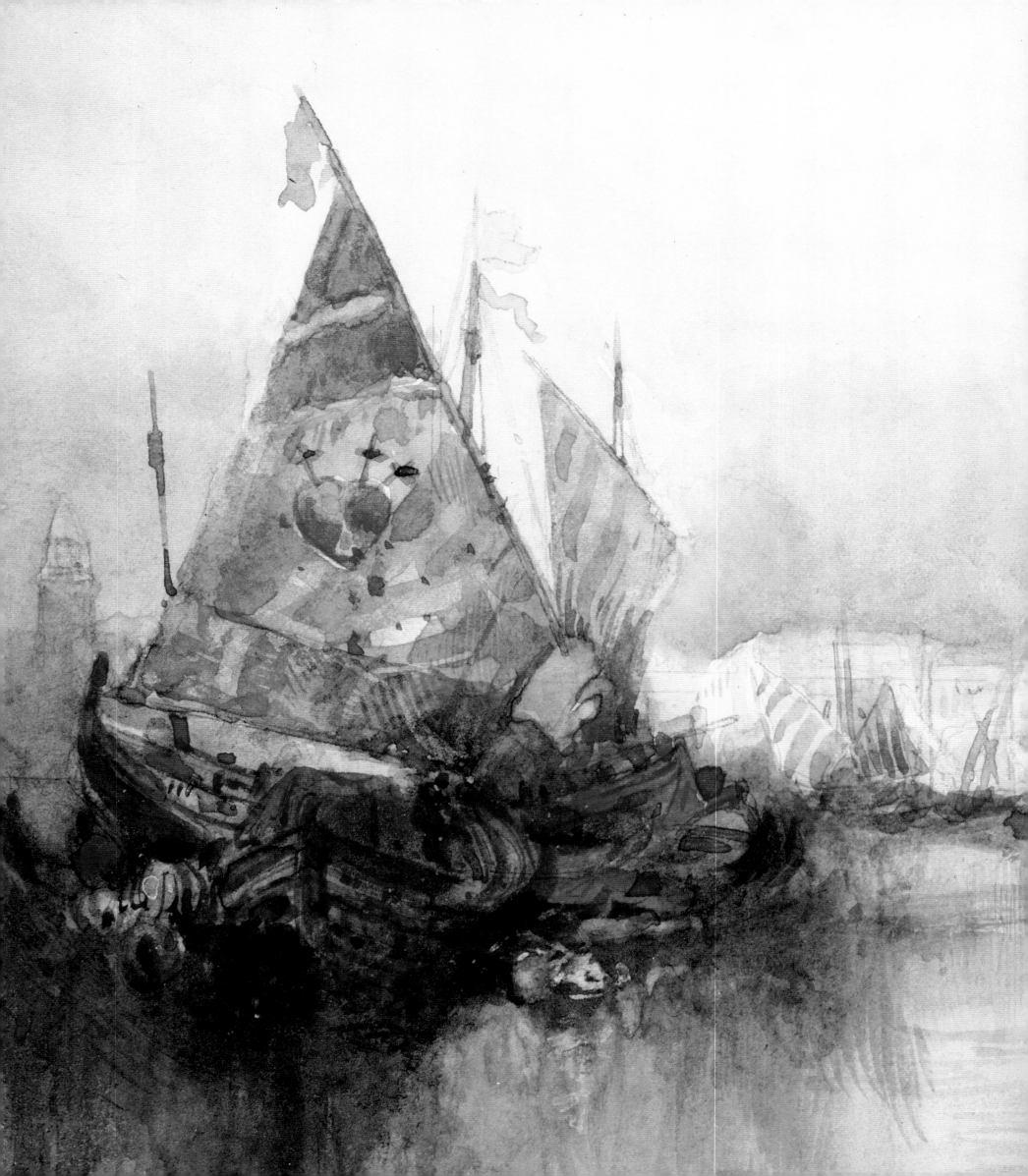

Christopher
FINCH

Nineteenth-Century Watercolors

Abbeville Press
Publishers • New York
London Paris

For Sam and Martha Peterson

EDITORS: Alan Axelrod and Cristine Mesch
DESIGNER: Nai Chang
PRODUCTION SUPERVISOR: Hope Koturo
PICTURE RESEARCHERS: Massoumeh Farman-
 Farmaian and Carol Haggerty

FRONT COVER: Winslow Homer. *Watching from the Cliffs*
 (detail), 1892. See plate 335.
BACK COVER: Paul Cézanne. *Still Life*, c. 1900–1906.
 See plate 369.
FRONTISPIECE: Thomas Moran. *Venice* (detail), 1896.
 See plate 253.

Library of Congress Cataloging-in-Publication Data

Finch, Christopher.
 Nineteenth-century watercolors / by Christopher Finch.
 p. cm.
 Includes bibliographical references and index.
 ISBN 1-55859-019-6
 1. Watercolor painting—19th century—History. I. Title.
 II. Title: 19th-century watercolors.
 ND1797.F56 1991
 759.05—dc20 91-21463
 CIP

Table of Contents

Introduction

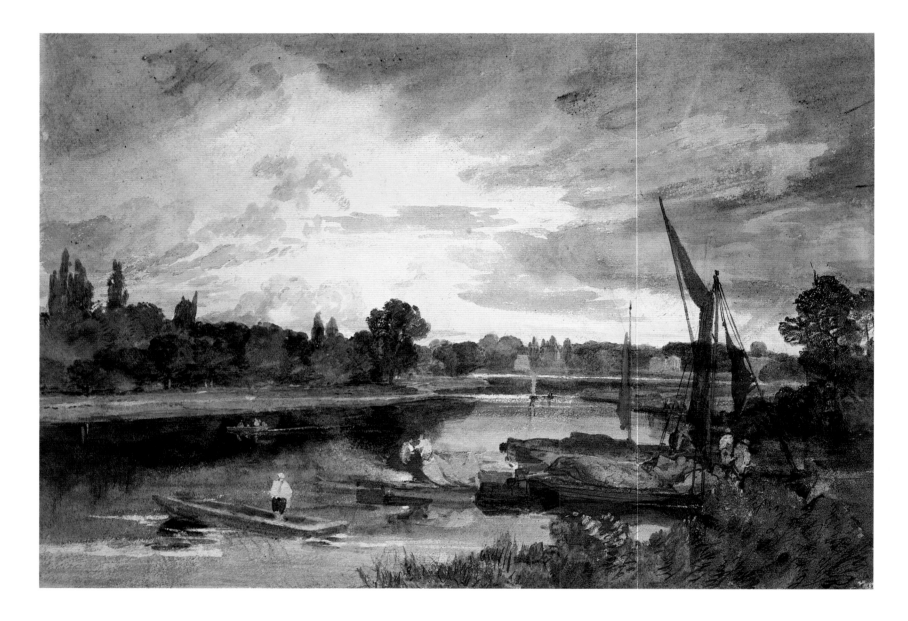

1. Joseph Mallord William Turner
(1775–1851)
*Scene on the Thames with Barges
and Figures*, c. 1805–6
Pencil and watercolor on paper,
10⅛ × 14⅜ in. (25.8 × 36.5 cm)
Tate Gallery, London; Clore
Collection; Courtesy Art
Resource, New York

The history of watercolor in the nineteenth century resounds with individual triumphs that, taken as a body of work, constitute one of the most felicitous episodes in the annals of Western art. So pleasurable are the accomplishments of watercolorists during this period that the importance of the discipline's achievements to the evolution of art as a whole has often been overlooked.

The watercolor tradition, in the form of the British School, came of age with the new century, bringing with it one of the greatest of all watercolorists, Joseph Mallord William Turner (plate 1), whose practices influenced advanced art for two generations. The century ended with the culmination of the career of another superlative master of the medium, Paul Cézanne, whose watercolors were to have a crucial impact upon the evolution and character of modernism. In between came other key figures who turned to watercolor at important moments, and scores of gifted *petits-maîtres* who made watercolor their chief means of expression.

Why did watercolor painting thrive in the nineteenth century? In part, at least, because the portability of the medium was ideally suited to the spirit of an age in which the more free-spirited artists placed much emphasis upon a direct response to nature. When the Impressionists began to set up their easels beside the Seine or on the beaches of Normandy in the 1860s, they were following a practice that had been espoused by watercolorists a century and more earlier. At the same time, watercolor proved to be so adaptable that it lent itself well to the needs of social commentators, satirists, fantasists, and even historical painters.

It is the intimate quality of nineteenth-century watercolors that is most likely to appeal to the modern viewer. Turner might record awesome Alpine scenery, and Delacroix might take his sketchbook and colors into exotic Moroccan locations, but they set down what they saw with immediacy and intimacy. Used fluently, watercolor records not only what is seen, but also the actual thought processes of the artist, since the way the image has been set down remains apparent in the end product. Because the washes are transparent, the underpainting, along with the sequence of various intermediate phases, is visible in the finished work. This is one reason why watercolor is such a demanding medium; it tolerates few errors. Another prime reason, which also contributes to the strongly personal character of the medium, is that its fluidity demands quick decisions and rapid execution, so that the artist must rely on the accuracy and sureness of his touch and on the individuality of his calligraphy. In the hands of masters like John Sell Cotman, Richard Parkes Bonington, Adolf von Menzel, and Winslow Homer, such qualities become a form of handwriting that is finally inimitable, no matter how often it is imitated.

To a large extent, art historians have perceived nineteenth-century art as a battleground on which radicals, seeking a return to first principles, were pitted against what they perceived as the dead hand of the academy. Within this context, most of the great watercolorists have been placed, retrospectively, in the camp of the radicals (a location that might surprise some of them) largely because freshness is so inherent in the medium that watercolorists anticipated almost by accident advances that the Impressionists and others had to fight for. Certainly, watercolors were hung in the salons—where they must have seemed as welcome as a salad at the conclusion of a nine-course Victorian banquet—but they were always at odds with the suffocating airlessness of much official art. Even academic watercolors offered a relative lightness of touch, and the masters of the medium have provided us with much of what was and is most admirable in the art of the nineteenth century.

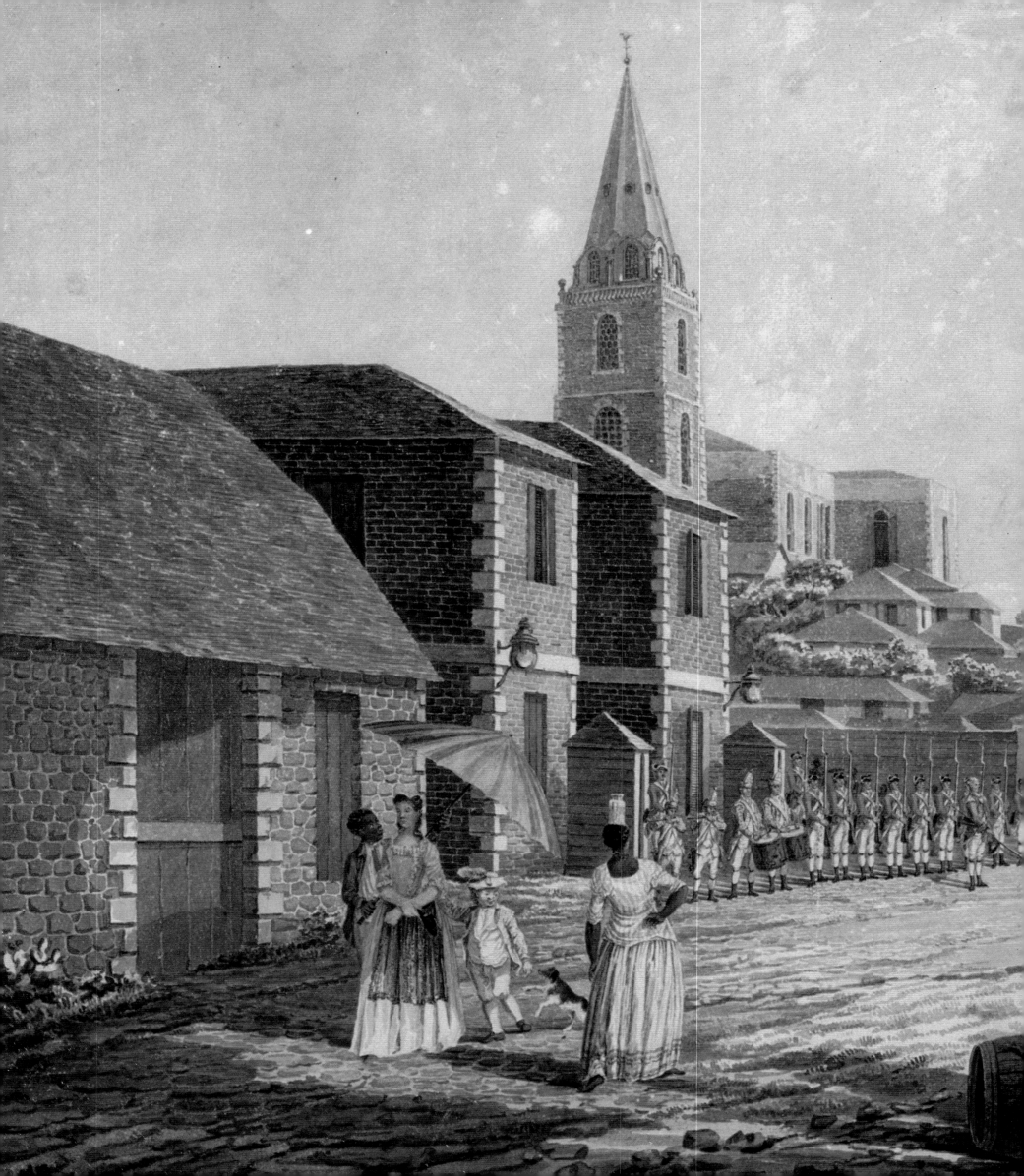

ONE

The Origins of a Tradition

2. Thomas Hearne
St. John's, Antigua, n.d.
Detail of plate 17

Artists have used water-based colors since prehistoric times, and great schools of painting dependent upon some form of watercolor have thrived in the Near and Far East. In the West, however, the term *watercolor* has come to describe a very specific method of painting (though some call it drawing) in which the image is built from superimposed layers of transparent colored wash. The tools used are soft brushes (once called pencils) and pigments, generally bound with gum arabic, that are capable of being dissolved in water. The usual support is paper, specially prepared with a size that prevents the fibers from soaking up the washes (though a few artists have preferred more absorbent papers). Sometimes transparent watercolor is used in conjunction with gouache, otherwise known as body color, a similar form of water-based paint that differs in that the colored pigments are blended with Chinese white to render them opaque. Some watercolor purists eschew the use of body color, but in the right hands it can be employed very effectively.

Among the obvious antecedents of the modern watercolor tradition are the illuminated manuscripts of the Middle Ages and the miniature portraits—popular from the sixteenth century into the early nineteenth—in which transparent water-based colors were used on a support such as card or ivory. Less often remarked on is the relationship between watercolor and cartography. Old maps were often tinted with watercolor and sometimes enhanced with imagery. Moreover, the mapmakers who traveled on the voyages of discovery and colonization often doubled as artists whose dual responsibility was preparing maps and making a visual record of flora and fauna, native types encountered, and so forth, especially where these might be of future commercial interest. Such men were Jacques Le Moyne de Morgues and John White, who visited the New World in the second half of the sixteenth century. White's studies of Indian life in Virginia are remarkably fresh and anticipate the aes-

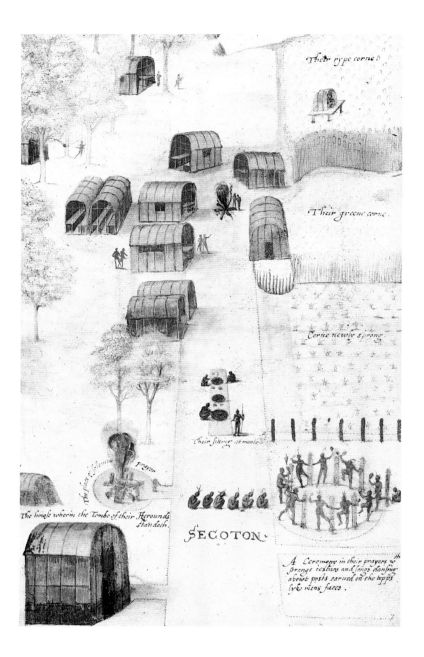

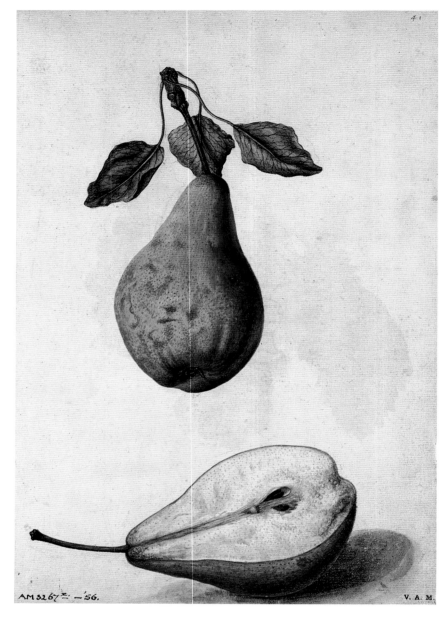

ABOVE, LEFT

3. John White (active 1575–1593)
Indian Village of Secoton, c. 1585
Watercolor on paper,
12¾ × 7¾ in. (32.4 × 19.7 cm)
British Museum, London

ABOVE, RIGHT

4. Jacques Le Moyne de Morgues
(d. 1588)
A Pear, c. 1568
Watercolor on paper,
10¾ × 7½ in. (27.3 × 19.1 cm)
Victoria and Albert Museum, London

OPPOSITE

5. Albrecht Dürer (1471–1528)
The Hare, 1502
Watercolor and gouache on paper,
9⅞ × 8¹⁵⁄₁₆ in. (25.1 × 22.7 cm)
Graphische Sammlung
Albertina, Vienna

thetic that would be espoused by later British watercolorists (plate 3). Le Moyne de Morgues, a French Huguenot who was exiled to England, also contributed to the development of the British School by helping establish a tradition of botanical draftsmanship that would become an important tributary to the mainstream of watercolor painting (plate 4).

To go back even further, the portability of watercolor (though prepared colors and papers were a thing of the future) may well have been a factor in recommending the medium to Albrecht Dürer, when he traveled to and from Italy in 1494–95. During these journeys he made remarkable landscape studies that anticipate the technical approach some watercolor specialists would adopt three hundred years and more later. He continued to employ watercolor to make landscape sketches and close studies of animals (plate 5) or of nature, such as John Ruskin and his disciples might have admired, but he seems to have attached little importance to this aspect of his work, and it produced no significant school of followers, though his great contemporary Lucas Cranach the Elder also made some fine watercolor studies. During the next two centuries artists such as Peter Paul Rubens and Anthony Van Dyck (plate 6) made occasional landscapes in watercolor.

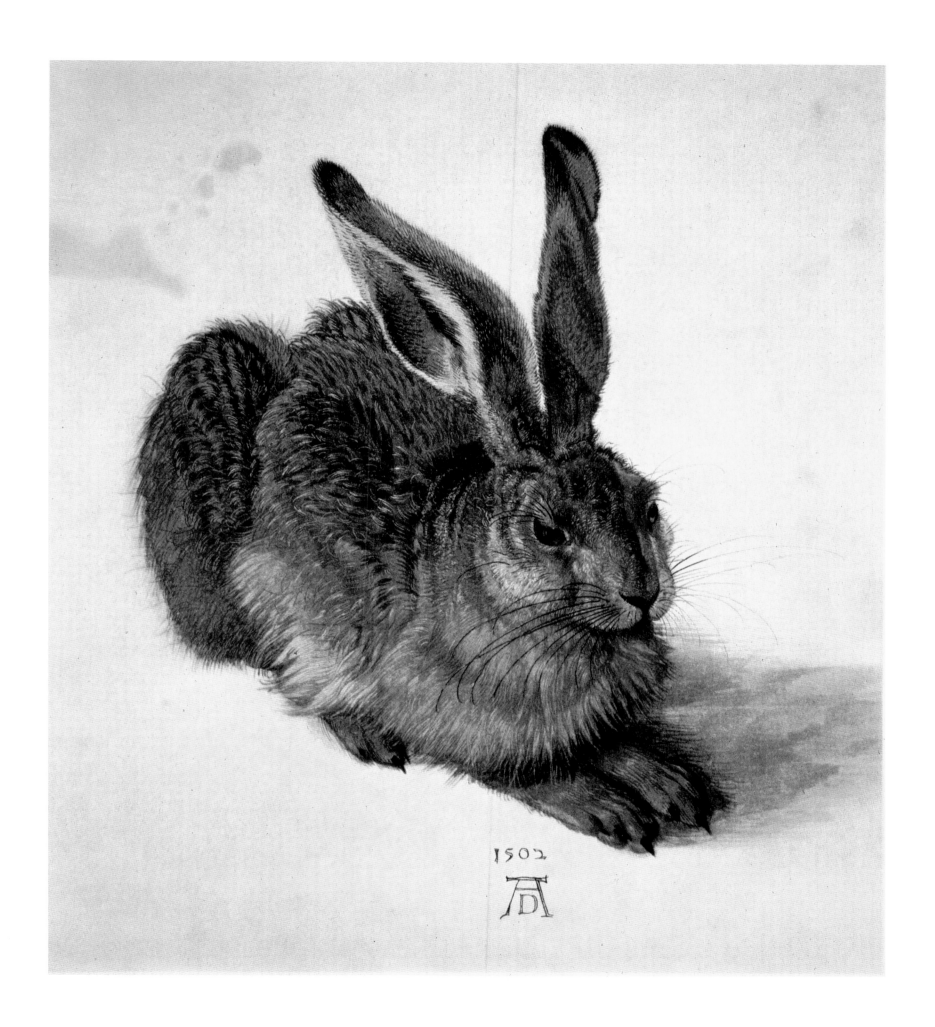

6. Anthony Van Dyck (1599–1641)
*Unfinished Landscape with
Meadows, Trees, and a Square
Tower in the Distance,* n.d.
Pen and brown ink and
watercolor on paper,
8¹³/₁₆ × 13⁵/₁₆ in. (22.4 × 33.8 cm)
Devonshire Collection,
Chatsworth, England;
Reproduced by permission of the
Chatsworth Settlement Trustees

7. Giovanni Battista Lusieri
(1781–1821)
*Baths of Caracalla from the Villa
Mattei,* n.d.
Watercolor on paper,
18¹/₈ × 25¹/₂ in. (46 × 64.8 cm)
Museum of Art, Rhode Island
School of Design, Providence;
Anonymous Gift

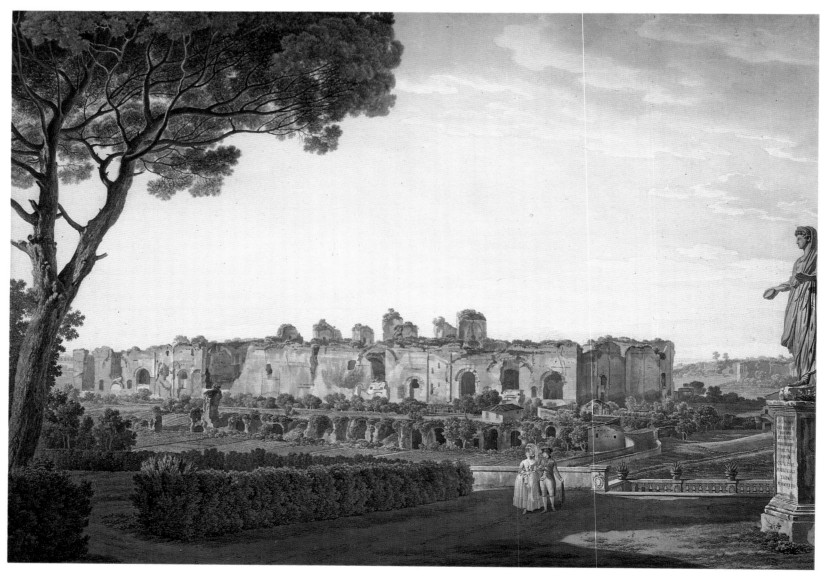

During the eighteenth century, especially at the court of Versailles, there arose a taste for a small-scale, intimate art that sometimes focused on contemporary social life and sometimes on an imaginary Arcadia. Gouache proved especially attractive to some of the painters who practiced these genres. It was used occasionally by Jean-Honoré Fragonard and more frequently by minor masters such as Niklas Lavrience and Gabriel de Saint-Aubin. A significant gouache school existed in Italy during the same period, but in Italy, as elsewhere, the use of transparent watercolor was on the rise. Often it was used in the service of antiquarianism and topography, as is typified by Giovanni Battista Lusieri's stiff but informative view of the *Baths of Caracalla from the Villa Mattei* (plate 7).

Other topographers of the eighteenth century included Louis-Jean Desprez, a Frenchman, and Johann Ludwig Aberli, a Swiss draftsman who frequently used colored washes as an adjunct to somewhat finished ink drawings (plate 8). The Swiss produced a number of skilled watercolorists, including the remarkable Abraham Louis Rodolphe Ducros, who painted large-scale, highly finished watercolors that worked within the limits of a severely restricted chromatic range and were enlivened by precision of execution and a soaring romantic vision (plate 9).

Ducros, who spent much of his career in Rome, arrived there around 1770 and may well have had contact with and influence on some of the many British watercolorists who made their way to the Eternal City in the second half of the eighteenth century, at the very time when the British watercolor school was taking shape as a distinct entity. Rome was a focus for these British artists for several reasons. It was a treasure house of classical remains at a time when the British interest in antiquarianism was at its height; and it had been the home of Claude, the patron saint of eighteenth-century landscape painters. Also, Rome was a key stop on the "Grand Tour," *de rigueur* for young English noblemen, some of whom brought topographic artists in their entourage or else patronized those British artists already established in the Eternal City.

Watercolor in something approaching the modern sense was known in England from Tudor times when it was practiced by men like John White. It did not receive

8. Johann Ludwig Aberli
(1723–1786)
View of Erlach and the Lake of Biel, 1778
Watercolor on paper,
15¹³/₁₆ × 21¹⁵/₁₆ in.
(40.2 × 55.7 cm)
Kunstmuseum Bern;
Bernische Kunstgesellscaf

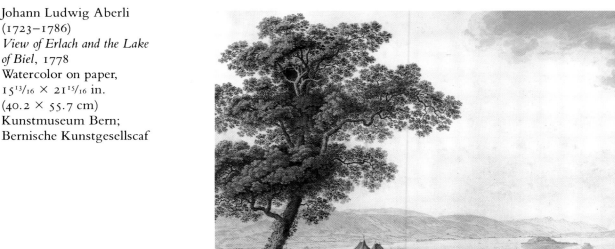

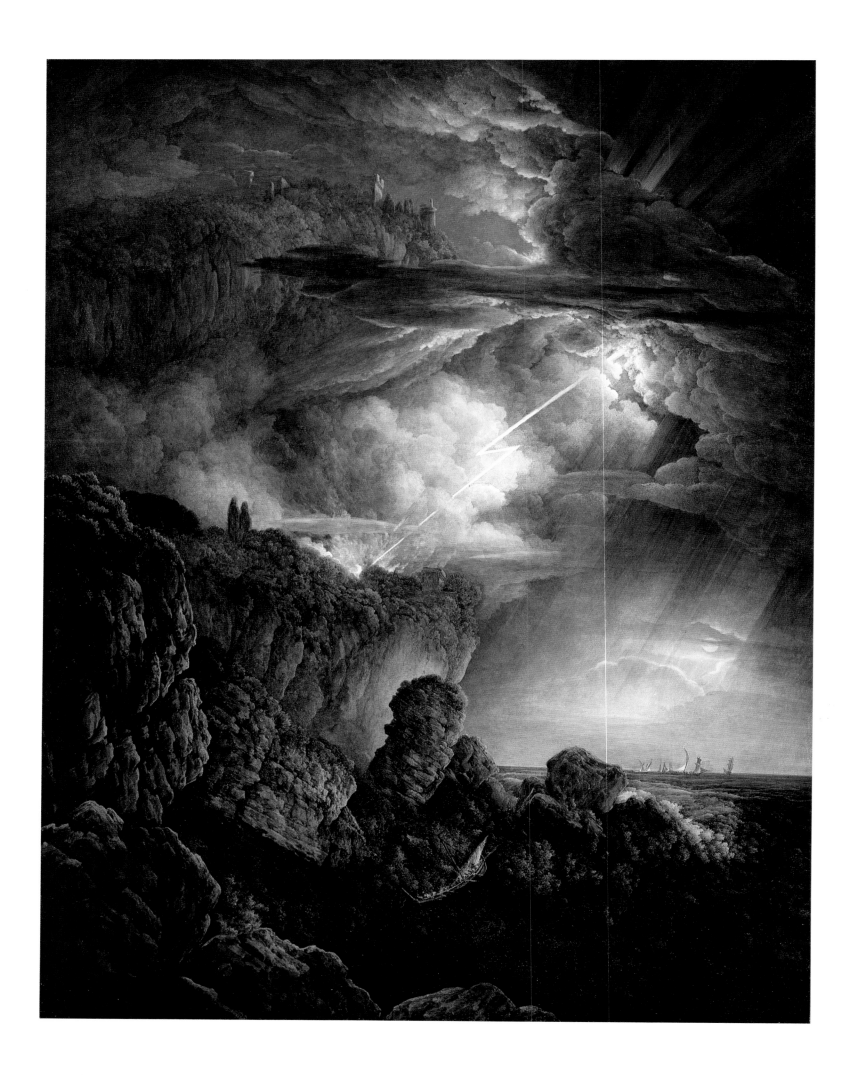

9. Abraham Louis Rodolphe
 Ducros (1748–1810)
 Orage Nocturne à Cefalou, Calabre,
 c. 1800
 Watercolor, gouache, and oil on
 paper pasted on canvas,
 37¹¹/₁₆ × 29 in. (95.7 × 73.7 cm)
 Musée Cantonal des Beaux-Arts,
 Lausanne, Switzerland

much attention, however, until the early eighteenth century when landscape became a major concern of British artists. The very word *landscape* was new to the language as late as 1606 when Henry Peacham noted "Landtskip is a Dutch word" in his treatise, *The Art of Drawing.* Indeed, it is possible to point to the Dutch as a primary influence, along with Claude, on British landscape art, though it should be noted, too, that Canaletto spent almost a decade in England beginning in 1746. Ultimately, however, the British landscape tradition prospered because its roots were firmly planted in native attitudes and philosophies. No one who has seen a performance of *A Midsummer Night's Dream* can imagine that Englishmen of Shakespeare's day were immune to the magic of the British countryside (even when it masqueraded as a wood near Athens). By the early eighteenth century, thinkers like Anthony Ashley Cooper, Lord Shaftesbury, were elevating the worship of nature to the point where it came to be seen as a moral principle, so that pantheism was virtually institutionalized. This attitude had a profound effect on landscape painting as well as on such related disciplines as landscape gardening.

Other and more practical influences were at work, too. As already mentioned, artists traveled on voyages of discovery, and it is hardly surprising that the British navy, then a great power in the world, should be fully cognizant of the value of having artists make topographic studies and charts of both friendly and potentially hostile harbors and havens. Artists—often working in watercolor—therefore performed the tasks that today are carried out by reconnaissance aircraft and spy satellites. Similarly, the British army recognized the value of having artists who could provide gunners with a knowledge of any given terrain that might be of strategic importance; as part of their training, artillery officers at the Royal Military Academy at Woolwich acquired a rudimentary expertise in draftsmanship and watercolor painting.

The popularity of topographic art in eighteenth-century England was fueled as well by the rage for antiquarianism, which found expression in such monumental and often ponderous monographs as Robert Woods's *Ruins of Palmyra,* published in 1753. Nor was it just the ruins of the ancient world that captured the British imagination. The nation's own past was explored in such exhaustive studies as John Nichols's eight-volume *History and Antiquities of the Town and County of Leicester* (1795–1805). The country seats and parsonages of Britain spawned hundreds of amateur historians anxious to unearth the secrets of every castle keep breached during the Wars of the Roses and each priory sacked by Cromwell's armies. (Indeed, the Restoration itself helped trigger this interest in the past, the remains of which had been vandalized during the Commonwealth.) Artists found lowly but welcome employment making drawings—often tinted with colored wash—of abandoned abbeys and overgrown fortresses, drawings that frequently served as a basis for engravings or other forms of prints.

The Romantic movement did not come into full flower in Britain until the end of the eighteenth century, but its seeds had been sown several decades earlier. When his *Emile* and *Du contrat social* were condemned by the Parlement of Paris as contrary to government and religion, Jean-Jacques Rousseau fled first to Switzerland and then, in 1766, found temporary asylum in England, where his influence became widespread. Poets like Thomas Gray turned to nature and the bucolic life for inspiration, and Thomas Chatterton's medieval forgeries found an eager audience seeking to transcend the civilized sentiments of the Augustans. In 1764, Horace Walpole—a great connoisseur of curios and antiquities—introduced into literature the gothic novel with his *Castle of Otranto.*

Not all of this had a direct influence upon English painting, but the fledgling

watercolor school participated in a general shift away from artifice and toward the natural—the natural often being found in conjunction with antique remains, preferably in their ruined and hence more picturesque form. The search for the picturesque became a kind of quest that found its guru in the Reverend William Gilpin, whose books, illustrated with aquatints after his own drawings, enjoyed wide circulation.

British art during the eighteenth century developed a strong sense of place, a sensibility that was shared by educated Britons in general. In part this was due to Britain's rise as a colonial power, which made its citizens aware of the world at large and, in turn, reinforced their consciousness of the singular beauties of their own island. Empire building also saw Britons—the ruling class, at least—taking measure of their historic role. To do so they would have to compare themselves with empire builders of the past, and this was one of the motives of the Grand Tour, the finishing school for young aristocrats, who sometimes spent several years traveling to the capitals of Europe, taking in the great sites of antiquity, a practice that was to be inhibited by the French Revolution and interrupted by the Napoleonic Wars. Doubtless some of these young men saw the Grand Tour chiefly as an opportunity to sow wild oats (which, in fact, was one of its purposes: indiscretions that would have been scandalous in Bath were permissible in Bergamo). Others, however, also availed themselves of the intellectual and aesthetic opportunities, bringing back antique statues and columns to erect in their parks and Guardis to hang in their drawing rooms. Some patronized the young British watercolorists they encountered on their travels or even sponsored their journeys. Still others swelled the ranks of amateur watercolorists who, along with the professionals, were patronizing English colormen and paper manufacturers.

These colormen and paper manufacturers responded to the growing demand for their products by introducing supplies tailored to the needs of the watercolorist. For the most part, watercolorists look for a paper that has a certain amount of tooth—texture—and until the late eighteenth century they would have had to search through sheets of ordinary drawing paper until they found something that came close to their requirements; then often they would have to treat it with a size to prevent it from being too absorbent. Starting in the 1780s, however, the family business headed by James Whatman began to produce in London special handmade, hard-sized papers intended for the use of watercolorists. Soon these were available

10. Francis Place (1647–1728)
Tenby in Pembrokeshire, 1678
Pen and ink, wash, and watercolor on paper,
7½ × 21¾ in.
(19.1 × 55.2 cm)
National Museum of Wales, Cardiff, Great Britain

11. William Taverner (1703–1772)
Sand Pits, Woolwich, n.d.
Gouache on paper,
14¼ × 27⅝ in.
(36.2 × 70.2 cm)
British Museum, London

in three distinct textures: smooth ("hot-pressed"), medium ("cold-pressed," referred to in Britain as "not," meaning "not hot-pressed"), and rough. (The tooth derives from the texture of the felt that is laid between the sheets of paper as they are drying.) These Whatman papers, which are still produced today, enjoyed an immediate success, and other British manufacturers quickly followed suit, though it would be decades before paper manufacturers on the Continent entered into competition with them. Not all watercolorists availed themselves of this innovation—as will be seen, some preferred ordinary wrapping paper, suitably treated—but, in general, these specially prepared papers were welcomed as a great convenience. A further convenience, introduced at about the same time, was watercolor paint made up into cake form, the invention of William Reeves. Such cakes cut out much time-consuming preparatory work and were a boon to artists such as the topographers who habitually worked outdoors and traveled light.

Among the first British topographers of significance was Francis Place, who, in the late seventeenth and early eighteenth centuries, traveled the British Isles making drawings—sometimes atmospheric, sometimes straightforwardly precise—which were often touched with watercolor washes (plate 10). The first watercolorist of interest to mature during the eighteenth century was William Taverner, an amateur who made neoclassical compositions in body color and more direct studies from nature that used transparent washes, generally over diluted sepia tints that gave the image its basic tonal structure (plate 11).

A very private man, Taverner seldom showed his work; in this respect he is the very opposite of Paul Sandby, a major figure in the evolution of English watercolor, even though his predilection for gouache was not to find much favor among the innovators of the next couple of generations. The younger brother of Thomas Sandby, himself a competent topographer best known for his architectural subjects, Paul Sandby was very much an establishment figure of the day: official artist to the Ordnance Survey, instructor in drawing at the Royal Military Academy, and, for a number of years, an adjunct to the king's household at Windsor in the capacity of drawing master to the royal children. He was also one of the founders of the Royal Academy, a fact that was doubtless instrumental in persuading that body—pregnant with high purpose under the leadership of Sir Joshua Reynolds—to accept watercolor paintings as being suitable for inclusion in its annual exhibitions, though

12. Paul Sandby (1725–1809)
View from the Back of Paul Sandby's Lodging, at Charlton, Kent, n.d.
Pencil, pen and ink, and watercolor on paper,
18⅞ × 14½ in. (47.9 × 36.8 cm)
Collection Her Majesty Queen Elizabeth II

these humble works on paper came to be confined to a back room where the lighting was somewhat less than ideal.

Born in Nottingham in 1725, Paul Sandby came to London in his teens to join his brother as a draftsman at the Military Drawing office, then headquartered in the Tower of London. In his twenties he spent several years in Scotland, engaged on a military survey, and it seems to have been during this period that he began painting for his own pleasure. At times, even in his personal work, he was a straightforward topographer, but he was also gifted at catching the figure in casual, almost candid poses. Like Taverner, Sandby worked in both body color and transparent color combined with ink washes. When he employed opaque pigments, his methods derived in part, it must be presumed, from French and Italian models.

Such models were close at hand. Francesco Zuccarelli, for example, was a leading exponent of gouache who from 1751 on spent much of his time in England and, like Sandby, was patronized by George III. Also Sandby collected gouaches by another Italian, Marco Ricci, but his gouache style is looser than the Italians' and even in his most finished pictures he generally maintains a mood of informality that distinguishes his work from that of Continental artists. This informality is sometimes heightened by his sure grasp of the art of caricature, which was at its height in Britain during this period.

When working with transparent color, Sandby employed what might be described as the classic methodology of topographers. First, a line drawing is made, using pencil, chalk, or ink. Next, the tonal structure is established, using sepia or other monochrome ink washes; then watercolor washes are added, mostly to describe local color. Finally—in some cases—ink is used again, either with a fine brush or a quill pen, to add detail. Images produced this way are tinted drawings rather than watercolor paintings in the full sense, but in the hands of an artist like Sandby they could be highly effective; his brushwork is expressive, describing form in a somewhat calligraphic way, and his monochromatic underpinning is nicely modulated so as to suggest a greater chromatic range than is in fact present (plate 12). Nor should we assume that his technique was always as simple as it might appear to be from this description. Contemporary reports indicate that he resorted to techniques that seem exotic by today's standards, saturating his pasteboard support with isinglass jelly mixed with honey (this for gouaches) and thinning his tints with gin.

Seen individually, Sandby's works sometimes appear a little too studied, but when the body of his work is considered as a whole, the variety of his output and his consistent level of execution make him seem like a major figure within the emerging watercolor tradition. As he grew older, his works softened and became more lyrical, and his felicitous way with the figure gave him a singular place among British watercolorists of the period.

Of the topographers whose careers were uncluttered by great ambitions, there were perhaps a dozen whose work stands out in one way or another. Jonathan Skelton's exact birthdate is unknown, but he was somewhat younger than Sandby and traveled to Italy where he made free and somewhat evocative studies of such subjects as the Castle of San Angelo (plate 13); he met an early death. Francis Towne, born in 1740, was another topographer who flowered in Rome. He developed a distinctive variation on the mainstream style, displaying a strong sense of composition that was developed in terms of firmly drawn but delicate outlines made with a fine pen then given solidity by means of skillfully laid down flat areas of wash (plate 14). The results sometimes tended toward the decorative, but Towne's best works possessed a sense of mystery and in their structural simplicity hinted at the future achievements of John Sell Cotman.

Two years Towne's junior, William Pars (1742–1782) was one of his companions in Rome who painted some handsome sheets there (as well as in Greece and Switzerland), but his style—in some ways the antithesis of Towne's—was best suited to gently atmospheric views such as he found in Wales and Ireland (plate 15).

Born in 1743, Michael Angelo Rooker—despite his splendidly Italianate name—is best known for faithful renditions of the English countryside and historic British buildings. Since he was a pupil of Paul Sandby, it is not surprising that Rooker liked to populate topographic subjects with little vignettes of provincial life—a cart being loaded with grain, children watching dogs fight—but description was his primary aim. His pictures are carefully made, usually over a light pencil drawing, and are seldom without interest, especially in their detail (plate 16).

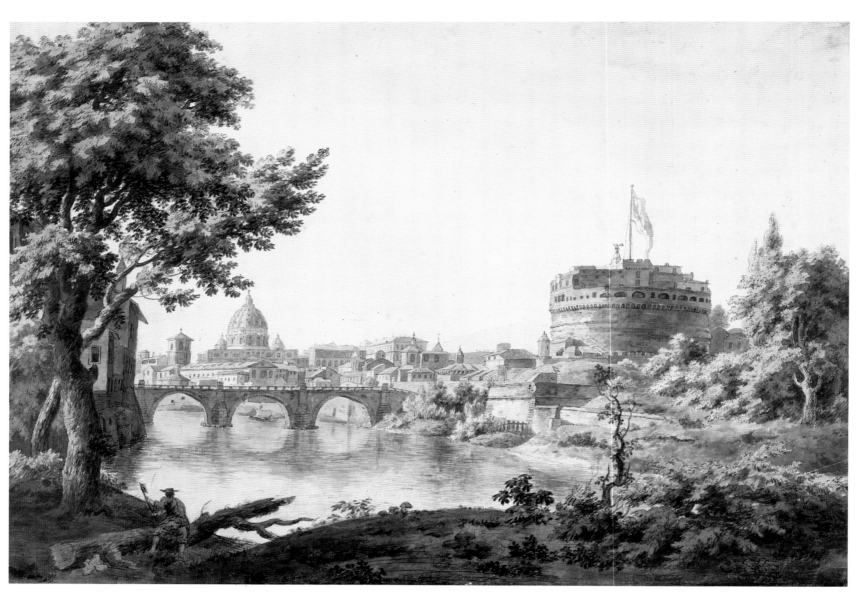

13. Jonathan Skelton (d. 1759)
 View of Rome, 1758
 Watercolor on paper,
 14⁹/₁₆ × 20⁷/₈ in. (37 × 53 cm)
 Victoria and Albert Museum,
 London

14. Francis Towne (1740–1816)
Larice, 1781
Watercolor on paper,
12¾ × 18½ in. (32.3 × 47 cm)
British Museum, London

15. William Pars (1742–1782)
Killarney and Lake, n.d.
Watercolor on paper,
12½ × 19 in. (31.8 × 48.3 cm)
Victoria and Albert Museum,
London

16. Michael Angelo Rooker
(1743–1801)
Godington, Kent, n.d.
Watercolor over pencil on paper,
14 × 10⅛ in.
(35.6 × 25.7 cm)
Victoria and Albert Museum,
London

Thomas Hearne (1744–1817) was another better than average topographer who dealt sensitively with British subjects; however, he did some of his most memorable work in the West Indies, where he spent time in service as draftsman to the governor of the Leeward Islands (plate 17).

Thomas Malton, Jr. (1748–1804), was professor of perspective at the Royal Academy Schools—where he taught Turner, who succeeded him in that position—and his watercolors reflect his professional interest; he specialized in townscapes of the kind that demand a thorough knowledge of the laws of perspective (plate 18).

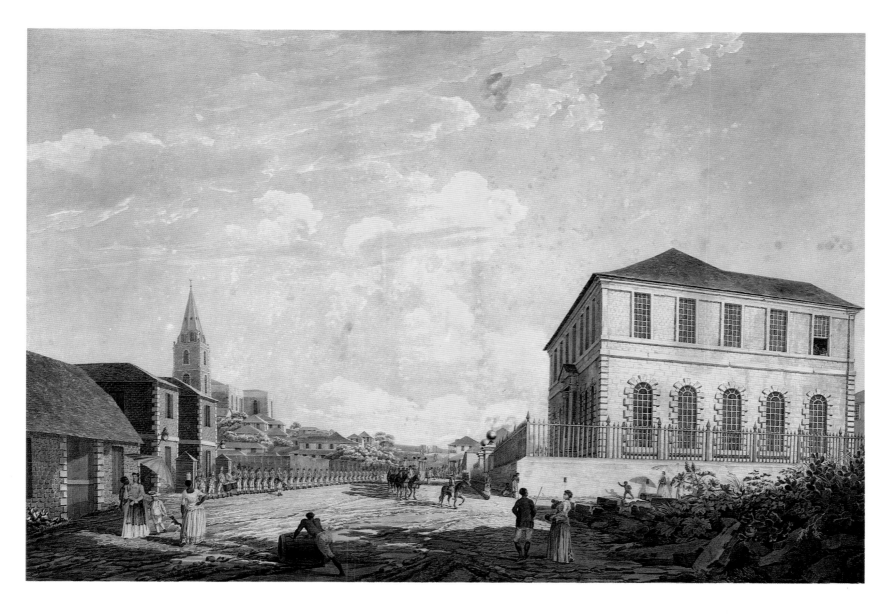

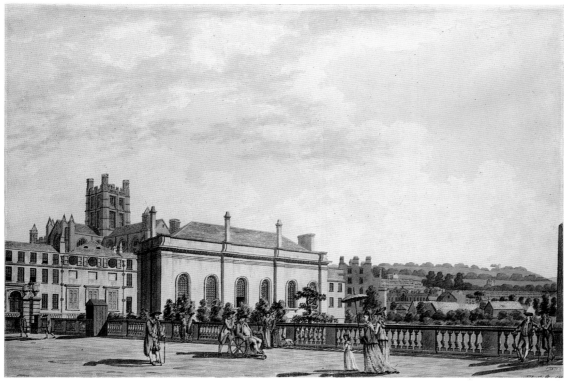

17. Thomas Hearne (1744–1817)
St. John's, Antigua, n.d.
Watercolor on paper,
20¼ × 28¹⁵/₁₆ in.
(51.2 × 73.5 cm)
Victoria and Albert Museum,
London

18. Thomas Malton, Jr.
(1748–1804)
North Parade, Bath, 1777
Watercolor on paper,
12⁷/₈ × 18⁷/₈ in.
(32.8 × 47.2 cm)
Victoria and Albert Museum,
London

John "Warwick" Smith (1749–1831) was something of an innovator in that he developed a way of painting that did away with the conventional underpinning of chromatically cool monochrome ink tints. Instead of sepia or India ink, Smith came to favor underpainting that featured colored washes modified by a neutral gray tint concocted from the three primary colors. In this regard he was building on the work of William Payne, who had developed a gray watercolor tint—still called Payne's gray—to replace ink when delineating objects in the middle ground of his drawings. Smith took Payne's idea somewhat further and, though he lacked the genius or force of personality to carry this innovation to its logical conclusion, he did help watercolor take a step forward, and his best sheets, whether made in England or Italy, have a freshness of palette that is very appealing. Some paintings executed in Rome around 1780, such as *The Villa of Maecenas, Tivoli*, look as if they could have been painted a quarter of a century later (plate 19).

A few topographers enjoyed private means, but the majority of them were journeymen traveling—often by foot—from one picturesque site to the next in the employ of aristocratic patrons or ambitious engravers, selling drawings for a few shillings or exchanging them for food and lodging. Just such a man was Edward Dayes, who was as capable of rendering a picturesque ruin in all its decaying glory as he was of capturing the social life of the capital. His skill could be matched by few of his contemporaries (plate 20). Hack work seems to have contributed greatly to Dayes's irascibility and sense of dissatisfaction that gained him a reputation for ill-temper and led to his writing scurrilous attacks on his rivals. Continued disappointment and frustration drove him to commit suicide in 1804 at the age of forty.

A very different figure was Thomas Gainsborough (1727–1788), whose success as a portraitist removed him from the daily tribulations and indignities of the topographers, whom he frankly despised as he deplored the very notion of copying

19. John "Warwick" Smith (1749–1831)
The Villa of Maecenas, Tivoli, n.d.
Watercolor on paper,
19³/₄ × 14¹/₈ in. (50.2 × 35.9 cm)
Victoria and Albert Museum,
London

RIGHT
20. Edward Dayes (1763–1804)
Norwich Cathedral from the River Wensum, 1788
Watercolor and pen and ink on paper, 12⁵/₈ × 16³/₈ in.
(32.1 × 41.6 cm)
The Whitworth Art Gallery,
University of Manchester,
Manchester, England

OPPOSITE, TOP
21. Thomas Gainsborough (1727–1788)
A Cart Passing Along a Winding Road, n.d.
Watercolor on paper,
8 × 11⁷/₈ in. (20.3 × 30.1 cm)
British Museum, London

anything directly from imperfect nature. His own idealized, sun-suffused Arcadian landscapes stand apart from the topographic tradition but, while they are not original in technique, they also embody a poetic vision of the English countryside destined to become characteristic of British watercolor (plate 21).

Despite the efforts of men like Gainsborough, Reynolds, and William Hogarth, the English art world in the second half of the eighteenth century was not entirely sure of its national identity and still welcomed foreigners as exemplars, as it had once welcomed Rubens and Van Dyck. Among those who took up residence in England in the 1760s and 1770s were three artists—Philip James de Loutherbourg, born in Strasbourg, and Samuel Hieronymus Grimm and Henry Fuseli, both born in Switzerland—who made distinct contributions to the development of watercolor. Fuseli's achievement and influence will be considered in Chapter 5. Grimm was a gifted topographer who began his career by painting dramatic Alpine scenes, then adapted easily to the gentler aspects of English landscape and provincial curiosities (plate 22). De Loutherbourg was a more formidable character—one of the figures who inaugurated the Romantic movement in British painting—and he thrived as a landscape artist, a painter of historical set pieces, a designer for the London stage, and even as the inventor of the *Eidophusikon*, an animated panoramic peepshow that anticipated some aspects of the motion picture. Watercolor was only one of his interests but his mastery of the medium, in its eighteenth-century guise, is obvious, and

22. Samuel Hieronymus Grimm (1733–1794)
Mother Ludlam's Hole, 1781
Watercolor on paper,
15⅞ × 23⅝ in. (40.3 × 60 cm)
Victoria and Albert Museum, London

23. Philip James de Loutherbourg
(1740–1812)
Cataract on the Llugwy, Near Conway, n.d.
Pen and ink and watercolor on paper, 9¹⁄₈ × 12¹⁄₄ in.
(26.7 × 35.6 cm)
Victoria and Albert Museum, London

24. Thomas Rowlandson
(1756–1827)
The Scots Greys at Waterloo, c. 1815
Pencil, pen and ink, and watercolor on paper,
9¹⁄₂ × 14³⁄₄ in.
(24.1 × 37.5 cm)
Henry E. Huntington Library and Art Gallery, San Marino, California

his taste for the sublime would influence many British watercolorists (plate 23).

Among the British caricaturists who flourished at this time, note must be taken of Thomas Rowlandson (1756–1827) because he was also a master of watercolor in the eighteenth-century mode, which he prolonged well into the nineteenth century (plate 24). It is Rowlandson's draftsmanship, of course, that assures him his historical place, but his use of color has much in common with that of the topographers (in fact he once aspired to be a topographer). In some ways his overall approach is not too far removed from that of an artist like Edward Dayes, but instead of chan-

neling his bile into battles with his fellow artists, Rowlandson turned a satiric eye on society at large and became one of the great social commentators of the age, a humorist to place alongside Fielding, Smollett, and Sterne (plate 25).

In the end, though, it was landscape painting that was to benefit most from the British predilection for watercolor. It was just a matter of time before someone would transcend the topographic tradition. The artist who fulfilled that destiny and set the stage for the triumphs of the nineteenth century was John Robert Cozens, the son of Alexander Cozens, himself a masterly and influential draftsman whose wash drawings, though monochrome, had a profound impact on the British watercolor movement. His best sheets display a highly developed sense of drama and mystery within a landscape context.

Born in 1752, the junior Cozens exhibited precocious gifts that benefitted greatly from his father's teachings and example. As a young man he traveled to Switzerland and Italy in the entourage of Richard Payne Knight, a famous connoisseur of the day, well known as a collector of paintings by Claude and a leading member of the Dilettanti Society, which did much to foster the serious study of classical antiquities. Later, Cozens traveled the Continent again in the train of William Beckford, the eccentric builder of Fonthill Abbey and author of the gothic novel *Vathek* who was both the pupil and friend of the elder Cozens. On these trips, J. R. Cozens recorded many picturesque vistas and noble ruins but did so in a way that transcended the practices of the topographers.

To begin with, his point of view was more lyrical than that of his predecessors. To a degree, he may have inherited this from his father, but it was his particular genius to be able to wed a powerful sense of mood to concrete, accurately observed reality. For the most part the topographers had done little with atmosphere—every

25. Thomas Rowlandson
(1756–1827)
The English Review, 1786
Pencil, pen and ink, and
watercolor on paper,
19¾ × 35 in. (50.2 × 88.9 cm)
Collection Her Majesty Queen
Elizabeth II

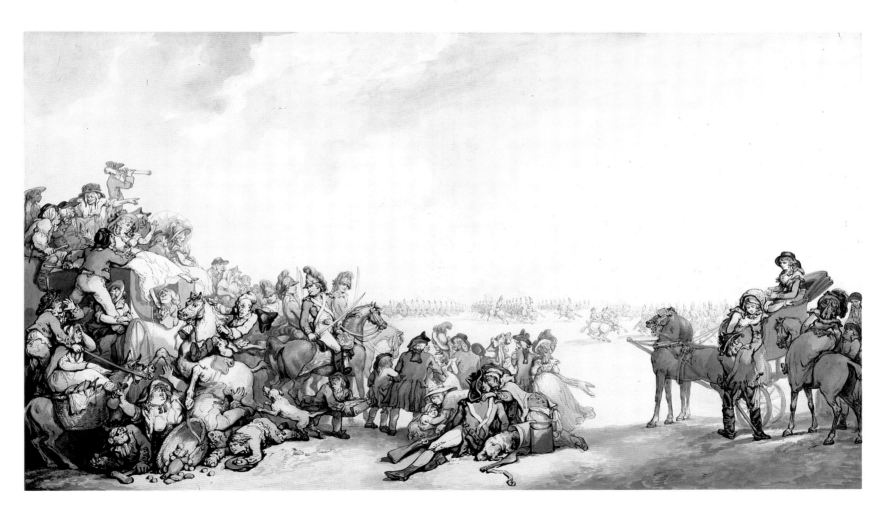

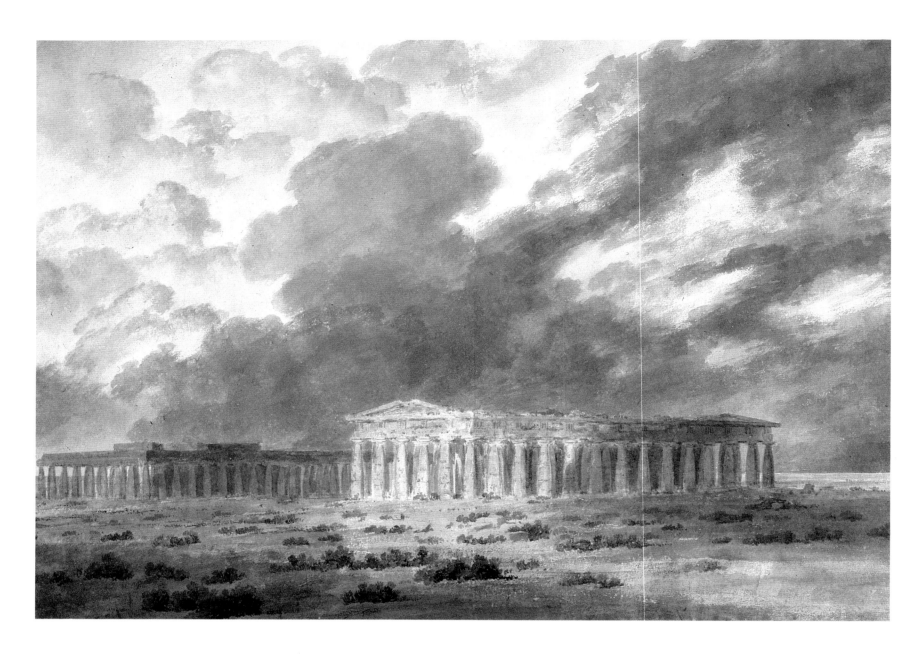

26. John Robert Cozens
 (1752–1797)
 *The Two Great Temples at
 Paestum*, 1782
 Watercolor on off-white paper,
 10³/₁₆ × 14¹/₈ in.
 (25.8 × 35.9 cm)
 Oldham Art Gallery, Oldham,
 England

subject seemed caught on a pleasant summer afternoon with even light and crisp
shadow—whereas, for Cozens, atmosphere was everything. He was a poet of twi-
light and gathering storms and broken clouds; his sense of weather was as sure and
significant as his sense of place. Often, indeed, he took the same basic image, pre-
sumably made on the spot in a sketchbook, and treated it in a variety of ways that
caught different moments. One view of the ruins of Paestum might show them on a
windswept day, a little sunlight splashing onto the stonework (plate 26). Another
version of the same subject might show them under quite different weather condi-
tions (plate 27). Accurately if loosely drawn, each would say something about the
condition of the monuments and their setting, but because of the emphasis on mood
the viewer would also learn about the way an eighteenth-century Englishman re-
sponded to the shattered glories of the ancient world.

Cozens was the first watercolorist to convey convincingly the sense of a land-
scape seen through mist or while the dew was still on the vine; to do this, he
evolved a way of using the medium that was as original as the vision to which it
gave substance. His father, though not known as a colorist, had written a treatise on
the use of watercolor pigments; perhaps it was this that provided the younger
Cozens with the impetus to explore the use of colored washes freed from reliance

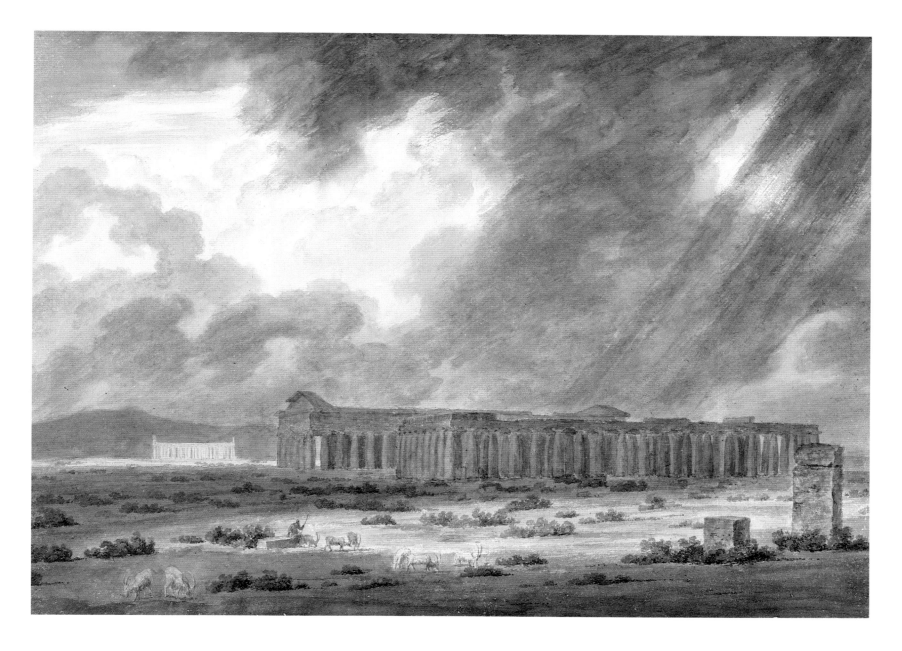

upon a monochrome substructure. His method varied somewhat over the years, but at his boldest he began with a light pencil drawing, then laid in colored washes to establish the underlying tonality, building from there with darker or denser but still transparent washes—usually working from dark to light—until the image was fully established. Since only layers of colored wash were employed, a very full chromatic range became possible, though, in fact, Cozens tended to prefer relatively limited spectrums that best suited his atmospheric approach.

Because even the underpainting is transparent, the white of the paper support glows through everything, lending the paintings a luminosity that he was the first to fully exploit. And the layers of wash combine with light reflected from the paper, permitting color to be mixed "in the eye" rather than on the palette, making for a freshness unknown in any other medium. Others, like John "Warwick" Smith, may have pioneered the method, but it was Cozens who was its first full-fledged master; the technique that he perfected is the basis of the modern method of watercolor painting still practiced today.

Indeed, in paintings like *The Lake of Nemi* (plate 28), *The Castle of St. Elmo, Naples* (plate 29), and *In the Canton of Unterwalden* (plate 30), Cozens is very much the modern watercolorist. The subtle tonality of these paintings does not detract

27. John Robert Cozens
(1752–1797)
Ruins of Paestum: The Three Great Temples, 1782
Watercolor on off-white paper, 10³/₁₆ × 14¹/₂ in.
(25.9 × 36.8 cm)
Oldham Art Gallery, Oldham, England

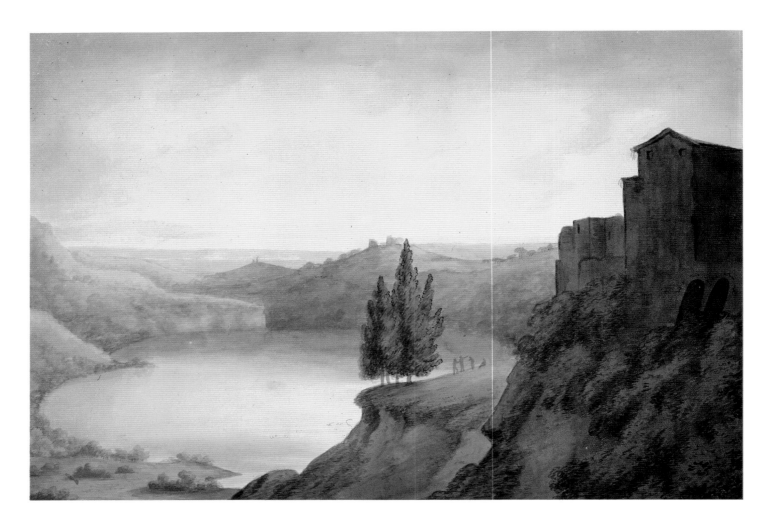

OPPOSITE, TOP
28. John Robert Cozens (1752–1797)
 The Lake of Nemi, 1778
 Watercolor on paper,
 14¼ × 20¾ in.
 (36.2 × 52.7 cm)
 Victoria and Albert Museum,
 London

OPPOSITE, BOTTOM
29. John Robert Cozens (1752–1797)
 The Castle of St. Elmo, Naples
 1790
 Watercolor on paper,
 12 × 17¾ in. (30.5 × 45.1 cm)
 British Museum, London

ABOVE
30. John Robert Cozens (1752–1797)
 In the Canton of Unterwalden,
 c. 1790
 Watercolor on paper,
 9⅜ × 14¼ in.
 (23.8 × 36.2 cm)
 Leeds City Art Galleries,
 Leeds, England

from their chromatic richness, and it is easy enough to see why Cozens, with his ability to play off warm colors against cool, was extravagantly admired by painters as distinguished as Turner and Constable.

 Unfortunately his career was brief since he was smitten by a nervous disorder that incapacitated him as an artist and led to his death in 1797 at the relatively young age of forty-five. During his last tragic years, Cozens was in the care of Dr. Thomas Monro, a distinguished surgeon who was a friend of many artists and a major collector of watercolors and topographical drawings. (He was himself an amateur artist of some ability.) Monro was well equipped to appreciate Cozens's talent and originality. As will be seen in the following chapters, he was largely responsible for transmitting to the next generation Cozens's legacy, along with that of the entire British School.

Girtin and Turner

31. Joseph Mallord William Turner
Kew Bridge, c. 1805–6
Detail of plate 43

In 1775, the year before Cozens's final trip to Italy, two future watercolorists of genius were born in London, on opposite banks of the River Thames but both within the sound of Bow Bell. Thomas Girtin was the first of the pair to enter the world, on February 18. Joseph Mallord William Turner followed on April 23, celebrated in England as St. George's Day and throughout the world as the birthday of William Shakespeare. Both were born into modest households, Girtin the son of a Southwark brushmaker and rope merchant, Turner the offspring of a Covent Garden barber. Both made an early acquaintance with death, Girtin losing his father when he was three, Turner his younger sister—and only sibling—when he was ten. In addition, Turner seems to have suffered psychological wounds as a consequence of the erratic behavior of his mother, the former Mary Marshall, who was given to violent fits of rage and eventually lapsed wholly into insanity.

Turner's relationship with his father was much happier and closer. Indeed, when the son became famous, William, the barber, became his bailiff and factotum, watching over the artist's property and serving as everything from informal butler to studio assistant. He seems to have encouraged his son's talent from the very first, and it should be noted that a Maiden Lane barbershop was not a bad place for a future artist to encounter the world. London was a vital, growing city, and Covent Garden was at its very heart, a place where farmers from Fulham and Highgate sold their produce in an Italianate piazza designed by Inigo Jones, a zone where the worlds of high fashion and street culture overlapped and blended, a kaleidoscope of theaters, coffee houses, ale houses, and brothels that had inspired John Gay's *Beggar's Opera* and some of William Hogarth's liveliest prints. Remember, too, that this was a world in which the wig was all important to personages of consequence— whether gentlemen of quality, actors, or demimondaines—so that the son of a barber might, in the natural course of things, come to see a good deal of the world.

As Ruskin would point out years later, a little bit of Covent Garden seemed to find its way into many of Turner's later paintings. Foregrounds were apt to include

"a succulent cluster or two of greengroceries at the corner. Enchanted oranges gleam in Covent Garden of the Hesperides, and great ships go to pieces in order to scatter chests of theirs on the waves."[1] Nor was Covent Garden the only world young Turner knew. Just across the Strand, a five-minute walk away, was the Thames, with its bridges and barges and all manner of sailing vessels. When his sister died, Turner was sent to live for a while with his mother's family in Brentford, where he encountered the Thames in its more idyllic aspect, meandering between wooded banks.

It seems, too, that he made at least one extended visit to his relatives in Margate, at the tip of Kent, where tides race between the Straits of Dover and the North Sea, and shipping is often forced to battle the stormy conditions Turner would be so fond of portraying.

It was in his father's barbershop, however, that he became acquainted with the world of art, for barbershops, in those days, sold and displayed prints of all kinds, from patriotic celebrations of great victories to the latest satirical broadsides. The young Turner copied these prints, colored some, and eventually began to make drawings of his own, which his father exhibited and sold for prices beginning at three shillings; he told customers that his son would be a painter one day. In a sense, then, Turner grew up in an art gallery and, given his early love of drawing and his father's encouragement, it was natural that he would seek professional instruction. Various names have been mentioned as possible early teachers, and certainly he studied for a while with Thomas Malton (plate 18), from whom it can be presumed he learned a good deal about perspective and rendering architecture.

In 1789 Turner submitted a drawing of an antique cast to the Royal Academy and was accepted as a student in the Academy Schools, thus beginning an association that would continue until his death more than sixty years later. The following year, while still just fifteen years old, he showed a watercolor at the Academy's Spring Exhibition.

Less is known about Girtin's early life. An older brother, John, became an engraver, and so there may have been some encouragement from the family for Thomas to pursue his talent. Southwark lies directly across the river from the City of London, and the two were joined, from medieval times, by London Bridge, giving Southwark—usually called "The Borough"—the kind of relationship with the City that Brooklyn has with Manhattan. In Shakespeare's day it was home to the Globe Theater, and because of its geographical importance—linking London with the southeastern counties—it was famous for inns and hostelries where coaches set out for provincial centers and country towns like Canterbury, Hastings, and Lewes.

Since his family was in the rope business, it is likely that it had a good deal to do with the shipping that tied up along the quays of Bankside. Certainly Girtin would have been as familiar with the Thames and its moods as Turner, but we do not know of any youthful travels that might have supplemented that visual feast. Clearly, he showed precocious talent because at an early age he was given drawing lessons by a Mr. Fisher of Aldersgate, and in 1789 he was indentured to Edward Dayes (plate 20), so that, like Turner, he received training at the hands of a leading topographer with a strong bent for architectural subjects. Legend has it that Girtin and Dayes got along poorly—and given Dayes's difficult temperament, this is very possible—but in the two years or so that Girtin spent as an apprentice he picked up a good deal from the older man, whose influence is evident in Girtin's early work.

Like Turner, Girtin had some early public success. Starting in 1792, when he was seventeen, engravings after his work appeared in *Copper Plate Magazine*, and he made his first appearance at the Royal Academy in 1794. It was at about this time

that he met Turner in the shop of John Raphael Smith, where both were employed coloring prints. Both artists also worked for various architects, adding skies and backgrounds to renderings of buildings, and around 1795—possibly earlier—both came to the attention of Dr. Thomas Monro, who set them to work copying sheets by established watercolorists and working up sketches by artists such as J. R. Cozens into finished paintings. At this time Girtin and Turner struck up a close working relationship that was to last for three or four years and was to transform the character of the British watercolor school, and indeed of watercolor painting in general. It is no exaggeration to say that between 1795 and 1800, these two laid the foundations for the entire course of nineteenth-century watercolor.

They were an unlikely pair—Turner short, uncouth, taciturn, secretive; Girtin tall, outgoing, something of a dandy—but each recognized the incipient genius in the other, and they were able to nourish one another, much as Braque and Picasso did a century later during the heroic phase of Cubism. The tragic difference is that Girtin had only a few years to live, while Turner would go on painting well into his eighth decade, establishing himself as one of the greatest artists of his or any other time.

Dr. Monro's Adelphi Terrace home overlooked the Thames, near London Bridge. Later it would house a kind of informal salon attended by many aspiring watercolorists, but when Girtin and Turner worked there it seems that they were his only protégés and that the relationship between Monro and the young artists was strictly commercial. They were paid from 2s.6d to 3s.6d an evening, plus supper, to make copies or work up paintings from the sketches of topographers such as Dayes and Hearne. They also made copies of borrowed drawings by Canaletto, learning much from his draftsmanship, but it was interpreting watercolors by J. R. Cozens that proved the decisive influence on both of them. It was not just the technical aspects of his work that affected them—the way he built from colored washes with no monochrome underpainting—but also his ability to create mood, to set down a poetical interpretation of a landscape instead of a topographical description.

Girtin and Turner worked together on these copies—engendering an uncommonly rich symbiotic relationship—with Girtin normally providing the outlines and Turner laying in the washes. In view of this, it is interesting that it was Girtin who first displayed signs of originality in the application of color in his own work. Both began to travel extensively throughout the British Isles—sometimes together—encountering favorite subjects of the topographers and gradually evolving a fresh and subtler approach.

Their starting point may be typified by *Tonbridge Castle, Kent* (plate 32), presently attributed to Turner but ascribed by some experts to Girtin.[2] There is, indeed, no way of knowing if this was the result of a sketching trip or a copying session at Dr. Monro's (a drawing or print by Paul Sandby has been suggested as a possible model). All that can be said with certainty is that this work is probably by Turner or Girtin—or both—and that it is a clumsy variant on the established topographical tradition. To be honest, it is rather an awful little drawing, reducing the conventionally picturesque to so many mannered devices, and deserves reproduction only to provide a measure of how far Girtin and Turner advanced in a very short period.

Girtin's *Peterborough Cathedral* (plate 33) and Turner's *Interior of Tintern Abbey* (plate 34) from about the same period show the artists at their early best. Both works are accomplished architectural renderings, skillfully drawn and expertly washed, achieving a sense of luminosity that points to the future. The effect of sunlight streaming through the ruins is especially fine in the Turner and makes this more than just another topographic drawing. The warmth of the washes in the Gir-

32. Joseph Mallord William Turner (1775–1851)
Tonbridge Castle, Kent, c. 1794
Gray and blue wash over pencil on paper, 7³/₄ × 10⁷/₈ in. (19.7 × 27.6 cm)
Fitzwilliam Museum, Cambridge, England

33. Thomas Girtin (1775–1802)
Peterborough Cathedral, 1794
Watercolor over pencil on paper,
15 × 11⁵/₁₆ in.
(38.1 × 28.7 cm)
Ashmolean Museum, Oxford,
England

34. Joseph Mallord William Turner
(1775–1851)
Interior of Tintern Abbey, c. 1794
Watercolor on paper,
13¹/₂ × 10 in. (34.3 × 25.4 cm)
British Museum, London

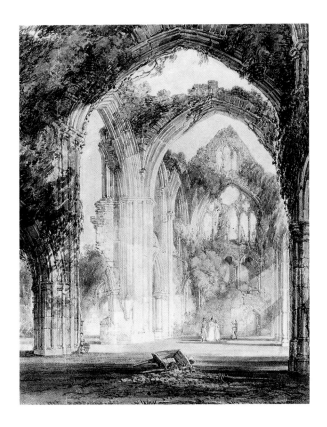

tin owes something to Dayes but also points forward vigorously to Girtin's mature style, which he achieved by the time he reached his majority.

When a modern viewer sees a mature Girtin, such as *Durham Cathedral* (plate 35), he finds little to shock him; yet an informed contemporary of the artist would have seen this as a radical sheet in several senses. Compositionally, it is straightforward in a way that would have seemed fresh and original, unencumbered as it is by proscenium arches of vegetation or such Claudian devices as overt reference to classical literature or mythology. Some of the topographers, to be sure, had done away with such conventions—but at the cost of being taken less than seriously in the established art world. From such a viewpoint, what the topographers purveyed were

mere "views" rather than paintings proper and so were not governed by the rules that applied to high art. Girtin's *Durham Cathedral*, however, is clearly a fully realized painting, rather than a tinted drawing, and it is this that made such informal compositions seem novel in his *oeuvre*.

More important still is the way in which the image has been built from carefully modulated washes. The underlying draftsmanship is as firm as always in Girtin's work, but it no longer dominates in the topographical manner. Until this moment, at the end of the eighteenth century, nobody (unless it was Turner simultaneously) had succeeded in using watercolor to establish such solidity. The viewer can feel the weight of the cathedral buildings, of the bridge crossing the River Wear, in a completely new way. Yet, at the same time, the sheet is suffused with atmosphere in a manner equally novel. Cozens, to be sure, had anticipated such a possibility, but here Girtin exploits that possibility with a control that is truly masterly. As Martin Hardie wrote in his great study, *Water-colour Painting in Britain*, the traditional antiquarian and topographical interests are supplanted by a more personal and spiritual approach, one in keeping with the rise of English Romanticism.[3]

35. Thomas Girtin (1775–1802)
Durham Cathedral, 1799
Watercolor over pencil on paper,
16³⁄₈ × 21¹⁄₈ in.
(41.6 × 53.7 cm)
The Whitworth Art Gallery,
University of Manchester,
Manchester, England

Girtin achieved these effects—solidity combined with atmosphere—by using colored washes in a way that was decidedly new. Contemporaries were astonished to discover that, having first established the principal compositional elements with pencil or pen, he often began painting by laying in local color first. That is to say, he ignored the practice of first establishing light and shadow with "cold" ink under-washes. Instead, he started out by coloring, say, a brick building the color of brick seen under even sunlight. Then, working from light to dark, he added shadows in the form of colored washes laid over the local color, achieving a chromatic resonance that was unknown to the topographers. (Even though it has been suggested that Francis Towne, for one, had anticipated Girtin's approach, Girtin was apparently the first to perfect the method.) Sometimes Girtin would vary his attack by making a conventional underpainting first, to establish massings of shade, but he would do so with a warm wash, such as burnt sienna, instead of with a cold India-ink wash.

In either case, the result was a warmth of palette that would have a profound effect on the rising generation of watercolorists and connoisseurs who sometimes spoke of Girtin's "golden drawings." As can be seen from *Durham Cathedral*, Girtin had a strong propensity for the use of earth colors and was able to achieve many effects while working with a limited range of pigments. As the support for these paintings, he favored a creamy, slightly absorbent cartridge paper that did not permit much reworking—such as rubbing or scraping out—but that enhanced the overall warmth of his palette, especially where he permitted it to glow through for highlights. (Girtin never used Chinese white but always relied on the white of the support.) It would be a mistake, however, to think of Girtin simply as an orchestrator of warm tones. He was extremely skilled at using cold tones in contrast and, indeed, was noted for the cool blues of his skies, which, of course, only enhanced and emphasized the warmth of the earth colors in the landscape. Girtin was original, too, in inventing with the brush. Whereas the topographers had depended on clean, flat washes, Girtin sometimes overlaid his washes with broken patches of color, often drawing with the brush, setting a precedent for the kind of calligraphic

36. Thomas Girtin (1775–1802)
Kirkstall Abbey, Evening, n.d.
Watercolor on paper,
12 × 20⅛ in. (30.5 × 51.1 cm)
Victoria and Albert Museum,
London

37. Thomas Girtin (1775–1802)
Cayne Waterfall, North Wales, n.d.
Watercolor on paper,
19³/₄ × 23⁷/₈ in.
(50.2 × 60.6 cm)
British Museum, London

approach that would be adopted by many watercolorists later in the century.

So much was adopted from Girtin that it is difficult for us today to take a measure of his originality. Other artists made his innovations seem familiar—indeed, this happened very quickly—but his best works still display a personality that is unmistakably his own.

If there is such a thing as an archetypal Girtin, it is, perhaps, *Kirkstall Abbey, Evening* (plate 36), a classic instance of the gentle side of English Romanticism. We find here the pastoral mood of Wordsworth blended with the fashionable interest in ruins, both transformed by Girtin's own poetic sense of mood, which is expressed by means of delicately handled aerial perspective and the introduction of a partial overcast that becomes as essential to the subject as the abbey itself. Much that is to come—from the panoramic views of Peter De Wint (plates 92–95) to the weather-filled skies of David Cox (plates 96–101)—is implicit in this image.

Cayne Waterfall, North Wales (plate 37) is an unfinished tour de force that provides an opportunity to study Girtin's method and appreciate the assurance with which he handled something as challenging as cascading water. It can be seen here from the unfinished passages that his way of sketching a subject still derived from the practices of the topographers, though his calligraphy is notably fluid. In the treatment of the waterfall itself, however, it becomes quite clear how the logic of Girtin's method builds the solidity of the rocks—they seem to spring up out of their two-dimensional setting—and the fluidity of the falling water.

The White House at Chelsea (plate 38), a painting that Turner held in particularly high esteem, is among Girtin's masterpieces. Here he carries informality of composition to an extreme that had seldom been approached before; for the most part, the

38. Thomas Girtin (1775–1802)
The White House at Chelsea, 1800
Watercolor on paper,
11³/₄ × 20¹/₄ in.
(29.9 × 51.4 cm)
Tate Gallery, London; Courtesy
Art Resource, New York

principal elements (in conventional terms) are simply strung out along the horizon line. The white house, with its reflections, makes a wonderful focus, but in reality the sky and the time of day are the true subjects. Some commentators have described this as a twilight subject, though the fact that the house is located on the Chelsea shore—the North Bank of the Thames—suggests exactly the opposite. Dawn, surely, is Girtin's subject here, the sun rising behind clouds beyond the fields of Battersea. In any case, this provided him with a splendid opportunity to demonstrate that he could orchestrate a cooler tonal spectrum when occasion demanded.

The poetry in *The White House at Chelsea* resides in the choice of subject and the conscious treatment of atmosphere, but Girtin had a poetic touch even when he was working in a journeyman's idiom. There was in Girtin's day a fashion for large-scale panoramas representing famous places or great victories, such as the Battle of the Nile, and Girtin entered this arena with the *Eidometropolis*, a panoramic view of London, which he executed in 1800 and 1801 and which was eventually shown, to excellent reviews but only modest popular success, in Spring Gardens. The full-scale original, which was nine feet high and more than two hundred feet in circumference, has been lost, but six watercolor studies remain (plates 39 and 40), and they are splendid examples of Girtin's mature handling of topographic themes. The architecture is accurately rendered, both the major landmarks—Westminster Cathedral, Somerset House, the Shot Tower on the South Bank—and the windmills, cottages, and row houses. The intention is clearly functional—these are studies—yet Girtin had developed such a facility and such an understanding of light and space that he could not help but capture the poetry of the city on a pleasant, sun-dappled day. By then Girtin's feeling for mood and atmosphere had become so instilled in his

39. Thomas Girtin (1775–1802)
Westminster and Lambeth (drawn
for the *Eidometropolis*), c. 1800
Watercolor on paper,
11 × 20¾ in. (27.9 × 52.7 cm)
British Museum, London

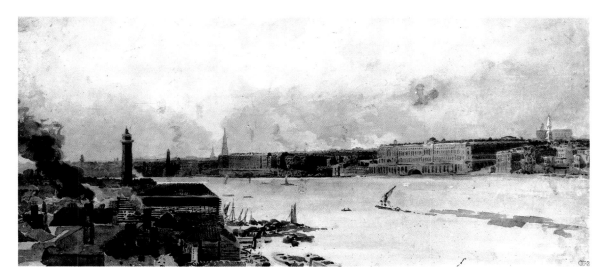

40. Thomas Girtin (1775–1802)
*The Thames from Westminster to
Somerset House* (drawn for the
Eidometropolis), c. 1800
Watercolor on paper,
9⅝ × 21¼ in. (24.4 × 54 cm)
British Museum, London

method that he transferred it from brush to paper almost without thinking.

In 1801 Girtin, recently married, traveled to Paris, hoping to show his panoramas there and perhaps entertaining plans for preparing a Paris panorama to exhibit in London. No such panorama resulted, but while he was in Paris, Girtin made a few magnificent watercolors, such as *Porte St. Denis* (plate 41), and prepared a series of prints, which he etched himself and which were published by his brother. By the time they appeared, however, he was gone. He died suddenly on November 9, 1802, at the age of twenty-seven, apparently as a consequence of a long-standing bout with asthma, which some contemporaries said he neglected.

Turner was among his mourners and is said to have remarked, "Had Tom Girtin lived, I should have starved." The remark is probably apocryphal, and, in reality, Turner was already the more successful of the two in terms of sales and public recognition. Although very much a solitary figure, he was assiduous in his devotion to the Royal Academy and was rewarded by that body in 1799 by being elected to an associateship, an honor Girtin never attained. In 1802 Turner became a full Royal Academician and the following year was voted onto the Academy's governing council. Later he served for many years as professor of perspective in the Academy

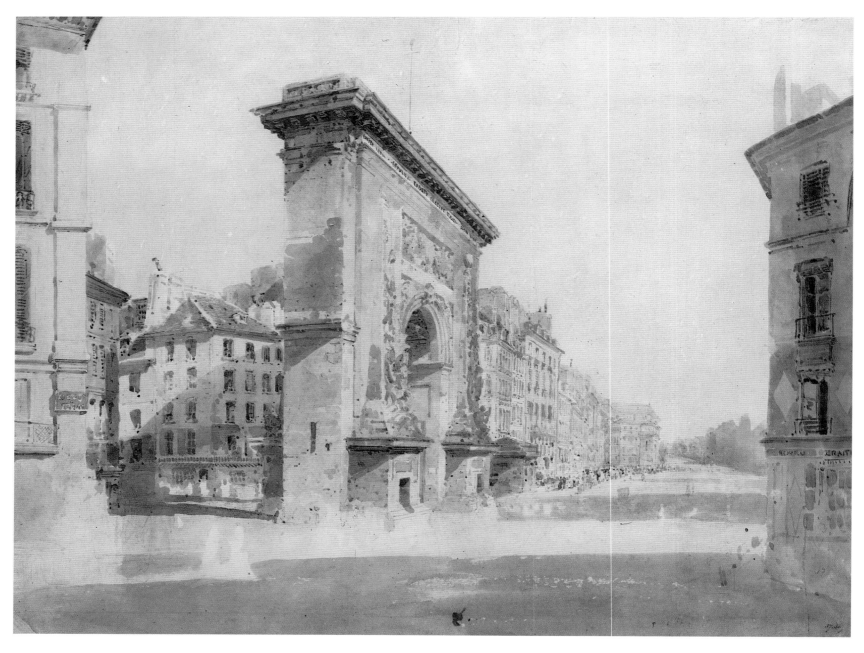

41. Thomas Girtin (1775–1802)
Porte St. Denis, c. 1801
Watercolor on paper,
18 × 23¾ in. (45.7 × 60.3 cm)
Victoria and Albert Museum,
London

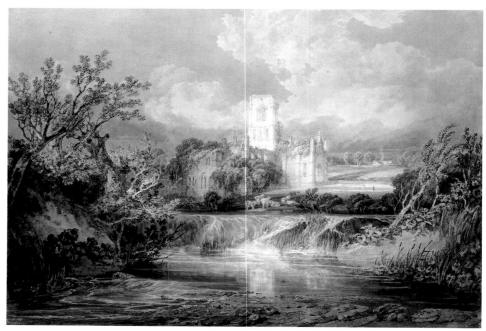

42. Joseph Mallord William Turner
(1775–1851)
Kirkstall Abbey, Yorkshire, 1797
Watercolor on paper,
20¼ × 29½ in.
(51.4 × 74.9 cm)
Fitzwilliam Museum,
Cambridge, England

Schools. Throughout all the years that he was perceived as the most radical of British artists, he remained a pillar of the establishment, so far as service to the Academy was concerned.

Meanwhile his development as a watercolorist, up to 1802, must be measured against Girtin's progress, and here there is some controversy. Most authorities favor Girtin as the leader, for the most part, though some experts strongly dispute this. For my part, I side with the Girtin proponents. Although Turner quickly learned how to build solid forms from colored washes, his palette remained relatively staid until after the turn of the century, and he leaned more heavily than Girtin on Claudian framing devices and overworked picturesque effects, as is apparent from his own view of Kirkstall Abbey (plate 42)—admittedly a commissioned work, which may have encouraged a conservative approach—painted for the second earl of Harewood in 1797. Even when dispensing with picturesque conventions, as in *Kew Bridge* (plate 43), he was unable to achieve the simple purity of Girtin's *White House at Chelsea*.

That said, however, it should be remarked that various factors may have affected the relative evolutions of the two artists. Except for the adventure of the *Eidometropolis*, Girtin had put all his efforts into watercolor. Turner, from 1796 on, was battling to establish himself as a painter in oils and thus was simultaneously

43. Joseph Mallord William Turner
(1775–1851)
Kew Bridge, c. 1805–6
Watercolor on paper,
10½ × 14⅜ in.
(26.7 × 36.5 cm)
Tate Gallery, London; Clore
Collection; Courtesy Art
Resource, New York

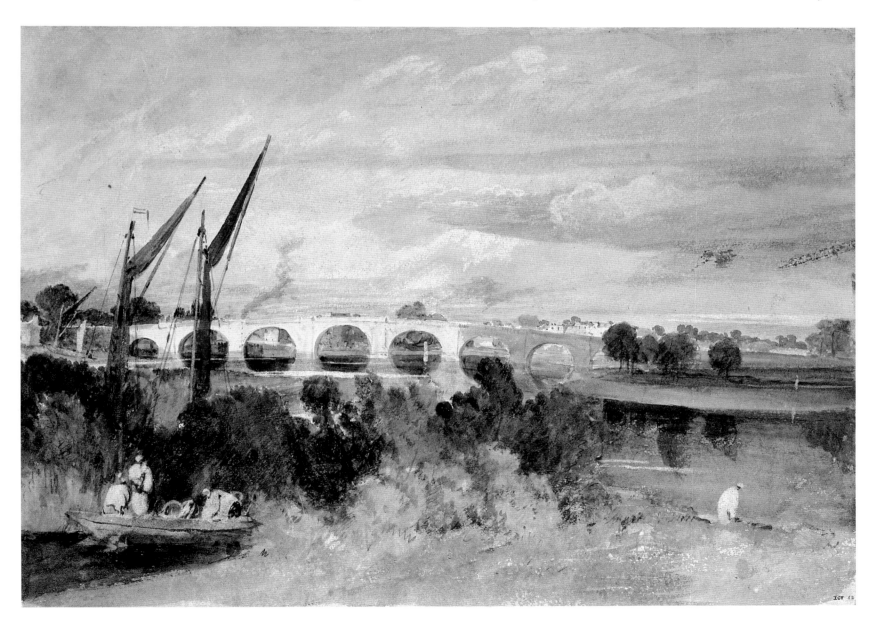

44. Joseph Mallord William Turner
(1775–1851)
Sailing Boats, 1797
Pencil, watercolor, and gouache
on brown paper, 4⁷/₁₆ ×˙7⁵/₁₆ in.
(11.3 × 18.6 cm)
Tate Gallery, London; Clore
Collection; Courtesy Art
Resource, New York

OPPOSITE
45. Joseph Mallord William Turner
(1775–1851)
The Passage of St. Gothard, 1804
Watercolor on paper,
38⁷/₈ × 27 in. (98.7 × 68.6 cm)
Abbot Hall Art Gallery,
Kendal, Cumbria, England

mastering a new medium. Also, obsessed with the history of art, he was constantly driven to set himself up for comparison with Claude, Nicolas Poussin, Richard Wilson, and others who had preceded him, whereas Girtin seems to have been unencumbered by such baggage. In any case, Turner had certainly caught up with Girtin by the time the latter died, and he was ready to launch out into new realms that would make him arguably the greatest watercolorist who has yet lived. If his development had been comparatively slow to that point, it was probably because of the complexity of his ambition, but those complexities would now bear fruit.

Turner was a tireless worker and an indefatigable traveler in search of new sights and subject matter. Starting in 1793 he made summer pilgrimages almost every year, initially exploring the British Isles, taking in certified areas of romantic scenery such as the Lake District, Scotland, and North Wales, but also acquainting himself with the gentler landscapes of the Midlands and the Home Counties and spending much time on the coast, where he came to know the English Channel and other British seas in all their unpredictable moods. Everywhere he went he took a sketchbook—often a very small one—and made notations of everything of interest that he encountered: landscapes, castles, village streets, people, shipping. Usually the sketches are made with great economy of means, and yet they manage to convey an enormous amount of information that, in concert with an astonishing visual memory, was all Turner needed to reconstruct a place or incident in his studio months or even years later. Typical of the sketches to be found in his early notebooks is a study of sailing boats in a heavy sea (plate 44), evoked with conciseness and ease. Here the pencil does most of the description, transparent washes are used to make the scene more concrete, and Chinese white, picking out the highlights on the waves, adds a touch of drama. Probably the whole thing was executed in five or ten minutes.

The reason Turner's travels had been confined to the British Isles was Napoleon's bellicose rise to power, but in 1802 the Treaty of Amiens was signed and England and France were briefly at peace. Turner immediately took advantage of this to visit Paris—where the Louvre was full of artworks brought back as war booty by Bonaparte—and to visit Switzerland, a country that he had dreamed of seeing since he studied and copied the Swiss landscapes of J. R. Cozens.

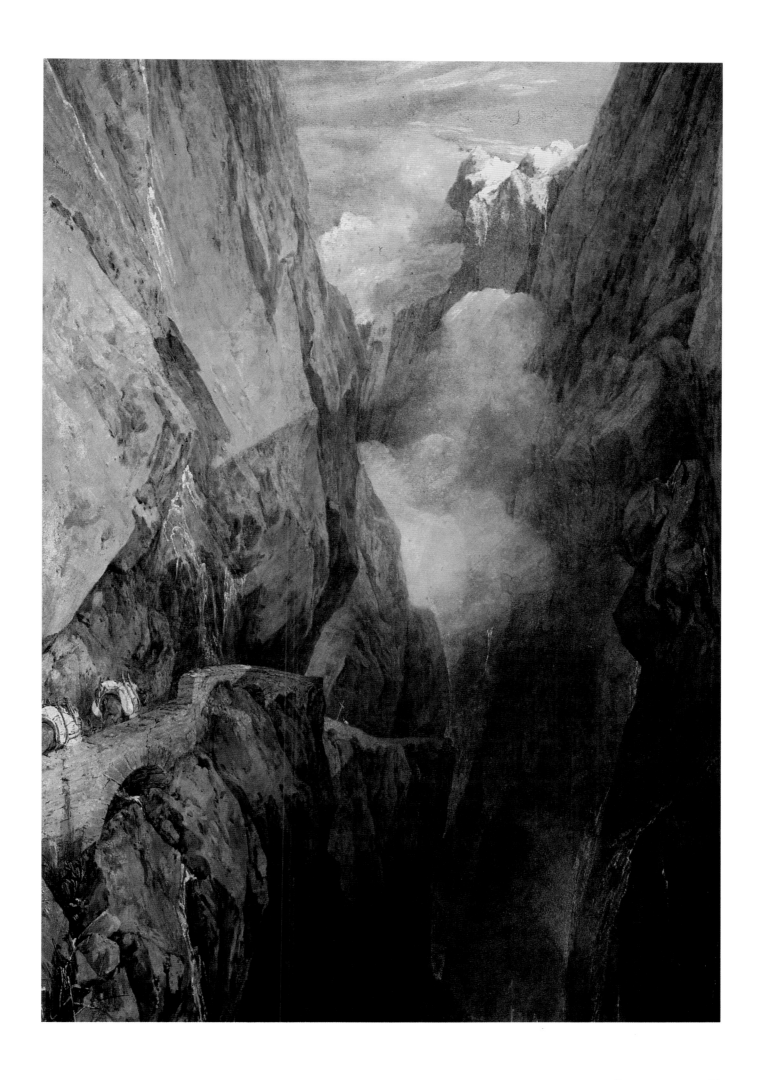

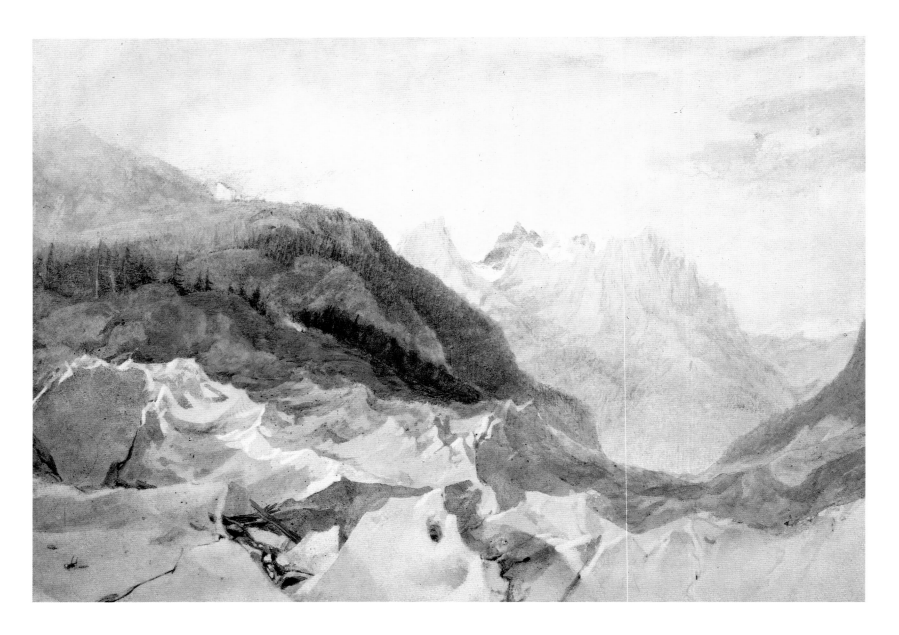

46. Joseph Mallord William Turner
(1775–1851)
*Mer de Glace, Chamonix, with
Blair's Hut,* c. 1806
Watercolor on paper,
10⅞ × 15⁷/₁₆ in.
(27.6 × 39.2 cm)
Courtauld Institute Galleries,
London; Sir Stephen Courtauld
Collection

It did not disappoint him. The more than four hundred sketches he brought
back with him furnished subject matter to work up for years to come (he did not
see the Alps again for seventeen years). Alpine forms found their way into his oils—
into genre scenes and historical subjects inspired by the works he had studied at the
Louvre—but, in particular, they provided him with the material for watercolors
that brought the medium to new heights.

The Passage of St. Gothard (plate 45) is an astonishing achievement, the large
scale and vertical format emphasizing the sublimity of the subject. The solidity of
the rocky precipices are skillfully set off against the drifting clouds, recalling one
of Girtin's favorite devices but in a context infinitely more dramatic than anything
Girtin ever attempted. And there is ample evidence here that Turner had mastered
the play of warm colors against cool. Beyond that, however, it is apparent that since
Girtin's death Turner had taken an enormous leap, technically, conceptually, and
emotionally. Here Turner demonstrates that watercolor can deal with a kind of po-
etic vision very different from the domestic lyricism that informs Girtin's work.
Turner is, in fact, closer to Cozens in mood, but he goes beyond Cozens in bring-
ing his scene to life with a technical virtuosity that is breathtaking. One senses that
he has reached a point at which he feels that nothing is beyond his means.

Mer de Glace, Chamonix, with Blair's Hut (plate 46) is more modest in scale, but

it, too, shows how far Turner had come since the turn of the century. He places the viewer right among the crevices of the glacier and lets him feel its weight and power by showing the way it can snap trees like matchsticks. (This is a subject that would have appealed to Caspar David Friedrich.) Once more, the technical command is amazing. The color on the background slopes is so delicately handled, the masses of the ice are suggested with such authority, and the whole is presented with so little fuss, it is difficult to grasp that this was painted by the same man who prettified Kirkstall Abbey so relentlessly less than a decade earlier.

Girtin had not been given much to trickery in his work. He built logically from washes and from dabs and patches of color, largely, as has been seen, because the paper he used did not stand well to "taking out." By the time Turner painted his first Alpine watercolors, however, Whatman was making a tougher, less absorbent, harder-sized paper that could stand a good deal of mistreatment. It was this paper Turner now favored, since it permitted him to use a wide variety of devices. As early as the latter years of the eighteenth century he had used rags, blotting paper, sponges, and bread crumbs to take out pigment, thus lightening areas that had already been laid in. He might create cloud effects in the sky, for example, by dampening it, blotting it, and pushing the wet pigment around. His friend Joseph Farrington noted, in 1798, that "Turner has no settled process but drives the colors about."[4] This was even more the case by the time he returned from Switzerland, and by then he had added new tricks. The hard-sized paper permitted him to scrape out with a knife blade, to etch into the surface with the sharp end of a brush, or to score in a highlight with a fingernail (one thumbnail was specially grown for this purpose). By no means a purist, Turner would mix body color with transparent color without qualms and would often use white chalk or Chinese white to help establish his lights, sometimes dragging transparent color across them with an almost dry brush to obtain a broken, flickering effect.

Turner's visit to the Continent did not mean that he abandoned British subjects. *A Lonely Dell, Wharfedale* (plate 47) is a product of one of Turner's Yorkshire tours. A more finished work, this is a relatively unusual subject for him in that it focuses on an enclosed, intimate space, yet the handling of light, the soft chiaroscuro effects that define the topography of the gulley from which a bird emerges, are all Turner. *Mossdale Fall* (plate 48), intended as the basis for an engraving for Whitaker's *History of Richmondshire*, is perhaps more typical of his Yorkshire watercolors. Based on an 1816 sketch, it shows his descriptive style at its peak. There is enough information here for the engraver to follow without difficulty, yet the watercolor itself displays a matchless subtlety of touch.

A different kind of documentary is the sketch for *Burning of the Houses of Parliament* (plate 49), a catastrophe Turner witnessed in 1834 and recorded with utmost economy in a number of studies, relying on his formidable visual memory to add detail when he came to make more ambitious records of the subject in his studio later.

That Turner's visual memory was a redoubtable tool is demonstrated by *A First Rate Taking in Stores* (plate 50), a splendid sea piece painted under circumstances that have come down to us in some detail. One of Turner's most avid patrons, and a connoisseur of watercolors, was Walter Fawkes, who on occasion had Turner as a guest at his Yorkshire estate. Fawkes was fond of sea pieces and one morning at breakfast said to Turner, "I want you to make me a drawing of the ordinary dimensions that will give some idea of a man-of-war." The idea must have appealed to Turner because he went off with Fawkes's oldest son, Hawksworth, then about fifteen, and began work on *A First Rate Taking in Stores*. (The title refers to the British Admi-

47. Joseph Mallord William Turner
(1775–1851)
A Lonely Dell, Wharfedale,
c. 1809
Watercolor on paper,
12 × 15½ in. (30.5 × 39.4 cm)
Leeds City Art Galleries,
Leeds, England

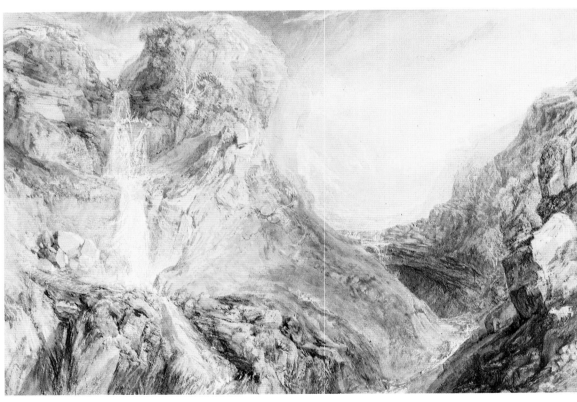

48. Joseph Mallord William Turner
(1775–1851)
Mossdale Fall, c. 1816–18
Watercolor (with highlights
taken out with end of brush
into wet color) on paper,
11½ × 16½ in.
(29.2 × 41.9 cm)
Fitzwilliam Museum,
Cambridge, England

ralty's classification of a warship carrying 100 to 120 guns as a "First Rate" vessel.) Young Fawkes watched with amazement as Turner conjured up the image out of seeming chaos: pouring paint onto the paper, tearing, scratching, scrubbing, until three men-of-war and attendant small boats appeared as if by magic. And Turner worked without any references, so that everything—sea, sky, rigging, cannon ports—was dredged from memory. By lunchtime the painting was finished and triumphantly displayed.[5]

49. Joseph Mallord William Turner
(1775–1851)
*Burning of the Houses of
Parliament*, 1834
Watercolor on paper,
9^{1}/$_{16}$ × 12^{13}/$_{16}$ in.
(23 × 32.5 cm)
Tate Gallery, London; Clore
Collection; Courtesy Art
Resource, New York

50. Joseph Mallord William Turner
(1775–1851)
A First Rate Taking in Stores,
1818
Watercolor and pencil on paper,
11^{1}/$_{4}$ × 15^{5}/$_{8}$ in.
(28.6 × 39.7 cm)
The Cecil Higgins Art Gallery,
Bedford, England

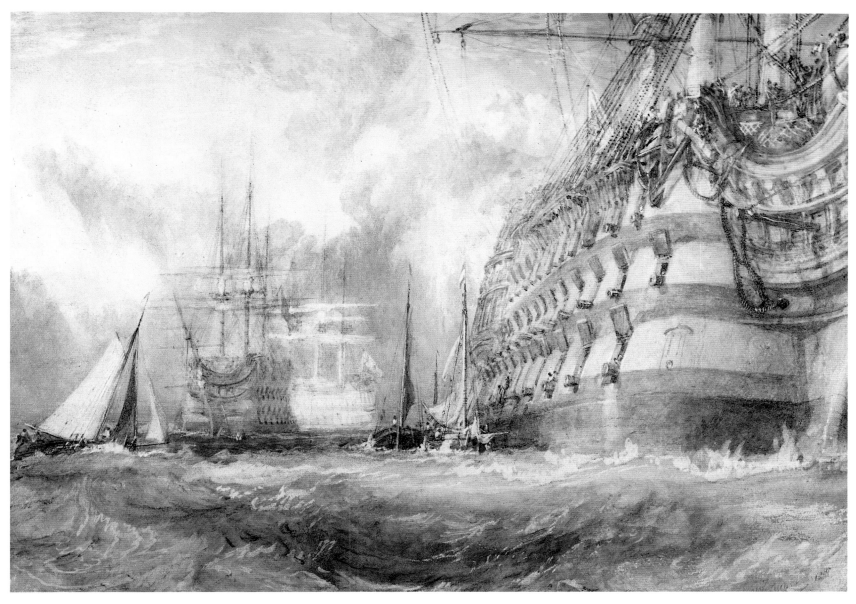

The Peace of 1815 enabled Turner to visit the Continent once more. In 1817 he traveled to the Rhine, and in 1819 he made his first, long-anticipated visit to Italy. He was not disappointed. The cities and countryside delighted him, but above all it was the light that engaged his imagination. That singular Mediterranean light, sometimes soft, sometimes harsh, provided him with renewed inspiration and permitted him to bring to fruition tendencies already partially expressed in his work.

One of the first discoveries Girtin and Turner made—they actually learned it in part from Cozens—was that shadows can hold significant color values; they were not just patches of darkness, but areas with their own significant luminosity. The logic of watercolor taught them this, and Turner soon began to apply the discovery to oil paintings, too. As his darks became more high keyed, so his lights had to become lighter, a fact that led to critics mocking him for making "white paintings." His experiments worked well enough for British subjects—they helped him capture dewy dawns and limpid twilights—but they were even better suited to sunrise over the Roman Campagna or noon on the Bay of Naples. One can imagine that, as he saw Venice for the first time, late in the summer of 1819, he must have felt he was entering a world he had already imagined, a world created for his palette. There would be no complete break with the past—he would still make some pictures that saw Italy through Claude's eye—but this first visit crystalized certain latent tendencies and set the stage for the last three decades of his career, in which, more fully than anyone before him, he explored the notion of color as surrogate for light. Such an exploration remained controversial in his oil work, but in his watercolors it could be pursued without arousing alarm because its logic was self-evident (though few contemporaries, of course, saw the most extreme experiments he carried out in the privacy of his notebooks).

A small group of illustrations can only suggest the variety Turner found in Italy on his several visits there. (On his first trip he is said to have made more than fifteen hundred sketches in the vicinity of Rome alone.) *Florence from near San Miniato* (plate 51) is among his more conventional treatments of Italian subjects,

51. Joseph Mallord William Turner
(1775–1851)
Florence from near San Miniato,
c. 1819
Watercolor on paper,
11⅛ × 16⅜ in.
(28.3 × 41.6 cm)
British Museum, London

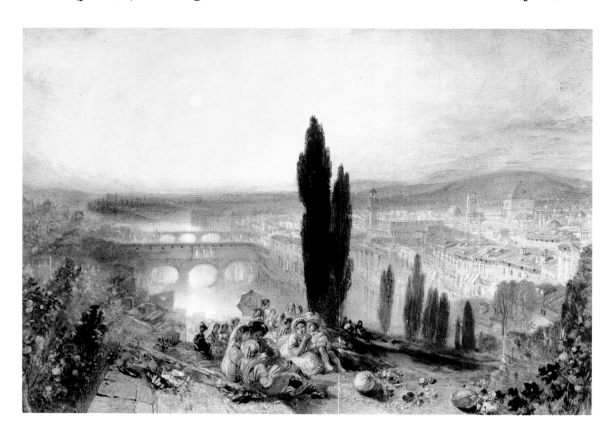

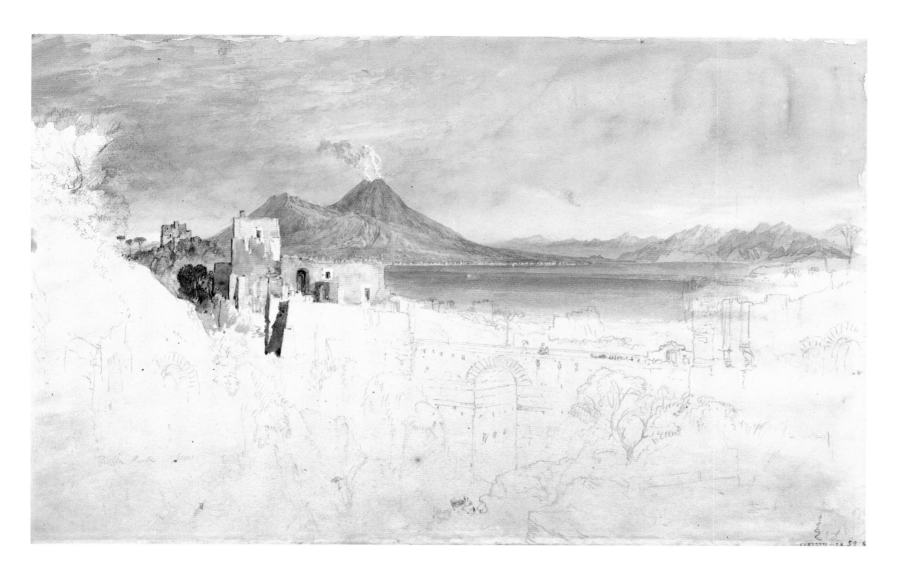

52. Joseph Mallord William Turner
(1775–1851)
*View from Naples Looking
towards Vesuvius* (or *Vesuvius*),
1819
Watercolor and pencil on paper,
9¹⁵/₁₆ × 15¹³/₁₆ in.
(25.2 × 40.1 cm)
Tate Gallery, London; Clore
Collection; Courtesy Art
Resource, New York

clearly topographic in intent, with genre interest very deliberately introduced into the foreground. The handling is extremely delicate, nonetheless, and the way the light bathes the architecture and gleams on the surface of the Arno is pure Turner.

View from Naples Looking towards Vesuvius (plate 52) offers an opportunity to study Turner's technique at its most straightforward in the form of an unfinished drawing. This is a sketchbook study, made *in situ*, and it may be that he colored in only those sections where he felt the need for chromatic information to supplement his memory. The great majority of his notebook sketches were simple black-and-white pencil notations, and it was, in fact, in Naples that he made his famous remark about not working in color on the spot because he could produce fifteen pencil sketches for every colored drawing. Clearly, the present example is a partial exception to that rule; as will be seen, other exceptions were even more dramatic. In any case, the color in this unfinished sketch is gorgeously fresh and the pencil work wonderfully delicate.

Turner was always competing with the masters of the past (and with his contemporaries, for that matter), so that in Venice he must have thought often about the Canalettos and Guardis he and Girtin had copied at Dr. Monro's. Yet Venice was a city made for Turner's most personal visions, as is evident from the slightest notebook sketches he made there. Probably executed on his first trip to Venice—he would make three altogether—*The Campanile, San Marco* (plate 53) is an amazingly modern-looking little study. The architecture is established with deftness and economy; effortlessly, Turner conjures up the feeling of stone bathed in golden light

53. Joseph Mallord William Turner
(1775–1851)
The Campanile, San Marco,
c. 1819
Watercolor and pencil on paper,
8⁷/₈ × 11⁵/₁₆ in.
(22.5 × 28.7 cm)
Tate Gallery, London; Clore
Collection; Courtesy Art
Resource, New York

against a summer sky that is itself just a blue wash dragged across the support so that the paper gleams through.

Venice: San Giorgio, Morning (plate 54) is the kind of Turner that would be much imitated by later watercolorists. Here the economy is even more striking. Not a brushstroke is wasted, yet the shimmering color casually evokes an atmosphere of lazy summer heat. Just as astonishing is *Venice, Storm at Sunset* (plate 55), in which it can be seen how effectively Turner could, in the latter half of his career, drive his color around. The sky is made up of a miniature cyclone of brushstrokes, and the broken strokes that evoke the chopping waves seem driven by the wind that fills the sails of the sailboats. This is a fine example of the way Turner could make his brushstrokes appear to embody the elements, as opposed to merely describing them. In sheets like this he seems almost to enter the subject he is painting, dragging the viewer with him.

Turner traveled extensively in France, Germany, the Low Countries, and as far afield as Greece. Some of the drawings he made on these journeys served to generate editions of engravings, such as his Rivers of France series, which appeared in the

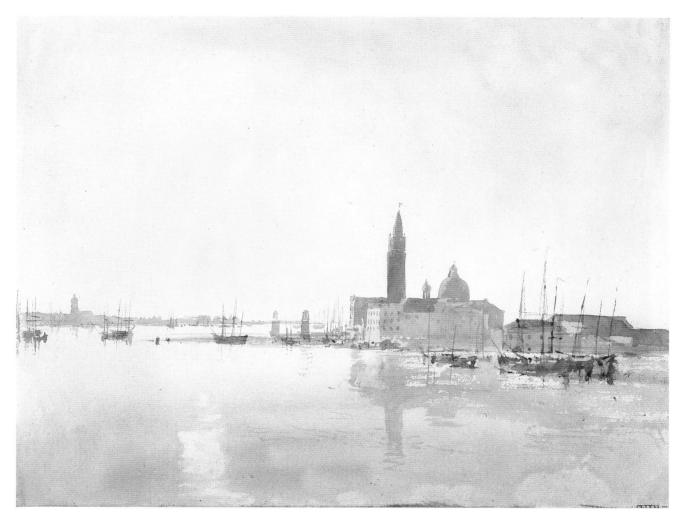

54. Joseph Mallord William Turner
 (1775–1851)
 Venice: San Giorgio, Morning,
 1819
 Watercolor on paper,
 8³/₄ × 11³/₁₆ in.
 (22.4 × 28.7 cm)
 Tate Gallery, London; Clore
 Collection; Courtesy Art
 Resource, New York

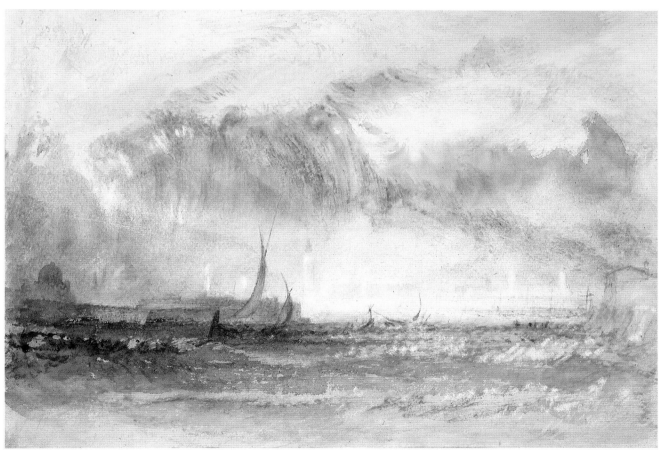

55. Joseph Mallord William Turner
 (1775–1851)
 Venice, Storm at Sunset,
 c. 1840–42
 Watercolor and body color with
 highlights scratched out and
 with faint red ink additions on
 paper, 8³/₄ × 12¹/₂ in.
 (22.2 × 31.8 cm)
 Fitzwilliam Museum,
 Cambridge, England

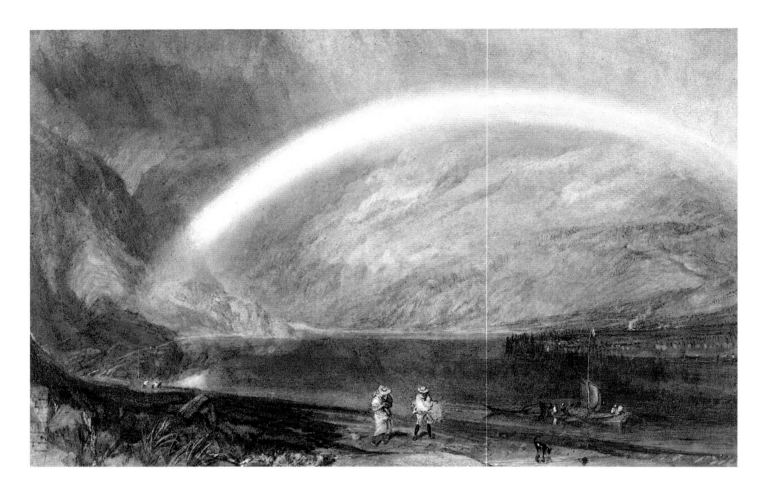

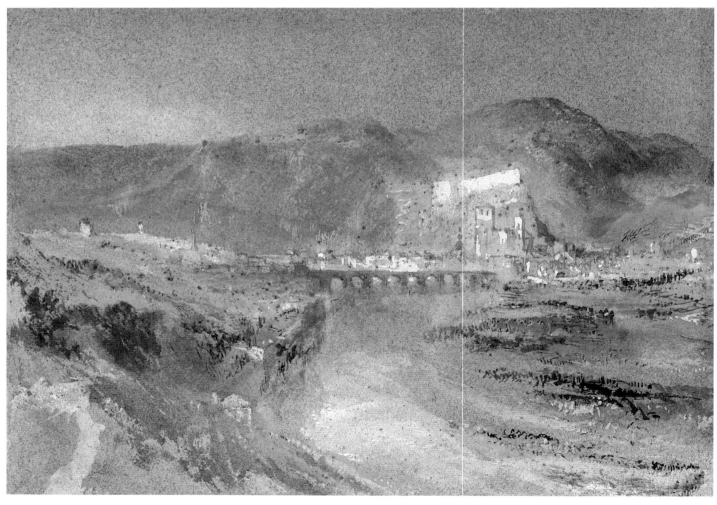

1830s. *Rainbow: Ostersprey and Feltzen on the Rhine* (plate 56) was apparently a result of his 1817 Rhine expedition. *Huy on the Meuse* (plate 57) seems to be based on sketches made on an 1826 trip to Belgium, though the painting may have been made some years later.

These are skilled but conventional watercolors of the kind that Turner continued to produce throughout his career. Far more daring is his study of the Acropolis (plate 58). There is hardly anything there, yet Turner evokes one of the great sites of Western civilization with matchless brilliance. It is not the architecture he emphasizes, but the magnificence of the site itself, the very thing that led men to crown it with temples in the first place. At the same time this little study is a celebration of light, the true subject of so much of Turner's later work.

Nowhere is the obsession with light more obvious than in the so-called "color beginnings" (a name posthumously assigned to them for cataloguing purposes). As noted, Turner generally relied on pencil alone to set down the topography of a place. Sometimes, however, he made wash sketches intended to capture not so much the topography as the atmosphere and mood expressed by color and luminosity. Occasionally these color beginnings appear to be studies for elaborate imaginative compositions. More frequently they represented a natural phenomenon—a storm, dawn light on wet sands—of which Turner wished to retain a record. Others deal with the sense of place as perceived in terms of weather, light, and shadow. Some may indeed be actual beginnings—paintings that were not completed for some reason or other—but there is every reason to suppose that most are as finished as they ever were meant to be, serving as studies for the artist's reference rather than for public display.

In a very real sense, the majority of Turner's later watercolors, from roughly

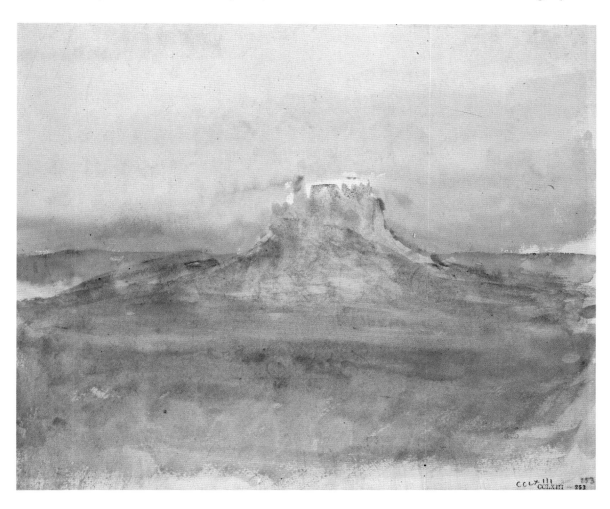

1820 on, could be said to be finished at almost any stage. Contemporaries describe how he began by pouring wet color onto the paper until it was saturated, then drove the colors around until the image began to emerge. At that point, in a sense, the basic statement was already made. From then on it was a matter of how much information to add, and that depended to a large extent on what the watercolor was intended for. If it was to be sent to the Royal Academy Summer Show, for example, or was to provide the basis for an engraving, then Turner was likely to work in a good deal of detail. A connoisseur visiting the artist's private gallery, however, would have found many exquisite sheets—such, for example, as *Venice, Storm at Sunset*, which once belonged to John Ruskin—that left much to the imagination, though they, too, were finished work. Work intended solely for reference might contain no detail at all. Such studies were meant for Turner's eyes only and would have made little sense to most of his contemporaries. The twentieth-century viewer, however, accustomed to nonfigurative art, has no problem in appreciating the color beginnings. If the contemporary viewer does encounter a difficulty, it is that of falling into the trap of reading the color beginnings as though they were twentieth-century works. To Turner they were decidedly figurative, though certainly they are prime examples of that magical moment—which recurred so often in the art of the nineteenth century and the early part of the twentieth century—when paint as representation is held in perfect equilibrium with paint as paint. With Turner's color beginnings and notebook jottings, the prelude to modernism sounds its opening chords.

A sky study from about 1820 (plate 59) shows a sliver of moon against the last glow of a sunset, the whole laid in with marvelous brevity. Another sheet in the same notebook (plate 60) probably represents the same sky minutes later, suffused now with the quiet grays of twilight, clouds scratched in with the sharp end of the brush or with Turner's elongated thumbnail. These studies are made in a kind of

59. Joseph Mallord William Turner
(1775–1851)
Sky Study (notebook CLVIII,
p. 54), c. 1820
Watercolor on paper,
4⅞ × 9¾ in. (12.4 × 24.8 cm)
Tate Gallery, London; Clore
Collection; Courtesy Art
Resource, New York

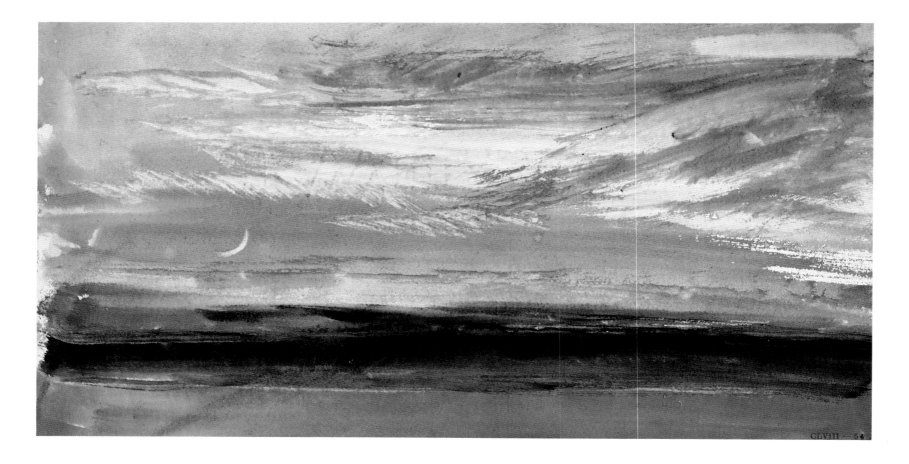

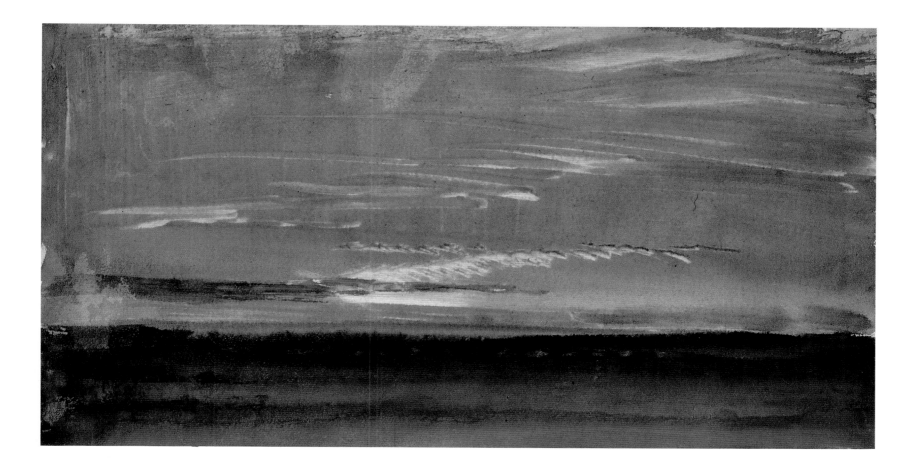

60. Joseph Mallord William Turner
(1775–1851)
Sky Study (notebook CLVIII, p. 53),
c. 1820
Watercolor on paper,
4⁷/₈ × 9³/₄ in. (12.4 × 24.8 cm)
Tate Gallery, London; Clore
Collection; Courtesy Art
Resource, New York

visual shorthand, yet they provide all the information Turner would need to introduce such skies into future paintings.

A more dramatic example of a sky study is *Arch of Clouds over the Sea* (plate 61), a vividly evocative sketch that, despite a more muted palette, anticipates watercolors made by Emil Nolde almost a century later. Dramatic, too, is *The Whaler* (plate 62), which related to whaling scenes exhibited at the Academy in 1845 and 1846. Despite the economy of the treatment, this sheet is full of incident. The shape of the whale is clear enough, as are the masts of the ship, and Turner has scribbled, in the bottom right-hand corner, "He breaks away." As in the case of *Venice, Storm at Sunset*, it is as if the artist, by some act of the imagination, has been able to enter into the picture, so that the scene is not so much represented as experienced. This is watercolor taken to a far extreme from the topographer's craft that had been Turner's starting place. In its modest way, *Arch of Clouds over the Sea* represents the culmination of the revolution he and Girtin had instigated half a century earlier.

The Shore (plate 63) is a far gentler work, saturated with a pale gray wash that carries hints of pink and blue. At a glance this sketch is the merest nothing, yet it embodies the very essence of watercolor. Like a Zen drawing, it is an apparent trifle that could be made only by a master.

In 1845 Turner paid his last visit to the Continent and afterward seems to have traveled little, even within the British Isles—though he made one final trip to Margate in 1845 or 1846. More and more of his time was spent in secretive seclusion in his cottage on the Thames at Chelsea, where he shared his quarters with a Mrs. Booth, a widow he had first met in 1833. True to character, he concealed this relationship from even his closest associates and maintained his privacy in Chelsea by taking the name Booth himself.

Later, Mrs. Booth would report that during his last years Turner was much

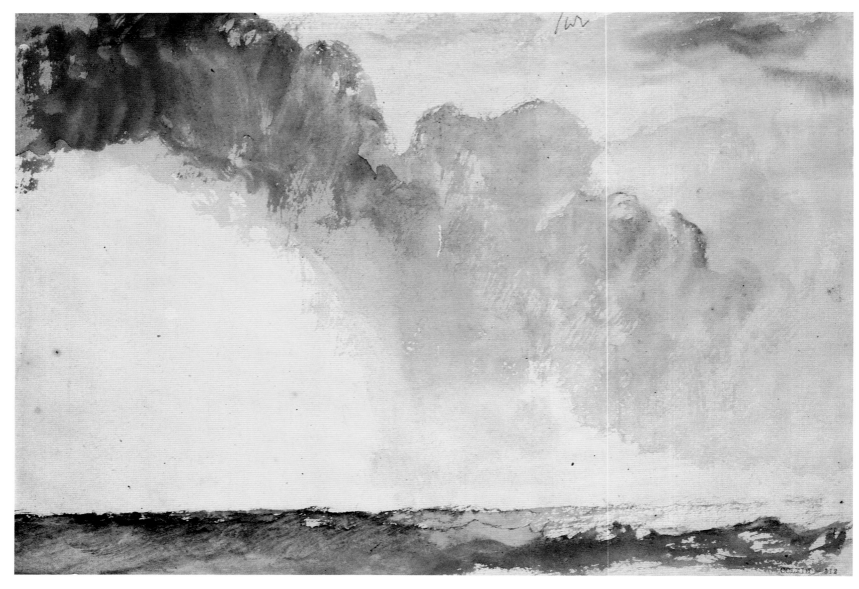

61. Joseph Mallord William Turner
 (1775–1851)
 Arch of Clouds over the Sea,
 1820–30
 Watercolor on paper,
 7¹/₂ × 10¹³/₁₆ in. (19 × 27.5 cm)
 Tate Gallery, London; Clore
 Collection; Courtesy Art
 Resource, New York

62. Joseph Mallord William Turner
 (1775–1851)
 The Whaler, 1845
 Watercolor and pencil on paper,
 8¹⁵/₁₆ × 12¹³/₁₆ in.
 (22.7 × 32.5 cm)
 Fitzwilliam Museum,
 Cambridge, England

preoccupied with painting sunsets. He seldom had the strength to tackle large-scale oils now, but his late sunsets (plate 64) show that he never lost his sublime touch with watercolor.

He died, in 1851, in his room overlooking the river, having bequeathed his entire artistic estate to the British nation. Included in the bequest are more than twenty thousand drawings and watercolors, which enable posterity to trace one of the most remarkable journeys in the entire history of painting, a pilgrimage that took Turner from the polite conventions of the topographers to the highest reaches of visionary art. In the footsteps of Cozens, and in early partnership with Girtin, he invented modern watercolor painting, then went on to exploit the medium with a skill, invention, and flexibility never surpassed.

THREE

The Apotheosis of English Landscape

65. John Sell Cotman
Greta Bridge, 1805
Detail of plate 82

Needless to say, Girtin and Turner did not exist in a vacuum. The first quarter of the nineteenth century saw the rise of an entire school of British landscape artists that is one of the high points of the history of watercolor painting. A few of the painters who made up this school—John Constable, John Sell Cotman, Peter De Wint, and David Cox, for example—were major figures, to be spoken of in the same breath as Girtin and Turner. Alongside them were lesser lights who still played a role in the advancement of the cause of watercolor.

Topography, in the old sense, continued to be a respectable if minor activity, and one of its most distinguished early nineteenth-century exponents was Augustus Charles Pugin. Born in France in 1762, Pugin came to England at the close of the century and was employed as a draftsman in the offices of John Nash, architect of Regent Street and the Brighton Pavilion. Pugin's son was the important architect and theorist of the Gothic revival, Augustus Welby Northmore Pugin. The senior Pugin made his own contribution to the systematic study of British Gothic architecture in his watercolors, many of which were engraved for such publications as *History of the University of Oxford* (1814). His mature style, as exemplified by *High Street, Oxford* (plate 66), is straightforward topography tempered by a Girtinesque sense of architectural solidity and even a touch of atmospheric aerial perspective. The work relates to artists like Malton and Dayes, yet the technique is more modern, making for a true painting rather than a tinted drawing.

Somewhat in tune with the spirit of the topographers, though more lyrical in approach, were the two most significant members of the Varley family (which produced several worthy watercolorists), John, born in 1778, and his younger brother, Cornelius, born in 1781. Like Girtin and Turner, though a few years later, John Varley came to the attention of Dr. Monro and quickly gained something of a reputation in the watercolor world. He was one of the founders of the Old Water-

Colour Society in 1804 and became one of the most prolific contributors to the Society's shows, sending sixty works to the 1809 exhibition alone. Along with sales of his work, Varley earned his living as a teacher, instructing both future professionals and eager amateurs, the latter being asked to pay the then handsome fee of one guinea an hour.

It seems that Varley was an excellent teacher, full of sound advice. He would tell his pupils that flat washes of color, in a good lay-in, are like silences, "for as every whisper can be distinctly heard in a silence, so every lighter or darker touch on a simple and masterly lay-in told at once, and was seen to be good or bad."[1] Varley also presented his pupils with his own arguments for the validity of astrology, palmistry, and other esoteric disciplines. He also liked to describe how he had witnessed William Blake summon from the dead such past luminaries as Moses and Julius Caesar, taking opportunity of these manifestations to make portrait sketches.

John Varley's own work, though hardly mystical in the sense of Blake's (plates 156–65), often displayed a certain spiritual lyricism, as is apparent from *Mountainous Landscape, Afterglow* (plate 67). Here the early influence of Girtin has been modified by a tendency to idealize the landscape, with Claude and perhaps Turner in mind. Later, Varley took this idealizing tendency too far, making rather archaic-looking paintings, but at his best he was a master of the clean washes he advocated to his pupils and built his images with a logical simplicity that was a direct expression of the inherent strengths of the medium.

His younger brother, Cornelius, also attended Dr. Monro's salon, but he was by no means as prolific as John, devoting much of his life to the design of optical instruments, including a device related to the camera obscura, which he may have used in making some of his more detailed topographic works. His relatively rare watercolors are occasionally first rate, as is the case with *Llyn Gwynant, North Wales* (plate 68), an early sheet in which the scene is set down with great economy, while being suffused with a somber lyricism reminiscent of Cozens.

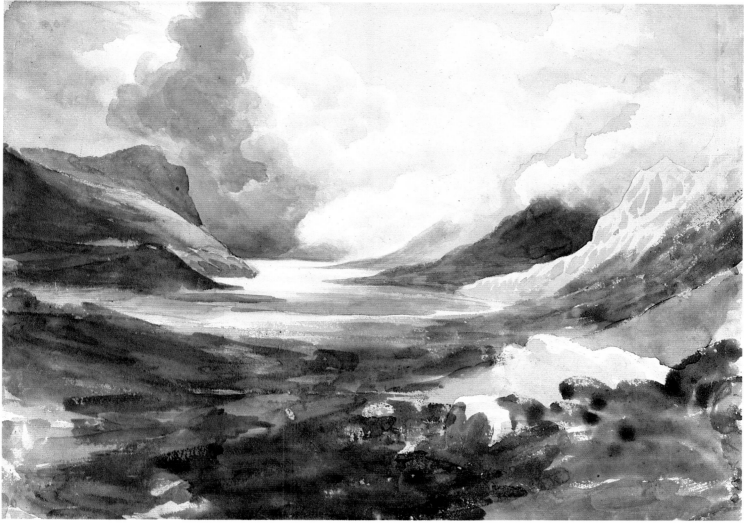

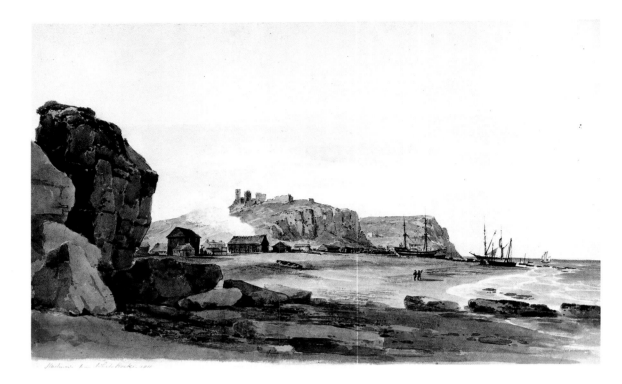

69. Paul Sandby Munn (1733–1845)
Hastings from White Rock, n.d.
Watercolor on paper,
10 × 16 in. (25.4 × 40.6 cm)
British Museum, London

70. Thomas Bewick (1753–1828)
A Starling, n.d.
Watercolor on paper,
7¹¹/₁₆ × 10 in. (19.5 × 25.4 cm)
Courtauld Institute Galleries,
London; Witt Collection

OPPOSITE
71. Robert Hills (1769–1844)
Alderney Cows and Calves, 1820
Watercolor on paper,
20⅞ × 18¾ in. (53 × 47.6 cm)
Victoria and Albert Museum,
London

Less inspired, but often charming and typical of the younger artists influenced by Girtin, is Paul Sandby Munn, the godson of Paul Sandby. In 1799 he became a member of the Sketching Club founded by Girtin and there met the Varleys, John Sell Cotman, and other watercolorists of the day. He was especially friendly with Cotman, with whom he made sketching tours, but never really evolved a distinctive style of his own. Paintings such as *Hastings from White Rock* (plate 69), however, are lucidly conceived and executed works that place him a cut above the general run of his contemporaries.

More original was Robert Hills, known from the 1790s on as a fine etcher and a painter of animals. When he turned to watercolor he evolved an effective technique that relied greatly upon the use of stippled effects over washes, which gave his pictures a degree of detail and a density of color destined to appeal greatly to watercolorists later in the century. In both his animal subjects (plate 71) and his rustic genre scenes, he was a decade or two ahead of his time. Another printmaker who sometimes worked in watercolor was Thomas Bewick, best known for his masterly wood engravings. He did not exhibit his watercolors during his lifetime, and it seems that studies such as *A Starling* (plate 70) must have been made purely for reference.

Bewick, in black and white, was one of the most important recorders of the British countryside. No artist, however, more thoroughly identified with the British countryside than John Constable, Turner's only real rival as a landscapist and a watercolorist of a very high order, though watercolor was for him a secondary medium.

The facts of Constable's life are well enough known. Born in 1776 into middle-class comfort in East Bergholt, near the Suffolk–Essex border, he was the son of a miller and landowner. He worked in his father's mills as a boy, and this undoubtedly had its influence on his later approach to landscape in that a miller, dependent on wind, must make a study of skies. As an artist he was a slow developer, not entering the Academy Schools until 1800, when he was twenty-four years old. Instead of reaching for early virtuosity, he searched for an original vision, one dominated by an unswerving fidelity to naturalism that was to make him one of the seminal fig-

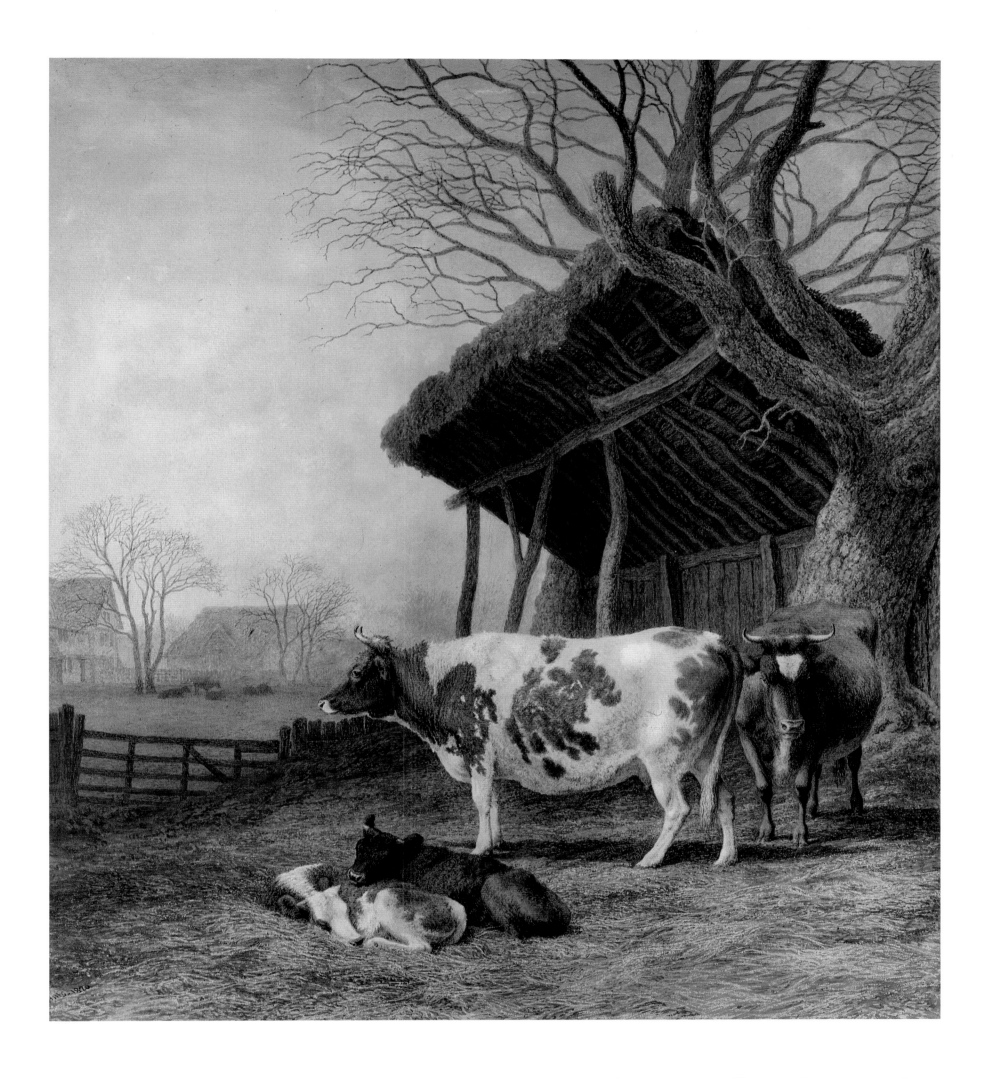

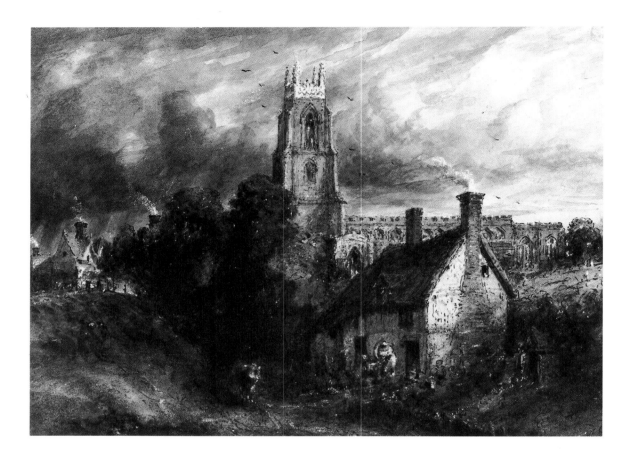

72. John Constable (1776–1837)
Stoke-by-Nayland, n.d.
Watercolor on paper,
5⅝ × 7¾ in. (14.3 × 19.7 cm)
British Museum, London

OPPOSITE, TOP
73. John Constable (1776–1837)
Trees, Sky and Red House
(page from a sketch book),
c. 1821–23
Pencil and watercolor on paper,
6¾ × 9¹⁵/₁₆ in.
(17.3 × 25.5 cm)
Victoria and Albert Museum,
London

OPPOSITE, BOTTOM
74. John Constable (1776–1837)
*London from Hampstead with a
Double Rainbow*, 1831
Watercolor on paper,
7¾ × 12¾ in.
(19.7 × 32.4 cm)
British Museum, London

ures of nineteenth-century painting. Unlike Turner, he did not travel to Switzerland
or Italy in search of the sublime—nor did he seek out the more romantic aspects of
British landscape—but, rather, found a quiet poetry in places like Hampstead,
Brighton, the Dorset coast, and, above all, his native Suffolk–Essex border country.

It is perhaps surprising that Constable was not drawn sooner to watercolor,
since his aims as a painter certainly had much in common with Girtin and his fol-
lowers, and certainly the influence of Girtin is apparent in his occasional early
efforts in the medium. He was very capable of making conventional watercolor
views, such as *Stoke-by-Nayland* (plate 72), actually a latish work, but his real pen-
chant in the medium—which was to emerge at about the time of his marriage, in
1816—was for lyrical evocations of landscape and, especially, weather that embody
a freedom of approach entirely his own, being more closely related to his oil studies
of similar subjects than to the work of any other watercolorist.

If Constable found poetry in the quieter aspects of the English landscape, he
also found drama in the skies above it, and it is in this respect that he came closest
to Turner. His sky studies, in both oil and watercolor, though not intended for exhi-
bition, are among the delights of nineteenth-century painting. In *Trees, Sky and
Red House* (plate 73), the sky is framed by a landscape, presumably Hampstead,
which is brushed in with great fluidity and spontaneity. In *London from Hampstead
with a Double Rainbow* (plate 74), the subject is virtually all sky, though the slope of
the heath is suggested with careful distribution of light and shadow that adds
greatly to the allover mood of the piece. In *Sky Study with Rainbow* (plate 75), the
landscape has vanished entirely, leaving a work almost abstract in concept.

At times Constable spoke of himself as a natural philosopher, and certainly he
was conscious of scientific theories with regard to the optical formation of such phe-
nomena as rainbows, yet he insisted "It is the soul that sees. . . ."[2] When painting
rainbows, as, like Turner, he did many times, he never permitted science to surpass

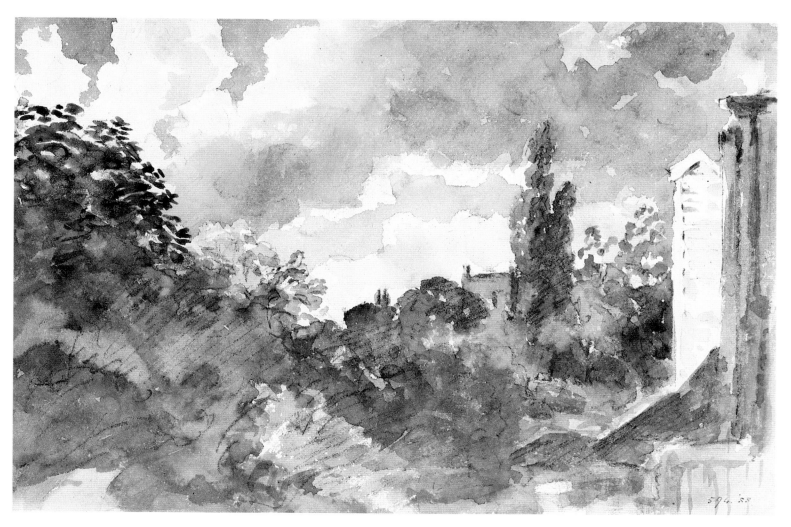

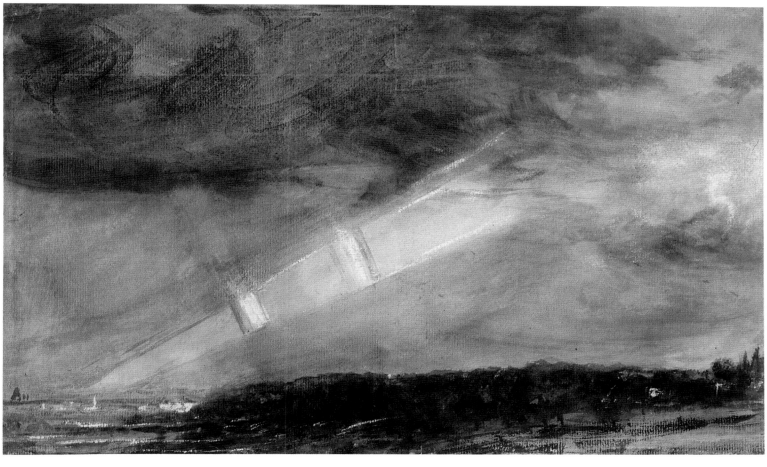

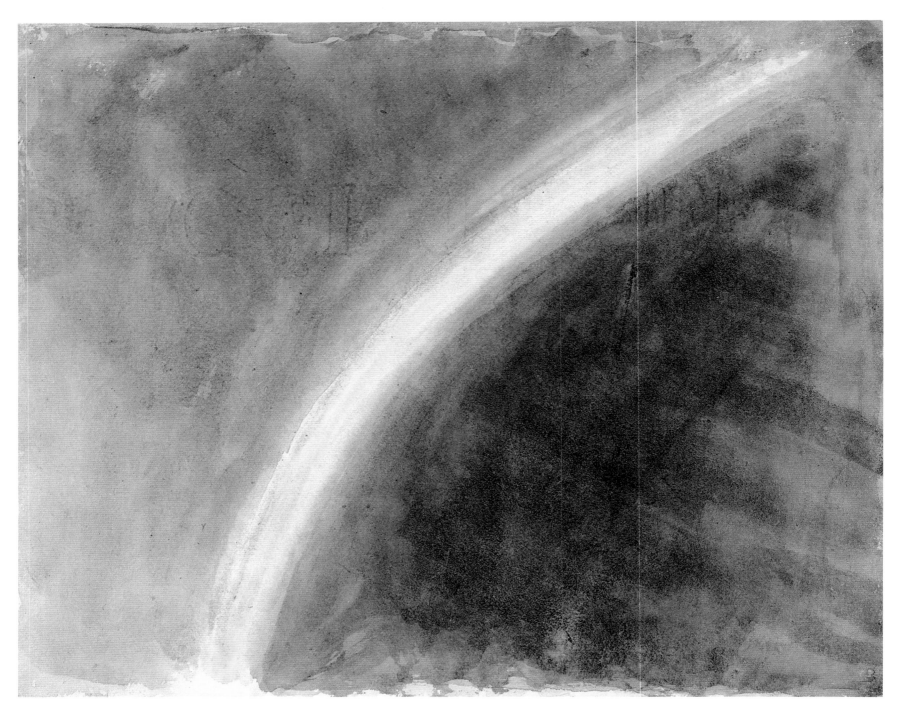

75. John Constable (1776–1837)
Sky Study with Rainbow, 1827
Watercolor on wove paper,
7¼ × 8⅞ in. (18.4 × 22.5 cm)
Yale Center for British Art,
New Haven, Connecticut; Paul
Mellon Collection

poetry. Indeed, what is so remarkable about much of Constable's work is that it balances the modern, scientific vision of the world with the poetic, a fact that helps explain his influence in France, especially on the Impressionists.

The rainbow in *Seaport with Storm Passing* (plate 76) may be a pictorial afterthought, but it is nonetheless effective, and here the viewer is presented with an example of Constable at his informal best. Like Turner, he seems to have driven his colors around; there is little drawing to be seen beneath the paint that is here dragged, here blotted, there scraped out to provide a highlight. There is no bravura display of virtuosity, yet Constable demonstrates his mastery of every aspect of the medium. The ships that have found the shelter of the harbor are evoked with a few casual strokes. Those on the horizon are represented as flicked-out white specks that read as sailing vessels because of their color and position rather than because of their forms. The windswept sky is skillfully built from overlapping areas of purple and brownish gray, with surprisingly little use of wet into wet, and the pale green on

the hillside speaks more of broken cloud, allowing the sunlight through, than would any tattered patch of cerulean.

It is still fashionable in some circles to speak of all watercolors as drawings, a convention that goes back to the eighteenth century, when drawings are precisely what they were. This Constable is a clear demonstration of the fact that, by the second decade of the nineteenth century, advanced watercolorists were making *paintings*. Line here is clearly subordinate to form, mass, color, and the manipulation of pigment.

Most of Constable's watercolors were made for study purposes, or for the pure joy of recollection. Toward the end of his career, however, he painted some that were intended for exhibition. Included among these is *Stonehenge* (plate 77), based on a sketch he had made years earlier. In this masterpiece, Constable once more brings into play all the tools of the watercolorist's trade to create a work at once painterly and poetic, descriptive and profound. Like Turner, Constable scrapes and blots and drags his brush, and like Turner he has the ability to enter into the mood of the piece. It is impossible not to suppose that the older man must have grudgingly admired this sheet when it was exhibited at the Academy in 1836.

Constable was not the only East Anglian to add to the achievements of the British watercolor tradition. The cathedral city of Norwich, a half-day's coach journey from Constable's native Vale of Dedham, was home to an entire school of painters that made considerable contributions both to English watercolor and English landscape painting in general. The Norwich School was provincial in the best

76. John Constable (1776–1837)
Seaport with Storm Passing, n.d.
Watercolor on paper,
5 × 8³⁄₈ in. (12.7 × 21 cm)
British Museum, London

77. John Constable (1776–1837)
Stonehenge, 1836
Watercolor on paper,
11¹/₂ × 19 in. (29.2 × 48.3 cm)
Victoria and Albert Museum,
London

sense of the word, combining an emphasis on local topography with a distinct regional inflection and a considerable degree of originality. Some of its members sent pictures to the Royal Academy, but they were not much noted by the world at large, and the Norwich School was not fully appreciated, outside of East Anglia, until the twentieth century. Its members lived a life very different from the fashionably bohemian existence of some of their contemporaries in the capital, earning their livings as drawing masters or frame makers. Their patrons were local squires, merchants, and clergymen.

John Crome—sometimes called "Old" Crome to distinguish him from his son and namesake—was the spiritual leader of the school and, along with John Sell Cotman, its most gifted member. Seven years older than Turner and Girtin, Crome was the son of a Norwich innkeeper. He was apprenticed to a journeyman house painter who, among other things, painted inn signs. In his spare time, Crome nurtured his own talent by copying landscapes by Richard Wilson and members of the Dutch School until he acquired the competence to offer his services as a drawing master. Much of his career was spent in this capacity in the employ of the Gurney family, Quaker bankers who did much to shape nineteenth-century Norwich. Besides teaching the Gurney daughters and other young women how to make respectable pictures, he also undertook sketching trips to the Lake District and elsewhere, with his various patrons, coaching them as they essayed to set down the picturesque.

So far as his own work was concerned, Crome was strictly a part-time painter, specializing in regional subjects such as the North Sea coast at towns like Yarmouth and Cromer, the Norfolk Broads, and especially the immediate surroundings of Norwich itself. Like Constable, he approached his subjects directly and without fuss or idealization. His style was distinctively his own, however, conceptually influenced by the Dutch landscape painters but very fresh and broad so far as the handling of paint is concerned. A master of mood—his *Moonrise on the Yare* is one of the gems of British romantic painting—Crome's art is also marked by a strong sense of space and a well-developed feeling for the simplification of form.

In 1803 Crome, along with a small group of associates, founded the Norwich Society, a kind of club dedicated to the advancement of the visual arts. From 1805 to 1825, annual exhibitions were held in Norwich; the artists who contributed to these shows were the founders of the Norwich School. Several were accomplished watercolorists. John Thirtle, for example—a frame maker by trade—made carefully thought-out watercolors in which the image is built from large areas and smaller patches of flat wash deployed in a style reminiscent of Cotman's early work. Thirtle lacked the powerful architectural sense that is always evident in the work of Cotman (who was his brother-in-law), but he possessed a fine sense of place evident in such paintings as *The Quay Side, Norwich* (plate 78). Because few of Thirtle's paintings are dated, it is impossible to say if he, the elder by five years, influenced Cotman or vice versa, but certainly Thirtle is a talent to be taken seriously in his own right.

Thomas Lound was too young to be a member of the Norwich Society, but he greatly admired Thirtle and studied with Cotman. A brewer by trade, he became an accomplished watercolorist who learned a good deal from Peter De Wint (plates 92–95) and even more from David Cox (plates 96–101), whose work he collected. *Ely Cathedral* (plate 79) recalls De Wint so far as format is concerned but is closer to Cox in handling. A young contemporary of Lound's, John Middleton, spent some time in London but returned to Norwich, where he died at the age of twenty-nine. During his last years he made some crisp and elegant watercolor studies that prove

78. John Thirtle (1777–1839)
The Quay Side, Norwich, n.d.
Pencil and watercolor on paper,
12³/₄ × 18⁷/₈ in. (32.5 × 48 cm)
Victoria and Albert Museum,
London

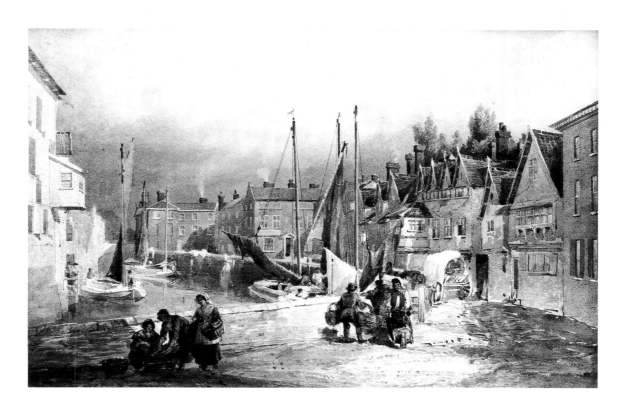

him to have been a gifted exponent of the medium. Often, as in *Dock Leaves* (plate 80), he concentrated his efforts on the minutiae of nature in a way that would surely have satisfied John Ruskin.

An artist of an entirely different magnitude is John Sell Cotman, who was not just the finest of the Norwich watercolorists but also one of the key figures in the entire evolution of watercolor painting. Only one or two other artists whose reputation depends primarily on watercolor can come close to matching his position of importance, and, as will be seen, he was the ultimate master of one of the basic styles of classic watercolor technique; there are those who might argue that his was *the* classic style.

Like Turner, Cotman was a barber's son. Born in 1782, he obtained some education at Norwich Grammar School, then, at the age of sixteen, went to London to seek his fortune as an artist. Like Turner, he colored prints to earn a few shillings, and, like Turner, he came to the attention of Dr. Monro, in whose hands he fell under the influence of Girtin. He became a member of the Sketching Society and there was associated with artists like John Varley, who seems to have been another early influence, and Paul Sandby Munn, who became a traveling companion on sketching tours. Cotman traveled to Wales and the West Country, making drawings to be worked up into watercolors in the studio at a later date, and in 1803, 1804, and 1805 went to Yorkshire, where he found enthusiastic patrons. From these Yorkshire visits came some of his greatest watercolors, but not long afterward his fortunes began to change. Marriage and the responsibilities of family life caused him to return to Norwich, then on to Yarmouth, seeking security in the lowly career of a drawing master to the minor gentry. One patron sent him on three expeditions to France, to make drawings to be etched for a proposed book on the architectural antiquities of

79. Thomas Lound (1802–1861)
Ely Cathedral, c. 1850
Pencil, watercolor, and
body color on paper,
12¹³/₁₆ × 25⁵/₁₆ in.
(32.5 × 64.3 cm)
Norwich Castle Museum,
Norwich, England

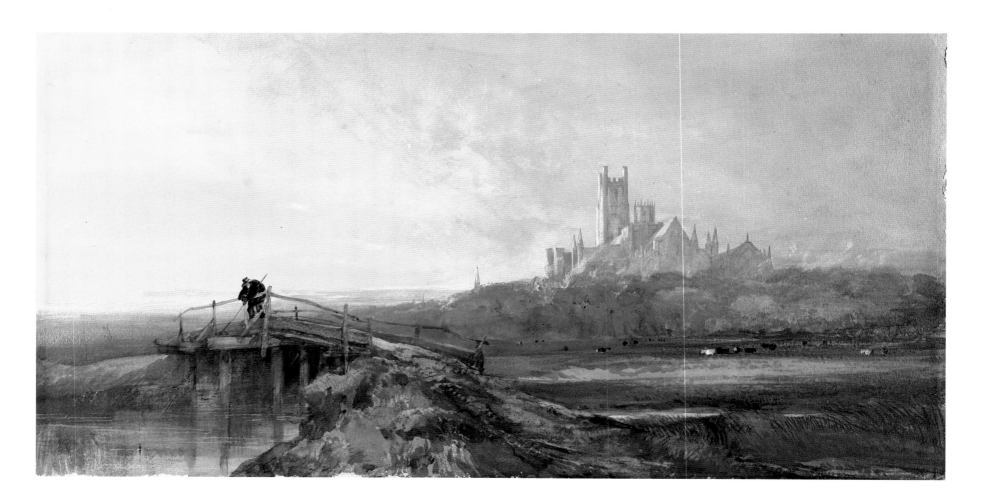

80. John Middleton (1827–1856)
Dock Leaves, c. 1847
Watercolor on paper,
8¹¹/₁₆ × 13½ in.
(22.1 × 34.3 cm)
Norwich Castle Museum,
Norwich, England

Normandy. Otherwise he languished in the English provinces until 1834 when, perhaps on Turner's recommendation, he was appointed drawing master at King's College, London, and there he spent the balance of his life.

Certainly, he never achieved the success he clearly longed for, and the second half of his life was marked by spells of profound depression and even mental breakdown. His great period of sustained brilliance came when he was in his early twenties, but Cotman's art remained interesting to the end of his life, and even at his lowest moments he was capable of turning out an occasional sheet of stunning quality.

Much of Cotman's genius is contained in *Chirk Aqueduct* (plate 81), which derives from an 1802 drawing made on his expedition to North Wales, though it was probably painted a year or two later. It is immediately apparent that Cotman had absorbed and transformed Girtin's influence and left Varley far behind. The architecture of the picture—and this is not merely a reflection of Thomas Telford's soaring masonry arches—is as powerful as anything in the annals of watercolor painting, in addition to which it seems amazingly modern, anticipating Cézanne in certain ways. Nor is Cotman's architectonic sense divorced from his other painterly instincts, since the way the picture is organized—the placement of forms, the patterns of light and shade—are directly related to the way in which the painting has been made, and it is this that finally guarantees Cotman his very high position in the pantheon of watercolorists.

81. John Sell Cotman (1782–1842)
Chirk Aqueduct, 1806–7
Watercolor on paper,
12¹/₂ × 9¹/₈ in.
(31.8 × 23.2 cm)
Victoria and Albert Museum,
London

Some watercolorists evoke an image with flickering calligraphy, others scrape, rub, and blot their subject into submission, but all must understand the basic notion of laying one transparent wash over another. This principle supplies watercolor with its essential logic, and it was Cotman more than any other artist who raised that logic to the level of poetry.

Over a delicate pencil drawing—Cotman was a superb draftsman—he laid down flat, carefully defined, interlocking areas of wash, overlaying the first washes when dry with others, equally well defined, that modified color and density of pigment. These layered areas of flat color combine to create a convincingly three-dimensional image. It is Girtin's method, but informed with a sense of structure and

simplification that neither Girtin nor anyone else had approached at that point. It is the opposite of Turner's later method in that, though the logic must have been apparent as soon as the first washes were laid in, the painting could not be said to be finished until the final layers of wash had been applied and Cotman had flicked in detail with the tip of his brush.

The logic of his method cannot be overemphasized. A predecessor such as Girtin would handle his skies somewhat differently from, say, a hillside, suggesting character and texture with different kinds of brushstrokes. Cotman, in a painting such as *Greta Bridge* (plate 82), a masterpiece from one of his Yorkshire trips, uses a single system to represent clouds, trees, masonry, rocks, and water. He permits himself a touch of expressive brushwork here and there, but all the essential effects, all the differences of texture and density, of airiness and solidity, are built from flat washes. Once again, Cotman's sense of pictorial architecture contributes greatly to the whole, reinforcing the concealed logic of his method. As in the case of *Chirk Aqueduct*, this painting also affords a fine example of how Cotman made skillful use of a relatively limited range of color. Like Girtin, he made especially effective use of earth colors, though he tended to employ them in cooler, but not cold, combinations. Both paintings show, too, his clear understanding that shadows should have color values, yet more than Girtin or Turner he used shadows as structural elements.

82. John Sell Cotman (1782–1842)
Greta Bridge, 1805
Watercolor on paper,
9 × 13 in. (22.9 × 33 cm)
British Museum, London

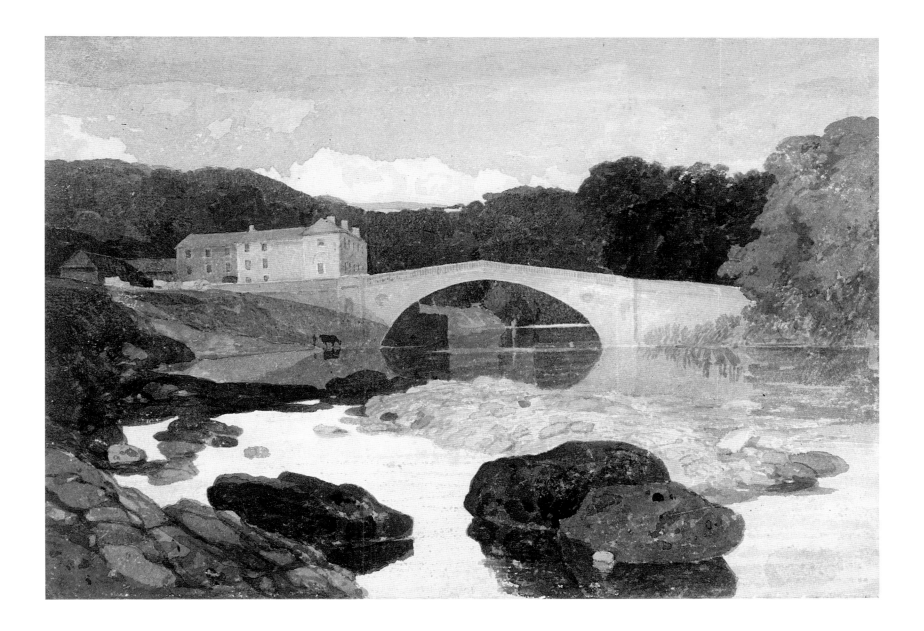

83. John Sell Cotman (1782–1842)
The Dropgate in Dunscombe Park,
1805
Watercolor on paper,
13 × 9⅛ in. (33 × 23.2 cm)
British Museum, London

Yorkshire provided Cotman with some of his most rewarding subjects. *The Dropgate in Dunscombe Park* (plate 83) is a fine example of his ability to orchestrate patterns of light and shade, and it is important to understand that, given the logic of his method, such patterns had to be clearly established in the artist's mind before he ever put brush to paper. Painted barely a decade after Girtin had broken with topography, this painting has left that discipline far behind. Here informality of subject matter and an allover painterly integrity place Cotman in significant ways closer to the twentieth century than to the nineteenth. Although his career was played out in relative obscurity, so that his influence (except on watercolorists) was slight, it is clear that he was one of the members of his generation who intuited most accurately where the future of art lay. By 1805 he had arrived at a point of view—with regard to seeing nature honestly, yet with the structural sense of a classicist—that was close to the viewpoint espoused by Camille Corot two decades or more later.

Like many of the nineteenth century's greatest artists, Cotman had a knack of blending a powerful sense of the weight and presence of the material world with a

84. John Sell Cotman (1782–1842)
The Marl Pit, c. 1809–10
Pencil and watercolor on paper,
11⅝ × 10¹/₁₆ in.
(29.5 × 25.6 cm)
Norwich Castle Museum,
Norwich, England

85. John Sell Cotman (1782–1842)
A Ploughed Field, c. 1807
Watercolor on paper,
9½ × 13¼ in.
(24.1 × 33.7 cm)
Leeds City Art Galleries,
Leeds, England

highly developed feeling of pantheistic spirituality. This pantheism, in Cotman's time, was a hallmark of the Romantic movement, but Cotman was able to invoke it without indulging in the melodramatic rhetoric of sublimity that makes some products of Romanticism seem overwrought to the contemporary eye. Cotman was not blind to the ravishment of sublime scenery, but he could find as much spirituality in a marl pit (plate 84) or a ploughed field (plate 85), everyday features of the English countryside and specifically of the region around Norwich. A marl pit was a quarry from which chalky clay was dug out to improve sandy or sour soil. Cotman found his example on Mousehold Heath, on the outskirts of Norwich. In a painting less than twelve inches high, he transformed the subject into a statement about monumentality, achieving an impressive feeling of scale by selecting exactly the appropriate viewpoint, making the modest forms dramatic by means of the distribution of light and shadow. A trifling blemish on the landscape is transformed into a gorge such as topographers might have traveled hundreds of miles to see and draw. *A Ploughed Field* (it, too, may be on the edge of Mousehold Heath) is even less promising as a subject, by the tenets of early nineteenth-century art, but, like Constable, Cotman effortlessly finds the poetry in just such humble scenes.

Cotman is not generally thought of as a marine painter, but his occasional marine subjects are especially fine. Best known of these is *Dismasted Brig* (plate 86), another example of how Cotman could use flat washes to build up something as challenging as rough seas. His method is the exact opposite of Turner's in *Venice,*

86. John Sell Cotman (1782–1842)
Dismasted Brig, c. 1807
Watercolor on paper,
7³/₄ × 12¹/₄ in. (19.8 × 31 cm)
British Museum, London

Storm at Sunset (plate 55). Cotman does not so much enter into the subject as reduce it to its essential structural components. He even finds structure in the elements, as is evident from the way he uses the storm clouds here to create a proscenium-like framing device. *The* Mars *Riding at Anchor off Cromer* (plate 87) is an equally memorable painting, with its strange, towering, vertical clouds and waves laid in with such planar economy it is amazing that they are able to give the impression of heaving motion. The *Mars* itself and the other craft are hardly more than silhouettes, yet they are completely convincing presences. *The Needles* (plate 88), painted after one of his forays to Normandy, is rendered in a very limited palette, dominated by cool blues that cause the Isle of Wight to look rather like an iceberg. What makes this painting singularly Cotmanesque is the way it builds in layers, with the clouds in the background having as much substance and solidity as the chalk cliffs.

Toward the end of his life—beginning about 1830—Cotman experimented extensively with a new, self-devised medium in an effort to give water-based paint more substance and brilliance. This medium—which may have involved flour, egg white, and Chinese white—was mixed with watercolor to produce effects that are not dissimilar from those that can be achieved with egg tempera, though the medium remains somewhat transparent, so that some of the devices of watercolor can be brought into play at the same time. Some of Cotman's works in this experimental medium, such as *The Lake* (plate 89), are quite lovely; were they by a lesser painter, they might be prized as minor masterpieces. As it is, though, they inevita-

87. John Sell Cotman (1782–1842)
The Mars Riding at Anchor off Cromer, c. 1807
Watercolor on paper,
12¹/₁₆ × 8⁵/₈ in.
(30.6 × 21.9 cm)
Norwich Castle Museum,
Norwich, England

88. John Sell Cotman (1782–1842)
The Needles, c. 1823
Watercolor on paper,
8⁵/₁₆ × 12¹³/₁₆ in.
(21.1 × 32.5 cm)
Norwich Castle Museum,
Norwich, England

89. John Sell Cotman (1782–1842)
The Lake, c. 1830
Watercolor on paper,
7¹/₈ × 10¹/₂ in. (18.1 × 26.7 cm)
Victoria and Albert Museum,
London

OPPOSITE, CLOCKWISE
FROM TOP LEFT
90. Miles Edmund Cotman
(1810–1858)
*Early Morning
on the Medway*, n.d.
Watercolor on paper,
3⁷/₈ × 5³/₄ in. (9.8 × 14.6 cm)
British Museum, London

91. John Joseph Cotman
(1814–1878)
Gravel Pit, Sprowston, c. 1860s
Watercolor on paper,
9¹³/₁₆ × 13¹⁵/₁₆ in.
(24.9 × 35.4 cm)
Norwich Castle Museum,
Norwich, England

92. Peter De Wint (1784–1849)
*Westminster Palace, Hall and
Abbey*, n.d.
Watercolor on paper,
14 × 31⁵/₈ in. (35.6 × 80.3 cm)
Victoria and Albert Museum,
London

bly suffer by comparison with the great achievements of the artist's early period, paintings that have assured Cotman of his place in the first rank of watercolorists.

Two of Cotman's sons, Miles Edmund and John Joseph, followed in their father's footsteps and became drawing masters and watercolorists. Miles fell under the spell of Bonington and was capable of such atmospheric pieces as *Early Morning on the Medway* (plate 90). John Joseph, the younger and more gifted of the pair, inherited some of his father's powerful sense of structure as well as his mental instability. A bold colorist, he was not afraid to employ a light-keyed palette, and in his best works he amended the architecture of his father's style with a somewhat freer and more expressive use of the brush (plate 91).

Two years John Sell Cotman's junior, Peter De Wint was born in Shropshire of a family that came from Holland by way of New England. Despite this exotic ancestry, De Wint is among the most British of the wave of British watercolorists that came to maturity in the first decade of the nineteenth century. (He was also an accomplished painter in oils, though his reputation has always been based primarily on his watercolors.) Religious and curmudgeonly, De Wint enjoyed modest but continuing success during his lifetime, which was thoroughly unremarkable in incident. Apart from one brief visit to France, he concentrated all his attention on the English countryside and English cityscapes (a few genre scenes and still lifes aside). Not an original by the standards of Turner or Cotman, he nevertheless perfected much that was implicit in English watercolor at the turn of the century. In the best sense of the term, De Wint was the great *mainstream* watercolorist of his generation.

In a sense, De Wint was Girtin's most direct descendant. Like Girtin, he colored prints for John Raphael Smith, and, like Girtin, he spent many evenings in Dr. Monro's house at Adelphi Terrace. John Varley was an influence, too, but Girtin was the dominant force. *Westminster Palace, Hall and Abbey* (plate 92) is a cousin of Girtin's studies for the *Eidometropolis* (plates 39 and 40).

From a technical viewpoint, De Wint built upon Girtin's methods, taking them in a direction Girtin himself might have followed had he lived. Sometimes working

on a relatively large scale, De Wint often introduced more detail into his work than was common with Girtin, but he did so with a discretion that prevented this from diluting the breadth of his overall handling. He built carefully with transparent washes, but—unlike Cotman, who always allowed his preliminary washes to dry before overlaying them—he often worked into a wash while it was still wet. This gives the dark areas in his paintings a particular richness and depth that can be obtained in no other way. It is said that he painted with just two brushes, one round and one fine-pointed, and certainly there is little about his work that is fussy or finicky. He is one of the master technicians of nineteenth-century watercolor.

Gathering Corn (plate 93) shows his ability to exploit panoramic formats, which recur in his work throughout his career. This is an idyllic painting, while *Landscape with Harvesters and Storm Cloud* (plate 94) is a more dramatic exploration of the same theme, the laborers hurrying to gather the harvest before the rains arrive. Here it can be seen that, like all the greatest British watercolorists, De Wint was a master of skies. Not all his work is idyllic, and the brooding *View of a Harbor* (plate 95) is a

beautifully executed sheet that shows the impact of the Industrial Revolution on the British landscape. The subject is evoked with laconic brushwork that captures an atmosphere suffused with coal smoke, and the rusty colors used throughout the foreground and middle ground are the embodiment of industrial corrosion.

The other exceptional watercolorist of the same generation was David Cox, who was born in 1783, a year before De Wint and a year after Cotman. Cox, the son of a Midlands blacksmith, was prevented from following his father's trade by a childhood accident that led to a convalescence during which he displayed an aptitude for drawing and coloring. He spent some time as a scene painter for theaters and circuses and only gradually settled into being an easel painter, in both oils and watercolor, studying for a while with John Varley. In a career that lasted over half a century, Cox began by making somewhat stiff watercolors in the topographic tradition, evolved to more highly finished paintings that were nonetheless looser in handling, and in his final phase moved on to making exhilarating, freely brushed sheets full of windswept atmosphere. It was the watercolors of the middle period that won him his greatest success during his lifetime, but it is the paintings of the last period that have assured him of his lasting and distinguished position in the history of the medium.

Cox made two trips to France, and *The Pont des Arts and the Louvre from the*

97. David Cox (1783–1859)
Calais Pier, n.d.
Watercolor on paper,
9¾ × 14 in. (24.8 × 35.6 cm)
The Whitworth Art Gallery,
University of Manchester,
Manchester, England

OPPOSITE, TOP

98. David Cox (1783–1859)
The Night Train, 1849
Watercolor on paper,
10¹⁵/₁₆ × 14¾ in. (27.8 × 37.5 cm)
Birmingham Museum and Art
Gallery, Birmingham, England

OPPOSITE, BOTTOM

99. David Cox (1783–1859)
River Scene with Anglers, n.d.
Watercolor on paper,
10¾ × 14½ in. (27.3 × 36.8 cm)
British Museum, London

Quai Conti, Paris (plate 96) shows how skilled he could be in his middle period, but another French subject, *Calais Pier* (plate 97), is more indicative of his true talent. Along with Turner, Cox was a great painter of weather and, like Turner, had the ability to enter into a subject so that brushstrokes and description of the elements became one and the same. Cox understood as well as anybody the value of solid drawing and a clean wash, but he came to share with Turner (who may have borrowed from *him*) a willingness to drive the colors around, to make each work expressive.

River Scene with Anglers (plate 99), though more tranquil and suffused with sunlight, shows once again how the freedom of Cox's brushwork could be used to capture weather and atmosphere. Masterpieces like *The Night Train* (plate 98), *On Lancaster Sands, Low Tide* (plate 100), and *Rhyl Sands* (plate 101) are still more fluid. Cox's treatment of *On Lancaster Sands, Low Tide* is spare and does wonders with a palette so limited that the sheet is almost a monochrome. This painting looks forward to Whistler, while *Rhyl Sands* anticipates Eugène Boudin in its grouping of figures on the beach. Both paintings are saturated with weather.

Cox's late work owes a good deal to a paper he first encountered in 1836. This was not a handmade paper specially crafted for watercolor, but ordinary heavy wrapping paper manufactured by a Scottish company from raw materials that in-

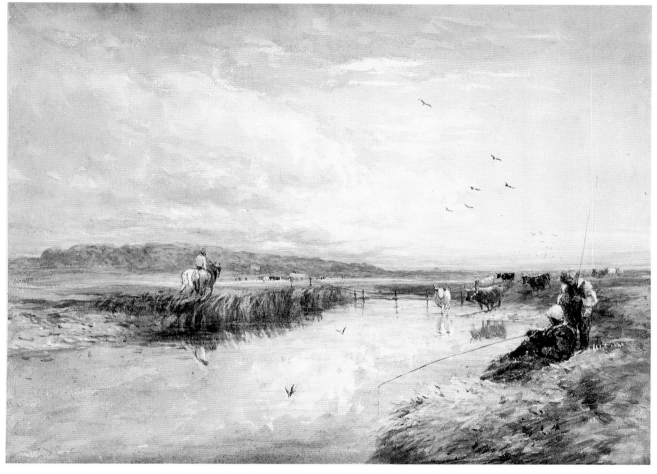

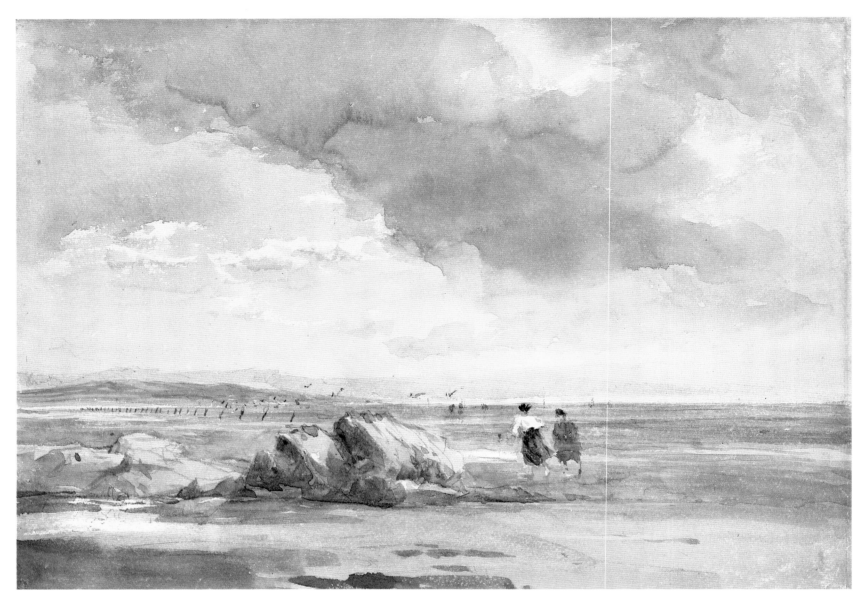

100. David Cox (1783–1859)
On Lancaster Sands,
Low Tide, n.d.
Watercolor with pen and black
ink over pencil on heavy wove
paper, 10³/₈ × 14⁵/₈ in.
(26.4 × 37.2 cm)
Yale Center for British Art,
New Haven, Connecticut;
Paul Mellon Collection

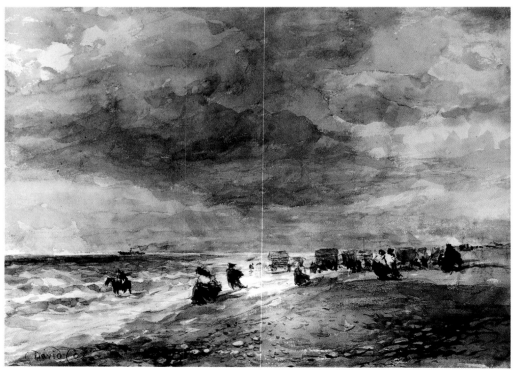

101. David Cox (1783–1859)
Rhyl Sands, n.d.
Watercolor on paper,
10¹/₄ × 14¹/₄ in.
(26 × 36.2 cm)
Victoria and Albert Museum,
London

cluded sailcloth and old rope.[3] Unbleached, it was off-white in color, and being more lightly sized than conventional watercolor paper, it was slightly absorbent, though not to the extent that it drained washes of color. Rather, it permitted them to be laid down with a singularly soft edge, acting in somewhat the same way as certain Japanese drawing papers (which were, of course, unknown in Europe at the time). So attractive were its qualities that a facsimile of this wrapping paper was later handmade for artists and is still available today as David Cox paper.[4] One of its characteristics is that it is full of impurities, which cause gray or brown specks to appear on the surface. Cox claimed that when these occurred in the sky, he put a couple of wings on them and turned them into birds.

Beyond the use of appropriate materials, the product of a lifetime's experience, there was little secret about Cox's late work; no unique system or method can be ascribed to him. Rather, he had absorbed all the lessons of early nineteenth-century watercolor and learned how to use them with a rare fluidity and flexibility. By the time he arrived at his personal idiom, he was no longer exploring the possibilities of a new medium, but was exploiting the potential of one that had come to maturity during the course of his distinguished career. It was his genius that he was not imprisoned by the technical devices of the evolving medium, but instead bent them to the needs of his own vision.

Cox was by no means the last major British watercolorist, but he was perhaps the last important figure of the first innovative generation to find himself. By the Victorian era, British watercolorists were too often trying to compete with painters in oils. The artists discussed in this chapter—though some lived into an age when they were forced to reconsider their original values—were products of an epoch of innocence, in which the simple virtues of watercolor were esteemed for their own sakes. Painters like Constable, Cotman, De Wint, and Cox were blessed with a freshness of vision that could never again be taken for granted.

The Tradition Spreads

102. Richard Parkes Bonington
The Leaning Tower, Bologna, c. 1826
Detail of plate 115

In the early part of the nineteenth century, watercolor was practiced fairly extensively in continental Europe, but it was largely an activity without cultural focus, a way of making art that carried no weight in influential circles. There was none of the camaraderie and professional intercourse of the British watercolor scene. The medium did not foster, in Paris or Dresden, an intimate exchange of ideas, as had happened between Girtin and Turner; there was no supporting cast of specialized colormen and papermakers, no systematic evolution of a tradition. There were men, equivalent to the British topographers, who crisscrossed Europe at the behest of wealthy patrons, recording antiquities and rare sights. There were architectural draftsmen and satirists (the latter much influenced by the British school of pictorial humor). But, for the most part, watercolor was regarded as a study medium or was a vehicle for private musings. It may be that the soft light of the British Isles—seemingly made for watercolorists—had contributed to Englishmen's devotion to the medium. In any case, during the first quarter of the nineteenth century, they had few rivals across the Channel. Not that European art was unduly impoverished because of this. Monochrome wash had many masters, and an artist like Goya could wring all kinds of subtleties from sanguine or sepia (plate 103).

Philipp Otto Runge was a German painter of Turner's generation and, like him, is looked on as an important representative of Romanticism. As is evident from *Arion's Sea Voyage* (plate 104), his approach to the challenges of Romanticism tended to be more purely literary than was the case with Turner, for all the latter's invocations of Virgilian and biblical themes. In this elaborate and symmetrically structured mythological scene, Runge delineates his fishborne goddess, his swans, and putti with a somewhat rigid line, then applies watercolor—keyed rather low—to give the scene substance, though not the solidity that British watercolor had attained a de-

COUNTERCLOCKWISE FROM LEFT

104. Philipp Otto Runge (1777–1810)
Arion's Sea Voyage, 1809
Watercolor and ink on paper,
20 × 46¹¹/₁₆ in. (50.6 × 118.4 cm)
Hamburger Kunsthalle, Hamburg, Germany

105. Caspar David Friedrich (1774–1840)
Coastal View, c. 1824
Watercolor on paper, 9³/₄ × 14³/₈ in. (24.6 × 36.5 cm)
Kupferstichkabinett und Sammlung der
Zeichmungen, Berlin

106. Caspar David Friedrich (1774–1840)
Der Heldstein bei Rathen an der Elbe, c. 1828
Watercolor on paper, 10⁵/₁₆ × 9¹/₁₆ in. (26.5 × 23.3 cm)
Germanisches Nationalmuseum, Nurnberg, Germany

OPPOSITE

103. Francisco de Goya y Lucientes
(1746–1828)
Tu Que No Puedes (*You Who Cannot*), 1797–98
Red and crimson watercolor on paper, 9¹/₂ × 6¹/₂ in.
(24.1 × 16.5 cm)
Prado Museum, Madrid

cade or more earlier. This is a tinted drawing, not a watercolor painting, but it is of some significance that Runge employed watercolor at all. A decade or two earlier he would probably have confined himself to monochrome wash.

Runge's great contemporary Caspar David Friedrich was a far more original painter—indeed, one of Turner's few peers when it came to sensing the spiritual and metaphysical power of landscape—and left some interesting watercolors that reflect his central concerns (plates 105 and 106). By British standards of the period, however, they are crude, and only the sensitivity of his line gives them a certain distinction. The viewer who is familiar with his crystaline oils, bathed in moonlight or the glow of dawn, may be tempted to project much into drawings such as these, but—raw subject matter aside—they offer little that suggests Friedrich's metaphysical yearnings. The oil paintings embody his vision. These watercolors do not.

The Dutch artist David Humbert de Superville is probably best known as a lithographer. In *The Flood* (plate 107) he creates an allegory that clearly reflects the turmoils of Europe during the Napoleonic period. As a watercolor, however, this

107. David Humbert de Superville
(1770–1849)
The Flood, c. 1835
Watercolor on board,
26¾ × 40³/₁₆ in.
(67.9 × 102.1 cm)
University of Leyden,
Prentkabinet, Leyden, The
Netherlands

108. Wijbrand Hendriks
(1744–1831)
*Maples Under Snow in
Haarlem Woods*, 1794
Black chalk and watercolor on
paper, 15⁹/₁₆ × 16⁹/₁₆ in.
(39.8 × 42 cm)
Gemeentearchief Haarlem,
The Netherlands

109. Jean-Auguste-Dominique
Ingres (1770–1867)
Ossian's Dream, 1812
Pencil, pen and ink,
watercolor, and Chinese white
on paper, 10¼ × 8⅜ in.
(26 × 21.3 cm)
Musée du Louvre, Paris

work harks back to the pre-Napoleonic era. Iconographically, it is dramatic, but the paint handling is uninspired, and there is no attempt to use watercolor to create atmosphere, as a British artist surely would have done, even when dealing with so forbidding a subject.

A far happier encounter with watercolor is *Maples under Snow in Haarlem Woods* (plate 108) by Superville's compatriot Wijbrand Hendriks. It is interesting to note that Hendriks was born in 1744, more than three decades before Girtin and Turner, but—while his technical approach lacks their modernity—he displays a sound feel for the potential of the medium. What links him to his British contemporaries is not a knowledge of their evolving school, but rather a shared respect for the Dutch tradition that had found room for such watercolorists as Philips de Koninck and Allart van Everdingen. (Everdingen was known to, and admired by, Constable.)

With Jean-Auguste-Dominique Ingres's *Ossian's Dream* (plate 109), we return once more to the world of the tinted drawing, but let it be added that this is tinted

drawing at its best, bolstered by all the elegance of Ingres's draftsmanship and all his sense of delicacy. More interesting as watercolor, however, are the portraits of Jean-Baptiste Isabey, a miniaturist of distinction, whose work displays a freedom of handling that makes him a bridge between the fashionable miniaturists of the eighteenth century (working in transparent color upon ivory) and watercolor portraitists of the nineteenth century. Isabey's *Portrait of a Woman* (plate 110) is delightfully windswept and fresh.

Very different is Louis-Léopold Boilly's *A Crossroads in Paris at the Time of the Revolution* (plate 111), a lively enough treatment of what by 1822 was already a historical subject. The horse and the citizens fleeing the metropolis are handled with considerable vigor, yet it's impossible not to imagine what Rowlandson might have done with this subject. It is just the kind of crowd scene that brought out the best in him, and he would have invested it with a panache that was in part his own genius but in part the product of a national watercolor tradition.

Certainly, by 1820, many Continental artists, from Ingres to Boilly, were familiar with watercolor as an available tool. What they lacked was an example to show them the full range of what might be achieved with it. Europe was ready for an incursion by the British School. It came in the third decade of the century, most notably in the form of Richard Parkes Bonington, who, because of his impact on French painting, must be seen as one of the most influential watercolorists of all time. By a quirk of fate, he received his initiation into the British tradition not from his fellow Englishmen but, rather, from a Frenchman who had spent a good deal of his career in England.

François-Louis-Thomas Francia (usually called Louis Francia) was born in Calais in 1772, moved to England at the age of about twenty, and soon came into contact with artists like John Varley and Girtin. Working alongside Girtin, he quickly mastered the basics of the Englishman's style—may even have influenced its development—then modified it by introducing a freedom of handling that was es-

110. Jean-Baptiste Isabey
(1767–1855)
Portrait of a Woman, n.d.
Watercolor over black chalk on paper, 14⁵/₈ × 11³/₄ in.
(37.1 × 29.8 cm)
Musée du Louvre, Paris

111. Louis Léopold Boilly
(1761–1845)
A Crossroads in Paris at the Time of the Revolution, 1822
Pencil, pen and black ink, gray wash, and watercolor on paper, 18⁵/₁₆ × 25⁵/₈ in.
(46.5 × 65.1 cm)
Musée des Beaux-Arts de Lille, Lille, France

112. François-Louis-Thomas Francia
Transports Returning from Spain,
1809
Watercolor on paper,
11⅛ × 15⅞ in.
(28.3 × 40.3 cm)
British Museum, London

pecially well suited to marine subjects (plate 112). In 1817 he returned to Calais, where he spent the rest of his life, though he maintained some contacts with England, exhibiting at the Royal Academy until 1821. It was in Calais that he took the young Bonington under his wing.

Bonington was born in 1802 near Nottingham, where his father had once been governor of the county jail, but was now the resident drawing master in the school for young ladies run by his wife. For a while this school seems to have been quite successful, but around 1816 the family suffered a reversal of fortune, and the following year the Boningtons emigrated to Calais, where the artist's father set up a lace factory that enjoyed modest success. The younger Bonington had perhaps received some instruction in drawing from his father. In any case, he took to sketching on the streets of Calais and around the harbor. It was there that Francia first spotted him, recognized his talent, and made him a protégé. From Francia, Bonington learned the secrets of Girtin's method, then developed them with a virtuosity entirely his own.

By the time he went to Paris, in 1819, Bonington was already an accomplished watercolorist and quickly drew the attention of Delacroix, Géricault, Isabey, and others. He studied under Baron Gros and made copies at the Louvre. Within a relatively short time he found a ready market for his own work in both oils and

watercolors and traveled extensively. In 1824 he was awarded a gold medal at the Salon—the same Salon that brought Constable to the attention of the French art world—and the following year he returned to England with Delacroix as his traveling companion. Although he remained based in Paris, Bonington began to submit work to British exhibitions and galleries, so that his reputation there was on the rise when, at the age of twenty-five, he died—apparently of consumption—while on a visit to London. Posthumously, his work became the rage of English watercolor circles and was much imitated by his countrymen, but it was in France that he had his greatest influence.

Off the English Coast (plate 113) shows Bonington's debt to Francia; indeed, it is thought likely that many Francia sea pieces have been sold as Boningtons, as many earlier Francia landscapes may have been sold as Girtins. This is not to say that Bonington's seascapes were unoriginal. He brought his own boldness of stroke to them, and his way of representing both sails and waves was to be inherited by scores of watercolorists throughout the nineteenth century. The handling of light in his seascapes was also especially fine.

The virtuosity and freshness that impressed Delacroix and others are readily apparent in *Paris: Quai du Louvre* (plate 114). The view is looking upstream from the Right Bank, with the Pont des Arts and the buildings on the Ile de la Cité prominent. It is a scene that would have appealed to a topographer like Malton; and, indeed, in his choice of subjects, in his careful delineation of architecture, and his reliance on linear description, Bonington often resembles a latter-day topographer. But this statement must be amended by pointing out that his watercolors are full of

113. Richard Parkes Bonington
(1802–1828)
Off the English Coast, 1825
Watercolor on paper,
5¹/₂ × 9 in. (14.1 × 23.1 cm)
Museum of Fine Arts,
Budapest

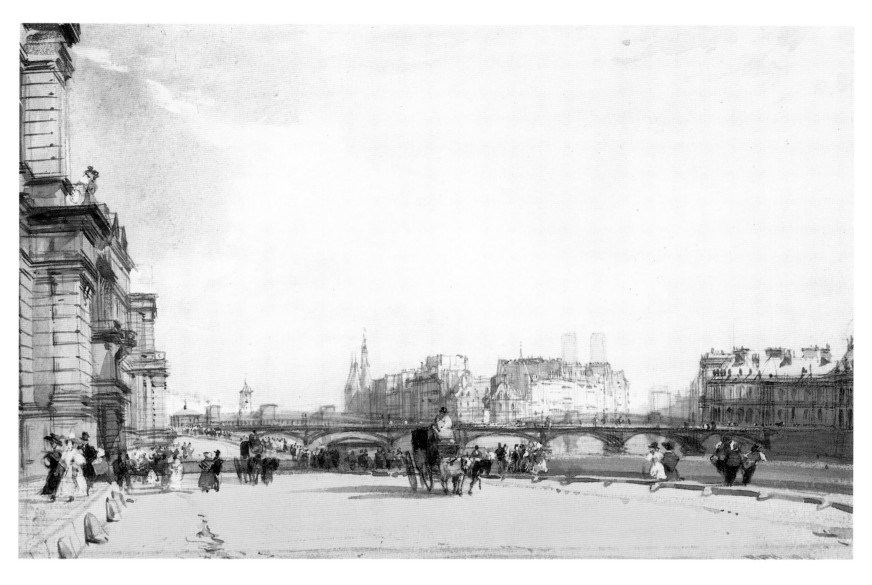

114. Richard Parkes Bonington
(1802–1828)
Paris: Quai du Louvre, 1828
Watercolor on paper,
5¾ × 8¾ in.
(14.6 × 22.2 cm)
Private collection

atmosphere, he is a master of building solid forms from layers of wash, and his work is characterized by a brilliance and fluidity of brushwork entirely his own. No watercolorist has ever been able to suggest more by drawing with the brush. No one has ever surpassed his ability to conjure up, for example, the facade of a building with a few quick strokes made with the tip of the brush. He could build carefully, as in *St. Sauveur, Dives, Normandy* (plate 116), but it was more typical of him to set down an image boldly, with bravura washes and flickering brushwork, as is the case with *Street in Verona* (plate 119) and *The Leaning Tower, Bologna* (plate 115). In the latter painting, Bonington makes effective use of light and shade, and the contrasts thus established play directly to his strong suit because each crisp brushstroke, on a cornice or balcony, reads as a patch of shadow that, in turn, helps articulate the structure of the various buildings. The washes, too, are laid in with enormous skill. Sometimes they are liquid and seem to melt at the edges. In other instances the brush has been loaded with almost dry pigment then dragged across the support, so that a broken texture is obtained, suggesting the weathered surface of old masonry or the sparkle of sunlight. It should be noted, too, that Bonington was a magnificent colorist, using bold touches of local color to set off carefully orchestrated schemes.

Bonington spent only a few weeks of his brief life in Venice, but it inspired some of his finest work, both in oils and watercolor. *The Doge's Palace, Venice* (plate 117) is painted from a viewpoint that has attracted many other artists, from Guardi

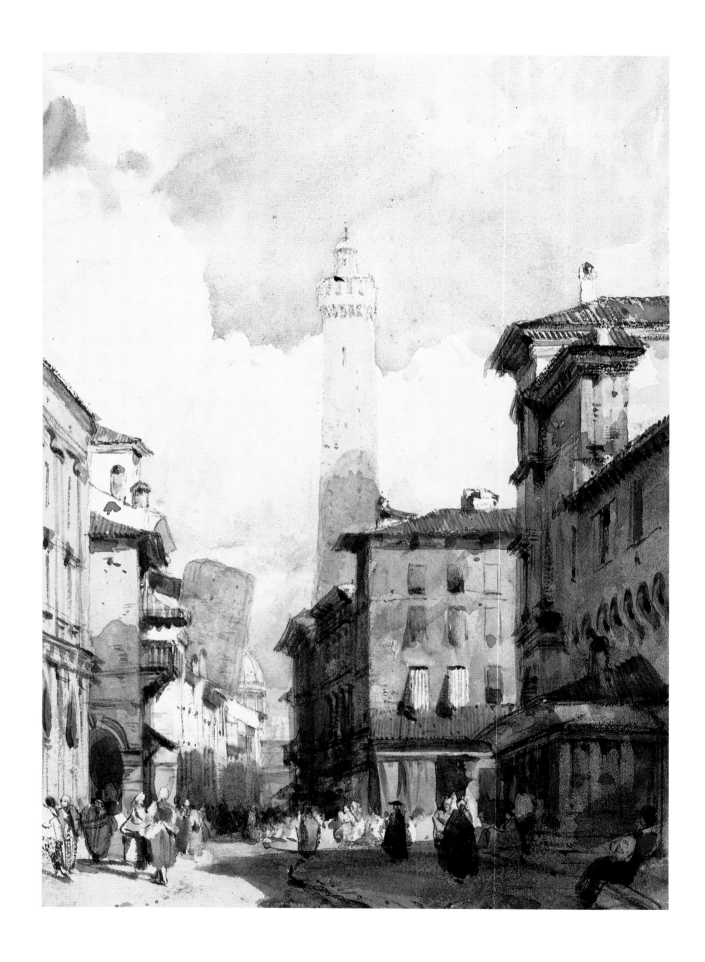

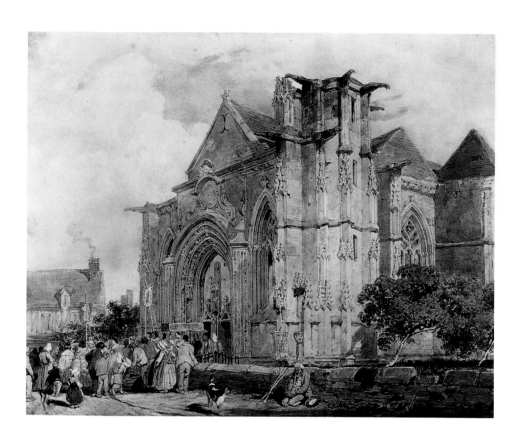

CLOCKWISE FROM OPPOSITE

115. Richard Parkes Bonington (1802–1828)
The Leaning Tower, Bologna, c. 1826
Pencil, watercolor, and body color on paper,
9³/₁₆ × 6⁵/₈ in. (23.3 × 16.8 cm)
The Wallace Collection, London

116. Richard Parkes Bonington (1802–1828)
St. Sauveur, Dives, Normandy, n.d.
Watercolor and pencil on paper,
12¹¹/₁₆ × 15 in. (32.2 × 38.1 cm)
Walker Art Gallery, Liverpool, England

117. Richard Parkes Bonington (1802–1828)
The Doge's Palace, Venice, c. 1827–28
Watercolor and body color on paper,
7³/₄ × 10¹¹/₁₆ in. (19.7 × 27.1 cm)
The Wallace Collection, London

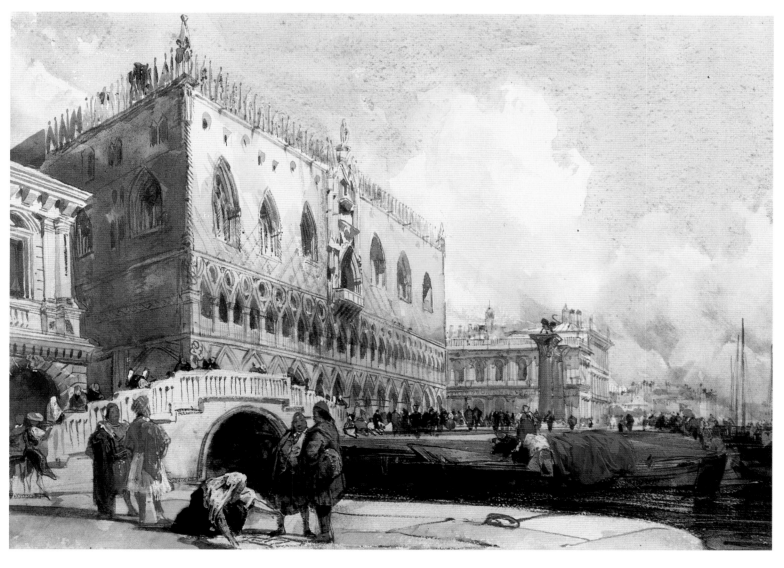

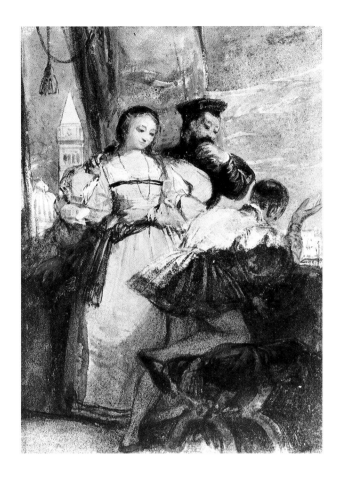

118. Richard Parkes Bonington
 (1802–1828)
 On a Venetian Balcony, n.d.
 Watercolor and gouache on
 paper, 6³/₈ × 4³/₈ in.
 (16.2 × 11.1 cm)
 Glasgow Art Gallery and
 Museum

119. Richard Parkes Bonington
 (1802–1828)
 Street in Verona, 1826
 Watercolor on paper,
 9¹/₄ × 6¹/₄ in.
 (23.5 × 15.9 cm)
 Victoria and Albert Museum,
 London

120. Richard Parkes Bonington
(1802–1828)
The Undercliff, 1828
Watercolor on paper,
5¹/₁₆ × 8⁷/₁₆ in. (13 × 21.6 cm)
Nottingham Castle Museum
and Art Gallery, Nottingham,
England

to Maurice Prendergast, but Bonington brings to it his own bravura touch, his own highly personal (though much imitated) calligraphy. Bonington was impressed not only by Venice but also by Venetian art, and the exotically costumed characters in the foreground of this painting are a product of this interest. A fascination with Veronese and other Venetian masters led directly to little figure studies such as *On a Venetian Balcony* (plate 118), made toward the end of his life, which perhaps indicated a direction he might have pursued had he survived. Given his enormous talent and his association with some of the most advanced and gifted artists of his day, there is reason to suppose he might have become one of the key painters of the century. Certainly, at the age of twenty-five he had achieved a mastery of both oils and watercolors equal or superior to that attained by Turner at the same age. Whatever he might have achieved, however, it is unlikely that he would have forgotten his watercolor roots, and it is only appropriate that his final work, *The Undercliff* (plate 120), is a moody sea piece in which his debt to the British tradition, as well as his gifts to it, are fully present.

Many of Bonington's watercolors are tiny, even by the modest standards of the medium, but their impact, especially in England and France, was enormous. His name will recur as an influence again and again in this text, but to measure the significance of his contribution it is only necessary to mention that Camille Corot—six years Bonington's elder—decided upon his vocation after being stunned by a little Bonington watercolor he spotted in the window of the Paris dealer L. Schroth. Much has been said, and with justice, of Constable's influence upon the Barbizon School and Turner's upon the Impressionists, but a strong case could be made that it

121. Théodore Géricault (1791–1824)
*Young Woman on a Dapple Gray
Horse*, c. 1821
Watercolor on paper, 11 × 9¹³/₁₅ in.
(27.9 × 24.9 cm)
Museum Boymans–van Beuningen,
Rotterdam, The Netherlands

122. Théodore Géricault (1791–1824)
Thoroughbred, c. 1820–21
Watercolor and gouache on paper,
12⁹/₁₆ × 15⁵/₁₆ in.
(32.2 × 40.5 cm)
Musée du Louvre, Paris

was Bonington who had the wider and more lasting impact on French painting.

One of the artists who befriended Bonington upon his arrival in Paris was Théodore Géricault. Géricault was a considerable Anglophile—one of Constable's early champions—and, after his *Raft of the Medusa* had been shown in London, he spent the period 1820–22 in England, where, among other things, he learned the lessons of the British watercolorists and learned them well. In all probability, Géricault was the first major non-British artist to master the new method.

That he brought his own genius to the method is immediately evident from *Young Woman on a Dapple Gray Horse* (plate 121), which is made on Whatman paper watermarked 1820 and presumably dates from his sojourn in England. Géricault always excelled at drawing and painting horses, and watercolor enabled him to capture the texture of a horse's coat with a breathtaking freshness and veracity. Many of Géricault's finest watercolors feature horses, and *Thoroughbred* (plate 122), probably from his English period, demonstrates how economical he could be while still capturing all the weight and muscular tension of the animal's anatomy.

Lion Hunt (plate 123) is interesting in that it anticipates the Oriental themes that would fascinate Delacroix and others a decade or more later. Here the handling is very loose and free, and this is the case, too, with *Munitions Cart Drawn by Two Horses* (plate 124), an example of watercolor used for study purposes. It becomes clear from this group of images that Géricault could do just about anything he wanted to with watercolor, and, given his other great talents, it is tantalizing to imagine what he might have achieved in the medium had he not died so young. As a watercolorist, his career was even shorter than that of Girtin or Bonington. He did not tackle the medium seriously until he went to England in 1820 at age twenty-eight; four years later he was dead.

So far as the Bonington connection is concerned, it would not be accurate to say that Géricault borrowed from him, since he had the advantage of prior exposure to the entire British watercolor school. Rather, he was one of Bonington's champions and helped spread his fame. In the case of Eugène Delacroix, however, the Bonington influence was very direct. It was not so much that Delacroix imitated Bonington's style—he was too much his own man for that—but it was Bonington

TOP
123. Théodore Géricault (1791–1824)
Lion Hunt, 1818
Watercolor and graphite, gouache, and brown ink on blue-gray paper,
12¹³/₁₆ × 15¹⁵/₁₆ in. (32.5 × 40.5 cm)
Fogg Art Museum, Harvard University, Cambridge, Massachusetts;
Bequest of Grenville L. Winthrop

ABOVE
124. Théodore Géricault (1791–1824)
Munitions Cart Drawn by Two Horses, c. 1818–19
Pencil with brown and blue-gray watercolors, 8¹¹/₁₆ × 11⁵/₁₆ in. (22.1 × 28.7 cm)
The Art Institute of Chicago; Gift of Tiffany and Margaret Blake

RIGHT
125. Eugène Delacroix (1798–1863)
Study for "The Massacre at Chios," c. 1824
Watercolor and pen and ink on paper,
13⁵/₁₆ × 11¹³/₁₆ in. (34 × 30 cm)
Musée du Louvre, Paris

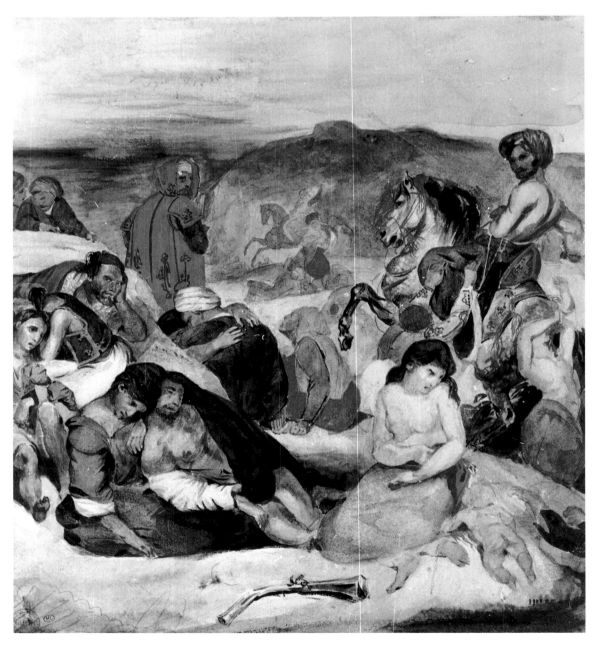

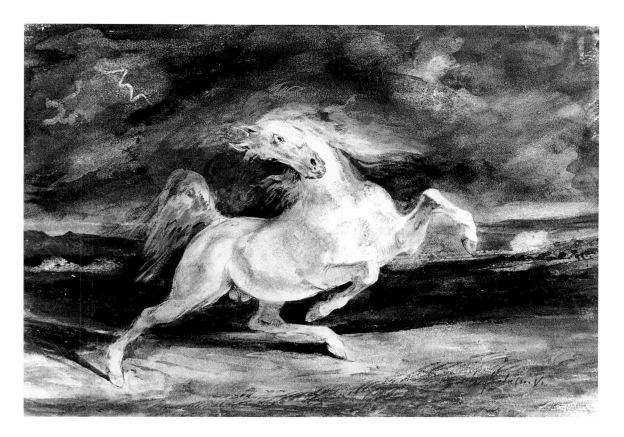

126. Eugène Delacroix (1798–1863)
Horse Frightened by a Storm,
1825–28
Watercolor on paper,
9³/₈ × 12³/₄ in.
(23.8 × 32.4 cm)
Museum of Fine Arts,
Budapest

who showed him the potential of watercolor and who, by example, offered up its secrets.

Years later, Delacroix recalled his early encounters, in the Louvre, with a "tall youth in a short coat who was silently making watercolor studies, for the most part of Flemish landscapes. Already he had a surprising skill in this method, which was in those days an English novelty."[1] Bonington and Delacroix became firm friends, traveling to England together and sharing a studio for a while. Always fascinated by color, Delacroix was taken from the first with the luminosity of Bonington's jewellike watercolors and soon began to experiment with the method himself. He found it useful as a sketch medium, as is clear from *Study for "The Massacre at Chios"* (plate 125), but more and more he came to use watercolor for its own sake, and did so with a directness and freshness that is the equal of anything to be found in the English school. *Horse Frightened by a Storm* (plate 126) is an image that might have been dredged from the imagination of Henry Fuseli, but Delacroix invests it with a dynamism that Fuseli never quite achieved.

Bonington had introduced Delacroix to the work of other English artists, and Delacroix had particularly admired the paintings that Constable sent to the 1824 Salon, taking special notice of Constable's broken color, his method of using, for example, many greens in a broken texture to create the illusion of a spring meadow. Delacroix built on such ideas in his own oil paintings and applied them in an especially pure way in his watercolors.

This is very evident in the notebooks he kept during his 1832 visit to Morocco, where both the exotic subject matter and the African light delighted his eye. Even the most cursory of his Moroccan sketches are full of life and color. *Interior of a Moorish House* (plate 128) is brevity itself. Liquid, blotted washes are contrasted with the white of the support to create a basic pattern of light and luminous shade; detail is set down with the briefest of notations—the tile work, for example, being suggested by the merest swirls of calligraphy. It is one of those watercolors that looks

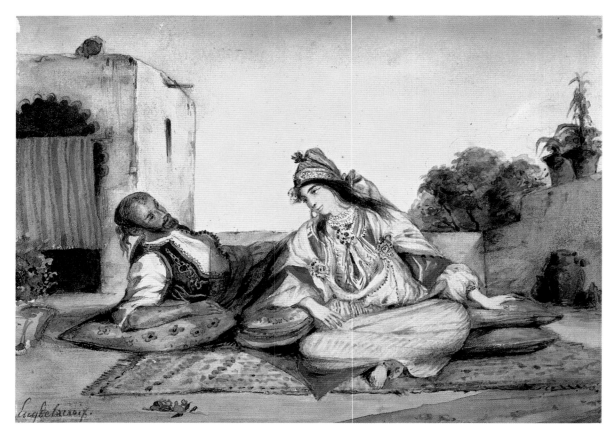

127. Eugène Delacroix (1798–1863)
Moorish Conversation, 1832
Watercolor on paper,
5⅝ × 7⅝ in.
(14.3 × 19.4 cm)
The Metropolitan Museum of
Art, New York; The Mr. and
Mrs. Henry Ittleson, Jr.
Purchase Fund, 1963

128. Eugène Delacroix (1798–1863)
Interior of a Moorish House, 1832
Watercolor on paper,
6³⁄₁₆ × 8⅜ in.
(15.7 × 21.3 cm)
Musée du Louvre, Paris

simple yet is the product of incalculable skill and experience. A more finished Mo-
roccan subject, *Moorish Conversation* (plate 127), recalls Bonington in its compression
of so much graphic and chromatic incident into so small a space. In his Salon work,
Delacroix was a master of monumental scale, but here, in this tableau set on a Tan-
giers rooftop, he demonstrates that he was a brilliant miniaturist, too. Delacroix

was among the first French artists to find inspiration in the Moslem world, though he was preceded in this by Alexander-Gabriel Descamps, who traveled to Turkey in 1828 and thereafter frequently turned to Middle Eastern subject matter. *Caravan Halted at an Oasis* (plate 129) is a very accomplished watercolor—note in particular the way in which he takes advantage of the tooth of the paper to achieve a sparkle effect—and it is apparent that he had studied English watercolors; it is highly probable that he was familiar with Bonington's work, as well as that of such artists as Thomas Shotter Boys (plate 233), who also worked in Paris in the 1820s.

By the time Théodore Chassériau visited Algeria in 1840, watercolor had become a standard part of the traveling French artist's arsenal. Paintings such as *Arab Horseman Setting Out for a Fantasia* (plate 131) and *Negress from Algiers* (plate 130) are little more than elegant sketches, but they demonstrate all the more clearly, because of their informality, how thoroughly watercolor had been absorbed into the French tradition by mid-century. French artists, with their feel for *matière*, quickly assimilated the lessons of the British and brought their own inflection to the medium.

For a number of French watercolorists, however, Bonington's example remained paramount. Like so many of his British contemporaries, Eugène Isabey—son of the miniaturist—made a career out of variations on Bonington's seascapes. With its bravura brushwork and its sensitive use of texture, *Fishing Boats Beating to Windward* (plate 132) is a delightful painting but hardly shows any advance on the similar subjects that Bonington and Francia made two decades earlier.

A more inventive beneficiary of Bonington's legacy was Eugène Lami, who adapted Bonington's method to the portrayal of fashionable society, a practice that brought him considerable success on both sides of the English Channel. At his most straightforward he delineated the styles and manners of society without much in the way of social comment, though always with a certain flourish. At his best, however, he was much better than that, as is evident from *Scene in Belgrave Square: Ladies*

132. Eugène Isabey (1803–1886)
*Fishing Boats Beating to
Windward*, 1841
Watercolor on paper,
5¹/₄ × 9¹/₂ in.
(13.3 × 24.1 cm)
Victoria and Albert Museum,
London

133. Eugène Lami (1800–1890)
*Scene in Belgrave Square: Ladies
Entering Their Carriage*, n.d.
Watercolor and gouache
heightened with Chinese
white on paper, 5³/₄ × 9³/₄ in.
(14.1 × 24.8 cm)
Victoria and Albert Museum,
London

Entering Their Carriage (plate 133). A product of one of Lami's London sojourns, this work is full of life and atmosphere. The debt to Bonington is evident in almost every aspect of the painting, but Lami switches the emphasis by focusing on the players rather than on the setting (though the setting is nicely handled). The ladies hurrying to the carriage are beautifully caught with a few telling details, and the horses are set down with an accuracy and animation that Géricault would have appreciated. In pictures such as this, Lami carved a unique little niche for himself in the pantheon of nineteenth-century watercolor.

Lami was also a master of the small-scale official painting, the kind of thing that was commissioned by monarchs and potentates to record important occasions. When Napoleon III welcomed Queen Victoria on a state visit to France in 1854,

Lami was asked to make a record of a supper given at Versailles, to be presented to the queen as a souvenir. The emperor was so pleased with the results that he then commissioned Lami to make a copy for the French Royal collection, the version that is reproduced here (plate 134). Totally committed to watercolor, Lami was, in his late seventies, the moving force behind the formation of the Société d'Aquarellistes. He was one of those fortunate artists who enjoyed the success of acceptance by the establishment yet retained the respect of more demanding critics such as Charles Baudelaire, who described him as the poet of official dandyism.

A greater favorite of Baudelaire's was Constantin Guys, who, though not a disciple of Bonington, had a good deal in common with Lami. Like Lami he worked on a small scale, on paper, and was a close observer of fashionable society. Unlike Lami, however, he was also a trenchant commentator upon low life—especially the life of brothels—and, unlike Lami, he frequently reverted to the more traditional use of monochrome wash. He was primarily, perhaps, a master of descriptive line but often used watercolor washes and highlights to great effect.

Young Woman in a Blue Bonnet with a Fan (plate 137) makes powerful use of massed blacks. The personality of the sitter is captured with a few quickly drawn lines; then washes are laid in to create a slightly mysterious air. *Riders in the Bois* (plate 135) is a marvelously economical sketch. Black lines, drawn boldly with the brush, do most of the work, but color is used dashingly to add life to the scene. *Hussars at Table with Several Girls* (plate 136) also depends primarily on line, but

134. Eugène Lami (1800–1890)
Supper Given by the Emperor Napoleon III for Queen Victoria of England in the Theater of Versailles, 1854
Watercolor on paper,
16⁹/₁₆ × 18¹/₈ in. (42 × 46 cm)
Musée National du Château, Versailles, France

135. Constantin Guys (1802–1892)
Riders in the Bois, n.d.
Watercolor and pen and ink on
paper, 7¹/₁₆ × 10⁷/₁₆ in.
(17.9 × 26.4 cm)
Musée du Louvre, Paris

watercolor washes are applied as local color to uniforms and costumes. Guys is an example of an artist who might have thrived in the eighteenth century, working in gouache or pen and ink. As it was, living in the nineteenth century, he incorporated watercolor into his vocabulary as a matter of course and convenience.

A very different kind of artist was François-Marius Granet, a friend of Ingres who split his career largely between Rome and Paris and enjoyed considerable official success both as a painter and as curator of Louis-Philippe's Musée Historique at Versailles. His paintings on canvas, although not quite forgotten today, have been relegated, for the most part, to the shadowy recesses of art history. During the final twenty years or so of his life, however, Granet produced a body of astonishingly fresh watercolors that recall the British School in their freedom from artifice and atmospheric lyricism but remain highly personal and free of influence in their execution.

It is highly probable that Granet was familiar with the work of Bonington and other British watercolorists, as well as with the paintings of their French admirers. He was not working in a vacuum, then, but his approach is quite singular nevertheless. Instead of painting on hard-sized, textured watercolor paper, he selected a relatively lightweight, almost smooth, slightly absorbent support. Instead of adopting Bonington's style of near-bravura brushwork, he preferred a somewhat self-effacing approach that eschewed gratuitous calligraphic display. Indeed, as a watercolorist, Granet was entirely self-effacing, never showing his watercolors during his lifetime and seemingly having made them entirely for his own pleasure,

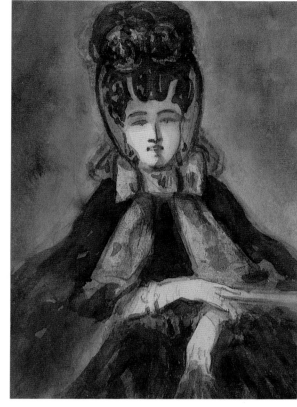

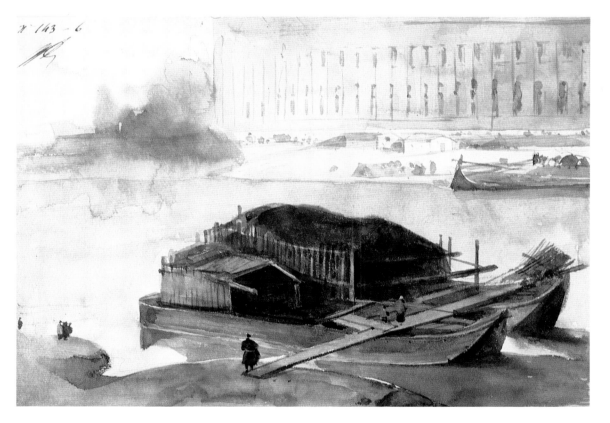

perhaps as an escape from the official art world of which he was so integral a part. His two principal subjects, as a watercolorist, are the Seine near the Louvre and the park of Versailles, both of which he painted scores of times.

Like so many of his watercolors, *Two Barges on the Seine, Opposite the Louvre* (plate 138) has a serenity that recalls Sung Dynasty landscape drawings and that

139. François-Marius Granet
(1775–1849)
The Pièce d'Eau des Suisses in the Fog, 1849
Watercolor on paper,
4 × 6½ in. (10.2 × 16.6 cm)
Musée Granet, Palais de Malte, Aix-en-Province, France

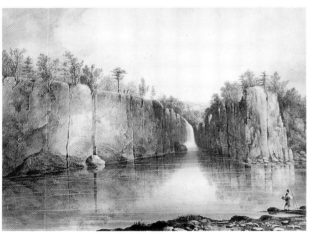

140. William Guy Wall
(1792–after 1864)
Falls of the Passaic, c. 1820
Watercolor on paper,
17³/₈ × 23¹⁵/₁₆ in.
(44.1 × 60.8 cm)
The Brooklyn Museum; Dick S. Ramsay Fund

looks forward to Whistler's paintings of the Thames. A mood is quickly established, chiefly by means of washes that have been softened by the paper, and incident in the form of the human presence is added without fuss but with considerable liveliness. *The Pièce d'Eau des Suisses in the Fog* (plate 139) is one of many paintings Granet made of this particular feature of the park of Versailles. In this instance, with a boldness worthy of Turner, he has dissolved the landscape, as though seen through mist, by splashing the painting with water, allowing it to sit for a while, then taking off some of the color with a sponge or a rag. Such a technique is perhaps a little extreme by Granet's usual practices, yet it is not entirely unexpected or unprecedented in his work. A master of quiet moods and delicate touch, he is a watercolorist who deserves to be much better known.

France was not the only place to which the British influence spread in the early part of the nineteenth century. Another country that was very welcoming of the British tradition was the United States, where, despite the breaking of political ties, English cultural influence was still strong. No Bonington traveled to America, however, and there was no Géricault or Delacroix there to welcome those who came. Rather, the English tradition came to America in the form of provincial topographers and drawing masters who arrived from the Old Country to earn a living in the New World. Such men were in America before the Revolution, but a new wave began to arrive in the nineteenth century, a wave that had been exposed to recent developments in the British Isles.

William Guy Wall, for example, came to the United States in 1818, having received his training in England. Not advanced by British standards of the period, he had, nonetheless, absorbed the basics of the methods evolved by artists like Girtin and John Varley. His work has a solidity and, sometimes, as in *Falls of the Passaic* (plate 140), a sense of atmosphere that goes beyond mere topography. On top of this, his New World subjects lent his work a particular freshness.

Watercolor painting in America quickly grew in sophistication, as is evident from the work of George Harvey, just eight years Wall's junior. Harvey, too, came from England and later revisited his place of birth, a trip that gave him the opportunity to study the most current watercolor methods. In particular, he picked up on

a technique of stippling, somewhat as practiced by Robert Hills (plate 71), which he applied with considerable success to landscape and genre scenes. *Rain Clouds Gathering—Scene Amongst the Allegheny Mountains* (plate 141) is an instance of how he used the stipple system to provide texture and detail without giving up the atmospheric effects usually obtained with more conventional methods.

Watercolor began to mature in America at about the time the West was opening up, and just as explorers traveling by sea had taken watercolorists with them, so watercolor kits and sheets of watercolor paper began making journeys into the American wilderness strapped to the backs of mules and packhorses. One of the first watercolorists to travel extensively west of the Mississippi was George Catlin. Born in Wilkes-Barre, Pennsylvania in 1796, Catlin had studied law before receiving some limited training in draftsmanship and painting skills. For several years, starting in 1830, he wandered the prairies making hundreds of on-the-spot studies (plate 143), many of which he later worked up into finished paintings. It is the studies themselves that are of primary interest, however, since they have a charming spontaneity and authenticity that captures the flavor of the Old West.

As noted in the first chapter, Switzerland had a native watercolor tradition; one of the most important artists of the American West was a Swiss citizen, Karl Bodmer, who came to America in company with Alexander Philip Maximilian, a Prussian prince and gentleman scientist who was preparing a book on the American wilderness. Bodmer made hundreds of watercolor paintings to be used as a basis for illustrations in Maximilian's book, many of them extremely fine (plate 144). Technically, Bodmer was the most accomplished of the early explorers of the West, but his

141. George Harvey (1801–1878)
Rain Clouds Gathering—Scene Amongst the Allegheny Mountains, c. 1840
Watercolor on paper,
8³/₈ × 13⁵/₈ in.
(21.3 × 34.6 cm)
The Brooklyn Museum; Dick S. Ramsay Fund

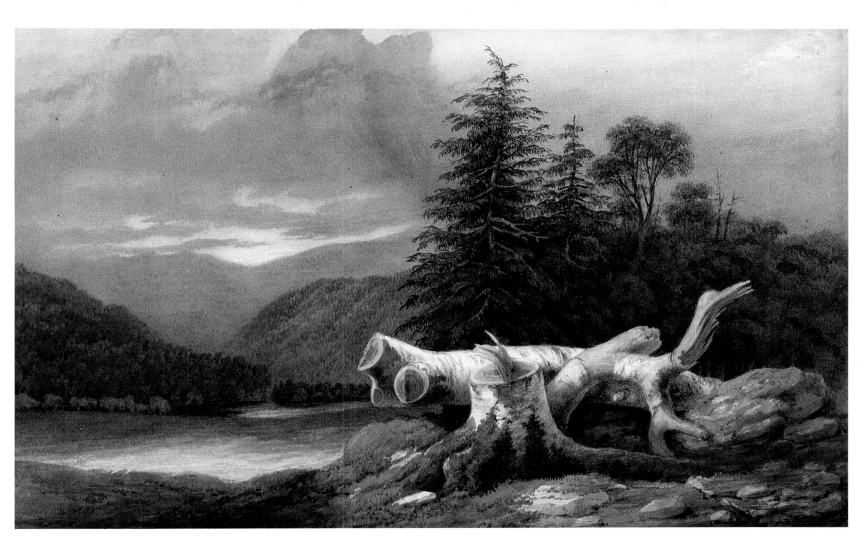

142. Peter Rindisbacher (1806–1834)
Sac and Fox War Dance or *War Dance of the Sauk and Fox*, c. 1830
Watercolor on paper,
8 × 14 in. (20.3 × 35.6 cm)
Courtesy The West Point Museum
Collection, United States Military
Academy, West Point, New York

143. George Catlin (1796–1872)
A Crow Indian, "The Jumper," in full costume on horseback from the *Album Unique*, 1861
Watercolor on paper,
17 × 24 in. (43.2 × 61 cm)
Courtesy Museum of The American
Indian, Heye Foundation, New York

observations were limited to one thirteen-month expedition, after which he returned to Europe, becoming a minor exemplar of the Barbizon School.

Another Swiss, Peter Rindisbacher, emigrated with his family to Ontario and, largely self-taught, made lively watercolors of Indian life in both Canada and the United States (plate 142). Less facile than Bodmer, Rindisbacher nonetheless had a strong feeling for frontier life, which he was able to translate into spirited designs.

Perhaps the most atmospheric of the frontier artists was Alfred Jacob Miller. Born in Baltimore in 1810, he had studied in Philadelphia, with the portraitist Thomas Sully, and in Paris before attempting to set himself up as a portrait painter in New Orleans. There a British explorer, William Drummond Stewart, found him and convinced him to join an expedition along what would become the Oregon Trail, traveling by way of Fort Laramie and across the Rocky Mountains. Like Bodmer, Miller made only one trip to the Far West. Unlike Bodmer, he used the material he gleaned there as the basis for his entire career. Not a classic watercolorist by any means—he frequently blended transparent and opaque color—Miller had

OPPOSITE, BOTTOM LEFT

144. Karl Bodmer (1809–1893)
*Makúie-Póka (Child of the Wolf),
Piegan Blackfeet Man,* 1832–34
Watercolor on paper,
12¼ × 9⅞ in. (31.1 × 25.1 cm)
Joslyn Art Museum,
Omaha, Nebraska

OPPOSITE, BOTTOM RIGHT

145. Alfred Jacob Miller (1810–1874)
Shooting a Cougar, 1859–60
Watercolor on paper,
11 × 9⅛ in.
(27.9 × 23.2 cm)
The Walters Art Gallery, Baltimore

BELOW

146. John James Audubon (1785–1851)
American Eider, 1833
Watercolor on paper,
25⅝ × 38 in. (65.1 × 96.5 cm)
Courtesy The New-York
Historical Society

enough skill to recapture dramatic moments, such as that shown in *Shooting a Cougar* (plate 145), with great vividness. If his technique is sometimes a little rough at the edges, it is the roughness of the frontier and only enhances the authenticity of his vision.

Another artist who wandered the American continent was John James Audubon, but his search was for wildlife rather than Indian customs and frontier ways. Born in Haiti of French parents, Audubon was educated in France and studied for a while with Jacques-Louis David. Coming to the United States, he attempted to set himself up as a businessman, but encountered financial failure and bankruptcy before, at the urging of his wife, he turned to the career of artist-naturalist that was to make his fortune. It was by the hand-colored plates of *Birds of America* that he was to become known, but each of these plates was preceded by painstaking watercolor studies, for which Audubon devised some highly personal techniques, such as combining watercolor with pastel and lacquer to simulate the texture and sheen of colored feathers. *American Eider* (plate 146) is a good example of a painting in which such a combination of media is used. It is also a fine instance of Audubon's ability to wed careful observation to a powerful sense of design.

Best known for his ornithological studies, Audubon was equally at home painting mammals such as Pennant's marten (plate 147) and at the time of his death was preparing another set of prints to be titled *The Viviparious Quadrupeds of North America.* He can reasonably be described as America's first great watercolorist,

147. John James Audubon
 (1785–1851)
 Pennant's Marten, 1841
 Watercolor on paper,
 18 × 30 in. (45.7 × 76.2 cm)
 Wadsworth Atheneum,
 Hartford, Connecticut; Gift of
 Henry Schnakenberg

148. Mary Ann Willson (active
 1800–1825)
 Three Angel Heads, n.d.
 Watercolor on paper,
 16 × 13 in. (40.6 × 33 cm)
 Museum of Fine Arts, Boston;
 M. and M. Karolik Collection
 of American Watercolors and
 Drawings

though his own requirements led him to a technical approach that exerted little influence, except with other artist-naturalists.

American watercolor, as will be seen, was to come to full flower in the last quarter of the nineteenth century. One aspect of watercolor that thrived throughout the century, however, was the way in which it was embraced, in the New World, by naive painters, many of them very gifted. For some, such as Mary Ann Willson, the experience of a continent uncluttered with obtrusive reminders of the European past provided the impetus for the creation of a personal mythology, a world of fantastic creatures with which to fill the dark nights and long winters of upstate New York (plate 148). In company with a Miss Brundage, she worked an isolated farm and devoted her spare time to watercolor painting, often using homemade pigments squeezed from berries or distilled from various vegetable concoctions. Willson took her work extremely seriously and built a reputation in surrounding communities, proudly claiming that she sold paintings as far away as Canada.

Jacob Maentel was a different kind of folk artist, a portraitist who performed

149. Jacob Maentel (1763–1868)
Family Portrait, 1830–40
Watercolor on paper,
17³/₈ × 22 in.
(44.1 × 55.9 cm)
The Henry Francis du Pont
Winterthur Museum,
Winterthur, Delaware

for the rural gentry of Maryland and Pennsylvania the same service that John Singleton Copley and Gilbert Stuart did for their urban counterparts in Boston and Philadelphia. Unlike these older and more famous contemporaries, Maentel knew little of classicism or the rococo and so concentrated his energy into achieving accurate likenesses—the primary requirement of his profession, after all. This often led to portraits in which the head is immaculately rendered while the body is like that of a rag doll. In *Family Portrait* (plate 149), however, Maentel does much with the grouping of the figures and makes good use of the patterns provided by the wallpaper, carpet, and other items in the room—yet none of this at the expense of providing the likenesses of his sitters. This is one of his most successful works.

The American merchant class required not only portraits of themselves, but also portraits of their possessions, from country estates to paddle steamers, thereby providing work for artists like Jurgan Frederick Huge. It would be unfair to treat Huge's marine portraits as mere celebrations of material success, however, since they are also sensitively executed mementos of a technology changing so rapidly that it generated almost instant nostalgia (plate 150).

The last three artists considered were all professionals in that they took commissions or made works that were intended for sale. W. M. Harding, on the other hand, was a true amateur, a New York businessman who lived in the city's first suburb, Brooklyn Heights, and made charming views of the harbor from his room (plate 151). Harding would not have been satisfied with the folksy distortions of Jacob Maentel. Doubtless he was familiar with the work of his European-trained contemporaries, as seen at New York exhibitions, and so in his own work he attempts to match himself against them; yet the slight awkwardnesses in drawing,

150. Jurgan Frederick Huge
(1809–1878)
Bunkerhill, 1838
Watercolor on paper,
19 × 32 in. (48.3 × 81.3 cm)
Mariners Museum, Newport
News, Virginia

151. William Martin Harding
(active 1865–1869)
New York Harbor from Brooklyn Heights Window, 1869
Pen and ink and watercolor on paper, 9⁷/₁₆ × 7¹/₂ in.
(24 × 19.1 cm)
Museum of Fine Arts, Boston; M. and M. Karolik Collection of American Watercolors and Drawings

the minute inconsistencies in perspective, betray him as an amateur, one of the great army of amateurs that had taken up watercolor by mid-century.

And this is perhaps the true measure of the spread of the medium. Aristocratic amateurs had worked alongside topographers in the eighteenth century, and young ladies of quality had taken lessons from John Varley and Cotman. By the mid-nineteenth century, however, the popularity of watercolor had become universal, practiced by amateurs of all social strata, often without formal instruction. This was in part a reflection of the inroads professional watercolorists had already made, and it would help guarantee a knowledgeable audience for watercolors throughout the century and beyond.

Visionaries, Poets, and Dissenters

152. John Simmons
Titania, 1866
Detail of plate 182

So far this text has concerned itself primarily with the mainstream of watercolor painting as it evolved from topography to an independent discipline capable of accommodating a variety of ambitions and technical approaches. It has been seen how what was originally a British specialty spread to continental Europe and the New World, and how an emphasis on landscape was eventually modified by some artists so that, as the nineteenth century progressed, watercolor became characterized by greater thematic variety. Within the mainstream, however, new themes—whether genre or social commentary—tended to be couched within terms of a naturalism that was the legacy of watercolor's landscape origins. This naturalism, to be sure, was sometimes inflected with the heightened values of Romanticism, but it remained rooted in observation of the forms and moods of the known world.

The very notion of a mainstream, however, implies the existence of alternate approaches, and from the late eighteenth century on there was a significant tributary of watercolor painting that ran counter to the norm. It is difficult, and perhaps not very productive, to define the character of this alternative tradition, since it was largely made up of dissenters. It can be said, however, that it provided a home for artists with a strong literary or narrative bent and that, by token of this, it lent itself to the needs of fantasists and those concerned with the creation of alternate worlds. Indeed, such alternate worlds were a significant aspect of the Romantic period, which spawned Beckford's *Vathek* as well as Wordsworth's pastorals. Some artists found alternate worlds in the literature of the past—Shakespeare, Milton, Dante—or in the prophecy-laden pages of the Old Testament. Others sought escape in the past itself, imagining a somehow more innocent pastoral world—a Judeo-Christian Arcadia—that must, they seemed to insist, have existed before the first coal fur-

naces of the Industrial Revolution sullied the virgin air. Artists who sought to recapture that Arcadian world came close to the mainstream at times, but they differed from Constable or Cotman in that they invested their landscapes with a pantheistic fervor that made these works poeticized ideals rather than portraits of actual places. This alternate tradition found room for a variety of ambitions even greater than those of the mainstream. What its members have in common is a tendency to create heightened worlds rather than to portray the everyday world.

An early contributor to this alternate tradition was Johann Heinrich Fuseli (né Füssli), one of several Swiss artists who made their careers in England. Fuseli first came to attention in Berlin with drawings based on episodes in Shakespeare's plays, notably *King Lear* and *Macbeth*. These brought him to England, where Sir Joshua Reynolds encouraged him to paint. In 1778, after an extended stay in Rome, where he fell under the spell of Michelangelo, he settled in England, becoming an influential member of the Royal Academy and a teacher who left his mark on students as varied as William Etty and Edwin Landseer.

The sublime, as embodied in Michelangelo, was Fuseli's ideal, as can be seen from *Oedipus Cursing Polynices* (plate 153), a large watercolor closely related to his work in oils. Compositions such as this are marked by a theatricality that borders on the grotesque. His more elaborate works often display an exaggeration of pose and facial expression that verges on the absurd, though his tendency to push his own mannerisms to extremes enabled him, on occasion, to achieve nightmarish visions that, if not quite as genuinely dreamlike as Goya's late phantasmagorias, are nonetheless convincing.

153. Johann Heinrich Fuseli (1741–1825)
Oedipus Cursing Polynices, n.d.
Watercolor on paper,
20¼ × 18¼ in. (51.4 × 46.4 cm)
Victoria and Albert Museum,
London

Fuseli was fascinated by the female fashions of his day—the clinging, decolleté gowns and elaborate hairdos—and among his most delightful and personal works are drawings brushed with wash that deal with this subject matter. *A Courtesan at Her Dressing Table with Client or Spirit* (plate 154) is a charming example of his output in this genre, entirely lacking in the bombast that afflicts some of his more ambitious work. *Mamillius with a Lady-in-Waiting* (plate 155) is an example of Fuseli's Shakespearean studies (drawn from Act II, Scene I of *A Winter's Tale*) that shows him at his best, presenting the subject in an entirely personal way without succumbing to overstatement.

Fuseli was among the few establishment figures to appreciate the genius of his younger contemporary, William Blake, who shared the Swiss artist's love of Michelangelo, Shakespeare, and Milton, but was able to transform these influences and inspirations into something far more original. Blake was one of the most original artists of his generation, an innovator to the point of completely confounding the great majority of his fellow artists. Indeed, he was not fully appreciated until the twentieth century, when his influence on movements as disparate as Art Nouveau and Surrealism enhanced his reputation.

Blake was born in 1757 in the Soho district of London, the son of a hosier who was an adherent of Swedenborg's mystical philosophy. He showed an early talent

154. Johann Heinrich Fuseli (1741–1825)
A Courtesan at Her Dressing Table with Client or Spirit, c. 1790–95
Pen and brown ink and watercolor over indications in pencil on paper, 6¹/₁₆ × 3¹/₂ in. (15.4 × 8.9 cm)
Ashmolean Museum, Oxford, England

155. Johann Heinrich Fuseli (1741–1825)
Mamillius with a Lady-in-Waiting, 1785–90
Pencil and watercolor on brown paper, 19³/₈ × 19³/₁₆ in. (49.2 × 48.7 cm)
Kunsthaus Zurich

156. William Blake (1757–1827)
Oberon, Titania, and Puck with Fairies Dancing, c. 1785
Pencil and watercolor on paper, 18³/₄ × 26¹/₂ in. (47.6 × 67.3 cm)
Tate Gallery, London; Courtesy Art Resource, New York

for drawing and was encouraged by his father, who enrolled him in Henry Pars's drawing school in the Strand. In his early teens, Blake was apprenticed to James Basire, an engraver, and during the period of his apprenticeship he made many drawings of the monuments of Westminster Abbey, which helped build his knowledge of the Gothic style that was to provide him with one of his ideals. Blake steeped himself in literature and even before his apprenticeship commenced had begun to write poetry, a vocation that was to bring him a posthumous fame equal to that earned by his achievements as a visual artist. His gifts as poet and draftsman were often so intertwined that it seems foolish to separate them, though the greatest of his poems need no visual support, and the greatest of his designs transcend literary interpretation.

Completing his apprenticeship in 1778, Blake set up as a journeyman engraver and earned his living by carrying out banal commissions for booksellers and publishers while using his own time to pursue higher goals. Despising the Academy—though he showed there on occasion—he developed an antipathy for paintings on canvas and from the first was drawn to watercolor. Early examples are sometimes light in mood, compared with his mature work, yet they are always lively and inventive; certainly, *Oberon, Titania, and Puck with Fairies Dancing* (plate 156) brilliantly catches the mood of Shakespeare's midsummer reverie. It should be understood

that, just as his poetry was intertwined with his graphic output, Blake's watercolors were intimately related to his prodigious output of prints and illustrated books. Watercolors were often studies for engravings, and engravings were frequently hand-colored with watercolor.

Blake perfected a system of relief etching (he claimed its secrets were revealed to him in a dream by his deceased brother Robert) that proved an ideal method for his needs. It provided an outline image that could be left plain or colored by hand. The forcefulness with which Blake colored images such as *Urizen Reading the Book of Los* (plate 157) virtually transformed these prints into original watercolors.

Urizen comes from the so-called *Small Book of Designs* and derives from Plate 5 of *The Book of Urizen*, one of Blake's Prophetic Books. This presents his elaborately reconceived version of Genesis; the name *Urizen* is, in fact, a pun on the words "you reason" or "your reason," rationalism being a force of repression in Blake's highly personal cosmography. It was Blake's belief that the artist must penetrate the surfaces of everyday reality to discover the "real" world that exists on a profounder, more spiritual plane. Blake was given to experiencing visions and even—as reported by John Varley to his pupils—raising the spirits of departed heroes such as Julius Caesar and Alexander the Great.[1] When asked, Blake was not shy about describing his experiences with the spirit world; this inevitably led to his being dismissed as an eccentric, even a madman. Add to this his espousal of unpopular causes, such as the French Revolution, and his dislike of academic art, and it will be understood that he did not enjoy any great favor with the establishment, though he did enjoy the support of a few enthusiastic patrons and the sympathy of a handful of artists such as John Varley, Fuseli, and the sculptor John Flaxman. To a large extent, however, Blake lived on the edge of poverty. He was barely supported by his trade as an engraver while working on his own immense projects with the help of his wife, Catherine, the daughter of a market gardener who learned to draw and paint well enough to serve as his assistant.

Blake was a fervent Christian, but one who detested religious orthodoxies, and his compositions often reach back for inspiration to the robust ecclesiastical art of the Middle Ages, evoking a world of miracles and hellish terrors, a universe in which angels and evil spirits had a very real existence. *The Four and Twenty Elders Casting Their Crowns Before the Divine Throne* (plate 158), in which the elders make

BELOW, LEFT

157. William Blake (1757–1827)
Urizen Reading the Book of Los,
c. 1795
Color-printed relief etching
finished in pen and ink and
watercolor, 3 × 4³/₁₆ in.
(7.6 × 10.6 cm)
Harry Ransom Humanities
Research Center Art
Collection, University of
Texas, Austin

BELOW, RIGHT

158. William Blake (1757–1827)
*The Four and Twenty Elders
Casting Their Crowns Before the
Divine Throne,* c. 1805
Watercolor on paper,
13³/₄ × 11¹/₂ in.
(34.9 × 29.2 cm)
Tate Gallery, London;
Courtesy Art Resource,
New York

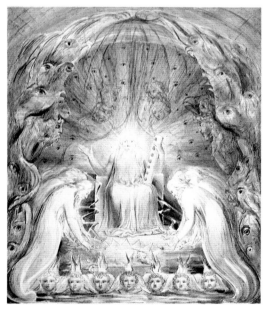

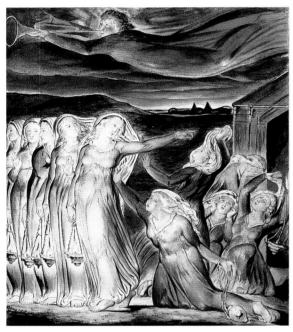

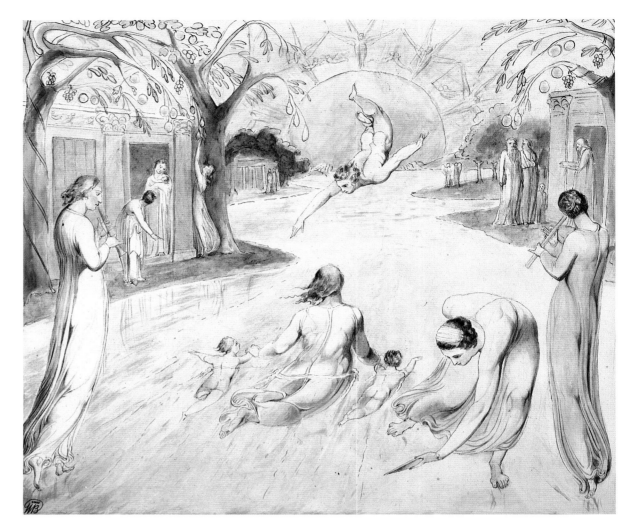

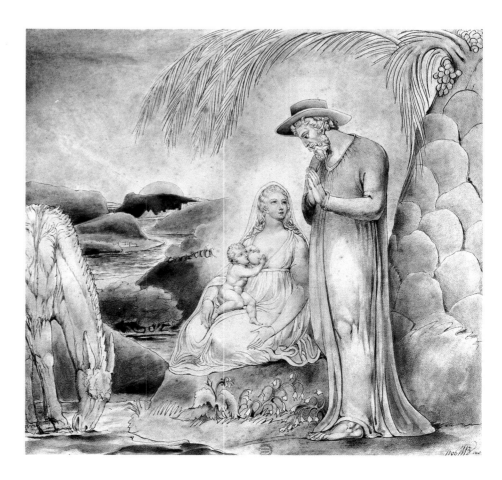

CLOCKWISE FROM ABOVE

159. William Blake (1757–1827)
 The Wise and Foolish Virgins, c. 1805
 Watercolor on paper,
 12 × 13¼ in. (30.5 × 33.7 cm)
 Tate Gallery, London; Courtesy
 Art Resource, New York

160. William Blake (1757–1827)
 The River of Life, c. 1805
 Watercolor drawing on paper,
 12 × 13¼ in. (30.5 × 33.7 cm)
 Tate Gallery, London; Courtesy
 Art Resource, New York

161. William Blake (1757–1827)
 The Flight into Egypt, 1806
 Watercolor and pen and ink on
 paper, 13¹³⁄₁₆ × 14⁹⁄₁₆ in. (35.1 × 37 cm)
 The Metropolitan Museum of
 Art, New York; Rogers Fund, 1906

162. William Blake (1757–1827)
Elohim Creating Adam, c. 1805
Watercolor on paper,
17 × 21⅛ in.
(43.2 × 53.7 cm)
Tate Gallery, London;
Courtesy Art Resource,
New York

up a Gothic arch, is reminiscent of illuminated manuscripts, while *The Wise and Foolish Virgins* (plate 159) is like a scene from a miracle play.

Blake's compositions could be gentle or full of energy. *The River of Life* (plate 160) presents a tranquil enough scene, though the sinuous curve of the river itself lends the image life, while the overall concept looks forward to the symbolism of Puvis de Chavannes. *The Flight into Egypt* (plate 161) is another peaceful subject, in which the Holy Family has been based, to some extent, upon Renaissance models, though Joseph's hat gives the group an oddly homey and contemporary touch. The landscape has an ethereal, other-worldly quality that anticipates Henri Rousseau, the Douanier. *Elohim Creating Adam* (plate 162), on the other hand, is full of dynamic movement that seems to embody the act of creation. Blake's sense of design here is so powerful that it might have stifled the energy of a lesser artist, turning the composition into mere decoration, but his line is so full of life that the figure of Elohim seems to fly, while Adam appears to be on the point of taking his first breath. The influence of Michelangelo, pervasive in Blake's work, is evident in the musculature of the bodies, yet nothing could be further removed, in mood, from the God and Adam represented by Michelangelo in the Sistine Chapel. Michelangelo endowed his Creator with an almost languid nobility that derives from Greek and Roman models as much as from the Bible. Blake's Creator, on the other hand, is very much the Jehovah of the Old Testament.

The Finding of Moses (plate 163) takes a biblical theme and transforms it into a curious image that is a hybrid of several styles and yet at the same time wholly Blakian. The Michelangelo influence is apparent, as always, yet the pharaoh's daughter is a princess out of Arthurian legend, while the pyramids derive from popular prints, and the palm trees are products of the imagination of a North European who has never left the temperate zones. From a naturalistic viewpoint, the picture

163. William Blake (1757–1827)
The Finding of Moses, n.d.
Watercolor on paper,
12⅝ × 12⅜ in.
(32.1 × 31.4 cm)
Victoria and Albert Museum,
London

OPPOSITE
164. William Blake (1757–1827)
*The Great Red Dragon and the
Woman Clothed with the Sun*, c. 1805
Pen and ink with watercolor
on paper, 16¹/₁₆ × 13¼ in.
(42.2 × 33.7 cm)
National Gallery of Art,
Washington, D.C.; Rosenwald
Collection

makes no sense, but Blake cared little for the naturalistic and was able to integrate disparate elements with a confidence born of the certainty of his own vision. At times that vision produced images as fantastic as anything imagined by Hieronymus Bosch.

Among Blake's contemporaries, only Goya equalled him in his power to conjure up the fabulous and nightmarish. *The Great Red Dragon and the Woman Clothed with the Sun* (plate 164) is an astonishing image that might almost be the vision of some medieval mystic—and here is where Blake differs from Goya. Goya's nightmare visions seem much more modern, belonging to the same world as Kafka's *Metamorphosis*, and proto-Freudian in character. Blake, on the other hand, always seems to be looking backward—to Milton, to Michelangelo, to Dante, to Gothic tombs and gargoyles, and above all to the Old Testament.

When Blake derived an allegory from James Hervey's "Meditations Amongst the Tombs" (plate 165), he created a miniature Sistine Chapel mural in which Christ, David, Solomon, Noah, Moses, and other biblical characters share a sinuous composition with twin cyclones of secular figures. The design here is startling, and the emphasis on drawing very distinct, reminding the viewer that Blake prized line above everything, having once declared that "the great and golden rule of art, as well as life, is this; that the more distinct, sharp, and wirey the bounding line, the

165. William Blake (1757–1827)
*Epitome of James Hervey's
"Meditations Amongst the
Tombs,"* 1820–25
Watercolor drawing on paper,
17 × 11½ in. (43.2 × 29.2 cm)
Tate Gallery, London;
Courtesy Art Resource,
New York

more perfect the work of art."[2] It was this devotion to line that resulted in Blake's choice of watercolor, since the transparency of the medium permitted him to use color without obliterating the line beneath. In this regard, then, he had more in common with the topographers than with watercolor revolutionaries like Girtin and Turner; but such comparisons are pointless since Blake was entirely his own man, an eclectic and eccentric in the purest sense of both words.

Like so many of the great British watercolorists, Samuel Palmer was a Lon-

doner, born in 1805 in the borough of Newington, the son of a bookseller. He showed early promise as a watercolorist in the prevailing post-Girtin style and might have developed into a mainstream artist of consequence had he not been befriended by the painter John Linnell, who in turn introduced him to Blake and the circle known as the Ancients, which included such young men as George Richmond, Edward Calvert, and Francis Oliver Finch. Palmer first visited Blake in 1824 and found him busy with his Dante paintings. Blake offered him encouragement, and the following year Palmer became enraptured with the older man's Virgil woodcuts, which Palmer described in his sketchbook as "visions of little dells, and nooks, and corners of Paradise, models of the exquisite pitch of intense poetry. . . . Depth, solemnity, and vivid brilliancy only coldly and partially describe them. There is in all such a mystic and dreamy glimmer as penetrates and kindles the inmost soul."[3]

Apparently at Linnell's suggestion, Palmer sought out the scenery of Shoreham, Kent, visiting the village in 1826 and settling there in 1827, making it his base until 1835 and often acting as host to the Ancients, who strolled the lanes with him, watching the moon rise above the chalk downs while conjuring up an Arcadia that owed much to literary sources such as Virgil's *Eclogues* and Spenser's *Faerie Queene*. Palmer spent these years honing his vision, working sometimes in chalk, sometimes in sepia wash, occasionally in oil or tempera, but most often—and always on a small scale—in watercolor or watercolor combined with gouache.

Some of his Shoreham watercolors, such as *Lane and Shed, Shoreham* (plate 166) are relatively straightforward descriptions of barns, haystacks, or hop fields. These come close to mainstream landscapes, though they are always informed by his own highly individualistic and original sense of line and by his habitual intensity of vision. Such paintings only hint, however, at the enchanted world he was able to evoke in his most personal works, compositions in which his genius was capable of transforming rural Kent into a vision of Paradise. Palmer drew upon the same sources as the other Ancients, but he was alone in having the ability to blend everything—landscape elements and literary models—into a constant and lyrical entity. The unifying factor in his vision was an overriding pantheism, to which any

166. Samuel Palmer (1805–1881)
Lane and Shed, Shoreham, n.d.
Watercolor on paper,
11 × 18 in. (27.9 × 45.7 cm)
Victoria and Albert Museum,
London

167. Samuel Palmer (1805–1881)
In a Shoreham Garden, n.d.
Watercolor on paper,
11¹/₁₆ × 8³/₄ in. (28.1 × 22.2 cm)
Victoria and Albert Museum,
London

literary elements remained subservient. Thus, looking at the classic images of the Shoreham period, the viewer suspects that each contains a story—and this adds to the resonance of the image—but the story is overwhelmed by the richness of the iconography. It is this that makes Palmer very different from Blake. Both might take a subject from Virgil, but whereas Blake would illustrate it and comment on it—however brilliantly—Palmer would translate it into something essentially plastic and painterly.

In a Shoreham Garden (plate 167) is an astonishing painting, decades ahead of its time. Van Gogh—even the Fauves and Expressionists—would have recognized this as a work by a kindred spirit. To paint a fruit tree in blossom is a difficult challenge for anyone, but Palmer seems to have been able to inject himself—his painterly intuition—into this image of rural fecundity. Just as Turner's brushstrokes some-

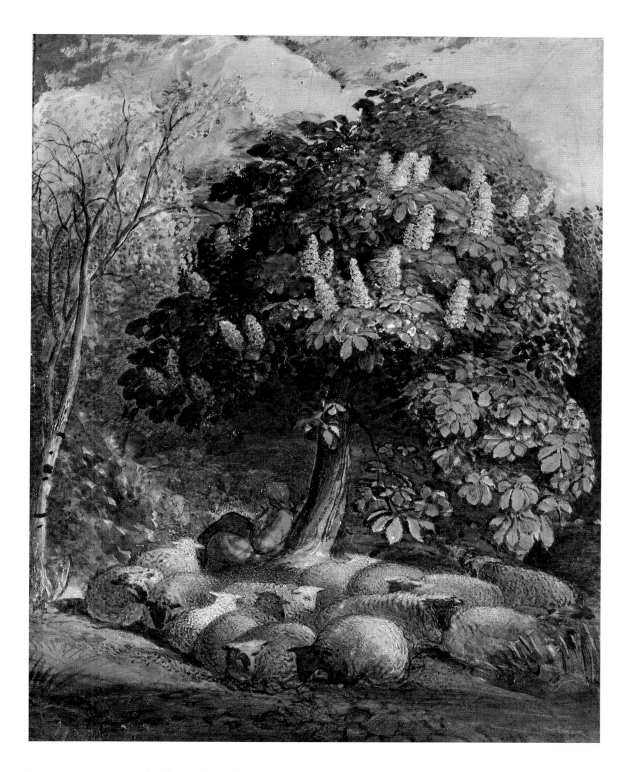

168. Samuel Palmer (1805–1881)
Pastoral with Horse-Chestnut, c. 1831
Watercolor and body color on
paper, 13⁵/₁₆ × 10¹/₂ in.
(33.8 × 26.7 cm)
Ashmolean Museum, Oxford,
England

times seem to embody rather than represent storm clouds or waves, so Palmer's
brushstrokes seem to incarnate the burgeoning pillows of blossom. Working for
himself and his friends, with no thought of exhibition or sales, Palmer took risks
with color that would have been unthinkable in establishment circles and that were
not thought of elsewhere for half a century, even by advanced painters. The single
female figure adds a touch of mystery, but the real story of this tiny painting is the
manner in which it is made and the fact that it seems to represent a wholly original
way of seeing the world. By turning to the past for inspiration, Palmer came up
with something that anticipated modernism.

Pastoral with Horse-Chestnut (plate 168) presents a similar subject, this time with
the Virgilian addition of a shepherd surrounded by his flock. Again we see nature
presented in a way entirely new in Western art. The image is remarkably self-

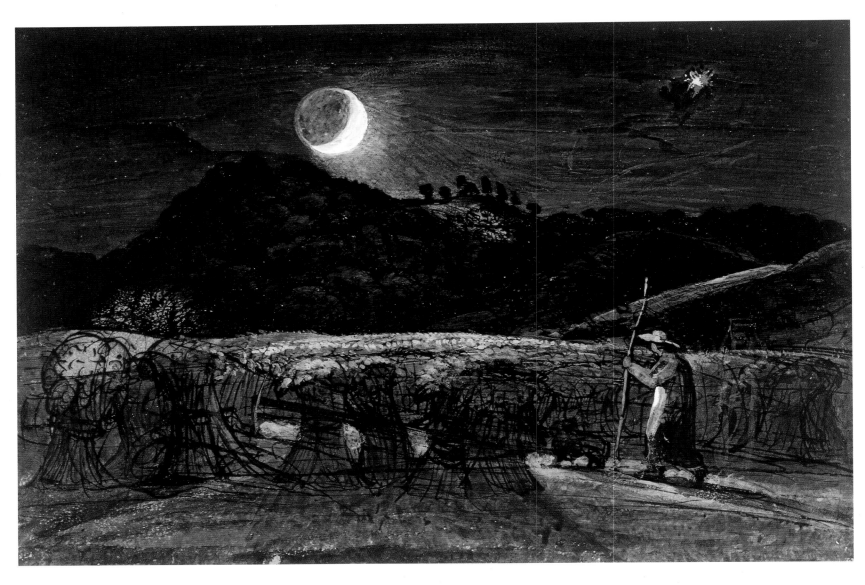

169. Samuel Palmer (1805–1881)
*Cornfield by Moonlight with the
Evening Star*, c. 1830
Watercolor, gouache, and pen
and ink on paper,
7¾ × 11¾ in.
(19.7 × 29.8 cm)
British Museum, London

contained, almost as an abstract painting is self-contained. That is to say, it does not
read as a rectangle of landscape seen through a window; the image is not arbitrarily
cut off at the edges of the sheet. Rather, those edges are used to help define the im-
age in a manner that anticipates the practice of some twentieth-century artists. Yet,
at the same time, Palmer is able to suffuse this almost emblematic image with what
can only be called life force. The viewer can sense the sap flowing through the
leaves and branches of the tree, the genetic necessity that transforms buds into blos-
soms. A painting like this is more than a representation. It is the embodiment of a
young man's poetic imperative, an imperative that Freud—had he known Palmer's
work—might have found worthy of commentary.

If paintings like *In a Shoreham Garden* and *Pastoral with Horse-Chestnut* are almost
orgasmic in their celebration of fecundity, other Shoreham paintings are more med-
itative, and these include a number of nightscapes that are among the most mem-
orable nocturnal subjects in the history of art. In *Cornfield by Moonlight with the
Evening Star* (plate 169), Palmer gently exaggerates the contours of the Kentish hills
and silhouettes them against the night sky, though the trees that line their slopes
still catch the moonlight, which is russet-colored there and golden when it touches
the harvest below. Palmer's use of color in his Shoreham period is frequently anti-
naturalistic yet conveys the impression of nature carefully and intensely observed.
It might be said that he uses color to heighten the viewer's (and his own) perception
of nature. Here, too, he seems to anticipate modernism. As for the shepherd, with

his dog and staff, his presence carries less literary weight than the figures in some of Palmer's paintings, yet still the viewer suspects some intended symbolism, however elliptical. Is this a Virgilian shepherd, or does he carry the weight of Christian semiology? The question is unanswerable, but it nonetheless lends nuance to the image.

Similar questions are raised by *Harvest Moon* (plate 170), a tiny watercolor, not much larger than a snapshot, in which the figures in the foreground include a Christ-like presence who may be blessing the laborers. But, as in religious subjects by Joachim Patenier, or in Bruegel's *Fall of Icarus*, the real subject is not the incidental human drama but rather the *mise en scène* of nature at its most spectacular. This is a painting about moonrise above the hills, and, while Palmer may be paying token respect to Christian themes, he is in fact indulging in a pagan worship of nature. The image evokes Britain's druidic past as much as the Judeo-Christian traditions grafted onto the pantheistic beliefs that inspired the burning of Yule logs and the carving of stylized men and horses into the chalk hills that appear in so many of Palmer's paintings.

That Palmer could wring magic from daylit versions of the same landscape is apparent from *Bright Cloud* (plate 171), and it is clear from *Study of a Garden at Tintern* (plate 172) that he could make even pedestrian themes luminous and lyrical. As his Shoreham period ended, however, Palmer's circumstances were on the verge of a change that affected his entire approach to watercolor, and to life. In 1837 he married John Linnell's daughter, Hannah, and suddenly found himself faced with the prospect of leading the life of an upstanding Victorian husband. No longer did he work for himself and a few friends, but instead he began to think of making paintings for exhibition and of finding teaching positions that would help support his family. In many ways his career became a repeat of Cotman's. He never entirely

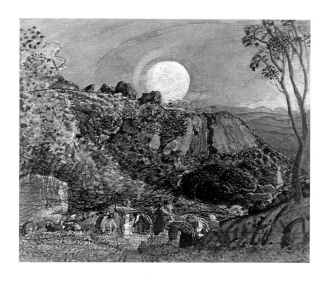

170. Samuel Palmer (1805–1881)
Harvest Moon, c. 1830–31
Watercolor on paper,
4⁷/₈ × 5⁷/₈ in.
(12.4 × 14.9 cm)
Carlisle Museums and Art
Gallery, Carlisle, England

171. Samuel Palmer (1805–1881)
Bright Cloud, n.d.
Brown and blue watercolor
wash and graphite on wove
paper, 5¹⁵/₁₆ × 7¹/₄ in.
(15.1 × 18.4 cm)
Yale Center for British Art,
New Haven, Connecticut;
Paul Mellon Collection

172. Samuel Palmer (1805–1881)
Study of a Garden at Tintern, 1835
Pen and ink, black chalk,
watercolor, and body color on
brownish paper,
14⅝ × 18¹¹/₁₆ in. (37.1 × 47.5 cm)
Ashmolean Museum, Oxford,
England

lost the power of his Shoreham days (indeed, he recaptured it in his late etchings), but, except for an occasional flash of brilliance, his watercolors became more conventional. Like Cotman, he experimented with opaque mediums to make his paintings conform to the taste of the Victorian era, and, like Cotman, he often bemoaned his fate. Still there were, from time to time, watercolors exceptional by any standards but those he had set himself. Some of his Italian subjects are very fine (plates 173 and 174), though they lack the ethereal quality of his Kentish paintings.

Of the other followers of Blake, only Edward Calvert had a poetic vision that bears comparison with Palmer's, and Palmer seems to have regarded Calvert's work more highly than that of any of his contemporaries. Calvert's pagan, hedonistic vision found its fullest expression in printmaking, however, though for one diminutive watercolor alone, *The Primitive City* (plate 175), he deserves a mention in any history of the medium.

Fantasists of a somewhat different order were John Martin and Francis Danby. If Blake's admirers were bent on finding the world in a grain of sand—or at least in the modest folds of a Kentish valley—Martin and Danby were given to apocalyptic

visions painted on a panoramic, even grandiose scale. They were cinematic painters, the forerunners of Cecil B. DeMille.

Martin grew up in poverty near Newcastle upon Tyne and eventually made his way to London, where he was clearly impressed by Turner's early exercises in the epic Romantic idiom. By 1816 he had appropriated this idiom for his own purposes and dazzled the London art world with the spectacularly dramatic *Joshua Commanding the Sun to Stand Still*. There followed other apocalyptic biblical and Miltonian

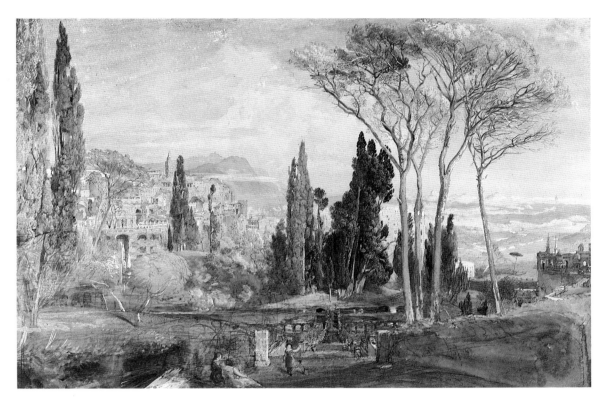

LEFT
173. Samuel Palmer (1805–1881)
View from the Villa d'Este at Tivoli, 1839
Watercolor and body color over
pencil, reinforced with pen
and ink, heightened in gold,
on buff paper,
13³/₁₆ × 19¹³/₁₆ in. (33.5 × 50.3 cm)
Ashmolean Museum, Oxford, England

BELOW, LEFT
174. Samuel Palmer (1805–1881)
The Villa d'Este, 1837
Watercolor and body color on paper,
10³/₄ × 14³/₄ in. (27.3 × 37.5 cm)
Victoria and Albert Museum, London

BELOW, RIGHT
175. Edward Calvert (1799–1883)
The Primitive City, 1822
Watercolor on paper,
3¹/₈ × 4¹/₂ in. (7.9 × 11.4 cm)
British Museum, London

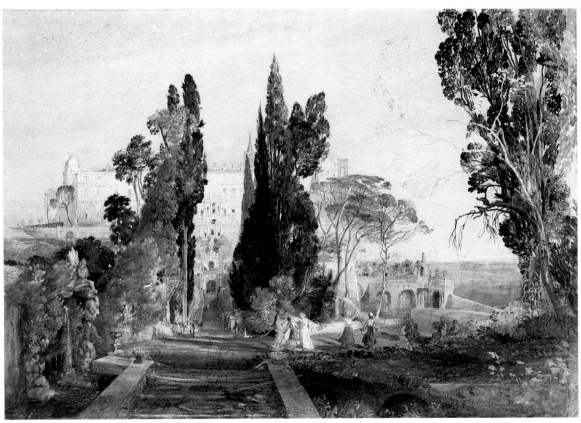

176. John Martin (1789–1854)
Coast Scene and Thunderstorm, n.d.
Watercolor on paper,
6¼ × 9½ in. (15.9 × 24.1 cm)
British Museum, London

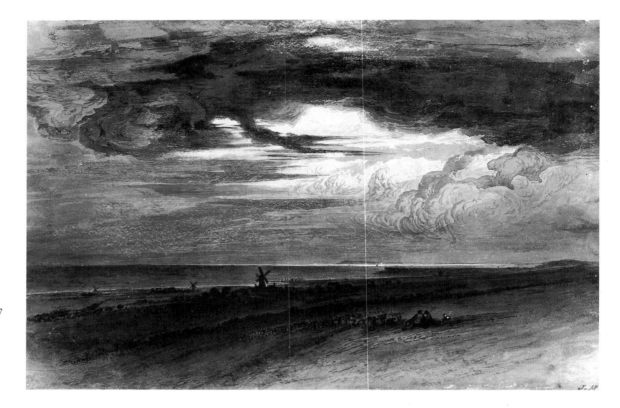

177. John Martin (1789–1854)
Manfred and the Witch of the Alps, 1837
Watercolor on paper,
15¼ × 22 in. (38.7 × 55.8 cm)
The Whitworth Art Gallery,
University of Manchester,
Manchester, England

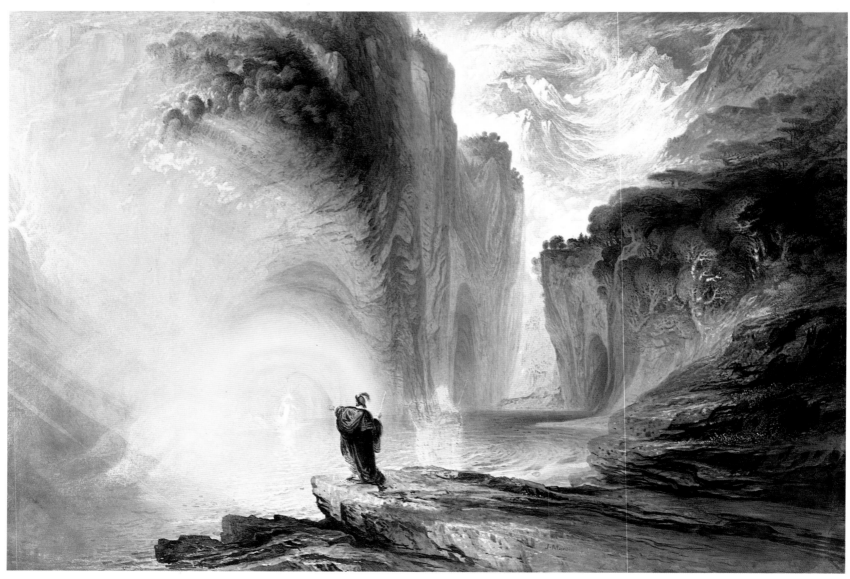

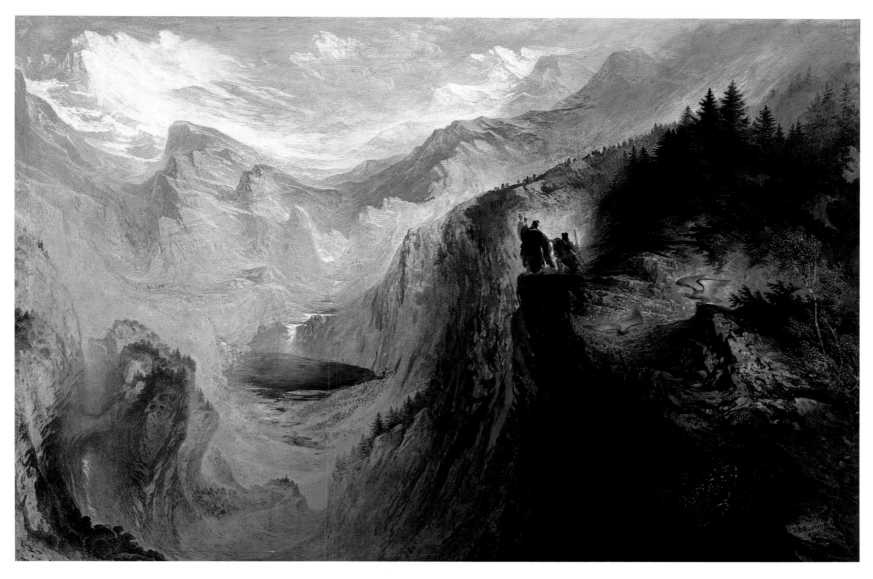

178. John Martin (1789–1854)
Manfred on the Jungfrau, 1837
Watercolor on paper,
15 × 21¼ in. (38.1 × 54 cm)
Birmingham Museum and Art
Gallery, Birmingham, England

subjects, such as *Balshazzar's Feast*, *The Fall of Ninevah*, and *The Deluge*, which earned the artist a European reputation. At the height of the Romantic revolution, Martin was the toast of writers and poets like Sainte-Beuve and Victor Hugo. Indeed, Martin's was somewhat a literary imagination, and his impact on European painters was negligible. They preferred Constable or Bonington.

Martin was often at his best and most painterly when working in watercolor or monochrome wash. Occasionally, he made straightforward landscape studies of great charm; *Coast Scene and Thunderstorm* (plate 176) has an almost Palmeresque cast, with its small scale, its pantheistic lyricism, and its watching shepherds. More typical of his watercolors, however, are his illustrations for Lord Byron's *Weltschmerz*-imbued epic, *Manfred*. *Manfred and the Witch of the Alps* (plate 177) and *Manfred on the Jungfrau* (plate 178) have the panoramic sweep of Martin's grandiloquent oils, but his handling of watercolor is a little freer than his handling of oil. The Turneresque influence has a more authentic feel in the watercolors, though Martin was no match for Turner as a colorist. He was at his most comfortable and most painterly in monochrome wash studies like *Cambyses on His Way to Desecrate the Temple of Jupiter* (plate 179).

Born near Wexford, Ireland, in 1793, Francis Danby settled in Bristol, England, where he first gained recognition as a landscape painter, then turned to visionary spectaculars of the Martin sort, becoming Martin's chief rival. Like that artist, he was often at his best, and certainly at his most personal, when working in

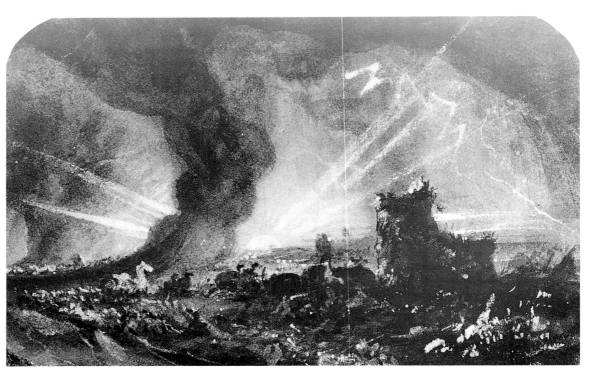

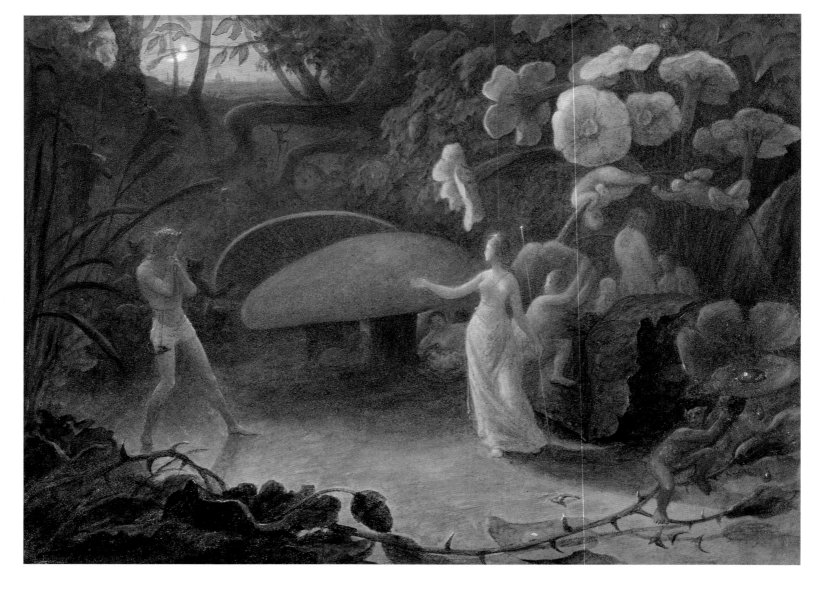

179. John Martin (1789–1854)
*Cambyses on His Way to
Desecrate the Temple of Jupiter*, n.d.
Monochrome wash on paper,
6 × 9⁵/₈ in. (15.2 × 24.4 cm)
Victoria and Albert Museum,
London

180. Francis Danby (1793–1861)
Landscape with Crescent Moon,
c. 1824–29
Watercolor on gray paper,
4¹/₂ × 5 in. (11.4 × 12.7 cm)
British Museum, London

181. Francis Danby (1793–1861)
A Midsummer Night's Dream, n.d.
Watercolor and body color on
wove paper, 6 × 8¹/₄ in.
(15.2 × 20.9 cm)
Yale Center for British Art,
New Haven, Connecticut;
Paul Mellon Fund

182. John Simmons (1823–1876)
Titania (from *A Midsummer
Night's Dream*, Act III, scene
I), 1866
Watercolor on paper,
13¹/₂ × 10¹/₂ in.
(34.3 × 26.7 cm)
City of Bristol Museum and
Art Gallery, Bristol, England

watercolor or monochrome wash. To a greater extent than Martin, he was freed
from grandiosity when confronted with a sheet of paper rather than a canvas. *Land-
scape with Crescent Moon* (plate 180) is a modestly scaled work, but one charged with
more genuine romantic feeling than any of his large oils. As for *A Midsummer
Night's Dream* (plate 181), this is a delightful overture to the fairy painting tradition
that was to be popular in Britain throughout the Victorian period. A later prac-
titioner of the fairy tradition, John Simmons, also turned to *A Midsummer Night's
Dream* for inspiration, displaying a sure touch with the watercolor medium that
belies his relative obscurity (plate 182).

George Cruikshank is best known as the caricaturist who pilloried the future
George IV during the Regency period. That he was James Gillray's greatest suc-
cessor as a political cartoonist is not in question, but satire was only one aspect of

his art, and he was equally at home illustrating the novels of Charles Dickens or the fairy stories collected by the brothers Grimm. Even the scope of these latter illustrations, however, hardly prepares the viewer for the grotesqueries of *A Fantasy* (plate 183), which harks back to the allegories of artists like David Humbert de Superville (plate 107) yet has a freer, more genuinely dreamlike quality. Cruikshank was no romantic, but the Romantic movement left its mark on artists of all persuasions, in some cases putting them in rather direct contact with the wellsprings of the unconscious.

Among the most curious and tragic of nineteenth-century fantasists was Richard Dadd, who studied at the Royal Academy Schools and in his early twenties enjoyed some success with relatively conventional yet already quite personal landscapes, portraits, and elaborate subjects, including a series of illustrations for *Manfred*. In 1842–43 he traveled to the Middle East, and upon his return showed increasing evidence of insanity. He composed a list of people he believed the world could get along without, and he began to implement his plan by murdering and mutilating his father while walking with him in a quiet section of parkland. Before the body was discovered, Dadd escaped to France, but he was soon arrested, having been caught in the act of preparing to slit the throat of a fellow traveler. For the re-

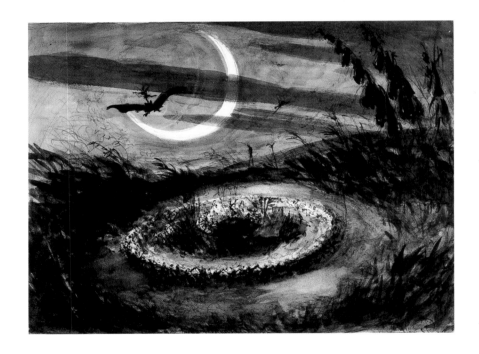

183. George Cruikshank (1792–1878)
A Fantasy, n.d.
Watercolor and body color over pencil on paper, 11¹³/₁₆ × 15⁵/₈ in.
(30 × 39.7 cm)
British Museum, London

184. Richard Dadd (1817–1887)
Fantasy of the Egyptian Harem, 1865
Watercolor heightened with white on pale blue-green paper, 10¹/₁₆ × 7 in.
(25.6 × 17.8 cm)
Ashmolean Museum, Oxford, England

185. Richard Dadd (1817–1887)
The Crooked Path, 1866
Watercolor on paper,
19¹/₂ × 14 in.
(49.5 × 35.6 cm)
British Museum, London

maining forty-three years of his life he was incarcerated, and during this period of confinement he produced an extraordinary body of work, much of it in watercolor and often more or less fantastic in character.

Fantasy of the Egyptian Harem (plate 184) is clearly a consequence of Dadd's journey to the Middle East, though it was painted more than twenty years after his return and probably owes as much to imagination as to memory. *The Crooked Path* (plate 185) is typical of the kind of elaborate allegorical themes Dadd tackled during his madness. He also painted many highly detailed fairy scenes—usually in oil—

186. Richard Dadd (1817–1887)
Port Stragglin', 1861
Watercolor on paper, 13⅝ × 7½ in.
(34.6 × 19.1 cm)
British Museum, London

187. Richard Doyle (1824–1883)
Girls Combing Beards of Goats, n.d.
Watercolor on paper, 5⅝ × 9¾ in.
(14.3 × 24.8 cm)
British Museum, London

OPPOSITE, CLOCKWISE FROM TOP RIGHT
188. Walter Crane (1845–1915)
Butterflies' Ball, n.d.
Pen and ink and watercolor on paper,
9⁷⁄₁₆ × 6⅝ in. (24 × 16.8 cm)
British Museum, London

189, 190. Beatrix Potter (1866–1943)
The White Rabbit, c. 1895
Watercolor on paper, each image
4¼ × 3⁹⁄₁₆ in. (10.8 × 9 cm)
The Linder Collection, National Book
League, London

191. Arthur Burdett Frost (1851–1928)
Br'er Rabbit, c. 1890
Watercolor over pencil sketch on paper,
14¾ × 10¾ in.
(37.5 × 27.3 cm)
Sterling and Francine Clark Art Institute,
Williamstown, Massachusetts

but his finest works transcend the literary elements that too often afflict fantasists, as is the case with *Port Stragglir.'* (plate 186), probably Dadd's best-known watercolor. Like most of his watercolors, this painting displays a delicacy of touch, with a love of detail and an intensity of vision uniquely his. In addition, this particular example also possesses a sense of atmosphere, expressed through aerial perspective, that makes it especially successful.

In the second half of the century, the vein of fantasy—though it continued to be mined by the Pre-Raphaelites (see Chapter 8)—became largely the province of illustrators, many of whom were talented watercolorists. It is not known what—if any—tale Richard Doyle was illustrating when he painted *Girls Combing Beards of Goats* (plate 187), and the lack of contextual information makes the image all the more powerful and intriguing.

A more fey approach is found in Walter Crane's *Butterflies' Ball* (plate 188), an unpublished drawing that anticipates, in some ways, the cartoon imagery of the Walt Disney "Silly Symphonies." Influenced by the Pre-Raphaelites and William Morris, Crane had a solid sense of design and enjoyed some of his most notable successes as an illustrator when working for the children's book publisher Edmond Evans. An even greater children's book illustrator was Beatrix Potter. Her finest achievements were to come in the twentieth century, but her early work is often quite remarkable, as is the case with twin images of the White Rabbit from *Alice in Wonderland* (plates 189 and 190), which are made all the more powerful by the forced perspective of the corridors, a device that looks forward, however ingenuously, to de Chirico and the Surrealists.

A very different rabbit is found in Arthur Burdett Frost's "Br'er Rabbit" illustrations (plate 191). Here the anthropomorphism of *Alice in Wonderland* has been transported across the Atlantic and grafted onto allegorical fantasies plucked by Joel Chandler Harris from Afro-American folklore. Br'er Rabbit's briarpatch is a long way from Blake's vision of Heaven and Hell, but not so far, perhaps, from Palmer's rustic paradise. There is no place for bears in Palmer's world, and maybe no tar babies, but wily foxes and wilier rabbits would feel right at home.

SIX

European Contributions

192. Giacinto Gigante
Approach from the Land to the Casa dei Spiriti, A Walk from Naples, c. 1832
Detail of plate 224

By the time Louis-Philippe was driven from power—and from France—by the insurrection of 1848, watercolor had taken secure root in France and throughout Europe. No longer a British novelty, it was taken up—and often taken for granted—by artists of every persuasion. Some, to be sure, had a sense of the medium's already-strong tradition and built upon British models, modifying them to suit their own needs. Others, however, were less concerned with tradition than convenience, using watercolor as the basis for a personal shorthand or, at the other extreme, as an alternative to oil paint for highly finished work. Often, artists felt free to mix watercolor with other media, especially gouache.

Antoine-Louis Barye is best remembered as a sculptor of animals, a genre popular during the nineteenth century. Not surprisingly, he made hundreds of studies on paper, often employing watercolor or a blend of watercolor and body color. For Barye, these works were essential but secondary components of his *oeuvre*. He was not performing for the public when he made them, but for himself; they belong to that category of watercolor in which the viewer can enjoy the sensation of entering the artist's mind and sharing in the creative process. They have an improvisational fluidity that has justly made them much admired in recent years.

Vultures on Tree (plate 193) is densely painted on a toothy paper, and it seems evident from the freedom of attack that Barye painted this with a great deal of enjoyment. Much the same applies to *Tiger Rolling on Its Back* (plate 194), in which the sinuous line seems almost casual and yet describes superbly the torque of the animal's body, its powerful musculature. This time a landscape background is provided, presumably an imaginary one, since it seems certain that Barye sketched this tiger in the zoological section of the Jardin des Plantes in Paris. Even the landscape depends largely upon linear energy, and it is clear that Barye was a master of drawing with the brush.

At the other extreme, in terms of approach to watercolor, is Ingres's late *Odalisque* (plate 195), in which the pencil brilliantly defines outline, while the paint is

RIGHT

193. Antoine-Louis Barye (1795–1875)
Vultures on Tree, n.d.
Watercolor on paper,
10¹¹/₁₆ × 15⅛ in. (27.1 × 38.4 cm)
The Metropolitan Museum of Art, New York;
The H. O. Havemeyer Collection, Bequest of
Mrs. H. O. Havemeyer, 1929

BELOW

194. Antoine-Louis Barye (1795–1875)
Tiger Rolling on Its Back, n.d.
Watercolor and gouache on paper,
9¹/₁₆ × 11½ in. (24.5 × 29.1 cm)
The Metropolitan Museum of Art, New York

OPPOSITE

195. Jean-Auguste-Dominique Ingres (1780–1867)
Odalisque, 1864
Watercolor on paper, 13⅝ × 9¼ in. (34.6 × 23.5 cm)
Musée Bonat, Bayonne, France

OPPOSITE

196. Louis Crapelet (1823–1867)
Entrance to a Cairo Mosque, 1853
Watercolor on paper,
10⅝ × 7½ in.
(27.1 × 19.3 cm)
Musée du Louvre, Paris

RIGHT

197. Jean-Léon Gérôme
(1824–1904)
The Old Arab, n.d.
Watercolor on paper,
11¾ × 9¼ in.
(29.8 × 23.5 cm)
Yale University Art Gallery,
New Haven, Connecticut;
Everett V. Meeks Fund

used to provide local color, to help define planes, and to pick out detail. As with most of the best of Ingres's harem subjects, a certain mystery pervades the image, probably because of the placement of the foreground figure, with her back to the artist, blocking the view, so that the spectator is cut off from the action around the pool. Ingres makes effective use of stippling and uses local color to create pattern in a way that looks forward to the methods Matisse would sometimes employ when dealing with similar subject matter.

Orientalism was still very much in vogue in France, as elsewhere, and Louis Crapelet's *Entrance to a Cairo Mosque* (plate 196) is an example of the naturalistic approach to Eastern subject matter. Well known as a stage designer, Crapelet had studied with Corot, whose influence is apparent in the directness and lack of fuss Crapelet brings to his subject. The theatricality that might be anticipated from a stage designer is entirely absent. Jean-Léon Gérôme's *The Old Arab* (plate 197) is

198. Victor Hugo (1802–1885)
View of a German Town, 1866
Pen and ink, gray and brown
wash, and watercolor on
paper, 12³⁄₈ × 19³⁄₈ in.
(31.4 × 49.2 cm)
Musée du Louvre, Paris

also naturalistic in its approach, but this is the naturalism of the academy, the sound
draftsmanship being matched by an attention to detail that permits the artist to
lavish as much effort on the tiles behind the sitter as upon the sitter himself. In
paintings like this the suggestive and evocative possibilities of watercolor are en-
tirely abandoned in favor of precise description, but the luminosity of the medium
still lends the subject a glow unobtainable in any other way.

Playwright, novelist, and author of one of the great bodies of French poetry,
Victor Hugo was a towering figure of nineteenth-century literature and among the
greatest representatives of the late Romantic movement. He was also a draftsman of
considerable ability, who covered thousands of sheets with drawings that sometimes
have the kind of dredged-from-the-unconscious spontaneity associated with Goya.
In particular, he was capable of investing architecture with an emotional charge, as
might be expected from the recreator of the medieval Paris of *The Hunchback of Notre
Dame*. He was drawn to the exotic side of historical material, and *View of a German
Town* (plate 198) is typical of the kind of Gothic fantasy to be met with in his
graphic work. Basically, like much of his *oeuvre*, this is a wash drawing, but in this
instance watercolor is used effectively to pick out highlights.

If Hugo was the ultimate radical—exiled to the island of Guernsey for his anti-
Royalist views—Henri Baron was a pillar of the establishment. Baron made his Sa-
lon debut in 1837 and had gained a considerable following on the strength of period
pieces that made a virtue of blending elegant players with exotic settings. *An Official
Fête at the Palais des Tuileries during the World Exposition of 1867* (plate 199) was com-
missioned by the Empress Eugénie and is an example of an elaborate set-piece
watercolor in the "official" style—skillfully executed, though Baron lacked the flair
that Eugène Lami brought to similar subjects (plate 134).

An artist of an altogether higher caliber was Honoré Daumier, the greatest cari-
caturist of the century and a master of several mediums. As a watercolorist, and in
most other areas, he was wholly his own man, able to set his vision down with a
directness and fluency that had no need of trickery or calculated effects. Like Barye,

199. Henri Baron (1816–1885)
An Official Fête at the Palais des Tuileries during the World Exposition of 1867, 1867
Watercolor on paper,
21⁵/₈ × 37⁷/₁₆ in. (55 × 95 cm)
Musée National du Château, Compiègne, France

200. Honoré Daumier (1808–1879)
Man Reading in a Garden, n.d.
Wash drawing on paper,
13¹⁵/₁₆ × 10⁵/₈ in.
(35.4 × 27 cm)
The Metropolitan Museum of Art, New York; The H. O. Havemeyer Collection, Bequest of Mrs. H. O. Havemeyer, 1929

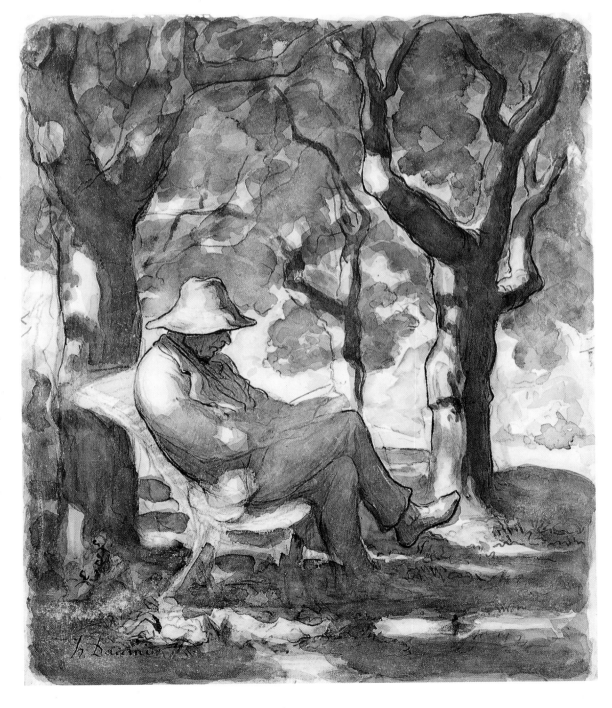

he was a master of drawing with the brush—often over a charcoal or crayon drawing—but his expressive range was much wider, and he had the knack of using brush drawing to help create vivid contrasts of light and shade, manipulating thickness and density of line to supplement boldly laid-in washes and build up a distinctive kind of chiaroscuro that was one of his trademarks.

Daumier is thought of as a satirist and social commentator, which of course he was, but in such watercolors as *Man Reading in a Garden* (plate 200) he belies his reputation by creating an idyllic scene dappled with sunlight. This painting demonstrates that his plastic gifts were not in any way dependent on the humorous, literary context that enlivens so much of his work. It was his genius as a caricaturist that he was able to build upon his purely plastic skills in such a way as to express the personalities of the attorneys, connoisseurs, and petits bourgeois who inhabit his work. Often his satire was barbed, yet he never dehumanized his subjects and often presented them with unexpected sympathy, as is the case with *A Pleading Lawyer* (plate 201). As a painter, Daumier was, in fact, very much a realist of Courbet's generation who understood that an honest, unvarnished treatment of a given subject was often more effective than the kind of exaggeration that conventional satirists and caricaturists were prone to. *The Butcher* (plate 202) does not make a great to-do

201. Honoré Daumier (1808–1879)
A Pleading Lawyer, n.d.
Watercolor, pen and ink, and gouache on paper,
6¼ × 8½ in. (15.9 × 21.6 cm)
The Armand Hammer Museum of Art and Cultural Center, Los Angeles; The Armand Hammer Collection

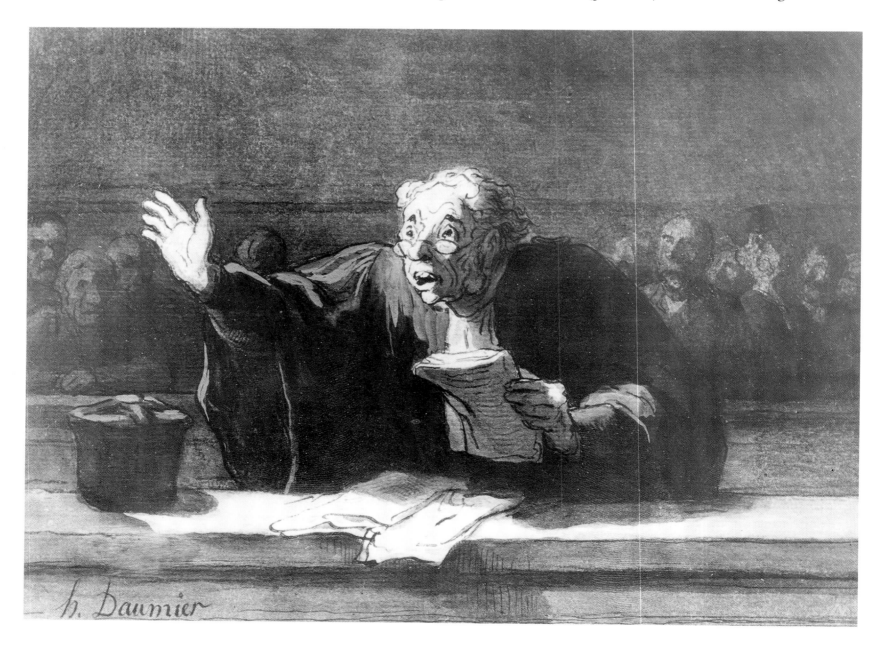

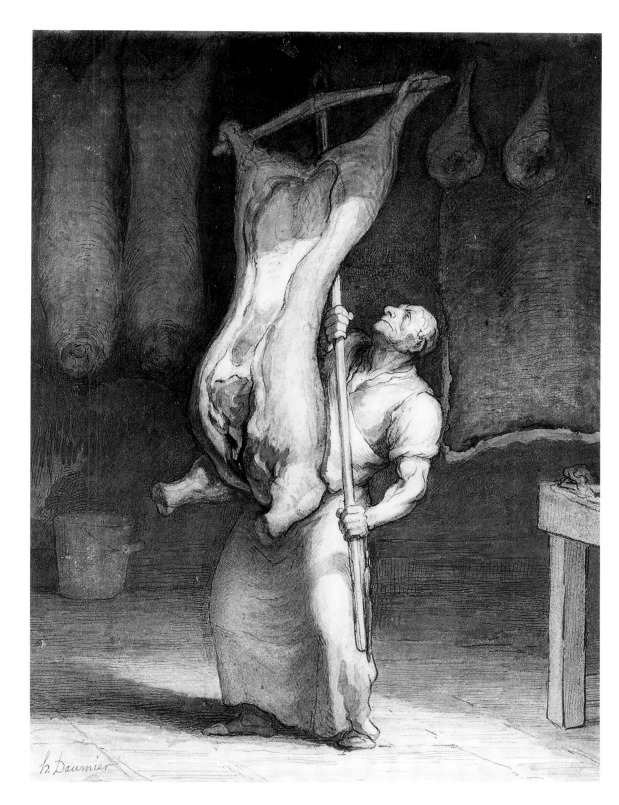

202. Honoré Daumier (1808–1879)
The Butcher, n.d.
Watercolor, pen and black ink,
graphite, and black crayon on
cream wove paper,
13¹/₁₆ × 9¹/₂ in.
(23.8 × 32.4 cm)
Fogg Art Museum,
Harvard University,
Cambridge, Massachusetts;
Bequest of Grenville L.
Winthrop

about the cruelties of the abattoir, but rather shows a hardworking butcher about
his business. If the carcass he is carrying reminds the viewer of a crucifixion,
Daumier is far too subtle to hammer the point home. *The Butcher*, incidentally, is a
good example of Daumier's use of watercolor in combination with other media. Al-
though a master of brush drawing, he was equally comfortable establishing an
image with charcoal, chalk, crayon, or pen and ink. Whatever the beginnings, how-
ever, he would use the brush to reinforce the linear underpinning.

Spectators (plate 203) is a "beginning" that gives the viewer an opportunity to
see how Daumier built his images, working from line to wash to brush drawing, so

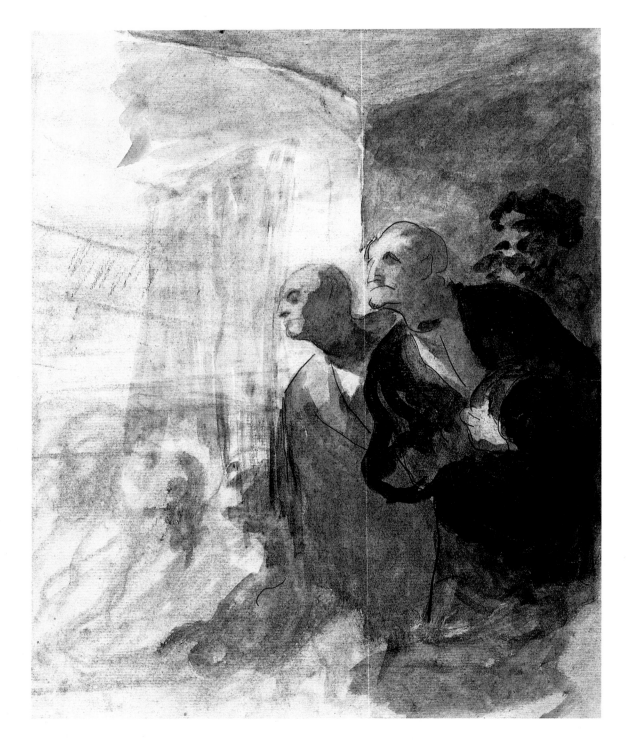

that the image is made concrete while its linear, descriptive energy is amplified. *The Amateur* (plate 204) is a very finished example of Daumier at his most typical. His satire is never obscure, and here the self-satisfaction of the connoisseur is captured in every particular of the man's pose and expression. Yet Daumier does not dehumanize this subject. His literary cousins are Balzac and Sterne rather than Voltaire and Swift.

Gustave Doré is best known as a book illustrator with fantastic leanings, but he, too, had a strong bent for caricature and, especially during a prolonged stay in London, sometimes displayed a gift for cogent social commentary. Watercolor was not a primary medium for Doré, but *London Fish Seller* (plate 205) demonstrates that he could handle it with considerable dexterity and, perhaps more surprising, with a fine sense of color. The Dickensian scene is conjured up with free brushwork and features a palette in which warm reds and cool blues are effectively contrasted.

205. Gustave Doré (1833–1883)
London Fish Seller, 1877
Watercolor, pen and ink, and
pencil on paper,
13¹/₁₆ × 18¹⁵/₁₆ in. (33.3 × 48.2 cm)
Musée du Louvre, Paris

OPPOSITE, CLOCKWISE FROM
TOP LEFT

206. Jean-François Millet (1814–1875)
*Peasant Woman Carrying a Jug of
Water*, c. 1857–58
Pen and ink, wash, and
watercolor on paper,
10¹/₂ × 13¹/₂ in. (26.7 × 34.3 cm)
Musée du Louvre, Paris

207. Jean-François Millet (1814–1875)
Cottages Among Trees, c. 1866
Watercolor and pen and ink on
paper, 7⁷/₈ × 10³/₁₆ in.
(20 × 25.9 cm)
Musée du Louvre, Paris

208. Henri-Joseph Harpignies
(1819–1916)
River Landscape, 1876
Watercolor on paper,
9¹¹/₁₆ × 8⁹/₁₆ (24.6 × 21.7 cm)
Musée Fabre, Montpellier, France

Another artist with strong social concerns was Jean-François Millet, best
known for peasant paintings such as *The Gleaners* and *The Angelus*. In his water-
colors he stayed with rustic themes but often displayed a lyricism that surpassed
anything found in his oils. *Peasant Woman Carrying a Jug of Water* (plate 206) is a typi-
cal Millet subject, and the foreground figure is finely drawn, but what is most
personal about the image is the landscape background, which is brushed in with
great delicacy, displaying an almost Oriental feeling for nature. *Cottages Among Trees*
(plate 207) is really a colored drawing, but is handled loosely so that it displays a
refreshing informality.

A fine landscapist was Henri-Joseph Harpignies, who was born in 1819, the
year Bonington arrived in Paris, and lived until 1916, the year dada was inaugurated
in Zurich. From the middle years of the nineteenth century to the end of his life he
produced modest landscapes that owed a debt to Corot and the British School yet
remained remarkably fresh while managing to avoid all taint of progressive influ-
ences. Harpignies worked extensively in oil, but it is his watercolors—little known
in his lifetime—that have the greatest appeal for the modern viewer.

River Landscape (plate 208) is typical of his watercolor style, a simple and bold
composition saturated with the dark tones he used so well. Certainly, Harpignies
was no innovator, yet he had an understanding of the basic power of the medium
that sets him apart from most of his contemporaries, and he employed that under-
standing with a personal inflection that makes his work immediately recognizable.
In particular, he describes with wristy calligraphy, builds with cleanly applied
washes, and relies compositionally on strongly defined tonal contrasts, making
good use of the support, both to create luminosity and to provide texture.

An artist who had something in common with both Millet, whom he admired,
and Harpignies was Anton Mauve, the Dutch painter who was to have a consider-
able influence on his wife's younger cousin Vincent van Gogh. A member of the
Hague School, Mauve painted small, modest landscapes and genre scenes. Some of

209. Anton Mauve (1838–1888)
The Sale of Timber, c. 1881
Watercolor and gouache on
paper, 13³/₁₆ × 19¹³/₁₆ in.
(33.5 × 50.3 cm)
Museum H. W. Mesdag,
The Hague

his oils are informed by the same silvery light that is found in many of Harpignies's
oils, and the sureness of touch he brought to his watercolors bears a relationship
with Harpignies's technical approach. In choice of subject matter, however, it is the
Millet influence that is more apparent, and *The Sale of Timber* (plate 209) reflects
this, though Mauve's peasants are more particularized, less archetypal.

By mid-century a significant watercolor school had evolved in Austria. One of
its pioneers was Jakob Alt, who was born in Frankfurt but settled in Vienna in
1811, at the age of twenty-two. Like most German and Austrian watercolorists of
his generation, Alt was not—by British or French standards—especially painterly,
but instead constructed crisp, sharply focused images in which the artist's hand is
subjugated to the overall vision. His approach tended toward the academic, but he
never permitted detail to overwhelm the larger concept.

More gifted was Jakob's son Rudolf von Alt, who often worked closely with
his father but developed a highly personal style, as spontaneous as his father's was
controlled. His method, as described by Walter Koschatzky, was a kind of "drawing
in watercolor," in which he began by painting "isolated points of crystallization,
leaving the rest of the paper blank, and juxtaposing dark and light color contrasts
without any intermediary shades."[1] Instead of unifying the entire sheet by laying in
margin-to-margin washes, then gradually building up the primary shapes and
masses, von Alt would begin by focusing on these primary shapes and masses,
often painting them individually, before concerning himself with pulling the
entire composition together.

That, at least, was the method of his mature period. Early works, such as *The
Graveyard of St. Peter's Church in Salzburg* (plate 210), employ a more conventional
approach, though this painting shows the sure touch von Alt possessed from the
beginning. The feel is loose and casual, the scene described with an easy, callig-
raphic touch. Certainly, this is a highly accomplished work for a seventeen-year-
old, but it lacks the originality of *The Anio Gorge near Tivoli* (plate 211), painted six
years later. In this striking work, it is possible to see how separate elements—the

210. Rudolf von Alt (1812–1905)
*The Graveyard of St. Peter's
Church in Salzburg*, 1829
Watercolor on paper,
6¹¹⁄₁₆ × 9½ in.
(17 × 24.1 cm)
Akademie der Bildenden
Kunste, Vienna

211. Rudolf von Alt (1812–1905)
The Anio Gorge near Tivoli, 1835
Watercolor on paper,
13⅛ × 10¼ in.
(33.3 × 26 cm)
Graphische Sammlung
Albertina, Vienna

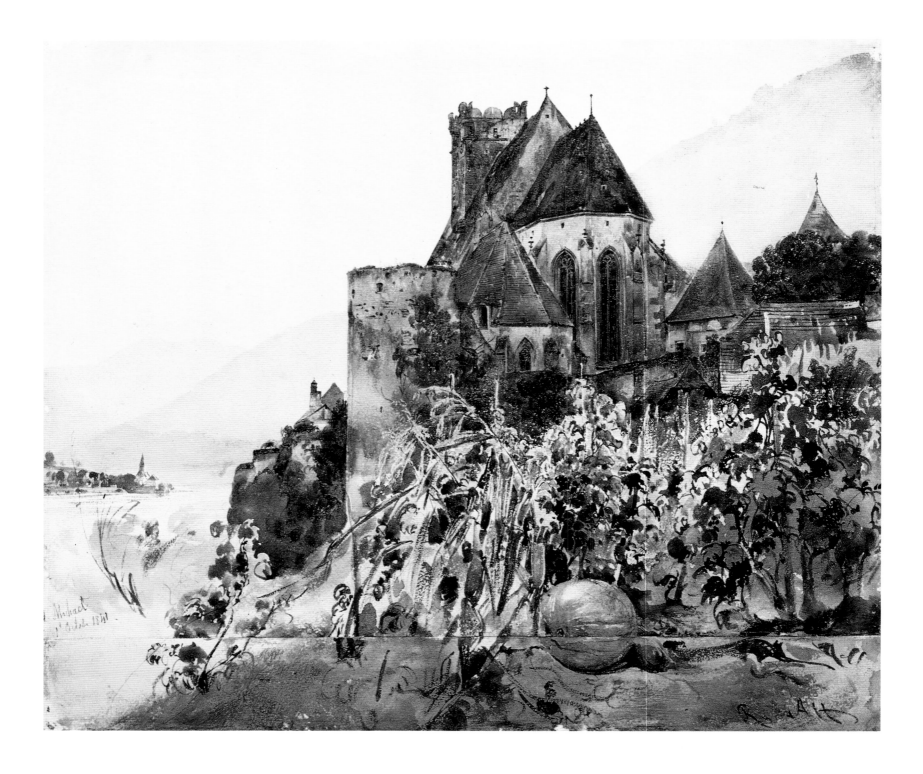

212. Rudolf von Alt (1812–1905)
St. Michael's Church, Kirche, 1841
Watercolor on paper,
12⁷⁄₁₆ × 14⁹⁄₁₆ in.
(31.5 × 37 cm)
Niederösterreichisches
Landesmuseum, Vienna

central rock formation, for example—have been painted almost in isolation, then fitted together rather as if the artist were assembling a jigsaw puzzle. This method had the virtue of emphasizing his practice of using luminous outlines, defining the edge of forms by letting linear slivers of pale underwash show through, a technique that was especially effective in representing sunlit scenes.

Von Alt traveled extensively in Austria and Italy, painting such subjects as *St. Michael's Church, Kirche* (plate 212). His career reached into the twentieth century, and he was so well regarded in Austria, even by the young rebels, that in the 1890s he was elected to preside over the avant-garde Vienna Secession.

A noteworthy watercolorist of Jacob Alt's generation was Thomas Ender, who was instrumental in introducing the freedom of technique and lack of artifice characteristic of the British School to Vienna. He was well known in his day for the

paintings he brought back from a government-sponsored expedition to Brazil, but his Austrian landscapes, such as *The Ruins of Durnstein Castle* (plate 213), show him at his best.

A nationalistic streak is found in the work of the Swiss artist Ludwig Vogel. Associated with the Nazarene group, and best known for his historical paintings depicting great moments from the Swiss past, Vogel made many watercolor studies, often of subjects to be incorporated into his salon paintings. *Valeria Castle, Near Sion* (plate 214) is a typical example of his approach, a handsome painting, if a little stiff, with line doing much of the descriptive work. A freer approach to watercolor is found in the work of Ernst Fries (plate 215), a German who forged a distinctive style of romantic naturalism before dying young.

Gottlieb Biedermeier was an imaginary character who began to crop up in humorous literature around the second decade of the nineteenth century and gave his name to a style of art and decoration that thrived in Germany and Austria from approximately the Congress of Vienna (1814–15) to the time of the revolutions that swept through Europe in 1848. Herr Biedermeier was honorable, upright, and decidedly ludicrous, a philistine with strong views about good and bad taste, a Teu-

213. Thomas Ender (1793–1875)
The Ruins of Durnstein Castle, 1837
Watercolor on paper,
8 × 10¹¹/₁₆ in. (20.5 × 27.5 cm)
Niederösterreichisches
Landesmuseum, Vienna

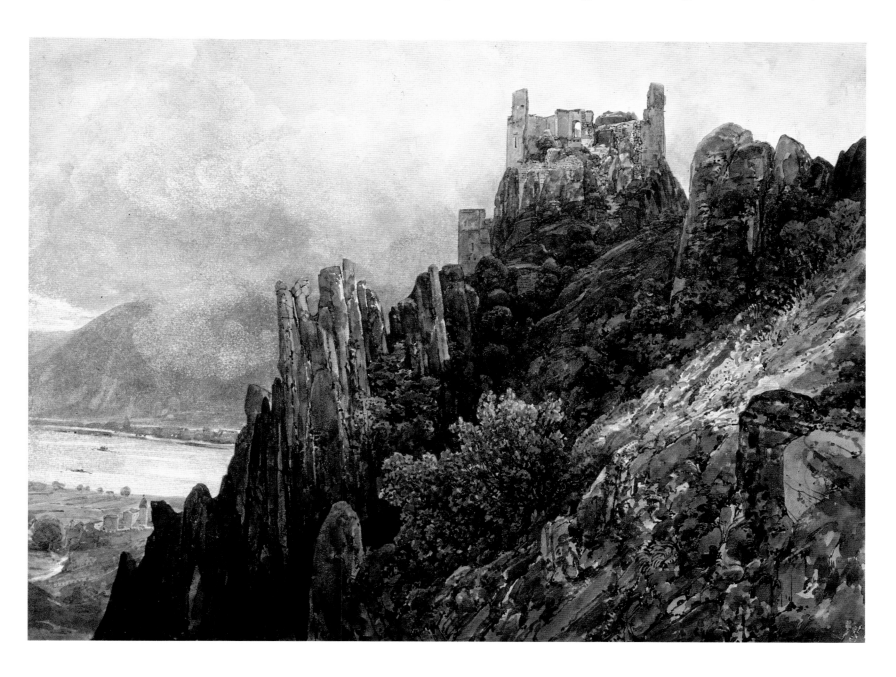

RIGHT
214. Ludwig Vogel (1788–1879)
Valeria Castle, Near Sion, c. 1830
Pencil and watercolor on paper,
9¼ × 16¾ in. (23.5 × 42.5 cm)
Schweizerishes Landesmuseum, Zurich

BELOW
215. Ernst Fries (1801–1833)
The Park of the Villa Chigi, Arricia, c. 1824
Watercolor over pencil on ivory paper,
15⁵/₁₆ × 21 in. (38.9 × 53.3 cm)
Staatliche Kunsthalle Karlsruhe,
Kupferstichkabinett, Karlsruhe, Germany

OPPOSITE, TOP
216. Johann Grund (1808–1887)
Portrait of the Artist's First Wife, 1831
Watercolor on paper, 5³/₈ × 4³/₈ in.
(13.7 × 11.1 cm)
Staatliche Kunsthalle Karlsruhe,
Kupfertichkabinett, Karlsruhe, Germany

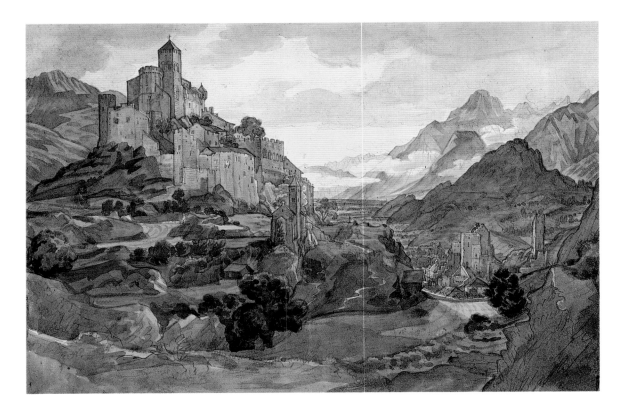

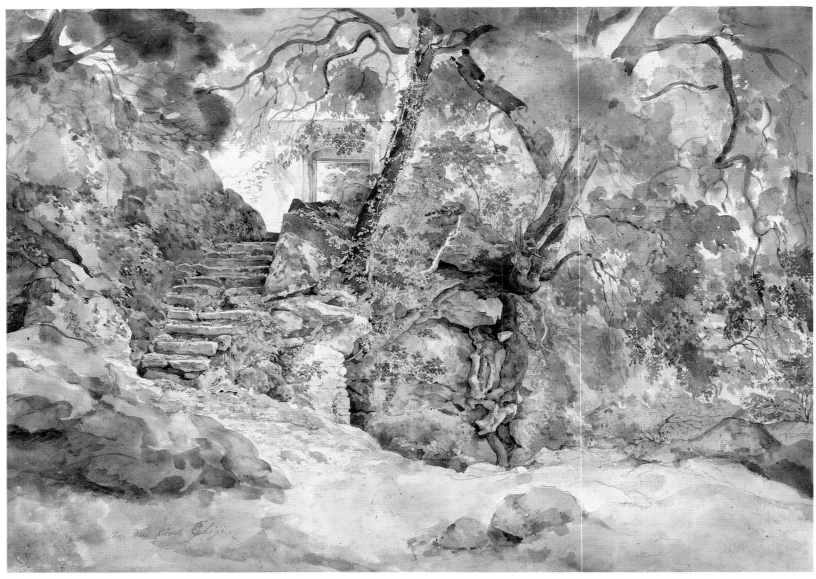

tonic cousin of Daumier's bourgeois connoisseurs, though without their greedy lust for possessions. (Not that Herr Beidermeier was indifferent to possessions, but he was far too buttoned-up to gloat over them.) The art that bears his name is worthy, beautifully crafted, resolutely bourgeois, and, perhaps oddly, often quite charming.

A well-known portraitist of the Biedermeier period was Johann Grund, who was born in Vienna and studied there but spent the latter part of his career in Karlsruhe. His watercolor and gouache portrait of his first wife (plate 216) is one of his most delightful works, an affectionate likeness of a young woman whose ambiguous smile would have intrigued Leonardo. The face and the elaborate pile of hair are highly finished, while the sitter's costume is sketched in with a few rapid strokes, yet the whole reads consistently. At his best, Grund was capable of transcending Biedermeier taste.

Joseph Danhauser, on the other hand, personified all that was Viennese Biedermeier, being especially well known for paintings in which the fashions and manners of the period are the real subjects. Some of his watercolors, such as *Girl in a Poke Bonnet* (plate 217), have a period grace that holds up well.

Danhauser was to some extent a follower of Peter Fendi, who began his career by copying antique coins in the Hapsburg Imperial numismatic collection. Later, he went on to paint portrait groups of aristocratic and *haute-bourgeois* sitters in genre settings (plate 218). Nothing could be more conventional and proper than Fendi's watercolors. There is none of the dash and rakish sophistication that infects Eugène Lami's sometimes similar subjects (plate 133). Fendi is totally uncritical, offers no comment, takes his sitters totally at their own self-evaluation. What saves his watercolors from being just saccharine caricatures of Biedermeier taste is his sure eye and his ability to lay down notably fresh, glowing washes.

A very different artist, and a bravura performer in oils, pastels, and gouache, as well as watercolor, was Adolf von Menzel, who, during a long career, was best known as an illustrator and as the author of a series of large paintings presenting incidents from the life of Frederick the Great, paintings that enjoyed great popularity

219. Adolf von Menzel
(1815–1905)
Sled and Team of Horses, 1846
Watercolor on paper,
6⁵/₁₆ × 10³/₁₆ in.
(16.1 × 25.9 cm)
Staatliche Museen,
Nationalgalerie, Berlin

in Bismarck's Prussia. Privately, however, he practiced a much more informal kind of art that seems to have been inspired by his exposure to Constable's sketches, some of which had been exhibited in Berlin in 1839. As a consequence of this, von Menzel made some oils now considered to be prophetic of Impressionism. He also began to make scores of studies either in watercolor or in a blend of watercolor and body color.

Sled and Team of Horses (plate 219) is a brilliant sketch, executed with evident rapidity. The impression given is that this sled paused for a few moments under von Menzel's studio window, and he committed it to paper before it hurried off. It is the quickest of sketches, yet all of von Menzel's virtuosity is present. Though no larger than *Sled and Team of Horses*, *In the Zoo* (plate 220) is a much more highly finished painting that demonstrates how von Menzel was capable of maintaining a feeling of freshness even when supplying a good deal of anecdotal detail.

Although Italy, from the eighteenth century, was host to scores of major watercolorists—visiting from England, Germany, Austria, Switzerland, France—it developed no strong watercolor tradition of its own to succeed the gouache tradition of the eighteenth century. Mariano Fortuny y Carbó was Spanish by birth but Italian by adoption, having studied in Rome, and he did build somewhat on the eighteenth-century tradition, as exemplified by Francesco Zuccarelli and Giovanni Battista Lusieri (plate 7), while bringing in a mid-nineteenth-century flair. His gouaches, such as *Toreador* (plate 222), display considerable virtuosity. He was also capable of working effectively in transparent color, as can be seen from *Italian*

220. Adolf von Menzel (1815–1905)
In the Zoo, n.d.
Watercolor on paper,
8³⁄₈ × 10¹⁄₈ in. (21.3 × 25.7 cm)
Staatliche Museen,
Nationalgalerie, Berlin

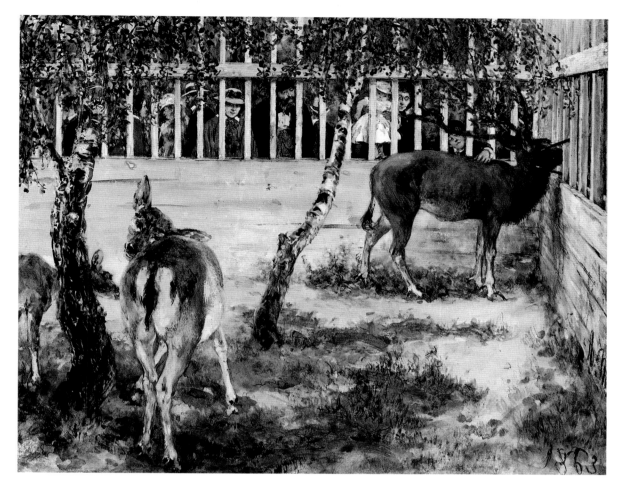

RIGHT
221. Mariano Fortuny y Carbó
(1838–1874)
Italian Woman, 1858
Watercolor over graphite
underdrawing on wove paper,
10 × 4¹⁵⁄₁₆ in. (25.5 × 12.6 cm)
The Fine Arts Museums of
San Francisco; Achenbach
Foundation for Graphic Arts,
Gift of M. H. de Young
Family to the M. H. de Young
Memorial Museum

FAR RIGHT
222. Mariano Fortuny y Carbó
(1838–1874)
Toreador, 1869
Gouache with pen and ink on
heavy white wove paper,
10 × 7 in. (25.4 × 17.8 cm)
Sterling and Francine Clark
Art Institute, Williamstown,
Massachusetts

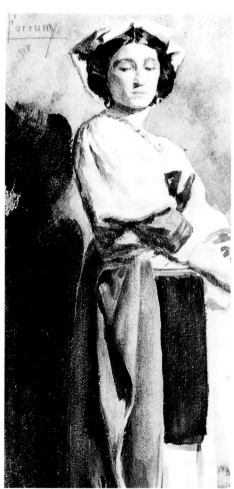

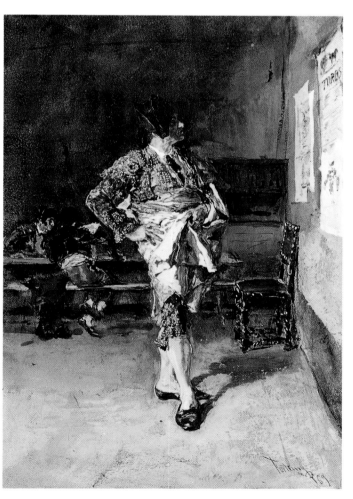

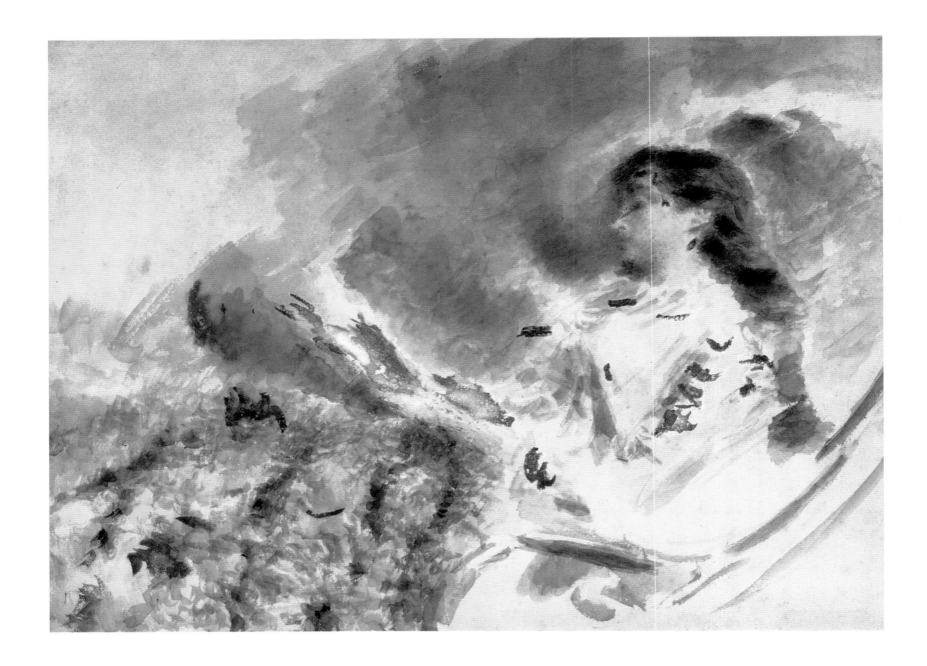

223. Domenico Ranzoni (1843–1889)
The Princess St. Leger on a Couch, n.d.
Watercolor on cardboard,
15¹/₂ × 21 in.
(39.4 × 53.3 cm)
Civica Galleria d'Arte Moderna, Raccolta Grassi, Milan

Woman (plate 221). Later in the century, fashionable Italian portraitists sometimes used watercolor, as in Domenico Ranzoni's impressionistic *The Princess St. Leger on a Couch* (plate 223), built from expressive dabs of wash with much good use made of the white of the support.

By far the greatest Italian watercolorist of the nineteenth century, however, was Giacinto Gigante, a major figure who, because he worked in relative obscurity, was not much known outside the Naples area and remains underappreciated today, probably because he had no natural successors to keep his name and work in the public eye. Indeed, had he not attracted the attention of British visitors to Naples, he might have been forgotten entirely—though Gigante is so good it's difficult to imagine this happening.

Born in Naples in 1806, Gigante lived there all his life, working for the Royal Topography Office, which enabled him to travel and paint throughout the region. He became associated with the so-called School of Posilipo, a group of landscapists that first came to modest prominence because of the paintings of Anton Simmick Pitloo, a Dutch-born artist long resident in Naples. Gigante's oil paintings are competent but unexceptional examples of the prevailing Neapolitan style. As a water-

colorist, however, he had a natural feel for the medium, a gift that seems to have been set free by exposure to Turner's work, possibly on an 1828 visit to Rome, and conceivably through exposure to other English watercolorists. His contact with British connoisseurs, like Lord Napier, makes this likely, but the evidence of the paintings themselves is just as compelling.

Approach from the Land to the Casa dei Spiriti, A Walk from Naples (plate 224) presents an interesting vertical composition that is enlivened by a sense of atmosphere—most immediately apparent in the sky—suggesting British anteced-ents, since it is precisely these kinds of poetic atmospherics that distinguish the

224. Giacinto Gigante (1806–1876)
Approach from the Land to the Casa dei Spiriti, A Walk from Naples, c. 1832
Watercolor on paper,
9³/₈ × 6⁵/₈ in. (23.8 × 16.8 cm)
The Pierpont Morgan Library, New York; Gift of De Coursey Fales

British School beginning with Cozens. *View of Lake Averno* (plate 225) is also atmospheric, though there is perhaps more emphasis on conveying information (Gigante's job at the topography office should not be forgotten), and chalk line is permitted to do a good deal of the work.

View of Capri, also known as *The Amalfi Coast* (plate 227), is a fully realized painting that displays Gigante's complete command of the medium. While sky, land, and sea are treated as almost equal horizontal bands, the distribution of light and shadow breaks up the symmetry and makes for a powerful composition. The handling, which combines transparent color with body color, is supremely confident, with detail being suggested rather than belabored. The surface of the water is described with a deftness worthy of the finest British masters.

A drawing with Mount Vesuvius in the background (plate 226) shows Gigante working exclusively with monochrome wash. The view is one that was very familiar to him, the house in the right foreground being his family home. Clearly, Gigante was a watercolorist who could do just about anything he pleased, without ever submerging his personality in effort or technique. He was not an innovator, perhaps, but he was an original, and his feeling for the medium was uncanny, earning him a place in the front rank of nineteenth-century watercolorists.

The Victorian Age

228. Charles Edward Holloway
On the East Coast, n.d.
Detail of plate 242

It is difficult to grasp, from a late-twentieth-century point of view, just how far-reaching the watercolor revolution was in nineteenth-century Europe and America, and its impact was all the stronger because it appealed to amateurs as much as to professionals. This was especially so before photography became affordable and portable with the invention of hand-held, roll-film cameras toward the end of the period. Watercolor may be the most difficult of all mediums to master at the highest levels, but a draftsman of modest ability can soon learn to make competent and even charming color-tinted drawings. Moreover, only the most rudimentary talent is required to push color about with an enthusiasm worthy of Turner, and the mess is minimal. This was a period when gentlemen scientists—amateurs, by today's standards—could still make original contributions to botany, geology, anthropology, archaeology, and other disciplines. Often when making finds, whether of shells or shards, watercolor was a valuable tool with which to record information. Even after the advent of photography, it remained useful because of its ability to describe local color. Science aside, watercolor had many functions that anticipated those of the family camera. In the hands of a halfway accomplished practitioner it could yield attractive "snapshots" of places, people, and things. Watercolor painting was among the great middle-class crazes of the nineteenth century.

It is not surprising, then, to discover that Queen Victoria, the ultimate icon of the century, was addicted to watercolor, receiving instruction over a considerable period of time from Edward Lear, among others, and carrying a sketchbook with her on many of her travels.[1] Her Majesty was not an outstanding draftsman, but a nice sense of place pervades her landscapes. It is easy to imagine her at the center of one of those Victorian sketching parties, with other amateurs, kilted or crinolined, poised at their easels on the heather-covered slopes above Ardverikie Lodge (plate 229).

229. Queen Victoria (1819–1901)
*Ardverikie Lodge and Loch
Laggan*, 1847
Watercolor with white
heightening over traces of
black lead on paper,
4⅝ × 10³/₁₆ in.
(11.7 × 25.9 cm)
Collection Her Majesty Queen
Elizabeth II

So far as professional artists were concerned, the queen tended to favor the
popular academicians of the day, such as Sir Edwin Landseer. Not surprisingly,
given her affection for the medium, a substantial number of watercolors entered the
Royal Collections during her reign, but here, too, the bias was toward the official
art of the day, often in the form of sheets by leading members of what would be-
come, in 1881, the Royal Water-Colour Society.

Founded in 1768, the Royal Academy had always accepted watercolors at its
exhibitions, yet watercolorists, with a few notable exceptions, were treated as
second-class citizens there, their work often badly hung. Turner's rapid rise to
eminence at the Academy was contingent on his work in oils. Other major
watercolorists—Girtin, Cotman, Cox, De Wint—failed to achieve even associate
membership because their reputation depended upon watercolor. They sought and
found respect in a succession of watercolor societies that provided them with exhi-
bition facilities and the potential for pursuing common goals. The first of these was
the so-called "Old" Water-Colour Society, which held its initial exhibition in 1805
and numbered among its members John Varley, Joshua Cristall, George Barret II,

John Glover, William Sawrey Gilpin, Robert Hills, and Paul Sandby Munn. Although some of these artists were progressives, at least relatively speaking, the overall impact of the "Old" Society, in this first incarnation, was somewhat reactionary. Almost everyone had learned from Girtin and Turner, but technical advances were offset by archaic visions—a throwback to seventeenth- and eighteenth-century models—very evident in the work of Cristall and Barret, though Cristall sometimes transcended his neoclassical models to produce idyllic pastoral scenes worthy of Palmer (plate 230), and also powerful studies of figures in genre or classical settings.

This "Old" Water-Colour Society was an exclusive organization, its exhibitions open only to members, so in 1807 the New Society of Painters in Miniature and Water-Colour was founded (plate 231). Its members included David Cox and, later, William Blake, and its exhibitions were open to nonmembers such as Cotman, De Wint, Francia, and Samuel Prout. Despite this policy, the New Society foundered and in 1812 was dissolved. The "Old" Society was in financial trouble, too, and was also dissolved later that same year, but it was revived almost simultaneously—with the addition of some members from the defunct New Society—and resumed exhibiting in 1813 with a more liberal policy that permitted nonmembers to submit work. It was this Society of Painters in Water-Colours (still sometimes called the Old Society) that became the Royal Water-Colour Society (plate 232). It did much to foster the interests of the medium, but by the time Victoria ascended to the throne, in 1837, it had also become something of a force for the institutionalizing of establishment taste, though so rich was the British watercolor tradition that the

230. Joshua Cristall (1767–1847)
Wooded Landscape with Cottages and Countrywomen, Hurley, Berks, 1818
Watercolor over pencil on wove paper, 11 5/16 × 18 3/16 in. (28.7 × 46.2 cm)
Yale Center for British Art, New Haven, Connecticut; Paul Mellon Collection

231. George Scharf (1788–1870)
Gallery of the New Society of Painters in Water-colours, 1834
Watercolor on paper,
11⅝ × 14½ in. (29.6 × 36.9 cm)
Victoria and Albert Museum, London

232. John Frederick Lewis
(1805–1876)
The Interior of the Gallery of The Society of Painters in Watercolours, 1830
Graphite on paper,
10¾ × 17 in. (27.4 × 43.2 cm)
Trustees of The Royal Watercolour Society; Diploma Collection

Water-Colour Society exhibitions also contained some genuine plums. A revived New Society of Painters in Water-Colours, to which many illustrators belonged over the years, eventually came under Victoria's patronage, becoming the Royal Institute of Painters in Water-Colours.

Other outlets for watercolorists of a topographic bent—often those influenced by the Bonington who gazed on the visual delights of Italy, as well as by Turner the illustrator—were the luxurious albums published yearly in the late Georgian and early Victorian eras. Publications such as *The Landscape Annual* and *Heath's Picturesque Annual* paid handsomely (fifty guineas and up) for watercolors that would be translated into engravings and accompanied by verses penned to order by aspiring poets, preferably of aristocratic lineage.

The relationship between engravers and watercolorists was often close, and Thomas Shotter Boys is an example of an engraver who turned watercolorist, apparently under the direct influence of Bonington, who befriended him in Paris around 1825. Boys, born in 1803, was a few months younger than Bonington and followed closely in his footsteps, yet in a sense he belongs to a different era, since he hit his stride as Bonington died and remained a force to be reckoned with well into the Victorian period.

If Boys's earliest work is studied alongside Bonington's, it is easy enough to understand why the paintings of one are sometimes ascribed to the other. Boys swallowed Bonington's technique whole. He was not alone in this, but he had the advantage of working directly with the master. Yet he possessed enough individuality that he was never a mere imitator. His draftsmanship is tighter than Bonington's, and when he draws with the brush, although he borrows Bonington's manner, he does so with an engraver's precision that is different in inflection from his compatriot's calligraphy. He is never as atmospheric as Bonington at his most fluid, but instead he brings to his subjects a feeling for solidity and detail that is

233. Thomas Shotter Boys
(1803–1874)
Boulevard des Italiens, Paris, 1833
Watercolor on paper,
14³/₄ × 23⁵/₈ in. (37.5 × 60 cm)
British Museum, London

his own. His way of painting figures into his streets also differs from that of Bonington, who relies on suggestion while Boys provides more information. Boys had more of a documentary sense of scale, as is clear from *Boulevard des Italiens, Paris* (plate 233), which is also full of such detail as the carefully painted street lamps suspended from cables. In the end, it must be acknowledged that whereas Bonington was a poet, Boys traded in prose—but it was good prose, and he remains a watercolorist to be reckoned with.

Boys is sometimes referred to as a latter-day topographer, which is true so far as choice of subject matter is concerned. It must be understood, however, that his methods have little to do with the topographers of fifty years earlier. In his work, the technique of tinted drawings has been left far behind. This is equally true of Samuel Prout, who provides an interesting example of how generations overlap. Prout, after all, was just a few years younger than Girtin and two decades older than Bonington, yet his impact was perhaps felt most strongly in the early Victorian period, probably because he was championed then by Ruskin.

Born in Plymouth in 1783, Prout is said to have suffered a severe case of sunstroke during childhood and was in poor health for virtually his entire life, plagued by violent headaches that often confined him to his bed. Despite this, he was an un-

234. Samuel Prout (1783–1852)
Porch of Ratisbon Cathedral, n.d.
Watercolor on paper,
25³/₄ × 18¹/₄ in. (65.4 × 46.4 cm)
Victoria and Albert Museum, London

OPPOSITE, BOTTOM
235. Samuel Prout (1783–1852)
The Beach at Low Tide, n.d.
Watercolor over graphite on
two joined sheets of wove paper,
13⁷/₈ × 19¹/₂ in. (35.2 × 49.5 cm)
Yale Center for British Art, New Haven,
Connecticut; Paul Mellon Collection

ABOVE
236. William Callow (1812–1908)
Wallenstadt from Wessen, Switzerland, n.d.
Watercolor and body color on
wove paper, 17¹/₂ × 25¹/₄ in.
(44.5 × 64.1 cm)
Yale Center for British Art,
New Haven, Connecticut;
Paul Mellon Collection

flagging worker, and after 1819 an indefatigable traveler, making many trips to Normandy, Brittany, Italy, and Germany and adding innumerable Continental subjects to his already considerable repertoire of British scenes. Sometimes, as is the case with *The Beach at Low Tide* (plate 235), he displayed a poetic painterliness that owed a good deal to Girtin. More often, he worked in a style indebted more to linear invention. Like Turner, Prout habitually made pencil sketches on the spot, and these are often very fine. For his exhibition works, presumably made in the studio, he often overlaid graphite lines with a reed-pen drawing before laying in washes. This penwork gives a sheet like *Porch of Ratisbon Cathedral* (plate 234) much of its character, though the way he built with washes was in the post-Girtin style.

Another figure who spanned the generations was William Callow, who knew many of the pioneers of British watercolor, yet survived well into the twentieth century, dying at the age of ninety-six. Like Boys, he was an engraver by training, and it was from Boys that he learned his watercolor technique, which often drew upon Bonington's mannerisms (a point on which Callow was extremely sensitive). In fact, some of Callow's paintings are more Bonington-like than anything by Boys, but on occasion the artist was capable of sidestepping these mannerisms and painting something as fresh as *Wallenstadt from Wessen, Switzerland* (plate 236).

Topography with local subject matter remained a concern of British water-

237. Samuel Bough (1822–1878)
View of a Manufacturing Town, n.d.
Watercolor on paper,
7¼ × 12⅝ in. (18.4 × 32.1 cm)
British Museum, London

238. James Holland (1800–1870)
Margate, 1861
Watercolor over black chalk on
paper, 4 × 6⅛ in. (10.2 × 15.6 cm)
Yale Center for British Art,
New Haven, Connecticut;
Paul Mellon Collection

colorists throughout the century, even when the subject was as unlikely as *View of a Manufacturing Town* (plate 237), a splendidly atmospheric painting by Samuel Bough, best known for his Scottish subjects. In the second half of the century, some watercolorists brought a very economical, almost impressionistic approach to

topographic subjects. James Holland was capable of very finished work, but typically he left a good deal to the imagination, rendering some parts of a composition rather fully while working other areas with just a few suggestive lines and dabs of wash. In *Margate* (plate 238) he takes this approach to an extreme, conjuring up a blustery day at the seaside with quick, bold strokes. Another masterpiece of nineteenth-century minimalism is John Absolon's *Coast Scene* (plate 239). Apparently painted around 1860, this is a work that in brevity of description surpasses Eugène Boudin of the same period, and in bold use of black evokes thoughts of Edouard Manet.

Absolon was well known as a marine painter; not surprisingly in an era when Britannia ruled the waves, marine painting attracted the attention of many watercolorists. A sizable proportion of these were influenced by Bonington, and this is especially the case with Charles Bentley, who, like Boys and Callow, trained as an engraver and spent time in this capacity in Paris, where he assisted in making plates

239. John Absolon (1815–1895)
Coast Scene, n.d.
Watercolor on paper,
9⁵/₁₆ × 14⁵/₈ in. (23.7 × 37.1 cm)
Victoria and Albert Museum,
London

240. Charles Bentley (1806–1854)
Fishing Boats, n.d.
Watercolor on paper,
18 × 26 in. (45.7 × 66 cm)
Victoria and Albert Museum,
London

241. Edward Duncan (1803–1882)
Spithead, 1855
Watercolor on paper,
13¾ × 20¾ in. (34.9 × 52.7 cm)
Birmingham Museum and Art
Gallery, Birmingham, England

242. Charles Edward Holloway
(1838–1897)
On the East Coast, n.d.
Watercolor on paper,
10⅝ × 15 in. (27 × 38.1 cm)
Victoria and Albert Museum,
London

243. David Roberts (1796–1864)
*The Great Temple of Ammon
Karnac, the Hypostyle Hall*, 1838
Watercolor on paper,
19¼ × 13 in. (48.9 × 33 cm)
Yale Center for British Art,
New Haven, Connecticut;
Paul Mellon Collection

244. William James Müller (1812–1845)
Venice, 1834
Watercolor on paper,
8⅝ × 15¾ in. (21.9 × 39.9 cm)
Victoria and Albert Museum,
London

after watercolors by Bonington. This early exposure to Bonington left a permanent imprint on his style. *Fishing Boats* (plate 240) is typical of the many paintings he made of subjects around the coasts of the British Isles, Normandy, and the Channel Islands. Victorian taste ran to more finished work than Bentley's, however, and greater success was awarded to artists like Edward Duncan, whose paintings, such as *Spithead* (plate 241), are skillful and possess period charm but are dry and airless by comparison with Bentley's efforts. A later marine painter who had a knack of capturing the freshness of sea breezes was Charles Edward Holloway. He often concentrated on the vastness of the ocean rather than on the particulars of shipping, and it is easy to imagine that a painting like *On the East Coast* (plate 242) would have held the interest of Winslow Homer.

William James Müller could handle a marine subject with aplomb when required to, but he is best known for his paintings of Venice and the Middle East. Müller, who died at thirty-three, was one of those watercolorists who ignored the stultifying effects of early Victorian academicism and instead remained faithful to the freshness and breadth of handling that had marked the early phases of the British watercolor revolution. He had a knack, too, of finding fresh viewpoints. In Venice he painted the great sights but also, as in the present example (plate 244), sought out the Venice that the tourist generally ignored, side canals and decrepit villas edging the lagoon.

Throughout the nineteenth century, British artists continued to crisscross Europe and to travel more frequently beyond the old stomping grounds, to Egypt, Palestine, and the outposts of the British Empire. One artist who earned considerable fame painting exotic architectural subjects was David Roberts, a Scotsman well known in his younger years as a painter of theatrical scenery. Like Prout and Cotman, he painted the Gothic sights of Europe, but he also traveled extensively in North Africa and the Middle East, making hundreds of drawings and watercolors, which served as the basis for both oil paintings and the chromolithographic illustrations for books such as *Views in the Holy Land, Syria, Idumea, Arabia, Egypt and Nubia*. The watercolors themselves are notable as much for accuracy of information as for artistic flair, yet it should be noted that Roberts had a real feel for architecture—the weight and volume of monumental masonry structures—and handled washes with a confidence that permitted him to blend topographic fidelity

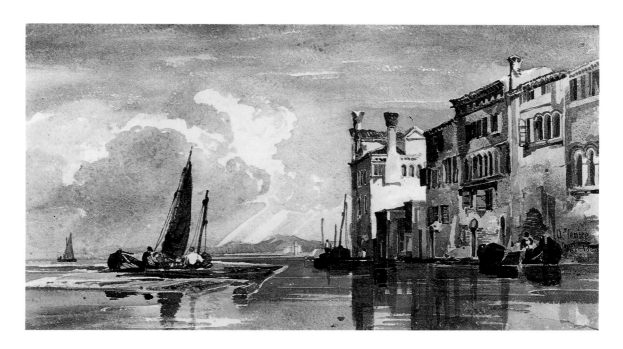

with atmosphere. In a sheet such as *The Great Temple of Ammon Karnac, the Hypostyle Hall* (plate 243) he picks his point of view carefully, so that the human figures are dwarfed by the pillars of the temple and engulfed in shadow, their significance further diminished. Yet the main architectural features are bathed in light that enables the decorative detail to read clearly.

One of the best known of the Victorian artist-travelers was Edward Lear, better appreciated today as an immortal master of nonsense verse. His topographical drawings did not reach the heights of sublimity scaled effortlessly by "The Owl and the Pussycat," or his many limericks, but he remains a singular figure among the

245. Edward Lear (1812–1888)
Choropiskeros, Corfu, 1856
Watercolor and pen and brown
ink on paper, 18⅞ × 15¾ in.
(47.9 × 40 cm)
British Museum, London

246. Edward Lear (1812–1888)
Gozo, Near Malta, 1866
Watercolor on paper,
6³⁄₈ × 9³⁄₄ in.
(16.2 × 24.8 cm)
Yale Center for British Art,
New Haven, Connecticut;
Paul Mellon Collection

watercolorists of his generation in that, to a large extent, he applied the methods of the eighteenth century—though with a new flexibility—ignoring almost totally the revolution wrought by Girtin and Turner.

Born in 1812, the youngest of twenty-one children, Lear first came to notice as a teenager on account of his ornithological drawings. From the mid-1830s he traveled extensively in France, Italy, Greece, and the Middle East, everywhere making scores of watercolor drawings. The term *watercolor drawings* is significant here because these were essentially pen-and-ink drawings in which colored wash played a secondary role. It seems he made the line drawings on the spot, then added color in the studio at some later time, a fact that probably explains the "generic" quality of the color in many of these works. Ocher is used to indicate dry Mediterranean terrain, purple and blues to represent distant hills. That said, Lear brought a delicacy of touch to his drawings that is all his own. This is very clear in *Choropiskeros, Corfu* (plate 245) and even more so in *Gozo, Near Malta* (plate 246), striking in its simplicity.

Among the British watercolorists who traveled even farther afield were Thomas and William Daniell. The Daniells—Thomas was William's uncle— traveled to India, oddly enough by way of China, as early as 1786 and remained there until 1794, making hundreds of watercolor drawings, sometimes with the aid of a camera obscura. One result of this extended visit was a spectacular publication, *Oriental Scenery*, put out in six volumes between 1795 and 1808, with 144 plates in color. Neither Thomas nor William ever returned to India, but Thomas in particular continued to paint Indian subjects well into the second quarter of the nineteenth century. Although steeped in the tradition of the old topographers, he was capable of interesting devices. Note, for example, how in *Palace at Madura* (plate 247) he places a group of sunlit figures in silhouette against a shadowy stretch of wall. The effect is striking and quite original.

A later visitor to India was William Simpson, a Scotsman whose approach to watercolor owed a good deal to the example of David Roberts, though Simpson's handling of paint was looser, giving his work the appearance of great spontaneity. Much of his career was spent as a visual reporter for the *Illustrated London News*, for

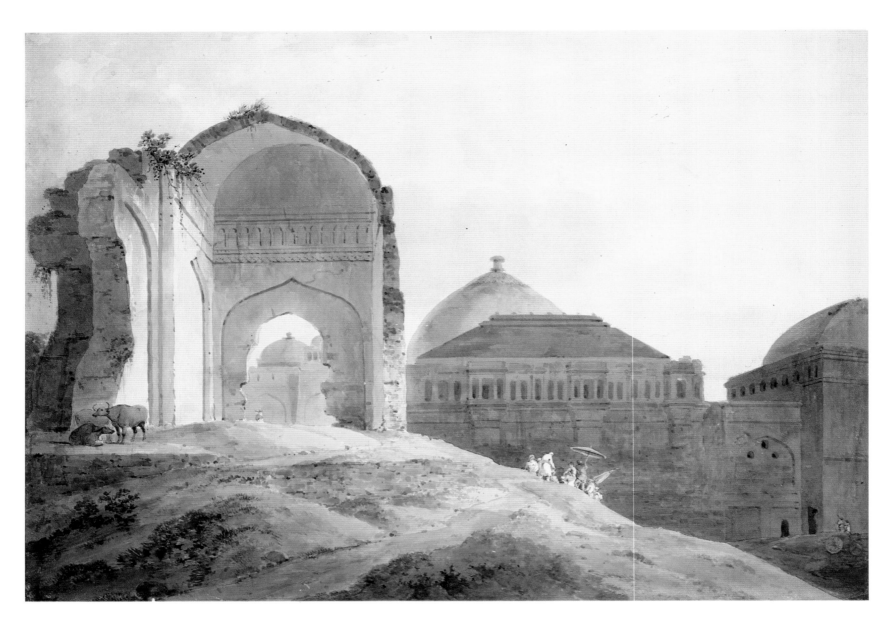

247. Thomas Daniell (1749–1840)
Palace at Madura, n.d.
Watercolor on paper,
16¼ × 23¼ in.
(41.3 × 59.1 cm)
Victoria and Albert Museum,
London

which he covered everything from royal weddings to military actions in the Khyber Pass. Often his journalistic work was carried out in monochrome wash, but when he had the time to make watercolors for his own pleasure he was capable of capturing the color, as well as the atmosphere, of the East with a good deal of élan. *Aurungabad* (plate 248) is a good example of the briskness of his brushwork and of his ability to create patterns of light and shade with quick calligraphic strokes.

By far the most popular of the British artists to peddle Orientalism to the gallery-going public was John Frederick Lewis, the son of an engraver who had made aquatints of works by Girtin and Turner. Born in 1805, Lewis was trained in his father's profession, but sold his first painting before he was fifteen. During the next several years he built a reputation as a draftsman specializing in animal studies, often working alongside Edwin Landseer, a boyhood friend. (It is reported that, as boys, they often bought carcasses of foxes and other game together, dissecting them for study and keeping them hidden under their beds.[2])

In 1832, already an established figure in the London art world, Lewis undertook an extended trip to Spain, and it was here that he was first exposed to Islamic culture in the form of the Alhambra and other Moorish remains. This Spanish expedition afforded him material for many paintings and two books, *Lewis's Sketches and Drawings of the Alhambra* and *Lewis's Sketches of Spain and Spanish Characters*, both

illustrated with color lithographs. In 1837 Lewis left England again, wintered in Paris, spent two years in Italy, then set out for the Middle East, arriving in Cairo toward the end of 1840 and making it his headquarters for the next decade, while traveling extensively to other parts of the Islamic world. Always something of a dandy, Lewis seems to have gone native with a vengeance. Thackeray, on a visit to Cairo, described the artist as favoring Turkish pants and long gowns, his head shaved, his beard curling over his chest, a Damascus steel scimitar at his waist, a cigar always in place between his teeth. During this period, Lewis sent little or nothing back to England and was half forgotten. He was far from inactive, however, and spent these ten years making hundreds of drawings and paintings, many of them featuring intricate detail and a new technical approach to watercolor that would take London by storm when he began to show there again in 1850.

A typical example of his new style is *Hhareem Life—Constantinople* (plate 249), painted several years after his return to England and just before he turned his attention to oil painting (because he felt watercolor paid too poorly). In subject matter, this is a Victorian genre scene done up in Oriental costume; certainly there is little of the latent eroticism found in Ingres's harem scenes. The chief interest lies in the way Lewis animates the scene by rendering the setting—the tiles, stucco work, cabinetry—in intricate detail and with an intensity and luminosity made possible by his technical innovations. Like other artists, such as von Menzel, and, in England, Palmer (during his later phase), Lewis evolved a method of blending transparent watercolor with Chinese white to achieve a chromatic opulence, but in addition he

248. William Simpson (1823–1899)
Aurungabad, 1875
Watercolor on paper,
10¾ × 17 in. (27.3 × 43.2 cm)
British Museum, London

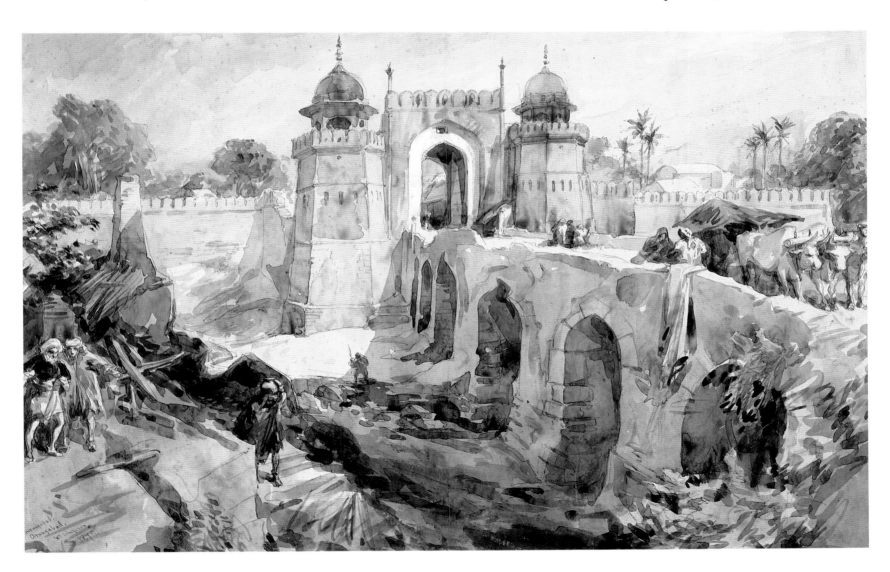

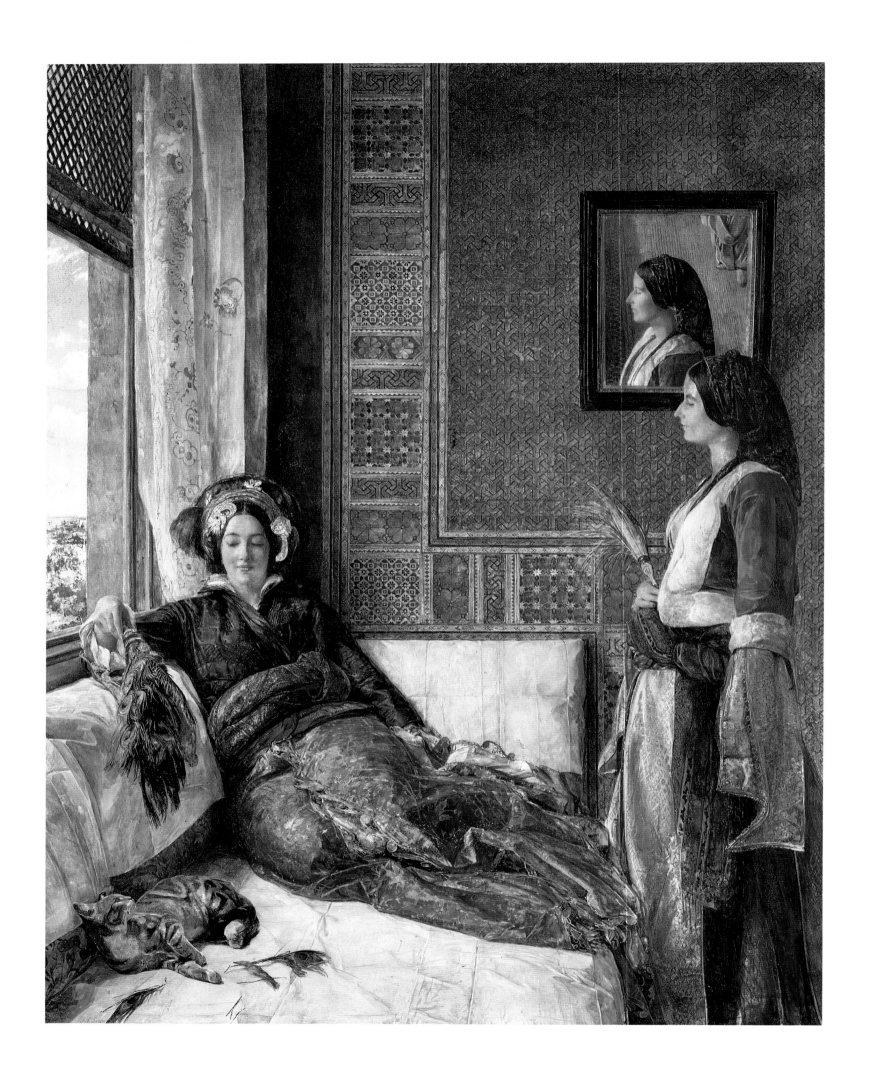

seems to have primed his paper with a thin coat of gesso, further enhancing the opulent effect. No one has ever surpassed Lewis in this kind of intense, sharp-focus work. There is, however, a sameness about his Islamic interiors and a tendency toward claustrophobia. Fresher seeming, by today's standards, are less highly wrought subjects such as *Sheik Hussein of Gebel Tor and His Son* (plate 250). It may well be, in fact, that Lewis was at his best as a documentarian. The harem scenes lack the spark of imagination that would make them more than the technical marvels they undeniably are.

OPPOSITE

249. John Frederick Lewis (1805–1876)
Hhareem Life—Constantinople, 1857
Watercolor on paper,
24¹/₂ × 18³/₄ in. (62.2 × 47.6 cm)
Laing Art Gallery, Newcastle
upon Tyne, England;
Reproduced by permission of
Tyne and Wear Museums

250. John Frederick Lewis (1805–1876)
*Sheik Hussein of Gebel Tor and
His Son*, n.d.
Watercolor and body color on
paper, 20³/₁₆ × 14¹/₂ in.
(51.3 × 36.8 cm)
Yale Center for British Art,
New Haven, Connecticut;
Paul Mellon Collection

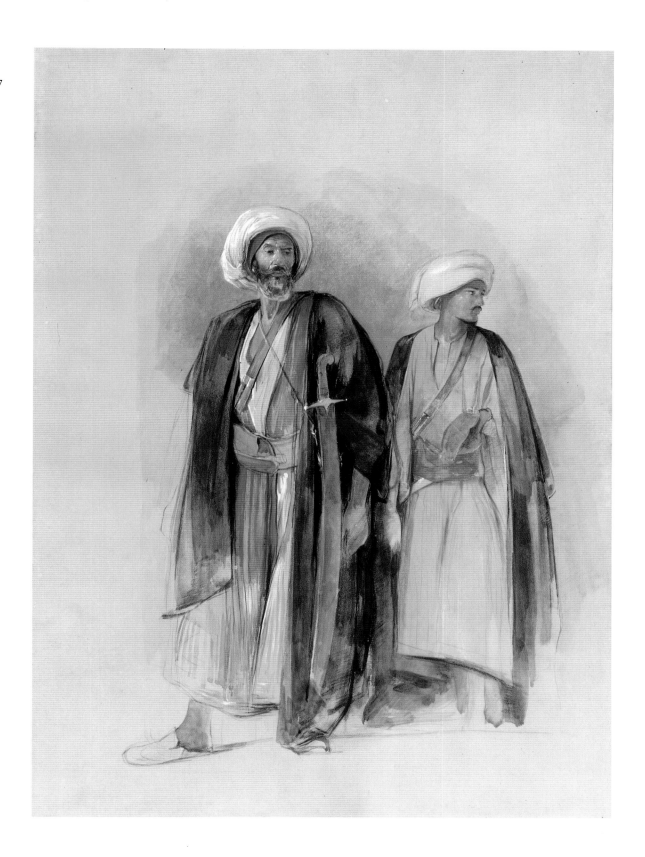

If Victorians were fascinated by the East, they were also fascinated by the American West. Increasingly, there were American artists capable of recording the western wilderness with a sophistication of vision and technique that put them on a level with their European peers. In watercolor, especially, the American School had become a distinguished provincial branch of the British School (and before long it would take over leadership). Of the American watercolorists who painted the landscape beyond the Mississippi, Thomas Moran was perhaps the most gifted.

Born in England in 1837, Moran came to the United States as a boy but returned to Europe to study and there learned much from Turner's example as a watercolorist. One thing he gleaned from Turner was the power of suggestion, and even the slightest of the sketches he made on his western journeys have the power to evoke more than is actually described. This is the case with *The Great Hot Springs, Gardiner's River* (plate 251), but even more finished paintings such as *From Powell's Plateau* (plate 252) deal as much in suggestion as in description. In an era when many artists became overly literal, Moran remained true to the strengths of the Turner tradition. The old master's influence became even more apparent when Moran turned away from western material and painted *Venice* (plate 253), a subject associated with Turner. Even here, however, Moran is not entirely unoriginal. In this particular instance he added a curiously Gothic touch in the form of the lighthouse-shrine that occupies the right foreground.

251. Thomas Moran (1837–1926)
*The Great Hot Springs,
Gardiner's River*, 1873
Watercolor and gouache on
paper, 8³/₄ × 13 in. (22.2 × 33 cm)
Spanierman Gallery, New York

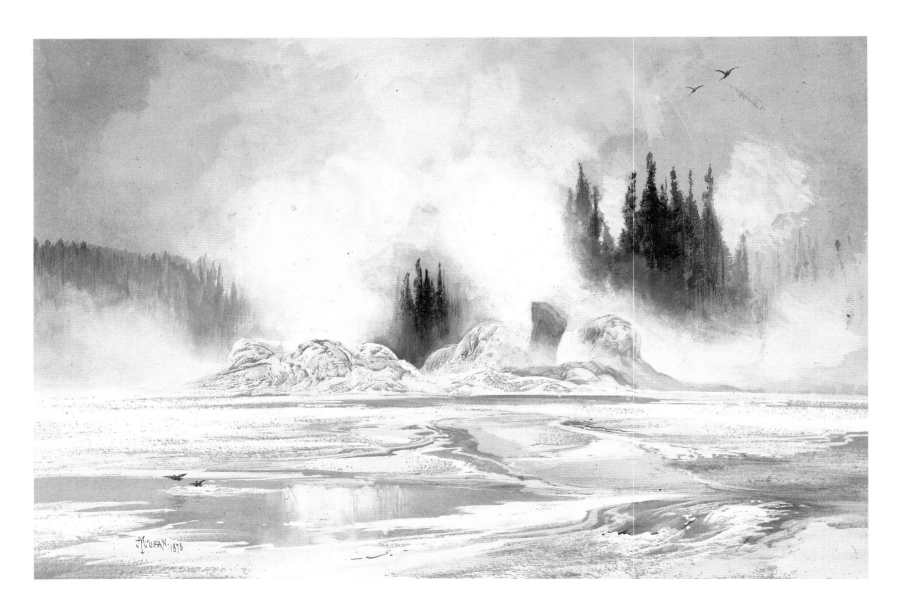

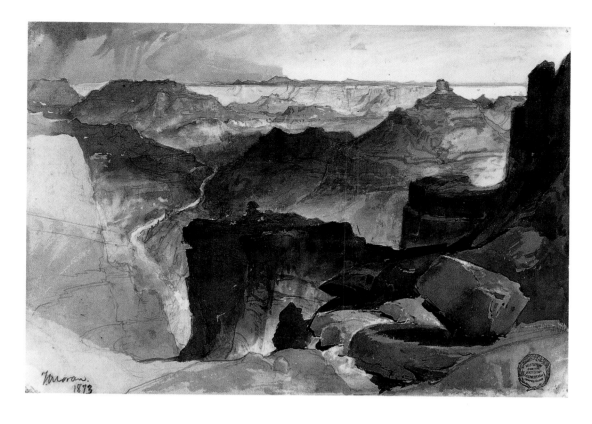

252. Thomas Moran (1837–1926)
From Powell's Plateau, 1873
Watercolor on paper,
7½ × 10½ in. (19.1 × 26.7 cm)
Cooper-Hewitt Museum,
Smithsonian Institution,
National Museum of Design,
New York

253. Thomas Moran (1837–1926)
Venice, 1896
Watercolor on paper,
8⅝ × 12⅜ in. (21.9 × 31.4 cm)
Coe-Kerr Gallery, Inc., New York

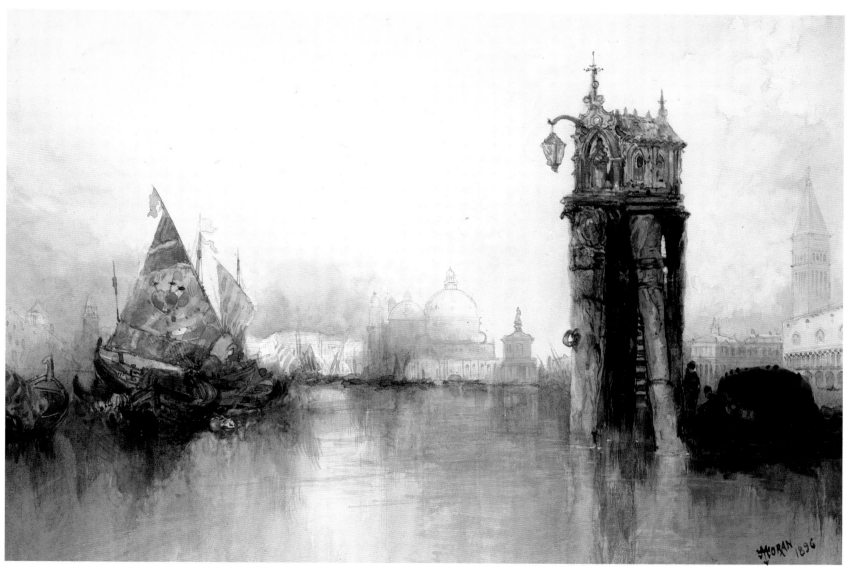

254. Alfred Edward Chalon
(1780–1860)
The Opera Box, 1838
Watercolor on paper,
18¹/₂ × 13⁵/₈ in. (47 × 34.6 cm)
British Museum, London

Turning to artists specializing in figure work, Alfred Edward Chalon was yet another Swiss-born painter to make good in England, as did his brother, John James Chalon. Alfred is best known for his theater scenes and his watercolor portraits of fashionable ladies. He painted portraits of Queen Victoria and received from her the honor of being appointed Watercolour Painter to the Queen. As a recorder of high society, Chalon lacked the élan of Eugène Lami, but his work is not without merit. As can be seen from *The Opera Box* (plate 254), he was highly skilled at rendering fabrics, and he had a knack for capturing the haughty innocence of the Victorian debutante.

ABOVE

255. Joshua Cristall (1767–1847)
A Girl Peeling Vegetables, c. 1810–15
Watercolor over pencil on
paper, 17⅝ × 14⅛ in.
(44.8 × 35.9 cm)
Yale Center for British Art,
New Haven, Connecticut;
Paul Mellon Collection

ABOVE, RIGHT

256. Kate Greenaway (1846–1901)
A Figure Study, n.d.
Watercolor and gouache on
paper, 17⅝ × 13 in. (44.8 × 33 cm)
Laing Art Gallery, Newcastle
upon Tyne, England

Joshua Cristall has been discussed as an exponent of neoclassical landscape (plate 230), but he also deserves mention for his figure studies, which were perhaps his most original contributions to British watercolor. Typically, he would isolate a single female figure either performing a simple task or lost in thought. Sometimes the setting had classical overtones, but often, as in *A Girl Peeling Vegetables* (plate 255), it was a typical nineteenth-century genre setting, furnished with a goodly supply of still-life props. Figure and setting alike were handled with a certain boldness, key forms being broken down into clearly defined planes.

Kate Greenaway is, of course, best known as the author and illustrator of such children's classics as *Under the Window* and *Marigold Garden*. This work aside, she was a thoroughly schooled artist capable of making highly proficient watercolors that were not dependent upon the stylization of her illustrations (plate 256).

As Greenaway is known for her illustrations, so David Wilkie is chiefly remembered for his genre scenes and anecdotal/historical paintings. Wilkie's works seem overly literary today, but this does not take away from the fact that he was a superb draftsman who often made scores of studies for a single painting. Most of the studies were in monochrome, but quite a few were enlivened with watercolor. Characteristic of these, in technique if not in the subject's odd pose, is the *Nude Study* (plate 257) reproduced here. It is the draftsmanship that impresses most, but washes are skillfully used to help suggest form.

Like Wilkie, Edwin Henry Landseer was one of the pillars of the Victorian artistic establishment—both were knighted for their achievements—and, like Wilkie,

257. Sir David Wilkie (1785–1841)
Nude Study, n.d.
Watercolor, body color, and
pencil on paper, 13 × 19 in.
(33 × 48.3 cm)
British Museum, London

Landseer was a first-rate draftsman, especially where animal subjects were concerned. Landseer was not a prolific watercolorist, but he did handle the medium fluently. Sheets like *Study of a Tiger* (plate 258) show him to good advantage, displaying a looseness of approach often missing from his finished work in oils.

Also immensely popular in his day was Myles Birket Foster. Born in 1825 in the north of England, Birket Foster came to London as a boy, apprenticed as a

258. Sir Edwin Henry Landseer
 (1802–1873)
 Study of a Tiger, n.d.
 Watercolor on paper,
 9½ × 13 in. (24.1 × 33 cm)
 British Museum, London

259. Myles Birket Foster (1825–1899)
 The Milkmaid, 1860
 Watercolor on paper,
 11¾ × 17½ in. (29.9 × 44.4 cm)
 Victoria and Albert Museum,
 London

wood engraver, and cut blocks for magazines like *Punch* and the *Illustrated London News* before working for those same magazines and others as an illustrator. In his early thirties he took up watercolor seriously and quickly established a reputation. Although he made paintings in Venice and along the Rhine, he became identified, above all, with the Surrey countryside, making innumerable idyllic views, sometimes peopled with children, sometimes with milkmaids and other rustic types (plate 259). From a technical viewpoint, Birket Foster was impeccable; his command of the medium cannot fail to impress anyone who enjoys highly finished watercolors. At the same time, unfortunately, he epitomizes the saccharine wing of Victorian popular taste, and this makes much of his *oeuvre* difficult to stomach for anyone reared on twentieth-century aesthetic standards.

Also prone to saccharine sentiments at times, but frequently able to rise above

260. Frederick Walker (1840–1875)
Spring, 1864
Watercolor on paper,
24¹/₂ × 19³/₄ in. (62.2 × 50.1 cm)
Victoria and Albert Museum,
London

Victorian cliché, was Frederick Walker, one of the most interesting British water-colorists of the third quarter of the nineteenth century. Born in 1840, Walker, like Birket Foster, began his career as an illustrator, and the technique he evolved was very close to Birket Foster's, combining transparent washes with body color and often using stippling to build up density of color and tone. (Later in his all-too-short career he modified his method to achieve much the same effects using transparent color alone.)

Spring (plate 260) is probably Walker's best-known painting, as it was widely circulated in reproduction. Like Birket Foster, he focuses on children in a rural setting, but there the similarity comes to an end. Birket Foster's children seem to have been plucked from some never-never land, in which the sun always shines and the fish always bite. Walker's children belong to the real world. After a cold winter, they search for primroses in an environment made convincing by extreme verisimilitude; Walker is said to have labored off and on for a year and a half on this one painting.[3] There were other Victorians capable of rendering nature with this kind of exactitude, but what makes this a Walker picture is the ease with which he has caught the girl's pose, clutching at her wrap with one hand, fending off branches with an elbow, caught a little off balance as she spots a cluster of blossoms. The mixture of grace and awkwardness lifts the picture out of the ordinary.

Despite occasional sentimental excesses, Walker was essentially a realist, with a healthy respect for ordinary people, as is evident in *The Fishmonger's Shop* (plate 261), a tour de force in which the glistening scales of the fish are set off to brilliant

effect against the deep shadow of the shop's interior. (Interestingly, Birket Foster exhibited a very similar composition titled *Fruiterer's Shop* in 1873, a year after *The Fishmonger's Shop* was painted.⁴) *Rainy Day in Bisham, Berks* (plate 262) shows Walker's realist tendencies at their unadulterated best. This painting is entirely without pretensions and instead sets out to represent a familiar scene with plain fidelity. The approach yields an unexpected poetry, and this little painting, as much as any of his more ambitious efforts, demonstrates why Walker deserves to be ranked highly among Victorian watercolorists.

Born the same year as Walker, Charles Green gained recognition as an illustrator of Charles Dickens's novels and often translated these black-and-white illustrations into watercolors, as is the case with *Little Nell Aroused by the Bargeman* (plate 263). He is typical of the narrative watercolorists of the Victorian period, and much the same might be said of George John Pinwell, a first-rate draftsman who, as a watercolorist, owed a good deal to Birket Foster and Walker, frequently blending transparent color and gouache. He was at his best when orchestrating varied textures, as in *King Pippin* (plate 264). An American who, like Birket Foster, was apt to overindulge in sentiment was John George Brown, immensely popular in his day for his paintings of children (plate 265). As a painter, Brown was no better than scores of others, but he remains of interest because his pictures epitomize, as fully as anyone's, a certain aspect of Victorian taste.

A much greater American artist was Thomas Eakins, who belongs in this chapter because there was about him a high seriousness that makes him—along with men like Thomas Carlyle and Henry James—one of the great Victorians. To study one of Eakins's masterpieces, *The Gross Clinic*, for example, is to enter the Victorian age at a point where its high-minded view of itself seems entirely justified. (This is the reverse of the coin from the whimsicality of Birket Foster and John George Brown.) Eakins's watercolors, because of the luminous character of the medium, are among his freshest-seeming works, but even when they celebrate the

recreational side of life, as in *John Biglen in a Single Scull* (plate 266), they remain charged with serious purpose. Competitive rowing, to begin with, is not a lazy man's sport, and the viewer senses that John Biglen has not taken up this pursuit in order to be second best. The expression on his face and the tautness of his muscles convey his readiness and concentration. And if the athlete brings high seriousness to his task, the artist matches him. Eakins prepared for this watercolor (an earlier version has been lost) by making a large oil sketch and a highly detailed perspective study. Nothing was left to chance, and it is, in fact, amazing that the painting remains so alive despite the lack of spontaneity.

The Zither Player (plate 267) also captures a moment of supposed relaxation that, in fact, calls for great concentration. Curiously, the face of the musician seems not quite finished, though his intensity of expression is not left in doubt, but his hands alone would tell the whole story. The dark tones that dominate the picture add to the seriousness of the mood.

265. John George Brown
(1831–1913)
Little Traveler, 1875
Watercolor over pencil on
paper, $17^{1}/_{2} \times 12^{1}/_{8}$ in.
(44.5 × 30.8 cm)
Spanierman Gallery,
New York

266. Thomas Eakins (1844–1916)
John Biglen in a Single Scull,
c. 1873
Watercolor on paper,
16¾ × 23 in.
(42.6 × 58.4 cm)
The Metropolitan Museum of
Art, New York; Fletcher Fund

OPPOSITE
267. Thomas Eakins (1844–1916)
The Zither Player, 1876
Watercolor on paper,
12 × 10½ in. (30.5 × 26.7 cm)
The Art Institute of Chicago;
Gift of Annie Swan Coburn in
memory of Olivia Shaler Swan

268. Joseph Michael Gandy
(1771–1843)
*Bird's-eye view of Sir John
Soane's design for Bank of
England*, c. 1830
Watercolor on paper,
28⅞ × 51⅛ in.
(73.3 × 129.9 cm)
Reproduced by permission of
the Trustees of Sir John
Soane's Museum

269. Alfred Waterhouse
(1830–1905)
*Natural History Museum,
London*, 1876
Pen and ink and watercolor on
paper, 16⅝ × 28½ in.
(42.2 × 72.4 cm)
Victoria and Albert Museum,
London

I began this chapter by commenting on the ubiquity of watercolor in the nineteenth century and will end it by noting yet another of its many uses, that of enlivening architectural renderings. Such renderings were made—either by the architect himself or by artists employed for the purpose—in order to make an attractive presentation to clients or competition juries. Perhaps the greatest architectural draftsman of the nineteenth century was Joseph Michael Gandy, who is es-

270. H. Gaye (active 1890's)
Charles Voysey's design of a house for Julian Sturgis, on the Hog's Back, Puttenham, Sussex, 1897
Pencil and watercolor on paper, 15¾ × 27⅜ in. (40 × 69.5 cm)
Royal Institute of British Architects, British Architectural Library, London

pecially associated with the practice of Sir John Soane. Gandy was a true virtuoso, and his cutaway view of Soane's Bank of England design (plate 268) is a tour de force. To say that Gandy was a master of perspective would be an understatement, but beyond that he invests the treatment with a Piranesi-like sense of drama.

Alfred Waterhouse was one of the architectural stars of the High Victorian era, famous for the stylishness of his own perspective drawings, many of which were enlivened by anecdotal detail. In presenting his well-known design for the Natural History Museum in South Kensington, for example, he filled the foreground with a parade of fashionable figures worthy of the brush of Eugène Lami (plate 269).

Toward the end of the century, Charles Voysey was one of the architects who, influenced by William Morris and Philip Webb, turned away from the fuss and ornateness of High Victorian taste and substituted a belief in clean lines and functional form based loosely on older vernacular styles. The solid simplicity that characterized his houses is reflected in the drawings that emerged from his office, such as the Julian Sturgis house drawn by H. Gaye (plate 270).

Seen in retrospect, Voysey seems more a protomodern figure than a typical Victorian, yet there is about the logic of his architecture something that is firmly rooted in his age and even, to some extent, in the preceding Romantic period. Certainly, the breakfast room of a Voysey house would be the perfect place to read Wordsworth or to linger over a folio of drawings by Cotman. Voysey's buildings are an expression of the same honesty and lack of affectation that inform the best British watercolors of the nineteenth century. They are the product of a philosophy that was given its clearest literary expression—as will be seen in the next chapter—in the writings of John Ruskin.

EIGHT

Ruskin and the Pre-Raphaelites

271. Dante Gabriel Rossetti
(1828–1882)
Portrait of Elizabeth Siddal, 1854
Watercolor on paper,
7¹/₈ × 6³/₈ in.
(18.1 × 16.2 cm)
Delaware Art Museum,
Wilmington; Pre-Raphaelite
Collection, F. V. DuPont
Acquisition Fund, 1985

As can be gathered from the previous chapter, the middle years of the nineteenth century saw the British watercolor world populated with scores of minor artists who were yet so skilled in the medium that they were on occasion capable of producing first-class work. The giants of British watercolor, however, were vanishing from the scene, and eventually the robustness of the British tradition would deteriorate into accomplished academicism and empty displays of facility. There was one last great moment, however, which coalesced around the most important British art theorist of the century and the most significant organized British movement of the century. That movement took the form of the Pre-Raphaelite Brotherhood; the theorist was John Ruskin, who is often presented as the movement's apologist. Although he was the Brotherhood's chief defender and shared many of the views of its members, the emphasis of his own theory was significantly different from theirs. Even within his lifetime it became conventional to call all Ruskinites Pre-Raphaelites (and this applies especially to his American followers), yet this was and is misleading. Those who followed Ruskin's lead had much in common with Millais, Hunt, Rossetti, and their followers, but they were not one and the same. The Ruskinites were primarily artist-naturalists. The chief Pre-Raphaelite painters were narrative artists with a strong bias toward employing naturalistic detail.

Significantly, Ruskin first came to prominence as the defender of the greatest of the British watercolorists, Turner, whose own career extended almost a decade and a half into the Victorian era. Ruskin extolled Turner in *Modern Painters* (1843–60), became his friend, and eventually his executor. In this latter role he did destroy a few of Turner's more "abstract" sheets, as being of no value, but in general he displayed

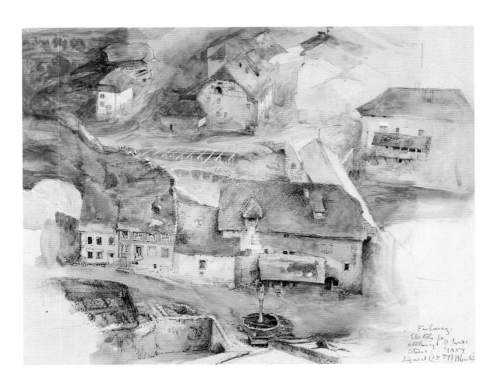

a sound appreciation of the scope of Turner's genius, understanding well enough how the looser studies related to the more finished works. What makes this remarkable is the fact that Ruskin became the high priest of precision and exactitude, the very qualities that seem least significant in Turner's work. Turner thought nothing, for example, of introducing British trees into an Alpine landscape on the grounds that the native trees he was replacing were ugly. Recognizing the magnitude of Turner's greatness, Ruskin seems able to have forgiven such aberrations of taste and factuality, though he would have deplored them in lesser men. Similarly, Ruskin was able to overlook Turner's delight in soft focus, something he would have found intolerable in his own disciples.

It was Ruskin's belief that when you painted a landscape (and he tended to prefer close-up fragments of landscape) you should render each blossom, each fern, each leaf of grass so faithfully and in such detail that a botanist would have no difficulty in recognizing the species. Similarly, rocks should be presented so that a geologist could tell if he was looking at gneiss or granite. This may not seem so radical a departure, yet the fact is that artists had come to deal somewhat in generic rocks and plants, and Ruskin would have none of that. "So a stone may be round or angular," he wrote, "polished or rough, cracked all over like an ill-glazed teacup, or as united and broad as the breast of Hercules. It may be as flaky as a wafer, as pow-

dery as a field puffball; it may be knotted like a ship's hawser, or kneaded like hammered iron, or knit like a Damascus sabre, or fused like a glass bottle, or crystalized like hoar-frost, or veined like a forest leaf: look at it, and don't try to remember how anybody told you to 'do a stone.' "[1]

Ruskin followed his own example. Although he did not consider himself a professional artist, he was a better than competent draftsman and was able to demonstrate his philosophy by example in works such as *Study of Gneiss Rock, Glenfinlas* (plate 273). That he was capable of a more atmospheric approach is shown by *Friborg* (plate 272), though this little painting, too, is packed with accurate information.

Among the artists Ruskin admired was William Henry Hunt (not to be confused with William Holman Hunt), who was of John Sell Cotman's generation, though today he tends to be bracketed with the Pre-Raphaelites, who were thirty years his junior. Hunt, who was a cripple from birth and hence attracted to the intimate scale of watercolor, studied with John Varley and early mastered the classic, Girtinesque method. Around 1825, however, he began to evolve a new system, in which he worked in a mixture of transparent and body color over a ground of Chinese white, often using stippling techniques to heighten his color. (It is generally acknowledged as being likely that John Frederick Lewis, Myles Birket Foster, Frederick Walker, and others learned much from his example.) His subject matter was quite varied, and Ruskin admired his unaffected rustic scenes such as *The Outhouse* (plate 274), but he became especially well known for his little "close-ups" of nature—a blend of landscape and still life—in which he concentrated on the loving replication of such plants and creatures as clumps of weeds or wildflowers, butterflies, and birds' nests. The latter subject, in fact, won him the nickname of "Birdsnest" Hunt, and his method of using watercolor over a Chinese white ground enabled him to render the surface appearance of a speckled egg or a sprig of apple blossom with great fidelity (plate 275). Indeed, Ruskin, not so literal an interpreter of his own doctrines as were some of his admirers, considered that Hunt sometimes

274. William Henry Hunt
(1790–1864)
The Outhouse, c. 1830
Watercolor on paper,
21¼ × 29½ in. (54 × 74.9 cm)
Fitzwilliam Museum,
Cambridge, England

went too far in terms of finish, robbing his work of life through overexactitude.

It should be noted here that Ruskin—in his admiration for traditional craft values, his espousal of protosocialist theories, and his predilection for design rooted in nature—was very much a precursor of William Morris and the Arts and Crafts movement. Certainly, Morris, an ally of the Pre-Raphaelites, learned much from Ruskin; his design for "African Marigold" chintz (plate 276) is very much in the Ruskinian tradition.

A few years older than Morris, George Price Boyce is a good example of an artist who espoused many of Ruskin's values and was close to the Pre-Raphaelites (especially Rossetti) yet managed to retain his own identity. A protégé of David Cox, he later knew Corot and other Barbizon-related painters in Paris. At times he used a heightened Pre-Raphaelite palette and a high-focus approach comparable to that of William Henry Hunt, but Boyce managed to remain free of the sentimental excesses that sometimes invaded Hunt's work. *The Mill on the Thames at Mapledurham* (plate 277) is a good example of his straightforward approach, but much more striking is *The Thames by Night from the Adelphi* (plate 278), in which radical simplification is used to excellent effect. Among Boyce's many friends was James Abbott McNeill Whistler, who may conceivably have learned something from paintings like this made several years before the first of Whistler's nocturnes.

The Pre-Raphaelite movement proper came into being in 1848 and, like so many other nineteenth- and twentieth-century movements, acquired its name in the form of a jest on the part of its detractors. John Everett Millais and William Holman Hunt, then precocious teenagers, were students at the Royal Academy Schools. Studying Raphael's *Angelus*, they criticized it on grounds of artificiality and insincerity, claiming that it marked a beginning of decadence in Italian painting. Other students mocked them, calling them pre-Raphaelites. A little later, when they came to know Dante Gabriel Rossetti, the son of a former Italian revolutionary, they se-

cretly became—along with a small group of sympathizers—the Pre-Raphaelite Brotherhood. A close ally, though never a member of the Brotherhood, was the slightly older Ford Madox Brown, who had contact in Rome with the Nazarenes, a German group with somewhat similar ambitions.

The name Pre-Raphaelite was accurate at least to the extent that the painters of the Brotherhood did seek inspiration in the artists of the fifteenth century, such as Botticelli and Gozzoli, and in the art of Italian primitives. They did not seek merely to imitate such painters, however, but hoped to emulate their approach (or what they imagined their approach to be). These young men had read Ruskin, though they did not know him yet. Like him, they sought an unaffected, direct approach to nature, one that emphasized accuracy over mannerism. What they added to the Ruskin formula, however (and here Rossetti was the man most responsible), was a literary dimension. Ruskin, it is true, felt that the good artist could indulge in

279. William Holman Hunt
(1827–1910)
Apple Gatherers in the Rhine Valley, 1885
Watercolor and body color on paper, 15³⁄₈ × 17⁷⁄₈ in.
(39.1 × 45.4 cm)
Birmingham City Museum and Art Gallery, Birmingham, England

flights of imagination, once he had mastered nature. The members of the Brotherhood were not prepared to take things in easy stages. For them, flights of inspiration and mastery of nature must occur simultaneously. Ruskin accepted the boldness of their strategy, even though he may have had some misgivings. When the critics began to attack the Pre-Raphaelites in 1850, he hurried to their defense. In reality, the Pre-Raphaelite revolution was short-lived. Among its founders, only Rossetti was a natural rebel by temperament, and both Millais and Holman Hunt soon settled into conventional roles as academicians. A definite Pre-Raphaelite style had evolved, however—ironically enough, a style full of mannerisms—and its influence would be felt for the rest of the century and beyond.

Of the original Pre-Raphaelites, Rossetti depended most on watercolor, but Hunt was perhaps the more accomplished technician, though he used the medium rather infrequently, working sometimes in transparent and body color, and sometimes using a method akin to what Andrew Wyeth calls "dry brush." This latter method, as employed by Hunt, involved the application of small strokes of hardly diluted transparent color, so that a great intensity could be achieved without use of Chinese white.

Victorian gallery goers were sometimes startled by the intensity of the color in Hunt's watercolors, and *Apple Gatherers in the Rhine Valley* (plate 279) demonstrates the chromatic brilliance he could bring to a sunlit landscape, making good use of patterns of shadow to structure the image while at the same time setting off the higher-keyed colors. Still more impressive, however, are Hunt's night scenes, such as *Ponte Vecchio* (plate 280), in which he concentrates on showing all that can be seen at night, rather than on the kind of simplifications preferred by Whistler in his nocturnes.

Ford Madox Brown was too much an individualist to knuckle under to Pre-Raphaelite doctrines, but the works he made in watercolor are perhaps closer to the spirit of the movement than his more ambitious paintings in oils. *The Coat of Many Colors* (plate 281) is an essay in narrative painting, much in the Pre-Raphaelite tradi-

282. Ford Madox Brown (1821–1893)
Hampstead—A Sketch from Nature, 1857
Watercolor on paper,
5½ × 9 in. (14 × 22.9 cm)
Delaware Art Museum,
Wilmington; Samuel and
Mary R. Bancroft Memorial

283. Sir John Everett Millais (1829–1896)
Girl by the Window, 1859
Watercolor on paper,
4⅛ × 3⅜ in. (10.5 × 8.6 cm)
British Museum, London

OPPOSITE
284. Dante Gabriel Rossetti (1828–1882)
The Blue Closet, 1857
Watercolor on paper,
13½ × 9¾ in. (34.3 × 24.8 cm)
Tate Gallery, London;
Courtesy Art Resource, New York

tion, with scrupulous attention paid to historical accuracy, within the limits of the scholarship of the day. *Hampstead—A Sketch from Nature* (plate 282) is a delightful exercise in the fulfillment of Ruskinian principles, full of freshness and careful observation.

Of these first-generation Pre-Raphaelites, the least interesting as a watercolorist is Millais, though on occasion he could hit a charming note (plate 283). By far the most ambitious of them, with regard to the medium, was Dante Gabriel Rossetti. It should be noted from the first that Rossetti did not take easily to watercolor, though during much of the main Pre-Raphaelite period—roughly 1848–60—he used it in preference to oils. As opposed to Millais and Hunt, who had great natural facility and more thorough training, Rossetti was somewhat awkward and inadequately schooled (though he had spent time under Cotman and Hunt, as well as at the Academy Schools). Beyond any of the other Pre-Raphaelites, however, he was a painter of vision, a poet with the desire to transcend words. His struggle to set down his vision lends his work strength yet in the end limits his achievement.

The depth of his vision can be judged from the fact that he could take a single woman, Elizabeth Siddal, and project into his paintings of her such fervor that he transformed her into a type, influencing not only other artists but also thousands of young women who aspired to be Pre-Raphaelite beauties, as now they might imitate the look of a movie star. Siddal modeled for Hunt and Millais, too, but it was Rossetti who transformed her, who installed her in his Chelsea home like a princess in a tower, who married her and two years later came home to find her dead, apparently of a self-administered overdose of laudanum, a popular Victorian opiate medicament. And it was Rossetti who buried his poems in her coffin (only to have her exhumed some years later so he could retrieve them).

Siddal was a striking-looking woman, with sensuous lips, heavily lidded eyes, and a firm jawline, her head set on a marble column of a neck and framed by a mass of red hair. Rossetti's 1854 portrait is as straightforward a picture of her as he ever painted, but even here she projects a neurotic sexuality (plate 271). More often he presented her in some dramatic narrative situation, as in *The Blue Closet* (plate 284), in which she is the gold-crowned figure second from the right. Even when Siddal

OPPOSITE
285. Dante Gabriel Rossetti
(1828–1882)
Woman in Yellow, 1863
Watercolor and pencil on
paper, 16¼ × 12¾ in.
(41.3 × 32.4 cm)
Tate Gallery, London;
Courtesy Art Resource,
New York

ABOVE
286. Dante Gabriel Rossetti
(1828–1882)
Arthur's Tomb, 1860
Watercolor on paper,
9¼ × 14½ in.
(23.5 × 36.8 cm)
Tate Gallery, London;
Courtesy Art Resource,
New York

died, Rossetti found other models, such as Annie Miller (plate 285), who resembled her and helped perpetuate the type.

It can reasonably be said that the term *Pre-Raphaelite* applied more aptly to Rossetti than to anyone else, since his imagery drew not just upon the earlier phases of the Italian Renaissance but again and again upon the imagery of the Middle Ages, his use of watercolor and body color sometimes calling to mind illuminated manuscripts, his way of laying down color often conjuring up crafts like embroidery and tapestry making. It has been observed that Rossetti picked his colors as though selecting threads, then "wove" them together on the paper, using his own variation on the stipple technique developed by such artists as William Henry Hunt and John Frederick Lewis. The results can be seen clearly in works like *Arthur's Tomb* (plate 286) from Rossetti's Arthurian cycle. The color is somewhat artificial, the overall effect verges on the decorative, yet these are intensely felt works that bear the mark of a strong and complex personality.

Lucretia Borgia (plate 287) is a later work that shows how Rossetti perpetuated his Pre-Raphaelite ideal of womanhood while evolving a more polished yet perhaps less personal style. As his skills increased, he began to lose some of the urgency that marked his earlier efforts. *The Passover in the Holy Family* (plate 288) is awkward in drawing and almost primitive spatially, yet it has a raw edge that makes it vital. Rossetti is generally a shade awkward when he is at his best, as in the amusing and anecdotal *Writing in the Sand* (plate 289).

Elizabeth Siddal herself proved capable of making attractive watercolors in the

CLOCKWISE FROM TOP LEFT

287. Dante Gabriel Rossetti
(1828–1882)
Lucretia Borgia, 1860–61
Watercolor on paper,
16½ × 9½ in.
(41.9 × 24.1 cm)
Tate Gallery, London;
Courtesy Art Resource,
New York

288. Dante Gabriel Rossetti
(1828–1882)
The Passover in the Holy Family,
1856
Watercolor on paper,
16 × 17 in. (40.6 × 43.2 cm)
Tate Gallery, London;
Courtesy Art Resource,
New York

289. Dante Gabriel Rossetti
(1828–1882)
Writing in the Sand, n.d.
Watercolor on paper,
10⅜ × 9½ in.
(26.4 × 24.1 cm)
British Museum, London

290. Elizabeth Siddal (1829–1862)
Clerk Saunders, 1857
Watercolor, body color, and
colored chalks on paper,
mounted on stretcher,
11 3/16 × 7 3/16 in. (30 × 18.3 cm)
Fitzwilliam Museum,
Cambridge, England

Rossetti style. *The Ladies Lament* (plate 291) is an illustration for "Sir Patrick Spence," an anonymous Scottish ballad. The subject is women on the shore mourning the loss of their menfolk at sea. The technique derives directly from Rossetti, though Siddal added a delicacy that was all her own. It was not only a technical approach she shared with Rossetti, however. She was perhaps the only Pre-Raphaelite to match his intensity of vision, as is exemplified by *Clerk Saunders* (plate 290). Other artists such as Simeon Solomon (plate 292) were technically more skillful but produced results that were relatively superficial, lacking Siddal's neurotic lyricism.

Just too young to have been involved with the birth of the Brotherhood, Edward Burne-Jones was Rossetti's truest heir and helped keep Pre-Raphaelite influence alive till the close of the Victorian era. When critical vehemence against the Brotherhood was at its height, Burne-Jones, with William Morris, was a student at Oxford, observing the fury enthusiastically from that comfortable remove. Moving to London in 1855, he, like Morris, forged a friendship with Rossetti that was made all the stronger by their shared interest in medievalism. In 1857 he and

291. Elizabeth Siddal (1829–1862)
The Ladies Lament, 1856
Watercolor on paper,
9 1/8 × 7 3/4 in. (23.3 × 19.7 cm)
Tate Gallery, London; Courtesy
Art Resource, New York

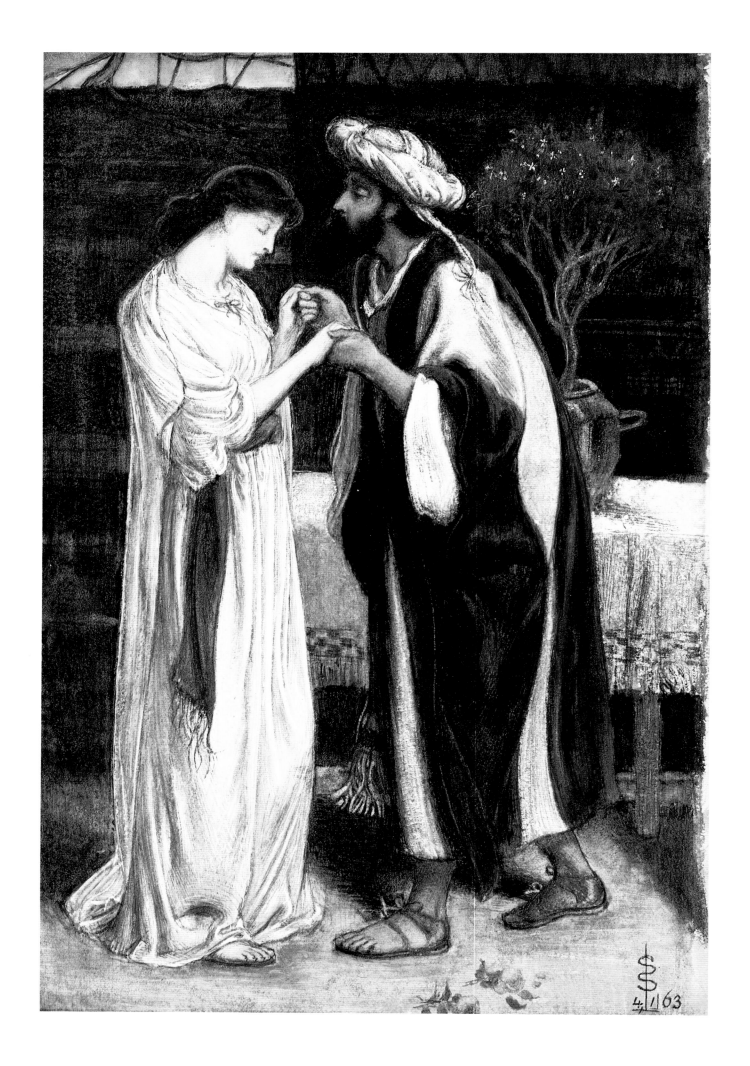

292. Simeon Solomon (1840–1905)
Isaac and Rebekeh, 1863
Watercolor on paper,
11⁹/₁₆ × 8 in. (29.4 × 20.3 cm)
Victoria and Albert Museum, London

293. Sir Edward Burne-Jones (1833–1898)
Sidonia von Borke, 1860
Watercolor on paper,
13¹/₂ × 9³/₄ in. (34.3 × 24.8 cm)
Tate Gallery, London; Courtesy
Art Resource, New York

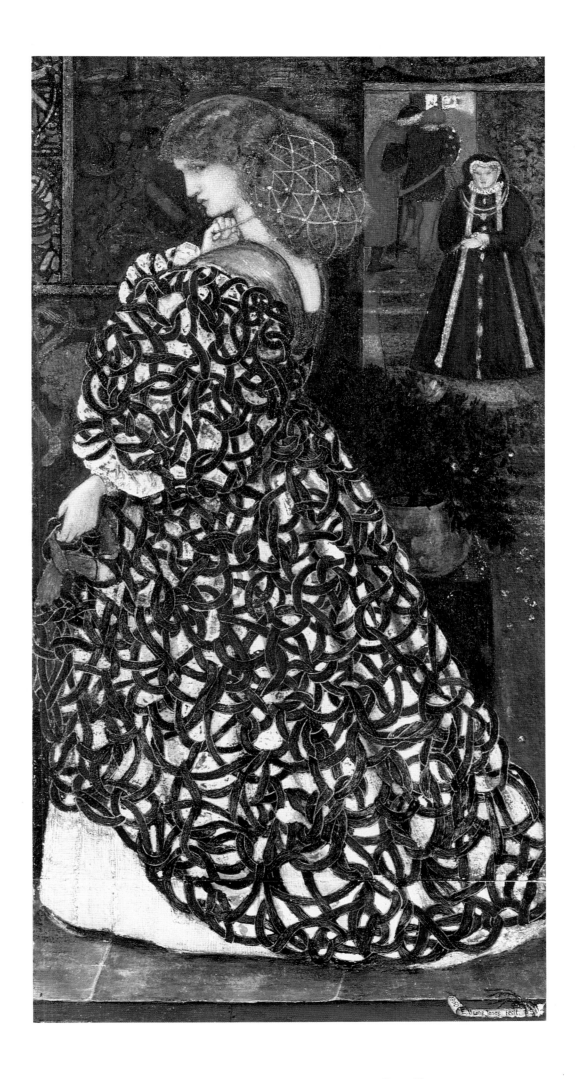

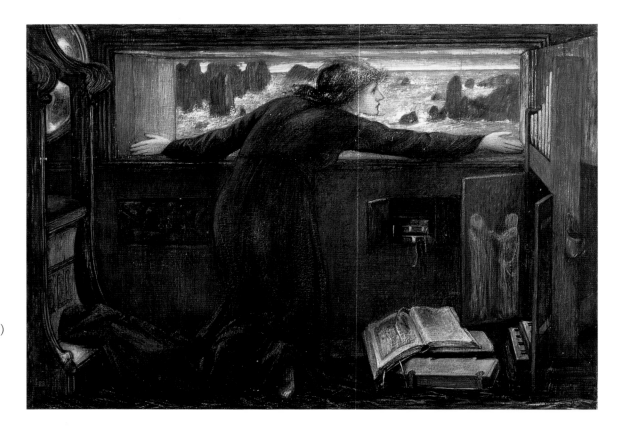

294. Sir Edward Burne-Jones (1833–1898)
Dorigen of Bretaigne, 1871
Watercolor on paper,
10½ × 14½ in. (26.7 × 36.8 cm)
Victoria and Albert Museum,
London

Rossetti worked together, along with Morris, on fresco decorations at the Oxford Union. Of all the Pre-Raphaelites, it was Burne-Jones who most excelled at large-scale work, whether in fresco or more conventional media, such as oil. In his earlier watercolors, however, he worked on a conventional scale and very much in a Rossetti idiom, though with a powerful sense of design that was entirely his own.

Sidonia von Borke (plate 293) represents a character from a gothic story by Wilhelm Meinhold. She is, in fact, a witch, but that hardly matters, since she exists as yet another incarnation of the Pre-Raphaelite woman (this time the model was Fanny Cornforth), here given great presence because of Burne-Jones's powerful use of pattern, far more sophisticated than is the case with Rossetti. The entwined motif that covers the woman's dress becomes symbolic of her character as well as making for an effective design element. Burne-Jones's work of this period—of which *Dorigen of Bretaigne* (plate 294) is another good example—was compared by Rossetti to the best of the Venetians, and, if this seems an exaggeration in retrospect, he does sometimes display a lushness and a way with costume that is reminiscent of Titian and Veronese.

Later, the design element in Burne-Jones's work began to dominate, and the lushness gave way to an ethereal quality that tended toward the languid. His work lost in intensity, but he did become master of the large-scale decorative watercolor. Most satisfying, among these huge watercolors, is *Sponsa di Libano* (plate 295), in which the overall design and especially the swirl of fabrics anticipate the highest achievements of Art Nouveau. It is probably true to say that Burne-Jones's later work had more importance for the decorative arts than for easel painting.

From 1854 to 1858, John Ruskin taught elementary drawing classes and landscape at the Reverend F. D. Maurice's Working Men's College (a Christian socialist school) in London, where Rossetti for a while taught figure-drawing classes. One of Ruskin's students there was Thomas Charles Farrer, who, about 1857, emigrated to New York, where he found the ground fertile for the sowing of his Ruskin-based

295. Sir Edward Burne-Jones (1833–1898)
Sponsa di Libano, 1891
Watercolor and body color on
paper, 128¼ × 62¼ in.
(325.8 × 158.1 cm)
Walker Art Gallery, Liverpool, England;
Courtesy National Museums
and Galleries on Merseyside

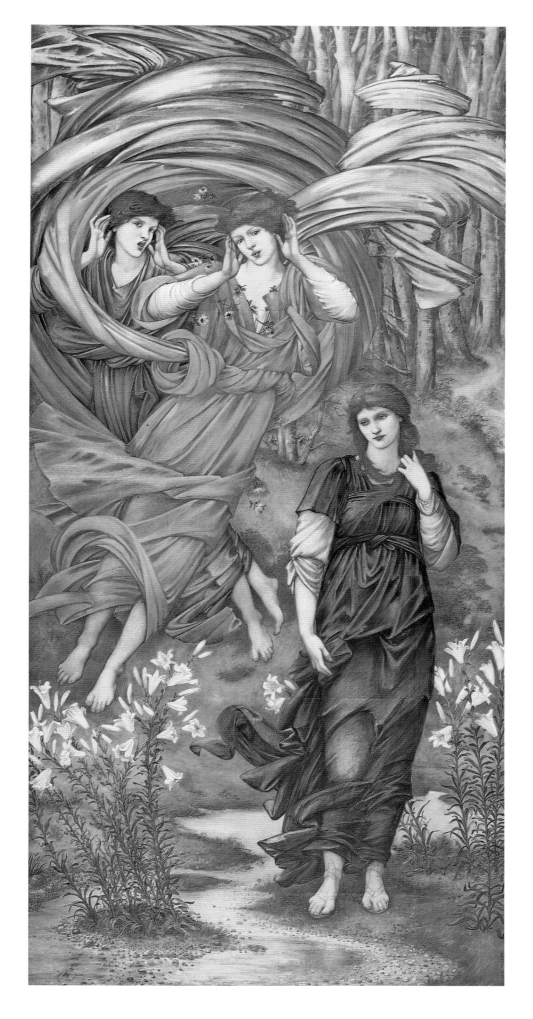

296. John William Hill (1812–1879)
Yellow Blossom, 1856–57
Watercolor, pencil, and pen and ink on
paper, 8⅞ × 9³/₁₆ in. (22.5 × 23.3 cm)
The Brooklyn Museum; Gift of Mr. and
Mrs. Leonard Milberg

297. John Henry Hill (1839–1922)
Natural Bridge, Virginia, 1876
Watercolor and pencil on paper,
21¼ × 14⅛ in. (54 × 35.9 cm)
The Brooklyn Museum; Gift
of Mr. and Mrs. Leonard Milberg

theories. (Ruskin's writings were, of course, well known in America.) In 1863 he
was instrumental in founding the somewhat smugly titled Association for the Advancement of Truth in Art, a group whose members came to be known as the
American Pre-Raphaelites, though it would be more accurate to describe them as
the American disciples of Ruskin.² Thomas Farrer was a fine draftsman and painter
in oils, but he did not make any significant contribution to the history of watercolor.
Several other members of the Association for the Advancement of Truth in Art,
along with other Americans influenced by the group (including Farrer's younger
brother Henry) were watercolorists of some consequence, and they brought
Ruskin's doctrine to life in the New World at a time when other forces were
on the rise in Europe.

Among these artists were John William Hill, born in England but brought to
the United States as a child, and his son, John Henry Hill. The senior Hill was
America's equivalent of William Henry Hunt and, during his Ruskin-influenced
phase, was drawn to such Hunt-like subjects as birds' nests and dead birds. His
stipple technique, too, owed a good deal to Hunt (whose work he may have seen
on a visit to England), though he did not employ a Chinese white ground but
rather made use of the white of the paper to glow through transparent color. Hill
possessed a deft touch and was at his best when presenting simple subjects such as
Yellow Blossom (plate 296). This painting, by the way, was made after he had read
Ruskin's *Modern Painters*, but half a decade before the founding of the Association
for the Advancement of Truth in Art, of which he became president.

His son, John Henry Hill, was also a founding member of the Association. He,
too, made small-scale watercolors of nests and grasses, though his touch was softer
than his father's, his handling just perceptibly broader. In the sixties he visited
England and spent much of his time there studying Turner. Although he never developed Turneresque mannerisms, this exposure did lead the junior Hill to
concentrate increasingly on vistas rather than close-ups. By the time he painted *Natural Bridge, Virginia* (plate 297), he was beginning to shy away from Ruskin's
theories so far as the painting of rocks is concerned. Instead of exactly reproducing
surfaces, he became more concerned with sculptural shapes and patterns of shadow.

A portrayal of rocks that comes much closer to Ruskin's teachings is to be
found in Charles Herbert Moore's *Landscape: Rocks and Water* (plate 298). A gifted
watercolorist, Moore made many attractive mainstream landscapes, often of New
England subjects, in which the focus is sharp yet not exaggeratedly so. At the
height of his Pre-Raphaelite period, however, he was capable of an intensity of focus
that is almost hallucinatory. *Landscape: Rocks and Water* displays this intensity that
would have been almost unthinkable prior to Ruskin. Moore came to know Ruskin
personally and traveled with him to Italy in the 1870s. Gradually, however, he
shifted away from a strictly Ruskinian view and even became critical of the Pre-Raphaelites for failing to see that nature had aspects that could not always be captured by unselective fidelity to factual detail.

Another member of the Association for the Advancement of Truth in Art was
William Trost Richards, who first came to notice for painstakingly painted images
of woodland glades and corners of conservatories, all very much in the Ruskinian
mold. Later, he specialized in a kind of seascape (or coastscape) in which, in common with other Ruskin-influenced artists, he came to a rapprochement with the
American movement that would later be called luminism. Often these coastscapes
represented rocks in a way that Ruskin would have approved, but they were primarily concerned with light effects. *Calm Before a Storm, Newport* (plate 299) does
not quite match Whistler in making something out of apparent emptiness, but it is

298. Charles Herbert Moore
(1840–1930)
Landscape: Rocks and Water, c. 1872
Watercolor and gouache over
graphite on off-white paper,
7³⁄₈ × 10 ¹¹⁄₁₆ in. (18.7 × 27.1 cm)
Fogg Art Museum,
Harvard University,
Cambridge, Massachusetts;
Transferred from the Fine Arts
Department

299. William Trost Richards
(1833–1905)
Calm Before a Storm, Newport, c. 1874
Watercolor on paper,
8⁷⁄₈ × 13¹⁄₂ in. (22.5 × 34.3 cm)
The Brooklyn Museum;
Dick S. Ramsay Fund

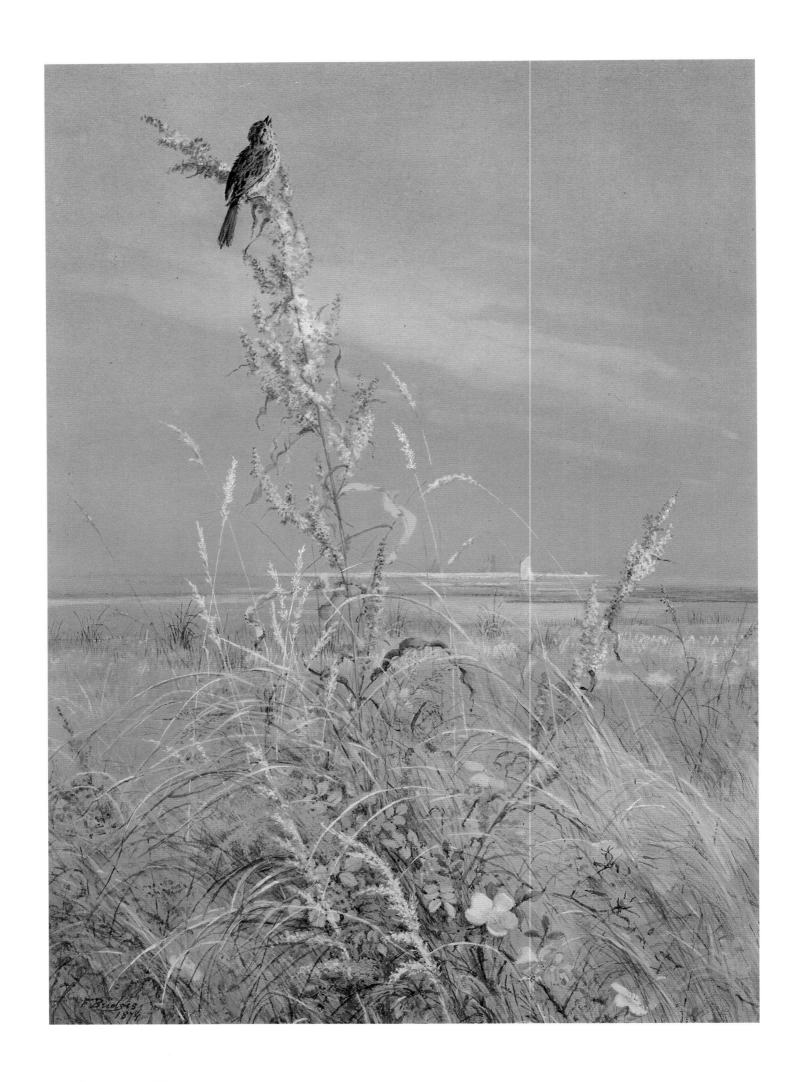

OPPOSITE

300. Fidelia Bridges (1834–1923)
Summer Song, 1874
Watercolor and gouache on
paper, 17¹/₈ × 12¹/₄ in.
(43.5 × 31.1 cm)
Wadsworth Atheneum,
Hartford, Connecticut;
Goodwin Marine Fund

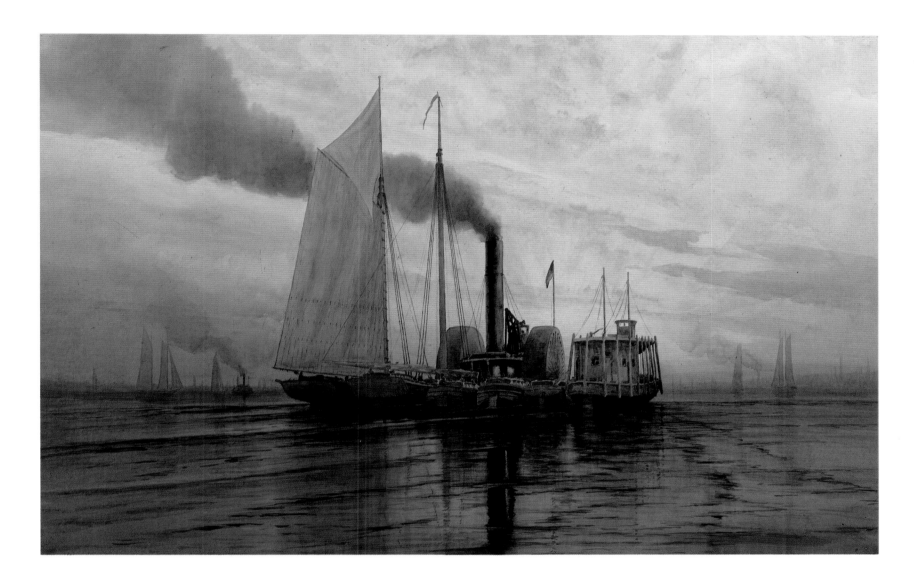

a fine painting nonetheless. Among Richards's most gifted students was Fidelia
Bridges, who made deeply felt close-up studies of nature in the Ruskinian spirit
(plate 300).

Thomas Farrer's younger brother Henry also traveled the route from fragments
of nature to something approaching luminism. He was still a teenager when the As-
sociation for the Advancement of Truth in Art was formed at his brother's house
and never became a member, but from the early sixties he made exquisite water-
color miniatures of such subjects as flowers and fruit, excelling at capturing the
texture of a blossom, the bloom on a plum. Later, though, he came under Turner's
spell and painted some fine, atmospheric paintings, including the large-scale *Sunset,*

ABOVE

301. Henry Farrer (1843–1903)
*Sunset, Gowanus Bay, New
York*, 1881
Watercolor on paper,
30 × 42 in. (76.2 × 106.7 cm)
Private collection

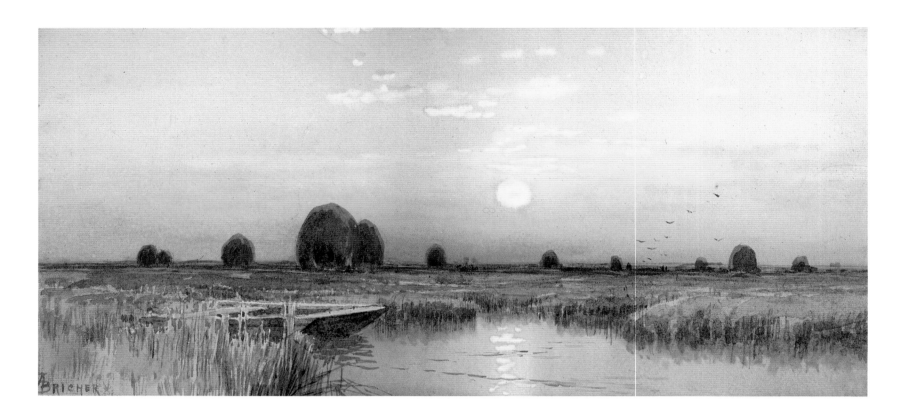

302. **Alfred Thompson Bricher**
(1837–1908)
Marsh Landscape at Sunset, n.d.
Watercolor on paper,
7 × 14½ in.
(17.2 × 36.8 cm)
Private collection

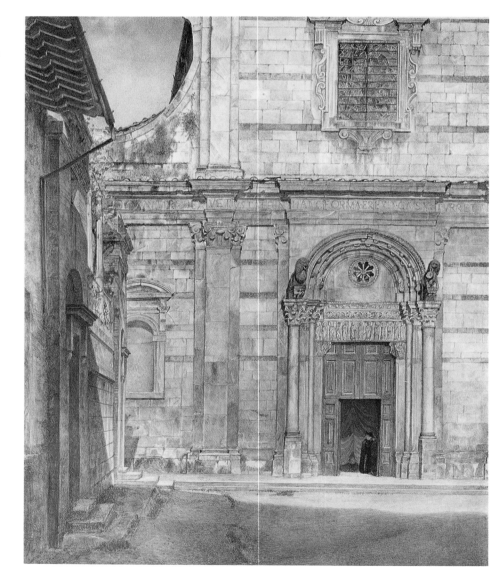

303. Henry Roderick Newman
(1833–1918)
Study of a Tuscan Cathedral,
n.d.
Watercolor over graphite on
heavy cream paper,
13¾ × 11⅜ in.
(35 × 28.9 cm)
Fogg Art Museum,
Harvard University,
Cambridge, Massachusetts;
Gift of Dr. Denman W. Ross

Gowanus Bay, New York (plate 301), one of Farrer's most ambitious works. This luminist mode was becoming more and more prevalent in American art during the sixties, seventies, and eighties. Its most famous proponents, like Martin Heade and Fitz Hugh Lane, preferred oils to watercolor, but many watercolorists did fine work in the idiom, as is the case with Alfred Thompson Bricher, whose *Marsh Landscape at Sunset* (plate 302) is a crisp example.

Of all the American artists who came under Ruskin's influence, the one who had the longest-lasting relationship with him was Henry Roderick Newman, a member of the Association for the Advancement of Truth in Art who, from 1870 onward, spent most of his life in Europe, settling eventually in Florence. Ruskin first saw Newman's work—buying several examples—in 1877, and two years later the two men met and subsequently undertook sketching tours of Italy together. One of Newman's specialties was architectural subjects (plate 303), and many of these were made specifically for Ruskin's St. George Museum, which was dedicated to collecting watercolors and drawings of ancient structures threatened with destruction or defacement.

By the 1880's, however, Ruskin's influence had run its course, even in the American art world. The cultural upheavals that were occurring in Paris and elsewhere in Europe would soon render all this provincial, yet so far as the history of watercolor is concerned, the American Pre-Raphaelites had made a real, if small, contribution. Looking at their achievements, it is easy to see that America was on the verge of finding its eventual place in the art world at large.

New Currents

304. Maurice Prendergast
May Day, Central Park, c. 1901
Detail of plate 345

There is a book to be written about the history of *plein air* painting and the furor it caused in nineteenth-century art circles. There are still plenty of artists who set up their easels on the streets of Montmartre, or on the quays of picturesque seaports around the globe, but the knowing observer suspects such artists of being amateurs or of pandering to the tourist trade, for the notion of open-air painting as a radical activity was knocked for a loop in the early years of the twentieth century, when first the Fauves and Expressionists did away with naturalistic color, then Cubists took avant-garde art back into the studio. Even while this revolution was happening, however, Monet was still moving from easel to easel in his garden, seeking to catch the light at just the right moment. As a younger man, he would stand out in the snow, his hands frozen, trying to catch the fugitive effects of winter sunlight on an ice-bound landscape. In this he was following the lead of the Barbizon painters, who had learned the value of painting directly from nature largely from the British School, and within the British School it was watercolorists who had led the way.

It was natural that this should be so, since British watercolor had grown out of topography, which was, almost by definition, a *plein air* activity. Yet the full extent of open-air painting by British watercolorists has perhaps been exaggerated. As has been seen, Turner mostly made black-and-white pencil studies from nature, then worked up finished watercolors back in the studio. Much the same seems to have applied to John Sell Cotman, though the documentary evidence is not so strong as with Turner, and Cotman did boast of working directly from nature. No doubt he made studies directly from nature, but the logic of his fully rendered paintings suggests that many of them must have been made—or at least finished—in the studio. It would be virtually impossible to lay in such even, firm-edged washes at an old-fashioned sketching easel. (The modern, fully adjustable sketching easel did not become available till mid-century.) A flat surface such as a table would be required. It is conceivable, of course, that Cotman worked at a portable table, but the improbability of this is compounded by the fact that it is clear he permitted each layer of wash to dry thoroughly before laying the next one over it. This made for a relatively slow and laborious approach that would have, in effect, undermined the whole point of *plein air* painting, the attempt to capture shifting effects of light and weather. These British pioneers were faithful to nature, but they were not averse to relying upon their visual memory. Even Constable—the patron saint of *plein air*—would use on-the-spot studies as the basis for studio watercolors sometimes made years later, as was the case with his *Stonehenge* (plate 77).

From the Barbizon painters onward, however, Constable's European admirers often took the *plein air* doctrine very literally, though some, such as Johan Barthold Jongkind, were transitional in this regard. Born in 1819 in the Netherlands, but domiciled principally in France, Jongkind was a key bridge between the Barbizon painters and the Impressionists. Like Constable, he made finished oil paintings in his studio, and like Constable—perhaps even more so—he based them on sketches made on the spot. His watercolors, indeed, are virtually all of the *plein air* variety. Compared with the work of almost all of his British contemporaries, they have a fresh, almost improvised feeling, as if they were set down very quickly, before the light changed. If a British influence is at work here, it is probably that of Bonington by way of Eugène Isabey, who was an early associate of Jongkind.

The *Jazon at Rotterdam* (plate 305) is a straightforward presentation of a harbor scene, economically described in bold strokes. There is no careful orchestrating of washes here. Rather, watercolor is employed as a succinct way of setting down information. Jongkind was a master of this approach to the medium and very influential because of it. *Windmills in Holland* (plate 306), too, is economical, atmospheric, calligraphic, and *The Quays of the River Seine in Paris* (plate 307) is a good example of the way pencil and watercolor can be combined to capture a scene with great rapidity. This is an instance of a painting in which Jongkind's debt to Bonington is clear. In subjects of this sort, Bonington had replaced the tautness of the topographical line with rapid calligraphy. Jongkind saw the potential of such a calligraphic approach and expanded upon it, leaving much more to the viewer's imagination.

Among the French artists influenced by Jongkind was Eugène Boudin, who, as a young man, ran a picture-framing and art-supply store in Le Havre, an occupa-

305. Johan Barthold Jongkind (1819–1891)
The Jazon *at Rotterdam*, n.d.
Watercolor and pencil on paper,
10³/₈ × 9¹³/₁₆ in. (26.4 × 25 cm)
Haags Gemeentemuseum,
The Hague

OPPOSITE, BOTTOM
306. Johan Barthold Jongkind
(1819–1891)
Windmills in Holland, n.d.
Watercolor and black crayon
on paper, 10³/₈ × 17³/₄ in.
(26.4 × 45.1 cm)
Fogg Art Museum,
Harvard University,
Cambridge, Massachusetts;
Bequest of Grenville L.
Winthrop

ABOVE
307. Johan Barthold Jongkind (1819–1891)
The Quays of the River Seine in Paris, n.d.
Watercolor on paper,
11³/₁₆ × 17¹⁵/₁₆ in. (28.4 × 45.6 cm)
Museum Boymans–van
Beuningen, Rotterdam,
The Netherlands

tion that brought him into contact with such artists as Thomas Couture and Millet, who encouraged him to paint. Later, he met Jongkind, Courbet, Corot, and the Impressionists, notably Monet, to whom he in turn offered encouragement. Boudin was a dedicated *plein air* painter, his favorite subject being the beaches at resorts such as Trouville (plate 308), which in summer were packed with fashionable tourists. Boudin is said to have despised these tourists as parasites, but so elegant is his brushwork in these beach scenes that he evokes a lost world with at least apparent affection. The artist he most recalls in these watercolors is Eugène Lami, yet another reminder of the pervasiveness of Bonington's influence in France.

A totally original watercolorist—as he was an original in so many other areas—was the great proto-Impressionist Edouard Manet. This is not to say that there was anything especially original about his technical approach to watercolor, but Manet used the medium with an assurance attributable chiefly to his confidence in his own means and aims, no matter what medium he was working in.

Related to *The Absinthe Drinker*, an oil painting rejected by the Salon in 1859, *The Man in the Tall Hat* (plate 309) is a relatively early work that shows how Manet was already capable of making a skillful character study with a minimum of fuss or detail. Everything—from the way the hat sits on the man's head, to the way his face is shaded—is made to count. The same is true of *Study of Young Woman Reclining in a Spanish Costume* (plate 311), again a study for an oil, in which the "Maja"-like pose is captured almost without effort.

308. Eugène Boudin (1824–1898)
Figures on the Beach, n.d.
Pencil and watercolor on paper,
6⅝ × 10⅜ in. (16.8 × 26.4 cm)
Yale University Art Gallery,
New Haven, Connecticut;
Collection of Francis and
Ward Cheney

RIGHT
309. Edouard Manet (1832–1883)
*The Man in the Tall Hat (Study
for "The Absinthe Drinker")*, 1859
Watercolor on paper,
11⁷⁄₁₆ × 7½ in. (29 × 19 cm)
National Gallery of Art,
Washington, D.C.; Rosenwald
Collection

FAR RIGHT
310. Edouard Manet (1832–1883)
Lola de Valence, 1862
Wash, watercolor, and gouache
on paper, 10¹⁄₁₆ × 6¹³⁄₁₆ in.
(25.6 × 17.4 cm)
Musée du Louvre, Paris

311. Edouard Manet (1832–1883)
*Study of Young Woman Reclining
in a Spanish Costume*, 1862
Watercolor on paper,
6½ × 9¼ in. (16.5 × 23.5 cm)
Yale University Art Gallery,
New Haven, Connecticut;
Gift of John S. Thatcher

Many of Manet's major paintings were preceded by watercolor studies. In the case of *Lola de Valence*, for instance, several have survived, and the example reproduced here (plate 310) is very fully realized, containing all the essential elements of the finished oil. It is especially interesting to see how Manet finds equivalents for the extreme tonal contrasts that are so characteristic of his works on canvas. The use of gouache here helps give tonal definition, but essentially he manages by adjusting to the range of contrast available without disturbing the overall balance.

Jeanne Duval (plate 312) is a delicious little painting in which Manet mischievously exaggerates the expanse of the sitter's crinoline, turning her into a kind of earthbound human butterfly. If Manet was a realist before everything else, that does not mean he lacked wit; indeed, his ability to combine wit with social commentary is worthy of Guys. Obvious once again is his great feeling for the watercolor medium, especially its application as a form of rapid visual notation.

Manet was a relatively late convert to painting out of doors, not doing so as a conscious policy until the 1870s, but he seems to have made on-the-spot watercolor studies well before that, as can be seen from *Race Course at Longchamps* (plate 313), in which a very full and busy scene is captured from an unusual viewpoint, that of an observer standing in the center of the course. It could be argued, in fact, that while the rapidity of execution and sense of atmosphere suggest a sketch made on the spot, this unusual viewpoint indicates a more synthetic approach. He can hardly have placed himself in the middle of the race course, unless he did so between races and then added the horses later.

Portrait of Berthe Morisot (plate 314) is a beautiful, straightforward painting of Manet's great friend and fellow artist, who sat for him on a number of occasions. Deftly drawn with the brush, this is an example of a portrait that contains nothing but the essentials yet calls for nothing more. *Flower Piece with Golden Rain and Irises* (plate 315) is another exercise in economy.

315. Edouard Manet (1832–1883)
Flower Piece with Golden Rain and Irises, n.d.
Watercolor on paper,
13¹³⁄₁₆ × 10¹⁄₁₆ in.
(35.1 × 25.6 cm)
Graphische Sammlung
Albertina, Vienna

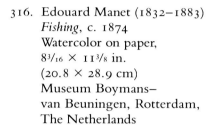

316. Edouard Manet (1832–1883)
Fishing, c. 1874
Watercolor on paper,
8³⁄₁₆ × 11³⁄₈ in.
(20.8 × 28.9 cm)
Museum Boymans–
van Beuningen, Rotterdam,
The Netherlands

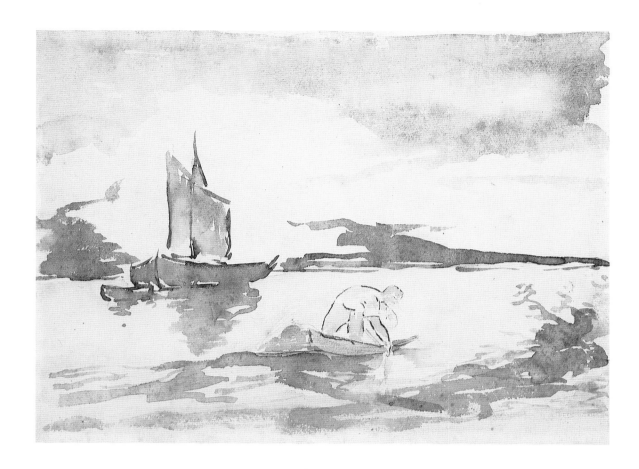

Even more striking is *Fishing* (plate 316), a sketch in which brevity of description makes for an almost abstract design. It may well be that this work reflects familiarity with Japanese prints, which were well known to the Impressionists and their friends by this date. Brevity of this sort was not unknown to Turner, of course, but in general the British School had employed watercolor to make "complete" statements rather than notations. During the heroic period of the British School, such completeness was tempered by a belief in economy of means—a Cotman did not smother his images with detail—but there was always the sense that watercolor must compete, at some level, with oil paint. French artists, by contrast—from Delacroix on—did not seem to be encumbered by such notions. Many of them treated watercolor as something very different from oil paint: neither better nor worse, but different, as a croissant is different from cassoulet. In Manet's watercolor, this Gallic attitude is very evident.

The same can be said of Berthe Morisot's *Harbor Scene* (plate 317), a wonderfully fluid evocation of boats and water that demonstrates how accomplished a watercolorist Morisot was, though she was not especially prolific in the medium. There is just enough information here to get the job done, yet getting the job done includes not only the essential task of description but also the evocation of atmosphere. There is no doctrinaire deployment of Impressionist techniques here, yet this watercolor is full of the light and air and freshness associated with the movement in its prime.

It is regrettable that Edgar Degas did not work more frequently in water-based paint. Watercolor, one suspects, would have lent itself very well to his inherently elegant approach. In general, however, he preferred to work in *essence*—oil paint thinned almost to the consistency and transparency of watercolor—which served him more than adequately. Occasional gouaches, such as *Portrait of Julie Bellelli* (plate 318), display a not surprising kinship with Manet's watercolors. Degas's most

317. Berthe Morisot (1841–1895)
Harbor Scene, n.d.
Watercolor over pencil on
paper, 8$\frac{1}{8}$ × 10$\frac{1}{2}$ in.
(20.6 × 26.7 cm)
Sterling and Francine Clark
Art Institute, Williamstown,
Massachusetts

318. Edgar Degas (1834–1917)
Portrait of Julie Bellelli, 1860
Pencil and oil wash on paper
mounted on wood panel,
15 × 10$\frac{1}{2}$ in. (38.5 × 26.8 cm)
Dumbarton Oaks Research
Library and Collections,
Washington, D.C.

interesting works in gouache or watercolor, however, are the fans he made under the influence of Japanese art. In *La Farandole* (plate 319), familiar Degas subject matter—dancers and stage scenery—is treated with a breezy looseness. The composition seems casual, but the limbs of the dancers overlap to form marvelous patterns that can hardly be considered accidental. Clearly, Degas had recognized the importance of apparent informality in Japanese art (that is to say, the appearance of informality that is, in fact, rooted in strict discipline) and caught this tone beautifully in works such as this fan.

Auguste Renoir was a far more prolific watercolorist than Degas, and his works in the medium show how Impressionist techniques could be modified to suit watercolor. When working in oil, the Impressionists frequently set colors side by side, rather than mixing them on the palette, in order to preserve their chromatic purity. The viewer's eye, they theorized, would do the mixing. Watercolorists, of course, had been relying on this principle for decades, and Renoir understood it very well. When working in watercolor he would set dabs of complementary color side by side, to a degree, but he would also allow colors to overlap, so that the white of the support, reflecting through the transparent washes, would permit the colors to be mixed optically. In short, he employed some of the characteristic mannerisms of Impressionism but was flexible enough to blend them with orthodox watercolor practice.

Fishing Village (plate 320) shows how well Renoir could use the paper support, also how beautifully he was capable of drawing with the brush. The coloration is typical of Renoir, with purples predominating, but it is the use of untouched white that is most effective. *River Scene* (plate 321) is a work in which color—especially rich in this case—seems to dissolve form. Although the format is conventional, with a centrally placed horizon line, this little watercolor anticipates the glories of Monet's great water lily paintings.

319. Edgar Degas (1834–1917)
La Farandole, before 1879
Gouache on silk over cardboard highlighted with gold and silver, 12 × 24 in. (30.5 × 61 cm)
Private collection

320. Auguste Renoir (1841–1919)
Fishing Village, n.d.
Watercolor on paper,
5$^{1}/_{2}$ × 9$^{3}/_{8}$ in. (14 × 24 cm)
Musée du Louvre, Paris

321. Auguste Renoir (1841–1919)
River Scene, 1890
Watercolor on paper,
9$^{15}/_{16}$ × 13$^{5}/_{16}$ in.
(25.3 × 33.8 cm)
Graphische Sammlung
Albertina, Vienna

322. Camille Pissarro (1830–1903)
The Funeral of Cardinal Bonnechose at Rouen, n.d.
Watercolor on paper,
8¹⁵/₁₆ × 11¹¹/₁₆ in.
(22.8 × 29.5 cm)
Musée du Louvre, Paris

Camille Pissarro's *The Funeral of Cardinal Bonnechose at Rouen* (plate 322) is another example of the French tendency to treat watercolor as a form of suggestive notation. Here the subject makes for an unusual but effective composition. The black clothes of the mourners become a strong compositional element, especially where they are silhouetted against the chilly-looking waters of the Seine. The most powerful design element, however, is the sweep of the road, as it turns to follow the river, a form that is emphasized because Pissarro has treated the figures in the cortege differently from those who are watching, making the former liquid and schematic, the latter static and somewhat more solid. There is no logic to this, given that it is is presumably a slow-moving procession, but the treatment works, as does the overall color scheme, which is suggestive of a drab, overcast day.

An Impressionist who deserves to be better known is Marie Bracquemond. Like Berthe Morisot and Mary Cassatt, she took naturally to the advanced tendencies of her day, but her career was cut short by marriage, her husband apparently disapproving of the idea of a woman being a professional artist. She continued to paint after marriage, but more as a hobby, abandoning oils and larger formats for

323. Marie Bracquemond
(1841–1916)
Interior of a Salon, 1890
Watercolor on paper,
18$^{1}/_{2}$ × 8$^{1}/_{2}$ in. (47 × 21.6 cm)
Musée du Louvre, Paris

324. Paul Signac (1863–1935)
Lorient, n.d.
Watercolor on paper,
11⁷/₁₆ × 17⁵/₁₆ in.
(29 × 44 cm)
Musée du Louvre, Paris

the more acceptable "amateur" medium of watercolor. *Interior of a Salon* (plate 323) is a highly accomplished sheet in which a domestic interior is brought to life through deft brushwork and an understanding of light that invests the subject with a strong sense of space.

As a painter in oils, Paul Signac is best known as Seurat's chief lieutenant and the most explicit advocate of divisionism. He was also, however, a prolific watercolorist, and—while he occasionally applied divisionist principles to his work in the medium—his watercolors tend to be much freer in approach than his works on canvas. Indeed, he is one of the classic examples of the kind of French artist who treated watercolor as a form of shorthand, calligraphic notation, evoking with a few quick strokes what a British artist would have built systematically from washes. These French artists were not ignorant of how to build from washes, but, as already noted, they excelled at suggestion rather than precise description and, in effect, evolved a new logic for the medium, one that took advantage of its properties but deployed them in a different way. In *Lorient* (plate 324), Signac uses brush-drawn line rather than blocks of wash as his chief descriptive tool, yet he still relies on transparency of color, and especially on the value of white paper, to infuse the subject with light and atmosphere.

Henri de Toulouse-Lautrec presents something of a different case, since his watercolors are essentially colored drawings. Artists like Signac and Berthe Morisot used the brush-drawn line to describe form, but they did so in an essentially painterly way. Lautrec, in his watercolors, used line to define the outlines of forms, then added pigment to help create solidity and to provide local color. His is the approach of a brilliant graphic artist. *Yvette Guilbert Taking a Curtain Call* (plate 325) needs only a little more definition to be translated into a poster.

Isaäc Israëls, a Dutch artist influenced by Impressionism, had some of Toulouse-Lautrec's ability to animate through the use of line. *Lady with a Cigarette, Reading* (plate 326) is quite painterly, yet it is the chalk underdrawing that brings the

RIGHT
325. Henri de Toulouse-Lautrec
(1864–1901)
*Yvette Guilbert Taking a Curtain
Call*, 1894
Watercolor and crayon on paper,
16³/₈ × 9 in. (41.6 × 22.9 cm)
Museum of Art, Rhode Island
School of Design, Providence;
Gift of Mrs. Murray S.
Danforth

OPPOSITE
326. Isaäc Israëls (1865–1934)
Lady with a Cigarette, Reading, n.d.
Watercolor and chalk on paper,
20 × 13¹³/₁₆ in. (50.8 × 35.1 cm)
Rijksmuseum Kröller-Müller,
Otterlo, The Netherlands

327. William McTaggart
(1835–1910)
Children Paddling, 1877
Watercolor on paper,
13½ × 20½ in.
(34.3 × 52.1 cm)
National Gallery of Scotland,
Edinburgh

sitter to life. The use of washes, however, with some exploitation of wet into wet, is effective and shows that Israëls was very much at home with watercolor. Another provincial Impressionist who made extensive use of watercolor was the Scotsman William McTaggart. He claimed to have arrived at his style without benefit of French models, and certainly he has a distinct accent of his own, but there is no doubt that the directness of his method, especially with regard to watercolor, had a good deal in common with his Parisian contemporaries. *Children Paddling* (plate 327) is a notation very much in the French style, though in its briskness of handling and its feeling for fresh air, it also harks back to David Cox. The treatment of the ocean is especially noteworthy. McTaggart has laid it in with broad, bold strokes, leaving the tooth of the paper to gleam through to represent surf and reflected sunlight.

James Abbott McNeill Whistler was born in 1834 in Lowell, Massachusetts, the son of an engineer, and spent several years in St. Petersburg, Russia, before entering the U.S. Military Academy at West Point. His academic work there was found unsatisfactory, and he was discharged. At the age of twenty-one he left the United States for the last time, heading first to Paris, where, as an art student, he was befriended by Gustave Courbet and Henri Fantin-Latour. After working under Courbet's influence he came to know and be accepted as an equal by the advanced artists of his generation, including Manet, Monet, and Degas. He continued to maintain close contact with the Paris art world throughout his career, but from 1859 onward he was based in London, where he found patrons while also making many enemies among those who disliked his avant-garde views and the razor wit with which he dismissed his opponents. His battle with the British establishment culminated in a notorious court case in which he sued John Ruskin for libel, the critic having likened Whistler's work to "flinging a pot of paint in the public's face." (After a financially ruinous proceeding, Whistler won the case, though he was awarded token damages of only one farthing.)

Whistler did not take early to watercolor, though he made some solid sketches in the medium during his Courbet period and at least one exercise in *ukiyo-e* style,

Study for "The Balcony" (plate 328), after he first encountered Japanese prints. His real watercolor career began around 1879 when, after the Ruskin trial, he made an extended sojourn in Venice. Like so many other artists before him, he found that watercolor was ideally suited to capturing Venice's moods, and when he returned to England he discovered that it was equally well suited to the moods of London, so influenced by climate and the burning of bituminous coal. Whistler was already famous for his mood pieces—the nocturnes, for example—with London for their elusive subject matter. Now he added to his catalogue of mood pieces, but on a tiny scale and in watercolor.

No one fuses the French and English schools better than Whistler, as is very apparent from *Grey and Silver: Chelsea Embankment* (plate 329), in which the delicate dragged washes derive from British practice, while the figures on the embankment

328. James Abbott McNeill Whistler
 (1834–1903)
 Study for "The Balcony," c. 1865–67
 Watercolor on tracing paper,
 24¹³/₁₆ × 19⅝ in. (63 × 49.8 cm)
 The Hunterian Art Gallery,
 University of Glasgow;
 Birnie Philip Bequest

329. James Abbott McNeill
Whistler (1834–1903)
*Grey and Silver: Chelsea
Embankment*, c. 1885–90
Watercolor on paper,
5 × 8½ in. (12.7 × 21.6 cm)
Sterling and Francine Clark
Art Institute, Williamstown,
Massachusetts

330. James Abbott McNeill
Whistler (1834–1903)
Little Scheveningen, n.d.
Watercolor on paper,
6¹¹/₁₆ × 10 in. (17 × 25.5 cm)
Museum of Fine Arts, Boston;
Gift of Walter Gay

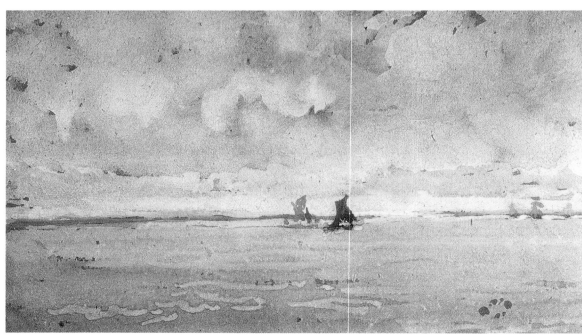

OPPOSITE
331. James Abbott McNeill
Whistler (1834–1903)
*Note in Pink and Purple: The
Studio*, n.d.
Watercolor on paper,
12 × 9 in. (30.5 × 22.9 cm)
Freer Gallery of Art,
Smithsonian Institution,
Washington, D.C.

are notations in the French style. The exquisite silhouette of the Albert Bridge in the
background, however, is all Whistler.

One thing that sets Whistler apart from the typical Victorian watercolorist is
his predilection for low-keyed color medleys. Earlier watercolorists like Girtin and
Cotman had also tended to favor relatively low-keyed color schemes, but as the
nineteenth century wore on, British watercolorists had attempted to intensify their
palettes in order to compete with oil paintings. Whistler felt no such pressure, and
in fact his own oil paintings were themselves low-keyed, sometimes orchestrated
from a range of grays that were in fact subtly tinted with blue, ocher, or green. It
was an approach ideally suited to watercolor, and even when he introduced more
definite color, as in *Note in Pink and Purple: The Studio* (plate 331), he did so with
great discretion, never upsetting the overall harmony.

Whistler's most striking watercolors, as a group, are his seascapes and beach

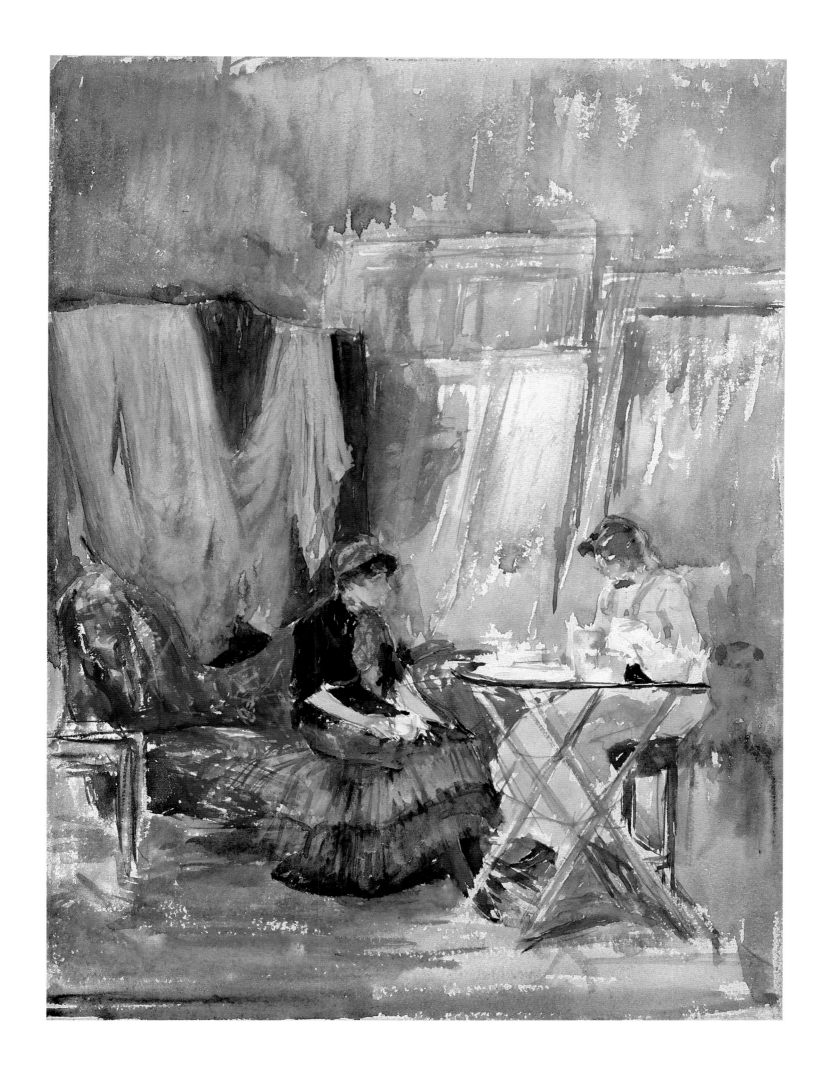

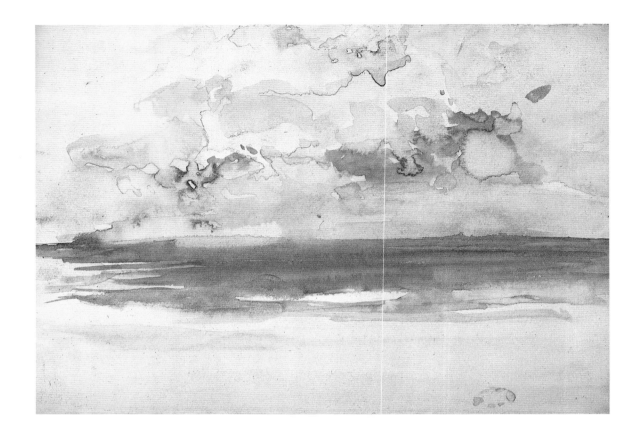

332. James Abbott McNeill
 Whistler (1834–1903)
 The Ocean Wave, c. 1883
 Watercolor on paper,
 5 × 6¹⁵/₁₆ in. (12.7 × 17.6 cm)
 Freer Gallery of Art,
 Smithsonian Institution,
 Washington, D.C.

scenes. *Little Scheveningen* (plate 330) is a classic instance, in which extreme simplicity conceals great technical control. The understanding of calligraphic understatement shown here is infinitely more Oriental in spirit than the large paintings into which he sometimes introduced Japanese motifs. In *The Ocean Wave* (plate 332), Whistler carried understatement even further. He may have been recalling Courbet's striking paintings of waves breaking on the shore, but here the subject is simplified to an extreme degree, the ocean suggested even more economically than in McTaggart's *Children Paddling* (plate 327), the sky made up of splotches of wet-upon-wet wash. Again the brevity of the treatment recalls French watercolors of the period, yet at the same time the way the image is built from washes—however cursory—reminds the viewer of Whistler's debt to the British tradition.

Whistler's seascapes are classic examples of *plein air* painting. The watercolors of his great contemporary Winslow Homer present a more ambiguous case; while many of them were made on the spot, the subject matter in some instances suggests that memory must have played a part in synthesizing the final image.

Two years younger than Whistler, Winslow Homer had a career very different from that of his fellow New Englander. Born in Boston, he was apprenticed to a local lithographer, then moved to New York, where he became a successful free-lance illustrator, working for magazines such as *Harper's Weekly*, which specialized in wood-block illustrations. In this capacity he covered the Civil War, which provided him with the subject matter for his first oil paintings. His *Prisoners from the Front*, exhibited in 1866, established his reputation as a painter. That same year, he sailed for France, where he remained for close to twelve months. Some of the oils he painted on his return to New York bear a passing resemblance to early Impressionist canvases, but there is no evidence to suggest that Homer had any contact with advanced French artists. Private to the point of secrecy, Homer was not given to making pronouncements about art (though he did once allow that he wouldn't cross the street to look at a Bouguereau). The evidence of his own work, in the decade or

so following this French visit, suggests that, far from being influenced by his European contemporaries, he was concerned with forging his own strain of Yankee realism.

During this period he began to work in watercolor, but the real flowering of his watercolor style came after 1881, when he returned to Europe, this time spending almost two years in a North Country fishing village, Cullercoats, near Tynemouth, England. While in England, he exhibited at the Royal Academy, and there is reason to suppose that he saw a good deal of British watercolor art, though, characteristically, he left no clues as to which artists he admired. In any case, the remarkable thing about Homer is that the more he was exposed to other people's art, the more he became himself. British watercolorists may have shown him what the medium was capable of, but they never deflected him from his personal vision.

By the time Homer, aged forty-seven, returned to America, settling now in Maine, he had become a watercolorist of enormous accomplishment, and during the quarter-century that remained to him, he turned out scores of masterpieces, becoming one of the greatest of all exponents of the medium, an artist who revived the glories of the British School while translating them into a language that could capture the majesty of the North American wilderness and the glare of the Caribbean.

Homer showed a single painting at the American Society of Painters in Water Color as early as 1871, but he seems to have first used the medium extensively in 1873, while summering in Gloucester, Massachusetts. Many of these Gloucester watercolors served as the basis for wood-block prints, and they had a somewhat graphic feel about them, line defining the image—though color is always skillfully applied. By 1878 he was making genre scenes, such as *Shepherdess Tending Sheep* (plate 333), that held up more convincingly as pure watercolors, the forms now emerging directly from his logical application of washes. At this point, his vision was somewhat conventional, but from a technical point of view he had become one of America's most accomplished practitioners.

During his sojourn in Cullercoats, however, there was a quantum leap in the quality of his watercolors, perhaps simply because he concentrated so hard on the medium for an extended period, perhaps because his exploration of a single, almost

333. Winslow Homer (1836–1910)
Shepherdess Tending Sheep, 1878
Watercolor on paper,
11⁹/₁₆ × 19³/₄ in. (29.4 × 50.2 cm)
The Brooklyn Museum;
Dick S. Ramsay Fund

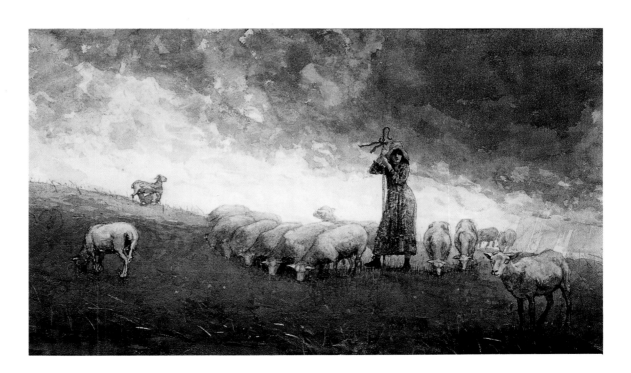

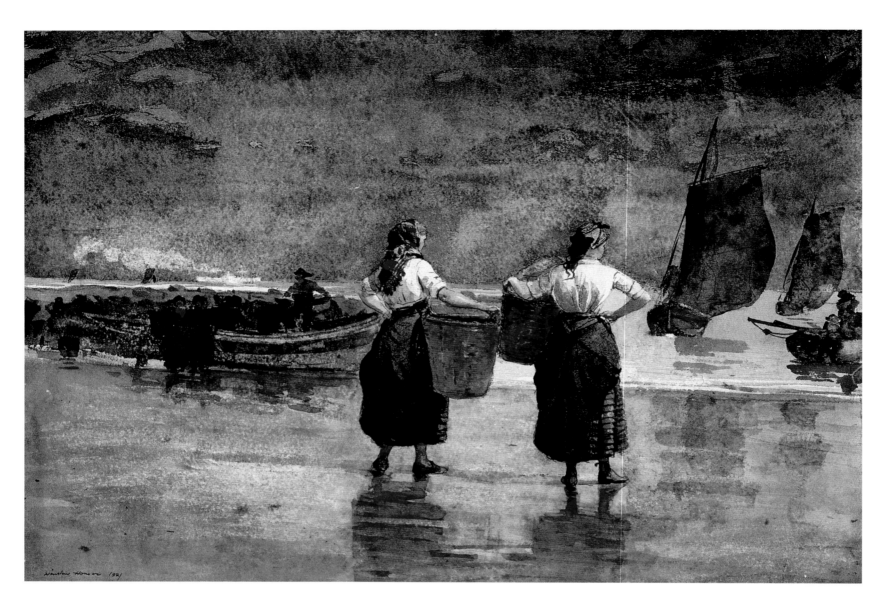

334. Winslow Homer (1836–1910)
Fisher Girls, Cullercoats, 1881
Watercolor on paper,
13⅛ × 19⅜ in.
(33.3 × 49.2 cm)
The Brooklyn Museum;
Museum Collection Fund

obsessive theme—the life of the fisherfolk of Cullercoats—provided him with impetus and focus. In particular, it was the women of Cullercoats who fascinated him, and time and again, as in *Fisher Girls, Cullercoats* (plate 334) and *Watching from the Cliffs* (plate 335), he painted the wives and daughters of the men who braved the fierce waters of the North Sea in their sturdy but vulnerable wooden cobles. Often these images are given a sense of drama by the depiction of stormy weather. The women, left on shore to mend nets or gut fish, can only watch as the menfolk brave riptides and waves breaking over the hidden sandbars. These are beautifully executed paintings (completed after his return to America) and show how thoroughly Homer had absorbed the lessons of British watercolor, not borrowing excessively from one source but rather arriving at a synthesis of much that was best about the British School, from the use of washes—here crisp-edged, there sponged and blotted—to the lyrical presentation of light and weather.

Indeed, there were few British watercolorists in the 1880s who could approach Homer's power in the medium, in large part because he had managed to do away with much of the fussiness of Victorian watercolor and return to the purity of the approach that had prevailed in the first quarter of the century. If he still had one Victorian habit of mind to discard, it was the need, evident in the Cullercoats paintings, to introduce a literary element into the work, to place his fisherwives in novelistic situations. He succeeded in ridding his work of such literary baggage al-

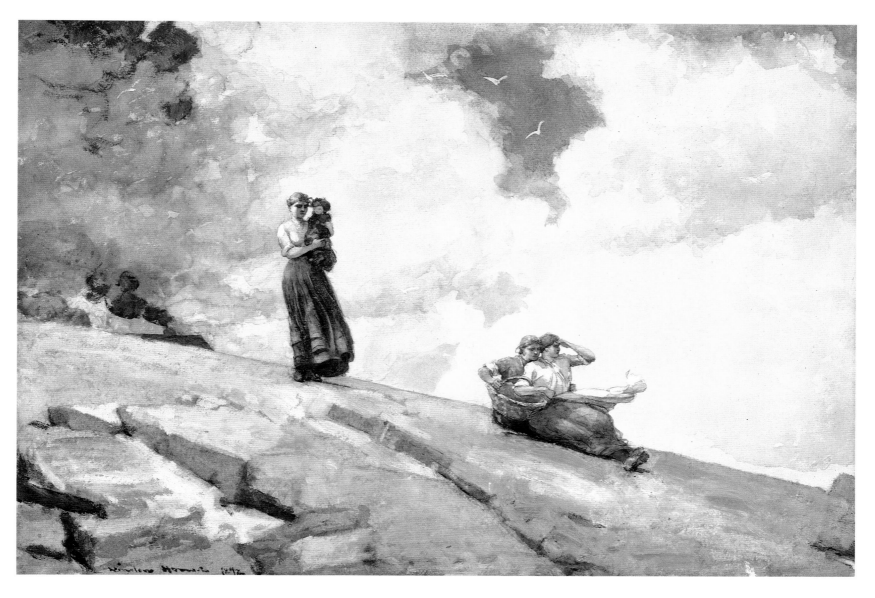

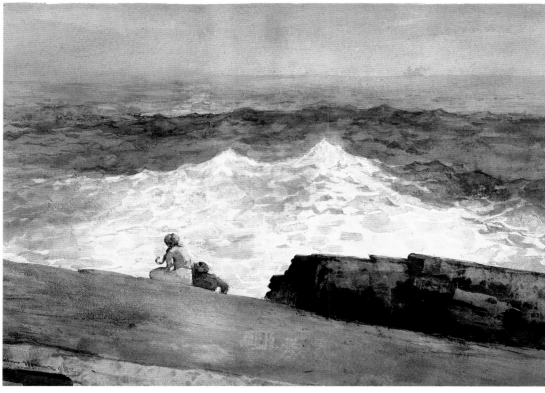

335. Winslow Homer (1836–1910)
Watching from the Cliffs, 1892
Watercolor on paper,
14 × 20 in. (35.6 × 50.8 cm)
The Carnegie Institute
Museum of Art, Pittsburgh

336. Winslow Homer (1836–1910)
The Northeaster, 1883
Watercolor on paper,
14⅛ × 19¾ in. (35.9 × 50.2 cm)
The Brooklyn Museum;
Bequest of Sidney B. Curtis in
memory of S. W. Curtis

most as soon as he returned to the United States. The shift is already apparent in *The Northeaster* (plate 336), a study of the Maine coast. The fierceness of the Atlantic is captured as skillfully as Homer had captured the fury of the North Sea, but the pictorial concept here is quite different. Instead of placing sentimentalized, heroically posed fisherwomen in the foreground, Homer positions two smallish figures of no special literary import—they may be tourists—in the middle ground. The psychological impact is quite different. Instead of a human drama played out against a backdrop of ocean, the viewer is now given the drama of the ocean itself. Just as he had rediscovered the power available to the watercolorist who avoided the fuss of Victorianism, so now he transcended Victorian taste and replaced it with something like the unforced awe that Turner felt when confronting the Alps.

In the last three decades of his life, Homer confronted untamed nature again and again, on trips to the North American wilderness, notably in the Adirondacks and Quebec, and on winter stays in more exotic locales, such as Cuba and the Bahamas. *Saguenay River, Lower Rapids* (plate 337) is typical of many of the watercolors Homer made in Canada. Once again rough water excites his brush, and once again, as at Cullercoats, there is an element of danger for those who brave the water. But there are no heroically posed observers to hammer the point home. The rocks and rapids, the canoes and tree-clad slopes are permitted to tell the whole story. And the story is told with an economy that is astonishing, the swirling waters suggested with the barest of means. The classic British method still provides Homer

337. Winslow Homer (1836–1910)
Saguenay River, Lower Rapids,
1897
Watercolor over graphite on
off-white wove paper,
14 × 20¹⁵/₁₆ in.
(35.6 × 53.2 cm)
Worcester Art Museum,
Worcester, Massachusetts

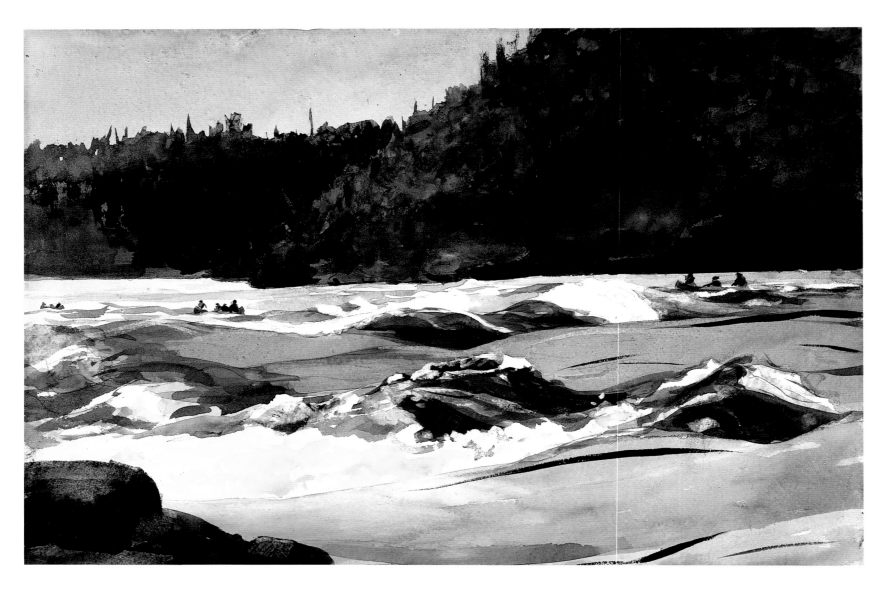

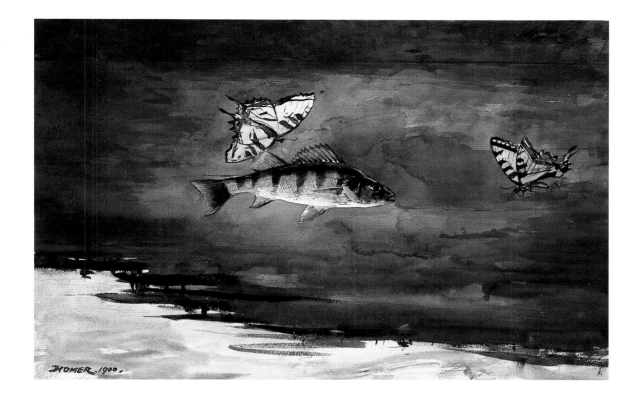

338. Winslow Homer (1836–1910)
Fish and Butterflies, 1900
Watercolor over pencil on
paper, 14¹/₂ × 20¹¹/₁₆ in.
(36.8 × 52.5 cm)
Sterling and Francine Clark
Art Institute, Williamstown,
Massachusetts

with his basic tools, but here he grafts onto it a calligraphic liveliness that matches anything found in the French School.

It may be assumed that this painting was made on the spot, from a campsite, perhaps, but the question of *plein air* painting rises again when the viewer is confronted with such related subjects as *Fish and Butterflies* (plate 338). Here a yellow perch and two monarch butterflies are juxtaposed against a dark ground. Presumably, the conjunction relates to something Homer saw while fishing, yet clearly he must have reconstructed it from memory, probably with the aid of freshly caught fish and butterflies. Even if the subject depends entirely on artifice, however, it is painted with such freshness that it hardly matters.

Very much the same applies to *Sharks* (plate 339), a product of Homer's 1884–85 trip to Cuba and the Bahamas. Whether he actually witnessed such a scene as portrayed here is not known. Clearly, he must have seen sharks at close range and presumably made notations of some kind, but it seems likely that this watercolor was made after the fact and largely from memory. (The thematically linked *The Gulf Stream*, perhaps Homer's best-known work, was not painted till 1899.)

Some of Homer's West Indian watercolors are positively sybaritic in their celebration of tropical color. The blue of the water in *Coral Formation* (plate 340) has an intensity foreign to European or North American seascapes, and Homer revels in the way the sun shining down through gaps in the overcast makes vivid patterns in both middle ground and background. The red tunics of the British soldiers on the sun-dappled rock formations (the setting is Bermuda) add an unexpected note of contrast and help provide the picture with a sense of scale.

After Cullercoats, however, Homer seems to have been obsessed with rough water, and even when traveling to southern climes he sought out such subjects as *Shore and Surf, Nassau* (plate 341), an acute piece of observation in which the color of the water and the placement of the surf tell much about the character of this lagoon, with its potentially lethal reefs. In one sense, this is a classic watercolor in the British tradition, but with a vigorous Yankee accent. Yet it is more than that. In its absolute simplicity and directness, this work stands on the threshold of the twen-

OPPOSITE, TOP
340. Winslow Homer (1836–1910)
Coral Formation, 1901
Watercolor over graphite on
off-white wove paper,
14 × 21 in. (35.6 × 53.4 cm)
Worcester Art Museum,
Worcester, Massachusetts

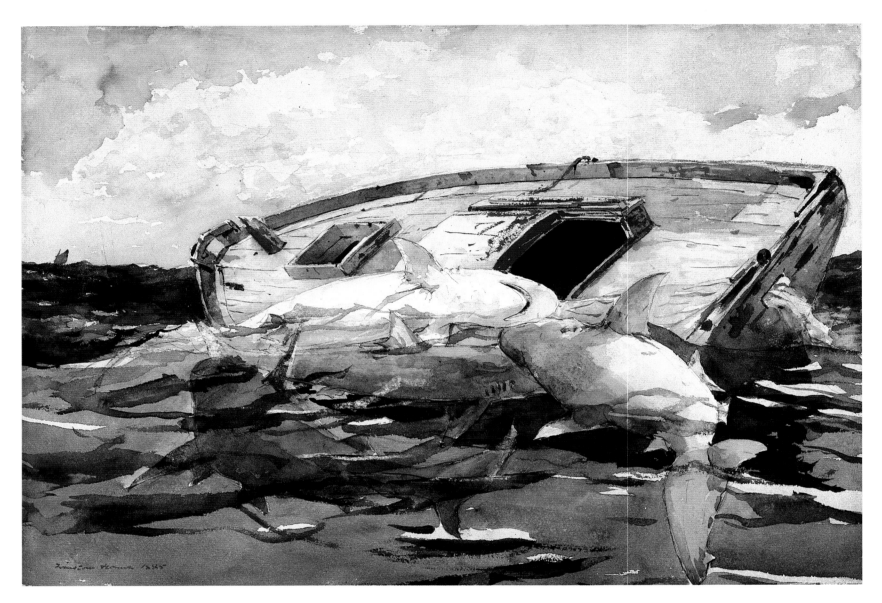

339. Winslow Homer (1836–1910)
Sharks (The Derelict), 1885
Watercolor over pencil on
paper, 14¹/₂ × 20¹⁵/₁₆ in.
(36.8 × 53.2 cm)
The Brooklyn Museum;
Bequest of Helen B. Sanders

OPPOSITE, BOTTOM
341. Winslow Homer (1836–1910)
Shore and Surf, Nassau, 1899
Watercolor on paper,
15 × 21³/₈ in. (38.1 × 54.3 cm)
The Metropolitan Museum of
Art, New York; Amelia B.
Lazarus Fund, 1910

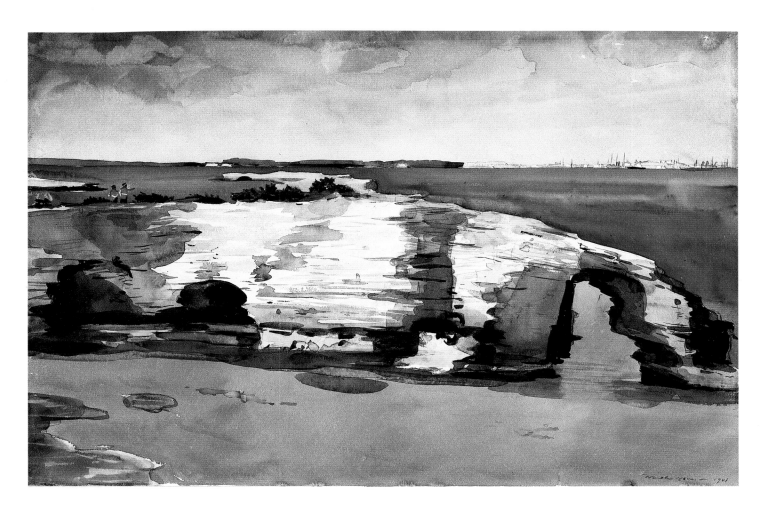

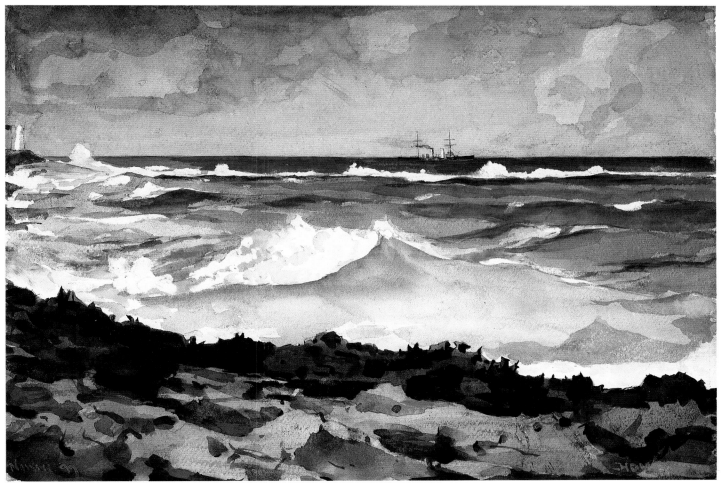

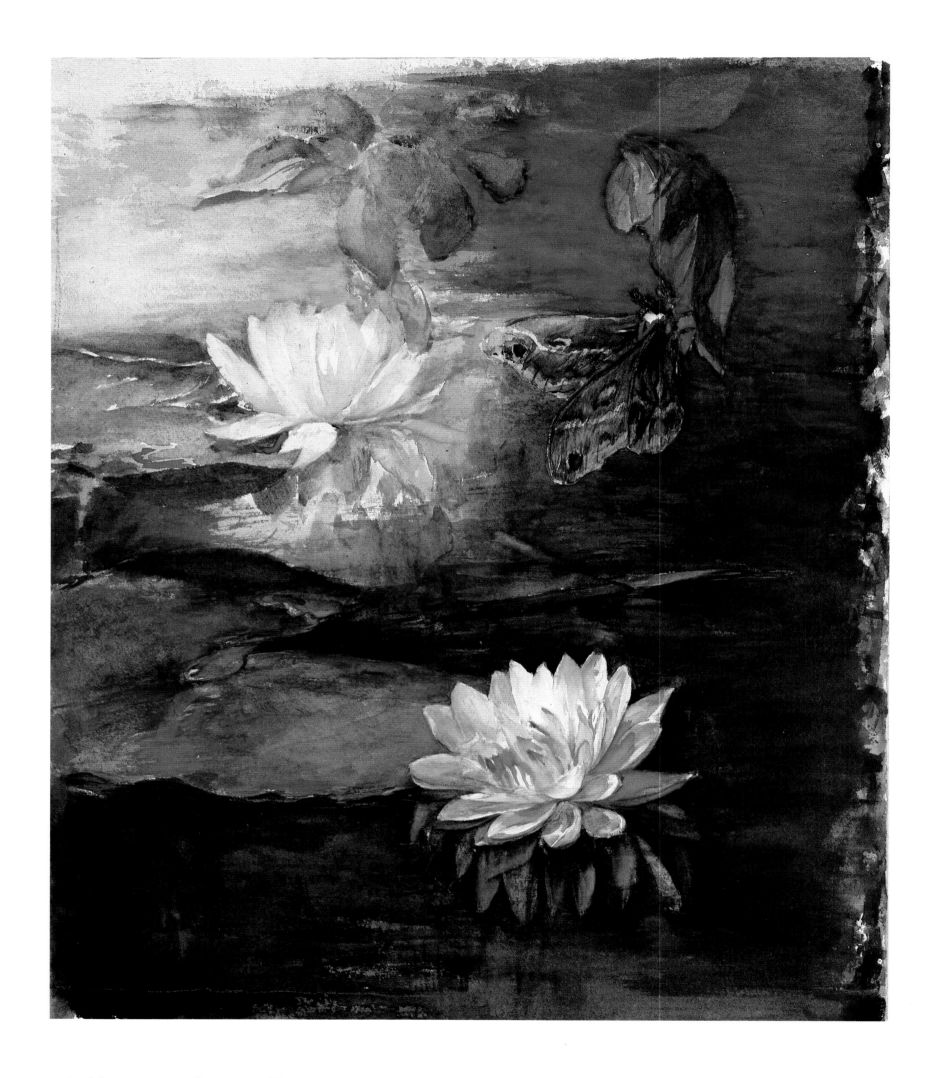

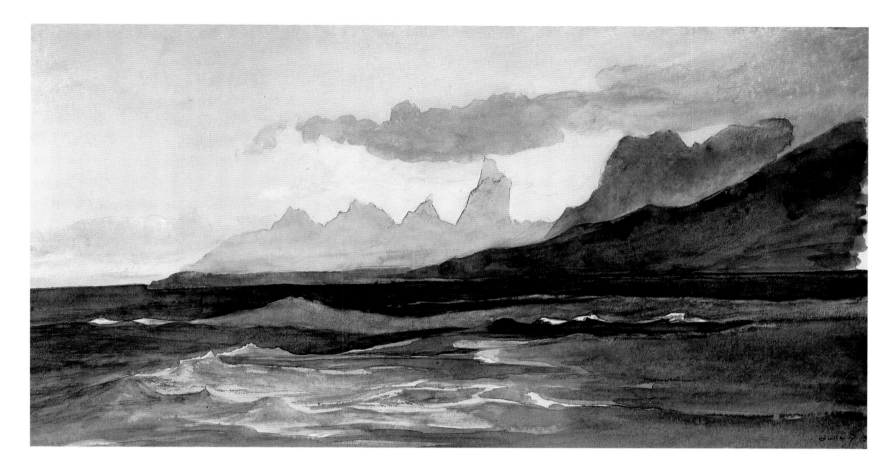

tieth century. In particular, it is a powerful representative of a new kind of realism—unadorned and without cultural ballast deriving from the Renaissance or the Enlightenment—that would thrive in the United States while European artists sought escape in fragmentation and antirealism. Homer was the culmination of the classic watercolor tradition that began a century earlier, and at the same time, he was the first representative of a fresh, uncluttered vision.

Homer was not working in a vacuum, since American watercolor was moving from strength to strength during the late decades of the nineteenth century. His friend John La Farge was an easel painter, muralist, and designer of stained glass, yet he did some of his finest work in watercolor. *Water Lily and Moth* (plate 342) is a good example of the many densely painted nature studies he made, watercolors that have a chromatic range and concreteness unique to La Farge. One of the first Americans to appreciate Japanese art, La Farge traveled extensively in the Far East, making records of his trips in delightful, atmospheric sheets such as *The Last Sight of Tahiti: Trade Winds* (plate 343).

Childe Hassam was among the first Americans to fall fully under the influence of the French Impressionists, especially Monet, whose paintings he saw while a student in Paris. His work on canvas is often tentative, but he was a fluid watercolorist who began to make his mark in the last decade of the Victorian era, even though his greatest work in the medium was made after the turn of the century (plate 346).

Also influenced by the Impressionists and Post-Impressionists was Maurice Prendergast, who, in paintings of Venice, Boston (plate 344), and New York (plate 345), captured people in cityscapes, using a highly personal technique in which he juxtaposed dabs and slabs of color with broader areas of wash to create an almost mosaic effect—a technique well suited to capturing contrasts of light and shade.

If England had dominated watercolor at the beginning of the century, the most vigorous schools at the end of the century were to be found in France and the

344. Maurice Prendergast (1859–1924)
Carnival, Franklin Park, c. 1900
Watercolor on paper,
13 × 14¹/₂ in. (33 × 36.2 cm)
The Museum of Fine Arts,
Boston; Gift of the Estate of
Nellie P. Carter

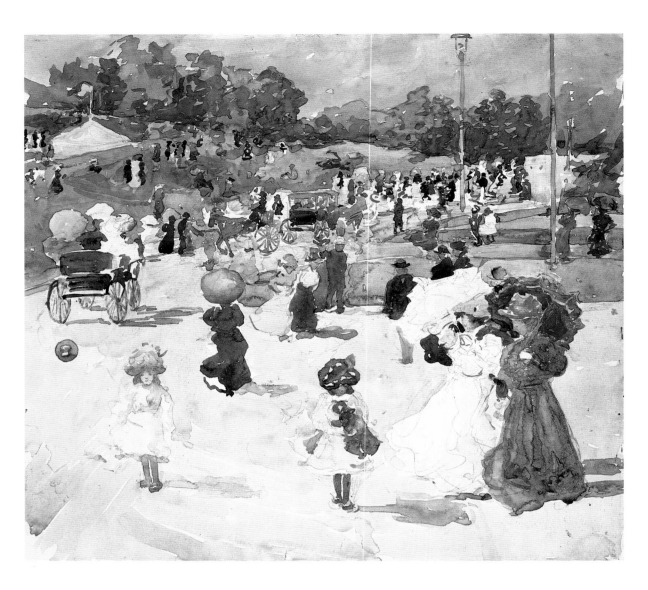

345. Maurice Prendergast (1859–1924)
May Day, Central Park, c. 1901
Watercolor on paper,
14¹/₂ × 21⁵/₈ in. (36.8 × 54.9 cm)
Whitney Museum of
American Art, New York;
Exchange

346. Childe Hassam (1859–1935)
Home of the Hummingbird, 1893
Watercolor on paper,
13³/₄ × 10¹/₈ in. (34.9 × 25.7 cm)
Mr. and Mrs. Arthur G. Altschul

United States. The American School would reach its peak in the twentieth century, with the continuing presence of artists like Homer, Hassam, and Prendergast being felt into the modern era, when they would eventually be replaced by talents like Edward Hopper and Charles Burchfield. The French watercolor tradition, on the other hand—as will be seen in the final chapter—may well have reached its greatest moments in the last two decades of the nineteenth century, spilling over into the twentieth as far as the deaths of Cézanne and Rodin.

TEN

Toward the Twentieth Century

347. Paul Cézanne
Still Life, c. 1900–1906
Detail of plate 369

When it comes to talking about watercolor, it makes perfectly good sense to isolate the nineteenth century, since it approximates the period in which the principal classic modes of watercolor evolved. The innovations of Girtin and Turner made the methods of the eighteenth century seem dated, yet the changes they inaugurated were complete by the advent of Cézanne's last period. The twentieth century brought radically new imagery, but little technical innovation, unless the combining of watercolor with other media, such as collage, is thought of as true innovation. (Collage was certainly an innovation, but its combination with watercolor was more of a convenience.) Essentially, it is true to say that the nineteenth century was the period during which the language of watercolor was forged.

When the visual arts of the nineteenth century are considered as a whole, however, no such coherence is evident, and it is probably useless to attempt a definition of nineteenth-century art, unless it is in terms of the persistence and growth of the battle between revolutionaries and the academy. As the century went on, the academics—whether in France, England, or Germany—became more and more set in their values. Although they sometimes reached a compromise with the establishment, advanced artists followed new idea with new idea, winning more and more supporters until, eventually, they had the momentum to demolish the walls of academicism. Those walls did not crack until the first decades of the twentieth century, but in retrospect it is possible to see how the destruction of the academies was in fact inevitable, so that the final phase of the nineteenth century—as enacted by artists like Gauguin, van Gogh, and Cézanne—has latterly been invested with a heroic glow. Deservedly so, no doubt, though from the perspective of the late twentieth century it is tempting to oversimplify things and transform the adventurous artists

348. Gustave Moreau (1826–1898)
Oedipus and the Sphinx, 1861
Watercolor on paper,
11³/₈ × 5⁷/₈ in. (29 × 15 cm)
Musée Gustave Moreau, Paris

of that generation into straw-hatted knights on a sacred quest. This view of the past is probably as foolish as the rigid notions about the modes of classical art once held by the academicians. The late nineteenth century was an enormously complex period in the European art world—perhaps more complex than any period before or since—and the seeds of modernism sometimes fell in curious places.

One of the lesser-known treasures of Paris is the Musée Gustave Moreau, formerly the home and studio of the artist, a hermetic retreat in which he worked on his obsessive images, largely isolated from the mainstream of the French art world. Like Dante Gabriel Rossetti, Moreau sought imaginative escape in the past, but, to an even greater extent than with Rossetti, this was a past of Moreau's own invention, in which Greek and Hindu myths took their place alongside Dante's *Inferno* and the Bible to inspire hybrid histories and mythologies. (In some ways, Moreau had much in common with William Blake.) To enter his former studio is to be plunged into a world of archaism expressed both by the paintings that hang there

349. Gustave Moreau (1826–1898)
Hercules and the Hydra of Lerna, 1870
Watercolor on paper,
9¹³/₁₆ × 7¹³/₁₆ in. (24.9 × 19.8 cm)
Musée Gustave Moreau, Paris

and by the architecture itself. Yet this was one of the cradles of modernism. Moreau, after all, was the teacher of Matisse and Rouault. More than that, though, he helped free young artists from what some of them were beginning to perceive as the shackles of realism, and in his watercolors he was an innovator who anticipated some of the approaches that would be favored by twentieth-century artists.

Near the start of his career Moreau made landscape watercolors in a somewhat British style and also scenes of social life rather in the manner of Guys. Soon, however, he turned to mythological subjects and began to construct his own world of monsters, heroes, and *belles dames sans merci*, often using watercolor both for studies and independent works. Early examples such as *Oedipus and the Sphinx* (plate 348) show that he possessed considerable fluency in the medium, a fluency that led to richer and richer statements such as *Hercules and the Hydra of Lerna* (plate 349) and *The Apparition* (plate 350).

In his most finished watercolors, Moreau sometimes came close to cataloguing the entire range of techniques that had been devised by his predecessors. In *Sappho, the Greek Poetess* (plate 351), for example, the background washes—notably those that make up the sky—are laid in with a purity and delicacy worthy of Girtin, yet in the foreground he uses stippling techniques as effectively as any High Victorian master, building up a jewellike surface. The image itself is entirely his own, owing little to established precedents. No one else would have draped the figure of Sappho over the rocks in quite this way, so that she seems to be half-supported, half-floating on air. In this way, he creates a visual metaphor for the poet's condition, earthbound, yet ready to soar.

In his later watercolors Moreau tended to use more innovative techniques, sometimes splashing and spattering paint onto the paper so that the image seems to grow out of apparently random spots and patches of color. The method anticipates those employed by *tachiste* painters more than half a century later. In many of these works, too, color is set free from its descriptive function and takes on a life of its own, again looking forward to twentieth-century practice. His version of *Leda* (plate 352) is very striking, the bodies of woman and swan entwined in a way that looks forward to the serpentine forms of Art Nouveau. The draftsmanship is assured—see, for example, the foreshortening of Leda's right leg—but most striking is the way in which parts of the image are freely brushed with gouache used in impasto.

Dead Lyres (plate 353) shows Moreau at his most *tachiste*, the image seeming to emerge from a web of dense brushstrokes that has a life of its own, independent of any descriptive function. The use of color here also displays Moreau's originality, the lush browns being relieved by ultramarine and orange. Often, too, Moreau would mix media in unorthodox and adventurous ways, as is the case in *Phaeton* (plate 354), where varnish is used in conjunction with watercolor. (Some of his watercolors have actually cracked because of his use of varnish.)

To his younger contemporaries, however, he was probably most significant because of his willingness to break so radically with the orthodox representation of reality, a willingness that has led to his being considered one of the fathers of the Symbolist movement. The notion that the artist could deal with a world beyond everyday reality would lead eventually to both abstraction and Surrealism, and in the latter part of the nineteenth century it was an idea whose time had come. If Moreau contributed to its dissemination, he may have done so almost despite himself—though his record as a teacher calls this into doubt.

Paul Gauguin, on the other hand, was clearly conscious that he was playing a prophetic role. To define that role briefly, however, is virtually impossible. Gauguin

OPPOSITE
350. Gustave Moreau (1826–1898)
The Apparition, 1876
Watercolor on paper,
41⁵/₁₆ × 28⁵/₁₆ in.
(104.9 × 71.9 cm)
Musée Gustave Moreau, Paris

ABOVE
351. Gustave Moreau (1826–1898)
Sappho, the Greek Poetess, n.d.
Watercolor on paper,
7¹/₄ × 4⁷/₈ in.
(18.4 × 12.4 cm)
Victoria and Albert Museum,
London

LEFT

352. Gustave Moreau (1826–1898)
Leda, n.d.
Watercolor, pen and ink, and
white gouache on paper,
13³⁄₈ × 8¹⁄₄ in. (34 × 21 cm)
Musée Gustave Moreau, Paris

BELOW

353. Gustave Moreau (1826–1898)
Dead Lyres, n.d.
Watercolor on paper,
14³⁄₄ × 9¹³⁄₁₆ in. (37.5 × 24.9 cm)
Musée Gustave Moreau, Paris

OPPOSITE

354. Gustave Moreau (1826–1898)
Phaeton, n.d.
Watercolor heightened with
white and varnish on paper,
39 × 29¹⁄₂ in. (99 × 75 cm)
Musée du Louvre, Paris

355. Paul Gauguin (1848–1903)
Study for a Fan after Cézanne,
before 1885
Gouache on canvas,
10$^{15}/_{16}$ × 21$^{13}/_{16}$ in. (27.8 × 55.4 cm)
Ny Carlsberg Glyptotek,
Copenhagen

356. Paul Gauguin (1848–1903)
Parau Hanohano [*Fearful Words*], 1892
Watercolor on paper,
6$^1/_{16}$ × 8$^5/_8$ in. (15.4 × 21.9 cm)
The Fogg Art Museum,
Harvard University,
Cambridge, Massachusetts;
Bequest of Grenville L. Winthrop

was an example to the young Symbolists and a visionary who dreamed of artists'
communities where like minds could stimulate one another to a new independence
of outlook. He challenged everyday reality in a variety of ways, liberating color
from its descriptive functions and placing a new emphasis on decorative, two-
dimensional representation as opposed to the various attempts to render the third
dimension accurately that had dominated European art since the Renaissance.
Gauguin's conscious ambitions were complicated by his inner drives, his flight from
his bourgeois past, his attempts to find refuge in the primitivism of Brittany and
the South Seas.

Study for a Fan after Cézanne (plate 355) is an intriguing and unusual work, made shortly after he finally gave up his career as a stockbroker. In it, his friend Cézanne's imagery is given an Oriental flavor that permits the viewer to see it in a new light. Gauguin's finest watercolors were made in Tahiti, however. In some instances, such as *Parau Hanohano* [*Fearful Words*] (plate 356), these are very similar in character to his works on canvas of the same period. (The draftsmanship here anticipates Picasso's experiments with primitivism at the time of *Les Demoiselles d'Avignon*.) Other examples, though, embody a very free approach that derives directly from the fluidity of the medium. In *Tahitian Landscape* (plate 357) it seems almost that Gauguin has surrendered himself to the tangle of trees and foliage and has set it down with a fluency that springs from some subconscious source. He is not describing a landscape so much as conjuring it up with an improvisational technique that has something in common with automatic writing. Gauguin displays an ability to "enter"

357. Paul Gauguin (1848–1903)
Tahitian Landscape, 1891–93
Watercolor on paper,
8½ × 9¹⁵/₁₆ in. (21.6 × 25.2 cm)
Musée du Louvre, Paris

the scene that is reminiscent of Turner at his most extemporaneous, though his method owes more to the calligraphic approach to watercolor evolved by other members of the French School, and his sense of pattern is very much in evidence.

Te Nave Nave Fenua [*Tahitian Eve*] (plate 358) is a handsome figure study, bearing the mark of divisionist influence, while *Papa Moe* [*Mysterious Water*] (plate 359) is an example of Gauguin's ability to interpret the mystical aspects of Tahitian culture, though it might be argued that he transformed that culture in his work by viewing it through a distorting lens of Western pantheism. In this instance he was probably

358. Paul Gauguin (1848–1903)
Te Nave Nave Fenua [*Tahitian Eve*], c. 1892
Watercolor on paper,
15¹¹/₁₆ × 12½ in. (39.9 × 31.8 cm)
Musée de Grenoble,
Grenoble, France

359. Paul Gauguin (1848–1903)
Papa Moe [*Mysterious Water*], c. 1893
Watercolor on ivory wove paper,
13³/₄ × 10 in. (34.9 × 25.4 cm)
The Art Institute of Chicago;
Gift of Mrs. Emily Crane
Chadbourne

also influenced by Egyptian mural paintings, of which he owned photographic reproductions.

In his exoticism, Gauguin was perhaps a true Victorian—heir to Orientalists like John Frederick Lewis—yet, in his ability to shed deeply ingrained artistic conventions, he was a genuine harbinger of modernism.

Vincent van Gogh was hardly a classical watercolorist, yet he often used watercolor, either alone or in conjunction with crayon, ink, or gouache. Watercolor lends itself naturally to the atmospheric use of color, but van Gogh tended to build instead from strong contrasts. This is true even in such early examples as *Women*

360. Vincent van Gogh (1853–1890)
Women Miners, 1882
Watercolor with gouache on
paper, 12 9/16 × 19 11/16 in.
(32 × 50 cm)
Rijksmuseum Kröller–Müller,
Otterlo, The Netherlands

OPPOSITE

361. Vincent van Gogh (1853–1890)
Summerhouse with Sunflowers, 1887
Pencil, pen and ink, and blue
and green watercolor on paper,
12 × 9 1/2 in. (30.5 × 23.9 cm)
Rijksmuseum Vincent van
Gogh, Amsterdam

Miners (plate 360), when his palette was still somber and almost monochromatic. The fundamental strength of his vision is apparent in such early works, and by the time he painted *Summerhouse with Sunflowers* (plate 361) he had arrived at the wholly original style that was to prove so influential and that is as fully realized in his works on paper as in his work on canvas. Paintings like *Summerhouse with Sunflowers* depend on a linear energy that was to influence many twentieth-century artists. In this instance, much of that energy is provided by the basic pen drawing, though drawing with the brush in color direct from the pan or tube amplifies it. Like Gauguin, van Gogh was among the first of the protomodernists to appreciate the power of two-dimensional pattern. In *Hospital Corridor at St. Remy* (plate 362), painted in the asylum to which he had had himself committed, he displays how effectively a strong two-dimensional design can be combined with the use of perspective. In this instance, the perspectival presentation of the architecture actually creates the two-dimensional pattern.

Of all the artists of this generation, it was Paul Cézanne who was to prove the most influential for the modernists of the early twentieth century, and much of his influence was due to his late work in watercolor. It could be argued, in fact, that no body of watercolors—with the single exception of Turner's—has had more influence on the art world at large, as opposed to the watercolor practitioner in particular. Undoubtedly, Cézanne is among the most important watercolorists of any century, and his ability in the medium is apparent even in such early works as

The Hilly Road (plate 363), a nicely handled landscape, loosely brushed and with a fresh feeling for color. The composition seems casual at first glance, but the fact that Cézanne has added a strip of paper at the left-hand side suggests that it was carefully considered. By the time he painted *Roofs at L'Estaque* (plate 364) he was in complete control of the medium, using its transparency to excellent effect. The presentation of the rooftops and chimneys in the foreground is already highly architectonic, anticipating a key aspect of his later work.

Swimmers (plate 365) is a sheet of figure studies drawn directly with the brush. These figures were incorporated into other paintings, but here the viewer has an opportunity to see Cézanne's visual intelligence at work. Thoughts are "frozen" in watercolor, and this, too, looks forward to Cézanne's late watercolors, which are like records of elaborate plastic and intellectual thought processes. *View of a Bridge* (plate 366) is a beautifully conceived sketch in which the deep perspective demanded by the viewpoint is offset by the symmetry of the bridge, which introduces a note of flat pattern.

This landscape makes extensive use of virgin white paper, which Cézanne would come to employ ever more effectively. Throughout the nineteenth century, watercolorists had used virgin paper to indicate the sparkle of sunlight on water, or to describe the white of a dress or a shirtfront. As soon as the paper support is used in this way it takes on the secondary responsibility of performing a spatial function. (Where is that white shirtfront located in relation to the red flowers?) Cézanne took increasing advantage of this until he reached the point where the spatial function was no longer secondary but could actually become a prime organizational factor. In

364. Paul Cézanne (1839–1906)
Roofs at L'Estaque, 1878–82
Watercolor on paper,
12¹⁄₈ × 18⁵⁄₈ in. (30.8 × 47.3 cm)
Museum Boymans–van Beuningen,
Rotterdam, The Netherlands

365. Paul Cézanne (1839–1906)
Swimmers, c. 1890
Watercolor on paper,
8³⁄₁₆ × 9⁷⁄₁₆ in. (20.8 × 24 cm)
The Metropolitan Museum of
Art, New York; Gift of Mabel
L. Rossbach, 1964

366. Paul Cézanne (1839–1906)
View of a Bridge, c. 1895–1900
Brush and watercolor over
black chalk on paper,
19¼ × 23⁹⁄₁₆ in. (48.9 × 59.8 cm)
Yale University Art Gallery,
New Haven, Connecticut; The
Philip L. Goodwin Collection

paintings like *Vase of Flowers* (plate 367) he was already using large areas of white paper to set off the signs, marks, and patches of color that define the image. Now the use of virgin white to describe local color becomes secondary. Instead, the virgin page becomes the air in which the image breathes.

By the time he painted *Rocks near Bibemus* (plate 368), Cézanne's watercolor style had reached its full maturity. The treatment of rocks and vegetation is very spare, and the washes—applied almost as vectors rather than patches—describe the scene but also build up an allover design almost independent of the subject, one that later observers would read as approaching abstraction, though Cézanne himself, presumably, did not see it that way. Cézanne's distrust of outlines has often been remarked upon, and here it can be seen how he suggested edges, rather than defined them, by means of an idiosyncratic pencil calligraphy. Watercolor must have appealed to him, in part, because its transparency provided him with a way of marking edges that was not quite so immutable as those made with pencil or ink. Indeed, by combining watercolor with multiple pencil marks, he was able to create a kind of "floating" edge that seems to redefine itself as the visitor looks at the picture. Because of this, the image almost vibrates with energy, possessing a feeling of life unique to Cézanne's late work.

In a sense, it can be said that Cézanne took the calligraphic approach of School of Paris watercolorists and slowed the process down. Instead of the rapid brushwork of Berthe Morisot, for example, he employed a considered, analytical approach, yet he preserved the linear energy of the calligraphic style along with its reliance on suggestion rather than precise description. It could be argued, too, that Cézanne's use of white paper to activate his images also derived from the calligraphic style that had evolved in France, though he employed the paper support with a deliber-

ateness and brilliance that was far beyond the ambitions of his predecessors.

In the last decade of his life, Cézanne would refine this technique to the point where he seemed able to define form and dissolve form at the same time. It was this spatial ambiguity, so much more marked in his watercolors and drawings than in his works on canvas, that would make such an impression on Picasso, Braque, and other members of their generation. Often so much paper is left bare in these late watercolors that they seem, at a glance, unfinished. Occasionally, however, he would take one of these paintings a little further in terms of detailed rendering and produce something as fully articulated as *Still Life* (plate 369). There is more of the future, perhaps, in *Rocks near Bibemus*, but this still life, with its purples and blues, its rich browns and rust reds, is one of the masterpieces of nineteenth-century watercolor.

Another artist whose watercolors would have considerable influence after the turn of the century was Auguste Rodin. His works on paper were often more advanced in concept than his sculptures, and *Horseman* (plate 370) is a splendid example of the artist's fluid strength in ink and gouache. If Cézanne had to struggle to express himself with line, Rodin was one of the century's greatest natural draftsmen, and the casual power of his line, combined with his ability to simplify form, gives this drawing a tremendous sense of scale. Considered as a watercolor, it is notable for its skillful and dramatic use of blotted pigment.

Just at the turn of the century, Rodin began to make radically simplified line-and-wash drawings, often of dancing figures, that are astonishing in their freshness

OPPOSITE
367. Paul Cézanne (1839–1906)
Vase of Flowers, c. 1890
Watercolor and pencil on
paper, 18⁵/₁₆ × 11¹³/₁₆ in.
(46.5 × 30 cm)
Fitzwilliam Museum,
Cambridge, England

ABOVE
368. Paul Cézanne (1839–1906)
Rocks near Bibemus, 1895–1900
Watercolor and charcoal on
paper, 12³/₁₆ × 18¹¹/₁₆ in.
(31 × 47.5 cm)
Staatliche Graphische
Sammlung, Munich

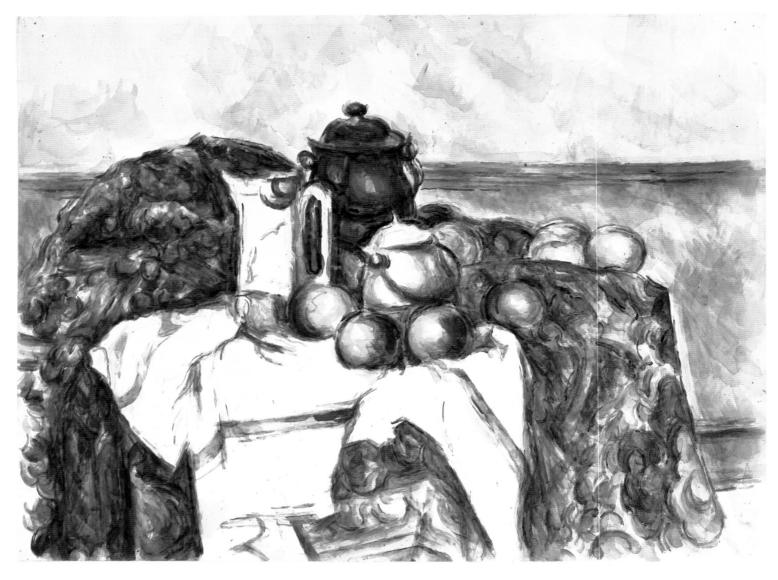

369. Paul Cézanne (1839–1906)
Still Life, c. 1900–1906
Watercolor over graphite on paper,
18⁷/₈ × 24⁷/₈ in. (47.9 × 63.2 cm)
The J. Paul Getty Museum, Malibu,
California

370. Auguste Rodin (1840–1917)
Horseman, c. 1889
Pen and black ink with wash and
gouache on ivory wove paper,
7⁵/₁₆ × 5¹/₂ in. (18.6 × 14 cm)
The Art Institute of Chicago;
Alfred Stieglitz Collection

371. Auguste Rodin (1840–1917)
The Rising Sun, c. 1900–1905
Graphite and watercolor on cream
wove paper,
19 × 12¹/₂ in. (48.3 × 31.8 cm)
The Art Institute of Chicago;
Alfred Stieglitz Collection

and freedom from artifice. Typically, like *The Rising Sun* (plate 371), they are the briefest of outline drawings tinted with a wash that often does not match the pencil lines but has an independent existence of its own. The impact these drawings had on Matisse and other modernists is quite evident, but they belong more to the history of drawing than to the history of watercolor, and they are more of the twentieth century than of the nineteenth.

In truth, however, the twentieth century is waiting to happen almost anywhere the viewer looks when studying the watercolors of the 1890s. On the one hand, future modernists like Franz Kupka (plate 372) were exploring the limits of Symbolism while still wearing all the trappings of Victorian illusionism. On the other, *fin de siècle* visionaries, like the Scottish architect and designer Charles Rennie Mackintosh, were exploring concepts that verged on abstraction (plate 373).

The interstices between the nineteenth century and the twentieth are fascinating to explore precisely because, from the present perspective at least, no two centuries could seem more different. It is easy to forget, in fact, that the pioneers of modernism were Victorians by upbringing. Photographs of Matisse show not a bomb-throwing anarchist, but a circumspect and proper bourgeois gentleman of the old school. Picasso and the other inhabitants of the ramshackle Bateau Lavoir Studios were simply living out a bohemian tradition that had been sanctioned decades earlier, while even so mercurial a spirit as Marcel Duchamp, for all his iconoclasm, was perfectly at home in his brothers' strait-laced Sunday salon at Pu-

372. Franz Kupka (1871–1957)
The Soul of the Lotus, 1898
Watercolor on paper,
15¹/₁₆ × 22¹¹/₁₆ in. (38.5 × 57.7 cm)
The National Gallery, Prague

373. Charles Rennie Mackintosh
(1868–1928)
The Tree of Influence, 1895
Pencil and watercolor on
paper, 8³/₈ × 6¹¹/₁₆ in.
(21.3 × 17 cm)
Glasgow School of Art

teaux. Probably it was not until the Café Voltaire that a real change of demeanor came about, and even those pioneer dadaists found it useful to dress like pompous Victorian stereotypes in order to parody and puncture Victorian conventions.

Of the first generation of modernists, nobody followed the logic of antinaturalism more vigorously to its conclusion than Piet Mondrian. With his horizontal/vertical grids and his strict use of primary colors, he became one of the artists who would define modernism for the public at large, a painter so far ahead of his time that a quarter of a century after his death his art was being imitated on T-shirts and mini-dresses. Yet Mondrian was very much a product of his nineteenth-century upbringing. The values he cherished throughout his long career were already abroad when he was a young man. When he painted *Chrysanthemum* (plate 374) in 1906, he was already thirty-four years old and still a decade from his final break with figuration. It becomes clear that a painting like this can be seen in two ways. In its

374. Piet Mondrian (1872–1944)
Chrysanthemum, 1906
Watercolor and charcoal on
paper, 14⁷/₁₆ × 8¹⁵/₁₆ in.
(36.7 × 22.7 cm)
The Minneapolis Institute of Arts;
Gift of Bruce B. Dayton, 1983

simplicity of concept and unfussiness of execution it looks forward to Mondrian's mature work. In its choice of subject matter and closeness of observation it looks back to Ruskin and his followers.

So it was with the whole of watercolor as the nineteenth century came to a close. This was the end of an era. The watercolor societies would never again enjoy the power and position they once had, and photography had already taken over many of the descriptive functions that had made watercolor such a valuable tool. Yet in the hands of Cézanne, Rodin, or Mondrian, watercolor was still a potent medium that would survive into the next century and continue to bear fruit.

In our own time, watercolor is enjoying a revival, as artists learn once again that the medium has unique properties that cannot be duplicated. Once more, watercolor is being put to many purposes, pushed in many directions, and as always is proving its flexibility and versatility. Wherever artists steer it, however, they will always find themselves looking back to the masters of the nineteenth century, who proved once and for all that watercolor was an expressive medium capable of supporting the highest ambitions.

Notes

CHAPTER TWO

1. Jonathan Wordsworth, Michael C. Jaye, and Robert Woof, *William Wordsworth and the Age of English Romanticism* (New Brunswick, N.J.: Rutgers University Press, 1987), p. 68.

2. For a complete discussion of the attributions assigned to *Tonbridge Castle, Kent*, see Malcolm Cormack's *J.M.W. Turner, R.A., 1775–1851*, a catalogue of the Turners in the collection of the Fitzwilliam Museum (Cambridge: Cambridge University Press, 1975).

3. Martin Hardie, *Water-colour Painting in Britain* (New York: Barnes and Noble, 1967), vol. II, p. 11.

4. Ibid., p. 26.

5. Martin Butler, *Turner Watercolours* (New York: Watson-Guptill, 1962), p. 34.

CHAPTER THREE

1. Martin Hardie, *Water-colour Painting in Britain* (New York: Barnes and Noble, 1967), vol. II, pp. 100–101.

2. Jonathan Wordsworth, Michael C. Jaye, and Robert Woof, *William Wordsworth and the Age of English Romanticism* (New Brunswick, N.J.: Rutgers University Press, 1987), p. 65.

3. Bernard Brett, *A History of Watercolor* (New York: Excalibur Books, 1984), p. 14.

4. Martin Hardie, *Water-colour Painting in Britain* (New York: Barnes and Noble, 1967), vol. II, p. 197.

CHAPTER FOUR

1. Martin Hardie, *Water-colour Painting in Britain* (New York: Barnes and Noble, 1967), vol. II, p. 174.

CHAPTER FIVE

1. Martin Hardie, *Water-colour Painting in Britain* (New York: Barnes and Noble, 1967), vol. II, pp. 102–3.

2. Jonathan Wordsworth, Michael C. Jaye, and Robert Woof, *William Wordsworth and the Age of English Romanticism* (New Brunswick, N.J.: Rutgers University Press, 1987), p. 29.

3. Martin Hardie, *Water-colour Painting in Britain* (New York: Barnes and Noble, 1967), vol. II, p. 159.

CHAPTER SIX

1. Walter Koschatzky, *Watercolor: History and Technique* (New York: McGraw Hill, 1970), p. 69.

CHAPTER SEVEN

1. For a discussion of Queen Victoria as a watercolorist, see Marina Warner, *Queen Victoria's Sketchbook* (London: Macmillan, 1979).

2. Martin Hardie, *Water-colour Painting in Britain* (New York: Barnes and Noble, 1967), vol. III, p. 49.

3. Ibid., p. 135.

4. Ibid., p. 136.

CHAPTER EIGHT

1. John Ruskin, *Collected Works* (London: George Allan, 1903–12), vol. IV, p. 368.

2. For an extensive discussion of Ruskin's influence in America, see Linda S. Ferber and William H. Gerdts, *The New Path: Ruskin and the American Pre-Raphaelites* (New York: The Brooklyn Museum, 1985).

Selected Bibliography

Brett, Bernard. *A History of Watercolor.* New York: Excalibur Books, 1984.

Butler, Martin. *Turner Watercolours.* New York: Watson-Guptill, 1962.

Clifford, Derek. *Watercolours of the Norwich School.* London: Cory, Adams & Mackay, 1965.

Cohn, Marjorie B. *Wash and Gouache: A Study of the Materials of Watercolor.* Cambridge, Mass.: Fogg Art Museum, 1977.

Daulte, François. *French Watercolors of the Nineteenth Century.* New York: Viking, 1969.

Ferber, Linda S., and William H. Gerdts. *The New Path: Ruskin and the American Pre-Raphaelites.* New York: The Brooklyn Museum, 1985.

Girtin, Thomas, and David Loshak. *The Art of Thomas Girtin.* London: Adam & Charles Black, 1954.

Hardie, Martin. *Water-colour Painting in Britain.* 3 vols. New York: Barnes and Noble, 1967.

Hoopes, Donelson F. *Winslow Homer Watercolors.* New York: Watson-Guptill, 1969.

Koschatzky, Walter. *Viennese Watercolors of the Nineteenth Century.* New York: Harry N. Abrams, 1988.

————. *Watercolor: History and Technique.* New York: McGraw Hill, 1970.

Lister, Raymond. *The Paintings of Samuel Palmer.* Cambridge: Cambridge University Press, 1985.

Paladilhe, Jean, and José Pierre Paladilhe. *Gustave Moreau.* New York: Praeger, 1972.

Reynolds, Graham. *A Concise History of Watercolors.* New York: Harry N. Abrams, 1971.

Selz, Jean. *Nineteenth-Century Drawings and Watercolors.* New York: Crown, 1974.

Wilkinson, Gerald. *The Sketches of Turner, R.A., 1802–20.* London: Barrie & Jenkins, 1973.

————. *Turner's Colour Sketches, 1820–34.* London: Barrie & Jenkins, 1975.

————. *Turner's Early Sketchbooks, 1789–1802.* London: Barrie & Jenkins, 1972.

Williams, Iolo A. *Early English Watercolours.* London: The Connoisseur, 1952.

Wilton, Andrew. *British Watercolours, 1750–1850.* Oxford: Phaidon, 1977.

Wordsworth, Jonathan, Michael C. Jaye, and Robert Woof. *William Wordsworth and the Age of English Romanticism.* New Brunswick, N.J.: Rutgers University Press, 1987.

Index

Page numbers in *italics* refer to illustrations.

Photography Credits

Every effort has been made to contact the current owners of the works reproduced and mentioned in this volume. We would appreciate hearing about any changes in ownership or credit lines so that we may update future editions. Please send this information to: Nineteenth-Century Watercolors, c/o Abbeville Press, 488 Madison Avenue, New York, N.Y. 10022.

The photographers and the sources of photographic material other than those indicated in the captions are as follows:

Courtesy Thomas Agnew & Sons, London: plate 114. All rights reserved, © 1989 The Art Institute of Chicago: plates 124, 267, 314, 359, 370, 371. Photography by Bernard: plate 111. Jacob Burckhardt, New York: plates 226, 227. Gamma One Conversions, New York: plates 304, 345. Carmelo Guadagno: plate 143. Seth Joel: plates 201, 203. Peter Lauri, Bern: plate 8. Layland Ross Photography: plate 120. All rights reserved, The Metropolitan Museum of Art, New York: plates 127, 161, 193, 194, 200, 204, 266, 341, 365. Courtesy Musées de la Ville de Paris: plates 136, 137. All rights reserved, © 1990 the Museum of Fine Arts, Boston: plates 148, 151, 330, 344. Courtesy Norfolk Museums Service, Norfolk, England: plates 79, 80, 84, 87, 88, 91. All rights reserved, © the Prado Museum, Madrid: plate 103. Courtesy Réunion des Musées Nationaux, Paris: plates 109, 110, 122, 125, 128, 130, 131, 134, 135, 196, 198, 199, 205–7, 310, 320, 322–324, 348–350, 352–354, 357. Courtesy the Spanierman Gallery, New York: plates 301, 302. Stedelijk Museum, Amsterdam: plate 361. Courtesy Tyne and Wear Museums Service, Newcastle upon Tyne, England: plates 95, 256. Elke Walford, Hamburg, Germany: plate 104. Copyright © 1987 Frederick Warne & Co.: plates 189, 190. Windsor Castle, Royal Library, London, © 1989 Her Majesty Queen Elizabeth II: plates 12, 25, 229.